# The Future of Art

*An Aesthetics of the*
*New and the Sublime*

Marcella Tarozzi Goldsmith

STATE UNIVERSITY OF NEW YORK PRESS

Published by
State University of New York Press, Albany

© 1999  State University of New York

For information, address State University of New York Press,
State University Plaza, Albany, NY 12246

Production: Laurie Searl
Marketing: Fran Keneston

**Library of Congress Cataloging-in-Publication Data**

Tarozzi Goldsmith, Marcella, 1943–
    The future of art : an aesthetics of the new and the sublime /
Marcella Tarozzi Goldsmith.
        p.    cm. — (SUNY series in aesthetics and the philosophy of
art)
    Includes bibliographical references and index.
    ISBN 0-7914-4315-9 (alk. paper). — ISBN 0-7914-4316-7 (pbk. :
alk. paper)
    1. Aesthetics.  2. Art—Philosophy.  I. Title.  II. Series.
BH39.T3695 1999
111'.85—DC21
                                                                    98-54723
                                                                    CIP

10  9  8  7  6  5  4  3  2  1

To the memory of Enzo Melandri *in primis*.

# Contents

# Acknowledgments

This work is dedicated to my intellectual friendships and friends who have inspired me through the years: to my sister Alba Maria Tarozzi, for providing me with precious books, to Paola Vincenzi, Alessandra Sandri, Paoletta Dalla Favera, and Véronique Fóti. And to Dr. David B. Friedman for giving me access to different ideas.

A special thank you to Carl Lesnor, whose help in deciphering French texts was invaluable. I also want to mention Adele Lerner from whom I learned to keep records and to value what is worthy of value.

Thank you to my husband, David Goldsmith for his patience and impatience with me concerning my use of the computer.

Thanks to the books that I have read, and to their authors both known and unknown to me.

# Introduction

The thesis presented in the following pages is both simple and enigmatic: my intention has been to ascertain the truth of art in its different aspects, subjective and objective, in other words, that which is necessarily possible, meaningful, and finally innovative. Once the priority of the work of art over theory has been accepted, philosophy is concerned with amplifying art's meaning, so as to make it as fully as possible accessible to thought.

Since the aesthetic sense was born together with art, that is, simultaneously, and considering that much has already been written about the structure and function of art since the official inception of aesthetic theory, and about the place of art in the overall space of philosophical discourse, what remains to be considered here is the development of an idea that points to the new and leads to a reevaluation of the work of art as being neither necessarily beautiful nor necessarily ugly. Moreover, once it has been established that the structure of each work of art underlies and determines the function of art (which may be quite different in each art form), the problem of whether the work is perceived as being purely subjective or objective becomes only one aspect among many.

This does not mean that the privileged point of departure for understanding what is involved in a work of art is devoid of subjective evaluations. The subject in question, however, must not be understood metaphysically as the substance or determining structure of traditional philosophy. The subject that is invoked here is in the making, just as the work itself is in the making, acquiring its truth and reality both by being

perceived and by hiding that same truth. It is, therefore, a volatile subject, ready to cancel itself out once the experience of art is replaced by different modes of perception. The new, since it requires a state of receptivity that is quite alien to the subject as theorized by its proponents, excludes any definition. The new requires, instead, a state of flux that can be ascribed only to a subjectivity in the making, never complete, and, therefore, never quite subjective. Subjectivity encounters something that is "material" and capable of being understood. In order to arrive at the union of subjectivity and materiality, what is required is a plurality inclusive even of those theories which deny plurality. Therefore, the first step will consist in examining those theories which are significant in terms of depth and originality.

It should be reiterated that art and the aesthetic outlook on the world are to be situated on the same plane. To say otherwise would be like saying that beauty is given a priori, to be admired and imitated. Even the beauty of nature does not always provide the condition needed for advancing in the direction of art and subsequently of an aesthetic theory. Art would have been invented without the help of a beautiful nature, since beauty is not a necessary component of the work of art. Artists do learn from nature, but also from theory thanks to their extraordinary perception. At the same time, philosophers learn from the artists how to use the hermeneutical instruments that will reveal the meaning of the work of art. To the theoretician is given the task of shedding light on the externalizations of genius, to the artists the difficult task of inventing the new.

The first part of this work starts with a discussion of what art is, according to a number of philosophers who ventured to interpret the significance of an activity that transcends the everyday. The role of subjectivity, therefore, must be considered, since the domain of art was viewed as the ideal terrain for the understanding of an inescapable freedom. Friedrich Schiller, in combining together form and play, discovers one possible locus for the untruth of art.

Some mention must be made of why the philosophy of Immanuel Kant is considered only peripherally and only in relation to the sublime. Kant opened the way to a view of art at least as influential as that of Georg Hegel or Schelling; however, in my view, his work presents the defect of consigning art to taste, an approach that has been defeated by history. Kant, notwithstanding his heroic transcendental deductions, tried in vain to give beauty universality and autonomy. The role of imagination, which is an important component of the artistic and aesthetic process, and the laudable

exclusion of concepts from art, are, however, insufficient for explaining the experience of art. Schiller sought to avoid Kant's intellectualism by focusing on a different aspect of art: that of reassuring that semblance is, after all, reliable, at least in combining ethereal beauty with freedom.

In trying to ascertain the viability of the notion of subjectivity, whether it is adequate to the task of containing the work of art, it became necessary to explore the role of imagination, desire, and the will and to point out the differences and similarities of their respective domains. (Faust, this artist *manqué*, is an example of importance here, since his elusive will brings about a self-transcendence which is neither real nor ideal *to him*.) But noting the insufficiency of a merely subjective approach, since it leads to the disappearance of the aesthetic act, the second chapter examines the role of myths and the necessity of art. Schelling provides the framework for understanding art as objective. He sheds light as to how and why art must have the role of representing the real side of an infinite intuition, whose aim is to reveal the truth of mythology and finally of allegory. Schelling's intentionally incomplete philosophy was easy prey to Hegel's sarcasm, but his theory of the mutual informing of the real and ideal potencies in the different forms of art indicates how the work of art can be the most accomplished and complete "object" that humans can ever envision. Metaphysics aside, an attempt is made to show the interrelations that obtain within the work of art once mythology leaves room for further intuitions. In foreseeing a future completion of philosophy, Schelling puts forth the idea of a "positive" outcome for art.

"Philosophy as the Organon of Art" (chapter 3) takes into account a different approach to aesthetics. Considering that an objective view of art's meaning encounters unsurpassable metaphysical problems, the attempt is made to make of Hegel's aesthetics a viable alternative. Hegel's trinitarian rationality, his systematic use of the concept, however, leave art open to negativity. Incapable of self-justification, art meets an honorable "death" at the hands of the concept itself. The concept's all-encompassing voracity makes art something that must be sublated. Symbolic art, classicism, romanticism, including the beautiful and the sublime, all concur in the defeat of their own premises. The Hegelian system treats art as if it were something to be dismissed once the logical categories have *again* been purified from the dross of sensuousness.

The Hegelian regression calls for a new beginning, which is undertaken in the three chapters of the second part, where I examine the New, conceived of as that particular element which challenges imitation, art's

relation to truth, and meaning. Wilhelm Dilthey's hermeneutics can be said to have started from the zero point where Hegel left art. The emphasis on meaningful expression, the psychology involved in the appreciation of beauty and the sublime, make art that human activity whose aim is to intensify the structure of intersubjectivity. Art so understood is the result of creative acts excluding neutrality in any form. However, the notion of neutrality can still be used to avoid a moralistic conception of art, it even becomes necessary when the idea that art must be beautiful (or ugly, for that matter) tries to prevail at the expense of style.

To put forth style as the ultimate requirement for art may involve the danger of abandoning art to a decadent formalism. "From Artifice to the Will" (chapter 5) reiterates the theme of the "resurrection" of art in a different guise, with the additional awareness that art may perish at the hands of nihilism. Nietzsche is the philosopher who, in consigning art to the artist of the future, to the Overman, and above all, to becoming, was well aware that art was in shaky hands. The danger of nihilism, of decadence, lurks at every step taken in an impossible project, that of pleroma, of an uncontaminated, unfragmented knowledge. Even so, art emerges as one of the few activities worthy of being cultivated. Art is the outcome of the will to power, which, in this case, assumes the antimetaphysical function of denying truth to its own creation. Thus, the possibility of a sublime nihilism emerges, a form of nihilism that desperately denies its own premises.

The philosophical and artistic consequences of Nietzsche's thought have been enormous. To him we owe the resurgence of rhetoric, the putting aside of beauty as the exclusive object of art, the attempts at saving what could be saved, that is, the relevance of the whole aesthetic domain, which came to be conceived of as consolation and also as having within itself the power to raise us to the sublime. All this is due to Nietzsche.

Chapter 3 of part two considers these factors as still pertinent to the contemporary world view, which has stressed negativity at the expense of beauty. Once utopia has been discarded and the impossibility of beauty acknowledged, we are ready to perceive the horizon of postmodernity. Yet this mode of understanding and interpreting the aesthetic domain is far from having the last word. If a transition is in the making, this does not mean or indicate that postmodernity is the definite answer to a philosophical crisis oscillating between the complete rejection of subjectivity and the affirmation of its own negativity.

Negation not being absolute, part three or "Subjective Aesthetics" of this work reactivates the subjective role of imagination together with the

sublime, thus returning to themes from the initial chapters which have established the relevance for art and aesthetics of self-transcendence. The subject that is here considered is not the Cartesian subject of certainty. The "aesthetic subject" is that subject which puts itself in question when facing the sublime or when asking itself the question of its own relevance vis-à-vis art. It is that type of subject which has resulted from the impact with a structure in which neither the object nor the subject gains definite prominence. Considering this "partial failure" of the subject (it is not completely subjective), even the role of the unconscious is limited to raising the question of the validity of its own doing. Because of this, hermeneutics becomes the indispensable philosophical tool through which the truth of art emerges as both transitory and constantly reconstituted. That is why the fleeting sublime has an important role to play, and that is why this theme recurs at almost every step of the discussion. The sublime enjoys a privileged status because the experience of beauty has been eroded by beauty's pretension to be beyond time. Its metaphysical ground has collapsed and cannot be revived.

Hermeneutics provides few definite conclusions, these are the result of interpreting philosophical language as it has been transmitted to us in such a way as to be held "hostage" to temporality. A method such as hermeneutics teaches that the truths of the past can be explored in a manner that opens the door to new, previously unexplored truths. Interpretation does require mental and linguistic tools capable of bringing to the surface what was implicitly said in a different language. One of the functions of hermeneutics is to connect these different languages so that, within bounds, it can be argued that everybody says the same thing in different ways. This paradox is exactly what points to the new—an indispensable category if art is to be understood *iuxta propria principia*.

The more one tries to find in the new the truth of art, the more the sublime will be seen as essential to the understanding of art, and the human response to the sublime will become an essential part of not only the aesthetic experience but also of theory. Art's "mechanisms," unforeseeable in their consequences, are responsible for the sublime and for the new, and also for the tragedies and comedies to which we must become accustomed if we want to retain the sense of a fertile uncanny. Nietzsche, I think, would accept this conclusion. In order to give their deserved prominence to these aspects of art, I devote an entire section to considering the debated role of tragedy and comedy in philosophical thinking. As antidotes to the stagnation of the "dead subject," tragedy and comedy

(like irony) distort and alter truth. They make clear that truth, as traditionally understood, is something neutral that must be questioned at every step. Psychoanalysis has attempted to question truth, seeing truth as that which eludes consciousness. Nihilism has gone further in this direction, since it has made consciousness the irrelevant advocate of acquired truths without resorting to any salvific remedy such as history (personal or suprapersonal) or the good. Because of the intrinsic importance of these movements, psychoanalysis and nihilism are discussed here for their contribution to aesthetic sensibility. However, psychoanalysis is not used for interpreting this or that work of art, immanent criteria are sufficient for this task. The insights of psychoanalysis are more important when its concepts are directed to art qua activity.

What is called in chapter 7 "the unconscious subject" is nothing but the volatile confluence of truths held together by imagination and intuition, consciousness and the unconscious. That is why the subject is both the tragedy and the comedy of truth. The subject is capable of ascribing meaning, if not to itself, at least to the truth of what results from the amalgam of given perceptions, which nowadays are called "data." The unconscious subject is both subjective and objective, comedy and tragedy. Especially in the present age the subject acts and reacts both at the conscious and at the subliminal level. When it subjectivizes, it can extend the domain of the objective, and when it objectifies, it expands the domain of the subjective. This chiasmus contains the truth of art qua self-transcendence, for self-transcendence is the in-between notion needed to circumvent the nihilism that became prominent from Nietzsche on as a barrier against systematism.

The new is an aesthetic category, but art requires also a formal style. In addition, the new is something objective but not objectifiable, at least not at its inception; and it will remain ineffable until further notice. The Overman is far from having a privileged viewpoint or perspective in this regard; indeed the Overman is pathetic more than tragic or comic. But in an age in which the tragic is trivialized (together with the comic) one possible answer to the prevailing indifference is to trust in the sublime. The sublime is the resolution of the tragic: in tragedy the subject is objectified; in the sublime it is forgotten, to become that which is "not yet."

The truth of art consists, therefore, in transcending the subject of knowledge and the insidious recurrence of the object. Hermeneutics finds there the becoming of its truth. But neither tragedy nor art's possible neutrality vis-à-vis the object and the subject nor "art for art's sake" will ever

give us a complete view of what art can be. Even the sublime, which is the supreme artistic "form," still deprives us, because of its limited intelligibility, of the full meaning of art.

Art, but also aesthetics, can be said to rest on a metaphysical nothingness, which becomes the "ground" on which subjectivity acts. Ineffable as art itself, subjectivity expands side by side with the sublime, whose ultimate significance is to give us the highest point that art can reach. The sublime is privileged because beyond it nothing can be thought. It is irreplaceable and dogmatic in its own way, it stands for a true beyond without beyond. (The sublime is dogmatic because its intelligibility cannot be communicated to another agent, one either experiences it or one does not. It is the result of an immediate apprehension.) It follows that an aesthetic theory reaches its consummation when it accounts for the sublime. Even though aesthetics leaves the experience of the sublime unexplained because aesthetics cannot show us its subjective or objective causes, a theory can at least make clear why the sublime is essential to art. Without the sublime, art itself would become, after the "disappearance" of beauty, a "perfect" *nihil*. The sublime is the extreme limit of art and of the subject itself. This fact brings the sublime close to nihilism. Even the will to power is permeated with sublime intentions. However, nihilism must yield to the sublime to proclaim the priority of the senses and of a sensuous truth.

I started from the subject, and after having subjected it to criticism, I return to a subjectivity which has been transformed in such a manner as to become ineffable. This is the meaning of the aesthetic experience, of an aesthetic act which belongs to the artist, to the receiving public, and to philosophy—not in equal measure, of course, for to the artist belongs the right, so to speak, of primogeniture. This is why artists understand their works in a way different from the way of the philosopher, and that is why the two modes of apprehension complement each other, forming the truth of an imperfect reciprocal self-transcendence.

# Part One

# The Historical Side of Aesthetics

In the beginning was the new

In the beginning is the new

# CHAPTER 1

# The Birth of Aesthetics

---

## ART ON THE OFFENSIVE

Quite literally, imagination, since Kant, Schiller, and Schelling, has been considered one of the sources of the beautiful and, consequently, of art. For Schiller art is close to feeling, and its supreme task is one of uniting, like intuition, what understanding separates. The synthetic proficiency of the aesthetic is something that must first be imagined and second demonstrated; such a task is possible since imagination demands a transcendental fusion of absoluteness and finitude. Forgetful of reason only to reintegrate it in the chiasmus that obtains between sense and form, imagination, assisted by feelings and intuition (also an instrument of synthesis), forms an "insubstantial realm,"[1] of a higher order than that offered by sense-dependent reality. What the aesthetic has to offer is neither truth or moral achievement, nor the useful, which is capable of taking care of itself; it is above all harmony and freedom, the search for a precarious completeness. In Schiller the aesthetic has separated itself from nature and sheer sensuousness (though it will reabsorb them at a higher level) and from absolute form. The intricate interconnections between these two aspects increase the danger of one prevailing at the expense of the other, but Schiller insists that they can reach a quasi-perfect union even by remaining distinct; and more cannot be expected given human finitude which can only long for an ideal, whole, completion.

As an end in itself the "play-drive," as Schiller calls the middle road between the immanent, natural drive and the rational one, offers serenity

and, in terms of the artworks, a tempered classicism. It also gives freedom, but, looking carefully, that result which is art is seen to be a determination which does not free itself from two different compulsions, and that is why freedom here coincides with necessity. The realized reciprocity of which ideally the two human drives are capable will be reflected in the finitude of the work of art. Finitude cannot reveal the "why" of art, beauty cannot be explained;[2] a residue of empiricism (beauty is a fact, a given) is counterbalanced by the Kantian framework which leads in the opposite direction: the formal, and therefore the antiempirical, is emphasized as explaining a "neoclassical" theory that justifies music's emotionality and architecture's formalism.

The immanence of the aesthetic excludes the imitation of the ideal in its transcendent function, what we have is semblance (*Schein*), whereby both the work and the ideal are semblances as compared with the inexplicable existence of matter. Here Schiller suspends judgment; his agnosticism as to the "why" of beauty leads him to declare the epistemological ineffectiveness of the aesthetic vis-à-vis truth. Yet, what cannot be denied is the human capacity to assent to an inner moral law and to give form to the passivity of sensations. An always unstable equilibrium, nonetheless an equilibrium, haunts Schiller's optimism as to the perfectibility of the human race via aesthetic education. This tentative optimism will be shattered by the nihilism of the twentieth century. The utopian element lurking here, if utopianism is not understood as the nowhere of art, consists in placing the aesthetic between a real determination and an ideal one; one-sided it cannot be, for then it would be abstract. There is nothing bombastic about a utopian element which makes art the rival of tragedy; Schiller's is a subdued utopia governed by taste, feelings, and a reasonable amount of reason. Tragedy does not belong to pure art because it hides within itself a purpose, namely, pathos;[3] its freedom is therefore limited vis-à-vis the other arts. However, it is impossible, within Schiller's framework, to assign to each art a definite place in a hierarchical order, as Hegel and Schelling did later; and this is because the ideal is the common source of the individual artists, and because feelings and reason, though distinct, share the same chiasmic structure.

The relation between reason and passion, or feeling, has puzzled more than one philosopher, Blaise Pascal being one of them; Schiller cannot add more to this venerable opposition other than the consideration that reason and feeling coexist, being distinguishable both empirically and philosophically. The resolution of such an opposition is typical of art, and

here resides its utopian character which separates it from every other endeavor. A third position, therefore, made necessary by reason itself, by the regulative, rational concept of Beauty,[4] leads to the necessity of form which is declared logically prior to the manifold; but the final harmony of art qua play is both our doing and a demand of reason. Gottfried Leibniz's distinction between truths of reason and empirical truths is not forgotten by Schiller; the "harmonization" of the two, which Leibniz tried to achieve logically,[5] is conceivable only thanks to art; it cannot be known. Two different principles cannot be absorbed into each other; however, they can, on account of their chiasmic reciprocity, go hand in hand harmoniously.

Being utopia, art's proper domain is that of the artificial; beauty is compatible with this artificial character, notwithstanding Schiller's declaration that the aesthetic is a gift of nature, because it is other than taste. Taste, an eighteenth-century subjective invention, signifies first of all spontaneity, an innate capacity whose relevance will vanish in the course of time when more objective standards replace it. Schiller makes taste the Ariadne's thread that brings forth the best in us; possessing it is an indication of spiritual accomplishment, the result of a rarefied milieu, opposed (also then) to the vulgarity of the times. Taste is the necessary but not sufficient condition for art; its ultimate provenance is mysterious, but, being allied to the beautiful, it completes the aesthetic dimension, which Schiller tries to divest of its potentially decadent power. Concerned as he is about giving a balanced account of beauty, Schiller formulates an aesthetic of the imagination and fantasy, fortunately not tied to a realistic vision of what constitutes art. Beauty is intangible, captivating power, the daughter of freedom, form, life; endowed with its own rationality, it is a matter of experience, but its explanation requires transcendental tools. Even so, the transcendental subject is not everything; confronted with beauty's semblance, artists also submit to their creations which are the product, simultaneously, of their rational power and of sensuous inclination, and of freedom.

Even though freedom is not a conquest in that it is "an effect of Nature . . . and not the work of Man,"[6] and therefore there is no special merit in the fact of being free, freedom can be cultivated. At this juncture the relevance of culture, bearer of a synthesis that leaves the sensuous and the formal drives unmodified according to what might be called a "principle of tolerance," must intervene. Taste helps to unify society, but it cannot build a new society out of disparate tendencies unless these are compatible with each other from the start. A certain amount of moralism is

present in such a view, which is appropriate to an opus that has not given up on the formation of humanity. As a result, the rejection, on Schiller's part, of a conception of art as having the direct aim of moral edification becomes ineffectual. If there is consistency, it must be looked for in the affirmation that art is play, a disinterested activity.

The mind, which guides play, is already an active synthesis; it is capable of unity thanks to its transcendental power. Far from espousing an empiricist position, Schiller must place the empirical, natural reality of the beautiful in a secondary position in order to construe it as growing out of natural human resources and rational principles. In the end, the result is everything but natural, since this surplus which is art combines the autonomy of play and the discipline of morality.

Is it possible to have an aesthetic, that is, a refined education without the actual existence of art? Given Schiller's premises it would not be possible. Beauty follows necessarily from freedom, sense, and form; if these are the preconditions of art, it is sufficient that one of these elements disappear to shatter the whole pedagogical edifice. That is why Schiller tends to identify freedom with necessity without categorically separating the two notions.[7] It is significant in this regard that the union of freedom and necessity is one of the prerequisites of morality and that the sphere of the beautiful is unquestionably close to the Kantian *Reich der Zwecke*.[8] Art, being akin to morality, runs the risk of losing its autonomy; however, since it elevates the human race to freedom, it is the mark of human spontaneity, whose reality is indubitable and at the same time unexplainable. Although it occupies an in-between region, the aesthetic is given nonetheless a high status among human activities; since it is an end in itself, it does not constitute a transition.

Schiller did not intend the autonomy of the aesthetic to be absolute; autonomy is so called because art and beauty point beyond reality;[9] that is why art and the aesthetic are ultimately free illusions. Consequently, this living form, necessary as it is, rests on both solid and shaky grounds: on the one hand nature must be taken into account, on the other hand spirituality and imagination must prevail.[10] The symmetry present in art testifies to a Zeitgeist when harmony was identified with beauty itself and when beauty's legitimacy was one with its power to harmonize. No definition of the beautiful is more telling than that which qualifies it as necessity. In this regard, the Ideal is the product of the artist who combines, in an expressive manner, the possible with the necessary.[11] While the sensuous drive is there to attest to primary needs, the formal drive specializes

in higher pursuits, making art a possibility; what makes art necessary, instead, is the mediation of the play-drive which partakes of the other two. The play-drive creates the beautiful and not the other way around, and that is why the aesthetic object is possible; its potentiality for being becomes finally actual through a natural and also historical necessity. However, perfection, the full realization of beauty as Idea and Ideal, is not attainable in reality since the two principles or drives will never be in absolute equilibrium given the particularity of experience.[12]

Granted these conditions, is it possible to declare aesthetics a science? Its necessity, a necessity resulting from the chiasmic operation, seems a good candidate to elevate it to such a status. Let us recall that it is reason that informs us about beauty, but reason will always be dependent, empirically, on the multiplicity of nature. The search for something absolute comes to its end when it finds an element that is declared unchangeable and self-grounded, and that is the Person. What better guarantee than a subjectivity made eternal, free to secure the necessity of art? And yet, Personality must reckon with time and Condition; in this game of hide-and-seek between the contingent and the necessary, in which what must be avoided at all costs is the admission of a merely empirical existence of art, Schiller never declares that his aim is to arrive at a science of the aesthetic that would explain the "how" of beauty.[13] This is not surprising, since the necessity of art is not only logical but also aesthetic and moral, based on freedom, not simply on a formal ground. It could not be otherwise since freedom is as much a potentiality as an actuality. The metaphysical affirmation of unchangeability battles, at almost every step of Schiller's account of the aesthetic, with the sensuousness of feeling; the result of this tension is a dual (but not dualistic) conception of beauty.

Reason finds itself in the ambiguous position in which Kant had left it. Destined to produce paralogisms and antinomies, it nevertheless directs human aspirations without dictating any constitutive use of its power. Reason is productive when it is integrated with sensuous reality; then it transforms itself into art. Logic is not completely abandoned by Schiller—the days in which the irrationality of art will be affirmed by the surrealists and the dadaists are still far away. The aesthetic needs reason and form because its object, beauty, is a product of reason as much as of, in its empirical reality, the senses. This circularity is what makes beauty real and ideal, and artists follow both directions; they do not stop at what is empirically given. It would be mistaken to attribute to reason and the Ideal alone an exclusive role, the subsequent imbalance would make art

non-art. The symmetry is obtained thanks to a conception of reason that differs from that expounded by Kant, according to whom pure reason, if extended, brings about logical disorder rather than order. Reason for Schiller is productive of form, and, once it is conjoined with intuition, it makes possible supreme unity.

Freedom itself is affirmed by Schiller unproblematically; such self-assurance is indeed the condition sine qua non for the development of a nonempirical aesthetics. Aesthetics cannot be empirical because Nature in and of itself is incomplete, fragmented. Schiller even advocates, now that the danger of barbarism is over, a "return to her [nature's] simplicity, truth, and fullness—a task for more than one century."[14] This never happened. At the same time, it must not be forgotten that Nature provides one of the two sides of aesthetic enjoyment when art stimulates the sense-drive and then gently yields to make the ideal reach its higher destination. Hence, there are two planes through which Schiller can be read. The first puts Man at the center of the aesthetic experience; the second is the naturalistic side, of which the human being is only a fragment. Human fragmentation may explain why there is more than one art form, but multiplicity is the expression of Nature, not of reason. As a consequence, artists seek to attain a never pre-given harmony; although their works display it as if it were the result of no effort, harmony is not the result of Nature—far from it; it is the intervention of the Ideal that overthrows matter's multiplicity by imprinting form upon the work of art. When Schiller, in his *Die Jungfrau von Orleans*, has Joan of Arc "resuscitated" after her death on the battlefield at the end of the fifth act of the play, he did not simply change and take liberties with history; he altered Nature to provide culture with an allegorical meaning (the final image of Joan covered with flags) dictated by his sense of harmony and morality. The "happy end," whether or not it is artistically valid, corresponds to the desire to make harmony, if not palpable, at least ideally acceptable. In this manner, the utopia of unity is reaffirmed. Hence, Schiller's cautiousness vis-à-vis pure and simple imitation. There is little to imitate if one adheres to a sensuous reality incapable of giving itself form; and, since form is not a substance, art is free, in the "insubstantial realm of the imagination,"[15] to evaporate into playful and pleasurable semblance. The beautiful, like freedom, is, in the end, illusion.

Once the transcendental method is accepted, even with reservations, Nature, at least in relation to the aesthetic, is the tool, the basis, on which art becomes a possibility. At the same time rationality is, anthropologically,

a human drive, albeit distinct from the drive that keeps human beings tied to Nature. Given this framework, why attribute so much importance to feelings? It is a warning to Schiller's age; more profoundly, it anticipates the utopian character of art presented in the pages that follow: art is a whole that never was. The rehabilitation of feeling is part of a "political" project. Feelings cannot be ignored since, if they were to be dismissed, we would be left at the mercy of science and utility; above all the aesthetic must not be confused with the understanding. It is again Kant's philosophy that is accepted and challenged at the same time. Intellectual art (a *contradictio in adjecto*) would result in complete lack of spontaneity and would freeze the mind; more significantly, it would be analytical, not synthetic. Therefore it would neither preserve, nor would it justify the educational goal that Schiller had in mind: the formation and restoration of the whole. It does not matter that the whole is posited as an ideal; it must be sought against all odds in order to elevate society. Qua Ideal, art resembles the nonexistent, and therefore the perfect knot in which everything is resolved.

Art, which is in reality only semblance, is a null objectivity; the thing-in-itself has left no trace, it represents no obstacle to the development of the aesthetic. Art is a subjective mode of being, subjective to the point of no return; humankind may well have two destinies, two focuses, but is one when it directs its invisible powers to visible art.

## THE ROLE OF IMAGINATION

The above discussion has introduced a theme which is essential to the understanding of aesthetics. The reference is to play and, more importantly, to imagination as the condition of desire and of self-transcendence, for both produce the new. The act of transforming reality by providing it with a surplus apparently demanded by reality itself, that is, imagining,[16] is the side effect of a nature understood ontologically; it is the result of necessity which frees itself from matter as mysteriously as matter persists in its state. Freedom, autonomy, and imagination, all concepts entailing one another, are not the same thing: each is the condition of the other, and each conspires in the forming of art; their respective merits are equal.

The origin of synthetic imagination is related to the overcoming of objects (if there were only objects there would be no art), or better, to the attempts at doing so. The mind, from now on caught in the struggle between finite and infinite, aims at the absolute whole. Imagination has a role to play in this search but it must be distinguished from fantasy. Categorically they

are close to each other, but something separates them: fantasy is unbounded, while imagination is still dependent on the reality which it tries to transform. The key word is "transform," because imagination does not make reality unrecognizable. The difference is between the possible and the impossible. Fairy tales are the product of fantasy, not, strictly speaking, of imagination. The fairy tale is the literary genre that best displays such characteristics; these are also found abundantly in mythology where the impossible (for example, the winged horse Pegasus, that "object" which is so worrisome to logicians and philosophers of language) gains the upper hand over the more subdued works of imagination and metaphor. However, fantasy is not confined to the traditional fairy tales and myths; Italo Calvino in his trilogy *Our Ancestors* offers extraordinary examples of the magic of fantasy applied to the moral of the story. *The Cloven Viscount* narrates the predicament of a viscount who, after the war against the Turks, returns home with only the left side of his body, for he has been cut from top to bottom, sagittally, by a cannon; he is then capable of committing only evil actions, having lost his good, right side. In the end the two sides, the left and the right, will be reunited, but not before the good side, separated from the rest, has revealed itself to be equally intolerable to the inhabitants of the village.

Fantasy violates the notions of realism and of imagination by proposing worlds at variance with reason from which one or more aspects of known perceptual reality are eliminated or put aside. Of course, fantasy remains within the bounds of the conceivable, and the distinction between imagination and fantasy in this context must be thought of as pertaining to the subject matter of artworks, not to specific mental acts. Lacking the perfect coincidence of real and ideal and even clarity on the issue (for instance, about what an ideal made actual could entail), art presents a semblance that is within reach of human capability. Still, the tendency toward unity eludes truth, and art, prey to imagination and fantasy, cannot aspire to knowledge. The more one insists on these elements, the more art reveals itself to be, from the intellectual viewpoint, a mirage.

The problem of the truth of art becomes secondary if imagination is to have a preeminent role in art. However, the meaningfulness of the volatile experience that is the aesthetic must not be jeopardized. Potentially truth and beauty are contained in art. Truth is not a reconstruction of the beautiful, and beauty is not a copy of the true, rather, the beautiful is the fanciful creation of an Idea that eludes the mind itself. There is no tinge of nihilism in putting aside the absolute value of truth since art is not a creation out of nothing, it is the "nothing" of the creation. A

consistent aesthetics of nothingness, if it were possible at all, would require that imagination and fantasy be silent; both correspond to reality only peripherally—not surprisingly, since imagination, as Edward Casey has analyzed it, shows more discontinuities than continuities with perception.[17] Imagination and fantasy can elevate common reality to the beautiful, while truth is both the principle from which the artist must begin and the effect of a concept of beauty understood rationally. Rationality can give birth to the beautiful, yet the beautiful is also dependent on a figural, and not only ideal, determination.

In a theory such as the one put forth by Schiller that wants to give to the aesthetic a universal meaning, one that cannot afford to neglect physical sensibility, the sought-for harmony would vanish in a one-sided a priori if there were no synthesis. No real, absolute transcendence is admissible, although Schiller is willing to call "transcendent" the aesthetic experience[18] in that its character is sacral. Such a point is debatable within his own premises. Even admitting that the source of beauty is mysterious, it does not follow that its origin is necessarily transcendent; the immanence of the senses and the transcendence of form should rather be synthesized in the notion of self-transcendence. Self-transcendence is the "tool" that permits us to avoid the metaphysical belief in the predominance of pre-given forms: Beauty, Truth, the Good; it allows us to dialectically negate the origin, any origin, be it sensuous or rational, of art and at the same time to affirm its value. It is, then, to be understood both psychologically and philosophically; in the first case it is an antidote to nihilism; at the level of aesthetics proper it uncovers its multiform potentialities, including imagination. In fact, the ultimate goal of self-transcendence is, heuristically, to single out the equilibria and disequilibria between the possible and the actual.

Admitting that reason is an instrument that allows one to transcend the given, it does not follow that its raison d'être and basis do not originate in the given. This means to accept the internal limitations of reason and to dismantle the notion of absolute transcendence. To construe the possibility of aesthetics as starting from the absolute unity of the mind in which sense and reason are immanent would give us the finite, but one of ambiguous ontological status. Instead, the structural asymmetry between unity and multiplicity, the one and the many, leaves room for an aesthetics which, while taking into account the given, challenges its epistemological and ontological priority. This is the meaning of self-transcendence and of imagination.

## SELF-TRANSCENDENCE

Self-transcendence (which is implicit in Schiller's work) provides us with a concept without having to resort to outside, still hidden forces such as that of absoluteness. Even starting from a naturalistic view of human beings, with an emphasis on empirical needs, one cannot ignore and should not misconstrue the drive to go beyond the given. This drive is responsible for a fundamental category of the aesthetic, namely, the new. The new results from the subjective side of experience and a free ontological space where imagination finds its "object." Freudian psychoanalysis offers illuminating answers on this issue. By locating imagination in the unconscious, it presents a model for explaining the transition from brute necessity to the subsequent development of the functioning mind, thanks to sublimation. Jacques Lacan pushed even further this dynamic structure by negating the physical aspect of mental phenomena: everything is resolved within a linguistic conception of the unconscious which operates with the two parameters of metonymy and metaphor. In this transition from *A* to *B* lies the possibility of self-transcendence, one of the preconditions for the aesthetic. Self-transcendence implies also a transformation from the potential to the actual, that is, the transition from desire to completion. However, self-transcendence, achieved dynamically thanks to desire, can find an obstacle in the death drive which puts an end to desire itself.

This is why another conception of self-transcendence that would silence nihilism, found in Nietzsche's advocacy of the Overman, becomes relevant to establish whether a subjective aesthetics can be reinstated and with it the possibility of the new. It is interesting to note how Gianni Vattimo has translated the *Über* that precedes *Mensch*: "*oltre*," which means "beyond." *Übermensch* becomes "Beyond-man."[19] It is not a secret that "*Über*" in German also means "beyond," as well as "on" and "over," but Vattimo, in adopting this translation, emphasizes the dynamic aspect implicit in that preposition, rather than the substantive character evident in the translation "Overman." The Overman is the vehicle of a self-contained process which has left finitude behind: Vattimo's interpretation of Nietzsche excludes the view that the philosophy of the *über* can be framed in a philosophy of finitude. Self-transcendence is implied in the crucial transition from Man to Overman, while the qualitative difference between the two admits of no return; once the known territory has been left behind there is no turning back. The unknown, in its contrast with the already known, is not at the origin; it is the point of arrival.

Self-transcendence does not necessarily imply an Overman; the latter is a sufficient but not necessary condition of self-transcendence. However, the Overman is a good example of self-transcendence if it limits itself to overcoming nihilism without the addition of a metaphysical apparatus. It is more important to concentrate on how the overcoming in question takes place than to consider the metaphysical implications of Nietzsche's doctrine. The Overman stands first of all for a replacement; the Overman is not Man plus something else—to think so would mean to miss the point completely; the Overman is more the result of desperate but hopeful prophesy than a rearrangement of already established premises. The two notions stand miles apart: while Man is supposedly the conscious being of traditional humanism, the Overman acts according to the will to power, which is something altogether different from consciousness; the will to power is comparable rather to a vitalistic drive directed toward constant activity.[20] The will to power refuses to be subjugated or to submit to a pre-given order; that is why only a radical transvaluation of values is an indication of the presence of the Overman. The violent disdain expressed by Nietzsche for everything that is already accepted reflects his attempt to prevail over the given in all its forms; the radicalism of his vision is at variance with any old regimentation or ordering, be it formal or experiential. Projected into the future and the new, the Overman is the foreseen solution and an antidote to passive nihilism.

In connecting the overcoming of nihilism with the belief in eternal recurrence, Nietzsche deprives the Overman of a "historical" and temporal dimension, becoming. However, the realization that being and becoming collapse into each other does not prevent the Overman from appropriating aesthetic values if necessary, but it implies, if one takes advice from Martin Heidegger, that the ontological affirmation of being as a whole, which is reflected in eternal recurrence, carries with it the "collision of future and past."[21] Past and future are indistinguishable if viewed essentially; therefore nihilism, with its long history in Western metaphysics, cannot be overcome.[22]

The way Nietzsche introduces the idea of eternal recurrence, fundamental for grasping the connections involved in the will to power, nihilism, and the transvaluation of values, indicates that tragedy reemerges powerfully as the core of his thinking. Nihilism, whether passive or active, is marked by tragedy. The will to power, and with it the Overman, have failed to overcome nihilism even through the doctrines of eternal recurrence and the transvaluation of values. This also means that

Nietzsche has failed to anticipate the new. Perhaps the new, so essential to art, will acquire credibility and find its chance in a different conception of self-transcendence.

## DESIRE'S IGNORANCE

A promising candidate for the overcoming of nihilism is desire. Even though desire does not in itself represent the royal road to an aesthetics of the new in that it can serve multiple functions, one of which is related to ethics, this alternative differs from Nietzsche's will to power in being indissolubly tied to the Other and to negativity in an explicit dialectical manner. Its inclusion of negativity makes possible true self-transcendence. A solipsistic and narcissistic individual knows nothing of self-transcendence. Caught in a stubborn immobility, s/he is eternally impermeable to outside forces and therefore is confined to a self-enclosed immanence. The dimension of otherness is, in this case, precluded. The soul that is convinced of its absolute value, initially unshattered by what it considers a remote reality, is a beautiful soul whose destiny of utter misery is well described by Hegel.[23] The contempt for the other, also typical of the Overman, in the case of the beautiful soul is not resolved in action and knowledge; it fades away into a nullity worthy of its own negative origin, but it never declares, consciously, its own nihilism.

One answer to the problem of overcoming nihilism lies in the Other, either internal or external. The potential let loose by the encounter with the Other leads to previously unacknowledged insights and it is a necessary step to overcome nihilism. As long as catharsis is conceivable, even tragedy is not yet nihilism, since nihilism, unlike tragedy, declares the inconceivability and nullity of meaning. In fact tragedy, since it rests on an excess of immanence, falls short of self-transcendence and that is what makes this position devoid of further development. Nihilism also can manifest an excessiveness of immanence. The difference depends on the inability of the nihilist to recognize desire, which is regarded as extrinsic instead of deriving from a structural negativity inclusive of the self. Ruling only on a personal belief, protected from desire's intrusions, the nihilist knows of no confirmations other than those related to a strict immanence and ignores what Heidegger called "care," "guilt," "conscience," "resoluteness"—all the existential categories or *existentialia*, which show the inadequacy of a merely immanent analytic of *Dasein*.[24] Nihilism, although immanent, does not exclude aesthetic sensibility, but

then it is lived passively, not actively. Qua depository of the death drive, the nihilist knows only certainties, refusing any outcome that must out of necessity remain precarious. In fact, it is not a matter of advocating what Manfredo Tafuri, in mentioning the contemporary scene and postmodern architecture in particular, calls with scorn "the anesthetizing clouds" that would overcome nihilism.[25] Far from being comforting, desire, as opposed to the death drive, absorbs futurity without attributing to it any preconceived rationality. The negative process in question marks self-transcendence: from the certainty of the death drive to the uncertainty of desire.

Furthermore, desire does not coincide with a pre-given structure. The indeterminacy and subsequent determinacy of the self come to the surface only if confronted by what is alien and yet similar. Desire proceeds in its parabola encountering all the conceivable real and imaginary obstacles; its Faustian journey will find a limit in its own negativity and in its finite capacity to assimilate its own experiences. In fact, desire, even if it amplifies its territory thanks to the collective, can remain ignorant of its own mechanism. If the emphasis is put on the collective, it is perhaps justifiable to speak of transcendence; however, such an approach is not necessary when the issue is desire, since desire is metonymic and already linguistic in its own essence. Desire's "irrational" trajectory can be symbolized in the following manner:

in which inner and outer duel with each other for supremacy. There is nothing particularly reassuring in this struggle, since nothing is assured: neither the inner which depends on the outer, nor the outer which depends on the inner. Artists, and not only artists, rely on such a model to ensure the possibility of the new.

Admittedly, the role of desire can be a romantic one; however, romanticism is not totally alien to Lacan's formulations if one considers

that desire for him is an end in itself. If it were otherwise he would not have conceived the maxim about the renunciation of desire as the only unethical stand.[26] It remains to be seen why desire is symbolic and therefore why it transcends the real and the imaginary, the two other Lacanian categories; this depends, following Mikkel Borch-Jacobsen's interpretation, on the nullity itself of desire[27] whereby what is desired is the Other, an unreachable, symbolic, transcendent being, a being that is not a substance but rather a function of desire itself. An already preexisting structure within which an infinite number of metaphorical variations are possible, the symbolic reduces the subject of desire to a few performative utterances, while the others are impoverished *flatus vocis* (what Lacan calls "empty speech"), mechanisms that pursue the impossible, that is the non-symbolizable real. For want of a referent, desire is, within this perspective, transcendence, with no connection to the self. The desiring subject is ultimately null and void; being devoid of content, the subject disappears in the signifier[28] where it will (perhaps) flourish at the expense of the Ego.

Whether such a creation ex nihilo of desire's productions, what is called its "transcendence," is a tenable standpoint, is doubtful. In order to be truly transcendent, desire not only would have to be devoid of a content of its own, but it would also have to be impermeable to all content. And this is not the case, for desire appropriates language; that is why its metaphors are not explainable if we confine it to a linguistic theory that takes into account only the unconscious dimension. The self-transcendent aspect of desire must include what is other than itself to the exclusion of the absolute Other. In other words, what must be put into relief is the power of desire to operate on a double level, to alternate between cataphora and anaphora, that is, forwards and backwards.

Two planes are present in Lacan's discourse, and they are not easily reconciled. The first is the unconscious dimension of metonymy (desire) and metaphor, following which the speaking subject comes to occupy a marginal position: we are spoken. Here metaphor stands not simply for performative language, but for the creative process itself. The second level, which takes precedence, is the ethical one, also qualified as symbolic and linguistic; according to the second perspective, which takes the form of a highly ideological defense of patriarchy, language and the full word (*parole pleine*) are not reduced to mere *flatus vocis*, on the contrary, they are significant, and provide, as Hegel would say, a "substantial content." It is the case, then, that Lacan does not succeed in eliminating altogether the notion of content and of self-transcendence. If one admits that the

full word is simply performative (the words uttered during the marriage ceremony are the usual example, but a declaration of war is just as admissible), it remains true that what is reputed to be transcendent is appropriated as a content, and becomes, necessarily, immanent. Since absolute immanence excludes all externality, desire can only be a form of self-transcendence in assimilating and negating the given at the same time. This is tantamount to asserting a dialectic between conscious and unconscious in which the affirmation of the unconscious does not rule out the existence of consciousness, as is instead the case with Lacan, for whom consciousness has no significant role to play.

The relevance of the preceding discussion for aesthetics is that it helps to locate art between the imaginary and the symbolic. But Lacan, leaving aside his early association with the surrealists, devaluates the aesthetic in comparison with the ethical to the point where form and norm coincide. The self-transcendence of desire consists in being related first to the imaginary and then in its "invading" the symbolic dimension. It is the emergence of imagination which demands to be recognized in full force. Even though imagination and the imaginary do not coincide, in that the imaginary is the structure that reflects the illusory and regressive concerns of the Ego, nevertheless the resources of imagination attach themselves to the specular assonances of that which does not yet have a form. In art the structure or the form remains symbolic, but the input rests on an imaginary apprehension of the real and the symbolic registers at once. It follows that the imaginary and the symbolic are not categorically divided once and for all as Lacan thought; from the perspective of the aesthetic, the symbolic is a continuation of the imaginary. There is an active imagining that is not accounted for by the symbolic order taken in isolation. The sheer existence of imagination legitimates the whole field of aesthetic, although not everything that is imaginative secures by itself the approval of the critic. The more-than-empirical self-transcendence of imagination, whose role is the production of the new, relegates the real to the background. Without the new there is no art worthy of its name, there are mere repetitions whose pathology and connivance with the death drive have been amply demonstrated by Freud.

On the opposite end, Pierre Boulez, in declaring imagination poetic, provides a good example, first hand, of how the tension between law, logic, and rigor on the one hand, and transgression and imagination on the other, must operate in the aesthetic domain. His poetics rests, from a privileged point of departure, on the dynamic between rigidities and

transgressions that bring about an imaginary and virtual reconstruction of music: "The reconstruction of the [musical] work in its totality is an imaginary reconstruction."[29] That is to say: from the part to the whole.

The symbolic owes to the imaginary whatever sense of continuity is left in Lacan's theorizing. The unconscious, as the locus of the unintentionally expressed, is a manifestation of the imaginary as much as of the symbolic; dreams, for instance, are not only the result of the unconscious structured as a language, but they also require, more often than not, a regression to imagistic representations. It is true that the unconscious speaks; its speech, however, cannot be reconstructed except by approximation and by inference; we do not have an immediate, intuitive, experience of the unconscious. It symbolizes without being completely symbolizable, and there is found the limit of interpretation, since the content of the unconscious remains partially indeterminate and formless.

Moreover, the apophatic approach is necessary here. Thought is not completely symbolic and does not coincide with language;[30] they do not have an identical structure, and, since thought cannot belong to the category of the real, it must partake of the imaginary, unless a fourth category is hypothesized whose name is still unknown.[31] Lacan's underestimation of the imaginary testifies to the fact that he privileges the actual over the potential; in this he is in perfect agreement with Hegel. To demonstrate the point it is sufficient to recall the relation that obtains between language and thought which in Lacan finds a solution in the "full speech" whereby thought and language metaphysically become one: "[Metaphorical] full speech . . . is defined by its identity with that which it speaks.[32] Such a union is an indication of the impossible convergence between the imaginary and the symbolic, but not of thought and language. Just as the real is not to be identified with reality, so imagination is not the same as the imaginary. Nevertheless, if imagination is not included in the imaginary, a full range of phenomena, among them the inception of art, cannot be assigned any other locus. On the other hand, in order to avoid the resurgence of an imaginary subject, it must be said that, like language, imagination "imagines us." To the objection that thought can be unconscious and that, therefore, it shares with language the same symbolic mechanisms of metaphor and metonymy, the only answer is that we are in the presence of a metaphysics of the unconscious. Language, thought, the unconscious, all become part of an identical, isomorphic structure.[33]

As Heidegger has noted, the very presence of metaphor is indicative of a metaphysical interpretation of reality: metaphor already indicates that

a split between the sensible and the nonsensible has taken place: "When one gains insight into the limitations of metaphysics, 'metaphor' as a normative conception also becomes untenable. . . . The metaphorical exists only within metaphysics."[34] There is no doubt that for Lacan metaphor plays a crucial role in settling the question of whether thought is symbolic, yet it is clear that to identify thought and symbolism in an immediate manner puts into question thought's intuitive character. As Enzo Melandri points out, a totally counterintuitive thought has, as ideal, a thoroughly symbolic thought, resting on the arbitrariness of the sign, whose infinite calculability is far from being an actuality.[35] Given these considerations, can it really be said that desire is wholly a symbolic structure? Oscillating between a new conception of the subject (divided and fragmentary, but capable of full speech) and its complete dismissal, Lacan opens the way to desire, which is not symbolic in itself because it is the mark of potentiality. Desire entertains a privileged relation to imagination, and, rather than being itself enclosed in the symbolic, it is better described by saying that it symbolizes; in symbolizing, desire makes clear that it is one of the mechanisms that make the aesthetic sphere first possible and then actual. One of its more significant shapes is illustrated by the myth of Faust, the ever-searching figure who knows how to attain knowledge.

### FAUST NEVER LOST IN DESIRE

What is valuable in Lacan is his conceptualization of metonymic desire, a notion that directly confronts the question of the overcoming of nihilism in art as in any other sphere. The Faustian motif of desire is first of all a good antidote to the passivity and inconclusiveness of the unhappy consciousness. His spirit relies on desire's and will's inexhaustible force, unconcerned about their ultimate end. The versions of the myth vary, understandably so, considering that poetic freedom and the different exigencies of the ages in which these versions were written or composed demanded alternative solutions to the riddle of Faust.

It is not a matter, though, of analyzing the reasons why Faust is ultimately saved or dammed; what counts and is found in the myth of Faust that is eternally captivating is, in Ernst Bloch's terms, its utopianism accompanied by desire's yearning[36]—desire to know, of course, to love and to experience without saying "no" to anything. Faust may have to pay for his excess of desire or not, the point is that desire is per se satisfying without satisfying, and it is so because it perpetuates itself endlessly. The void

that surrounds desire is the not-yet, as Bloch denominates it, from which is extracted a new actuality; therefore desire has very little to do with happiness in that it dwells in negativity. The moment of satisfaction marks the beginning of a new desire, of a new purpose, invented by desire itself. As an inborn, mental structure, desire attaches itself to the ever-receding horizon more than to the realization of the actual and the certainties of truth. The potential here has no rival, and, even though Faust achieves all that is possible and beyond reason to attain, desire itself is not extinguished; rather than being beyond good and evil, it is before good and evil.

Faust is the one who knows about desire, this kind of preknowledge before all knowledge puts in motion both time and eternity. At the same time, the alternation of emptiness and fullness becomes a matter of self-transcendence, considering that Faust is also in search of something within himself; the intervention from the outside, in the form of Mephistopheles, may lead us to the conclusion that there is transcendence after all, and that Faust must reckon with it in the end. On a closer look, however, it is possible to discover that the demonic is within Faust himself and, by extension, is found in every creative act.[37] Thus, the demonic is positive and negative at once, positive when it articulates itself, negative when it remains hidden, uncanny.

It has been said that Faust knows about desire; can it also be maintained that he appropriates it? The answer is "yes" if desire is an indication of immanence, "no" when one considers its self-transcending aspect. As long as Faust knows that he wants, he is not the master of himself since he is dependent on Mephistopheles; when he does not know what he wants, he is the master of his desire. Desire never fails when its object is indeterminate; only what is determinable (but that is not desire's essence) may or may not find realization. Ernst Bloch compares the Faustian search to Hegel's *Phenomenology* in which "desire is again and again aroused to perceive oneself as the question, the world as the answer, but also the world as the question and oneself as the answer."[38] Faust is the personification of a secular attitude, of a global perception that is interpreted in some modern versions (we will see which ones) as not being overly menacing. Beyond reason, Faust's desire prevails over its obscure side as well, the opacity of which is also one of its instruments. Thus, the priority of desire is affirmed over against everything else, yet desire includes implicitly this "everything else."

The object of desire can be imaginary or symbolic, can stop at utopia or go further toward actualization. In the literary domain, it manifests itself in symbolic form without ceasing to elaborate both imaginary and

allegorical themes. Desire is present in all the forms of the aesthetic, where it is converted into desire for the beautiful (such is the case of Goethe's Faust) or, as in much of contemporary art, into desire for the cerebral (we will see that this is Paul Valéry's solution). Both forms demand the labor of the negative, the demon whose negativity looks at the other who is also desire. The myth would fail if it had to confront indifference, an other who refused to be implicated, to be taken into the grips of the original desire. The myth would fail if the other were an absolute, a priori other, and therefore, no other at all in that the notion itself of 'other' is eminently relational. If self-transcending desire were to encounter an insurmountable limit, the absolutely Other, Faust could only be interpreted as a tragic figure, but this is not always the case. Schelling rightly called Goethe's *Faust* "a divine comedy"; writing before *Faust*'s completion, Schelling grasped its non-tragic, yet dramatic quality whereby Faust purifies himself "from the torments of knowledge and false imagination"[39] and reaches the essential by elevating himself above himself.

Faust's desire explores but remains unexplored, so that its own vector brings about incalculable results. In this epochal figure, the whole range of worldly and celestial phenomena is potentially present, the variations of desire being infinite.[40] Faust is the one who does not fear this restless proliferation; his inward motions are those which drive him forward—a bad numerical infinite, perhaps, but Faust's unlimited demonic and in the end divine resources aim at discovering the whole and, as a consequence, himself. The combination of internal and external, put in motion in order to appropriate both, and the cannibalistic dream of incorporation are realized thanks to a supernatural power, but the desire to know and to do is not the work of the devil; it preexists, *pace* the biblical narrative concerning original sin. Arrogantly, Faust declares the priority of metonymic desire and postpones the metaphorical resolution offered by the preexisting order of the Law. Instead, Faust's desire puts into question the stagnant ethical system as it is found and perpetuated. Faust risks, and Lacan himself, I like to think, would absolve him for remaining faithful to his desire.

### DESIRING THE WILL

Is Faust, then, the progenitor of the Overman? It is hard to deny the resemblances. The affinity between will and desire is close; if the Overman is the one who wills power, s/he is also a desiring being. Desire and

will to power form a pair from which it is difficult to extricate oneself. It would not be enough to point out that the two notions derive from different philosophical traditions; it is more interesting to note that desire makes its appearance before the advent of nihilism, whereas the will to power is the answer to such nihilism. Ideally, they both exclude doubt, but when desire is entrusted to a human being it may oscillate and reveal a less overbearing side: Faust is at times dismayed by his own intentions, the intensity of his desire may coincide with the awareness of desire's immateriality, and thus elude him. While the will to power stands for a global project, desire is closer to the single individual. Even so they are comparable since they operate on the same material, the same objects captivate them; both are inevitably fragmentary, but desire can progress while the will to power echoes only itself.

Applied to aesthetics, the two notions lead to different results. Starting with desire, one can say that desire does not necessarily opt for beauty, but when it does, the desire for beauty seems to contradict the dynamic character typical of desire and of modernism. If a resolution of this contradiction is to be found it will be thanks to the good offices of the new, a "relative" of desire. In fact, what has intervened in modern art, but not for the first time since all important art is directed toward a break with the past, is the volcanic succession of the unfamiliar, which indicates not the presence of mediation, but rather a fundamental elaboration of previously accepted ontological premises. By itself the new is not a guarantee that we are in the presence of art; as a necessary condition, though, it frees art from the unprovocative repetitions of the past, which would plunge us into the unsuggestive desolation of the already heard, said, and seen. Rapacious desire is itself an aesthetic phenomenon insofar as it avoids the monotony of the given; if it stops short of this "ideal" it is an indication that desire has surrendered to pathological formations and lowered itself to the level of insatiable demand, whose vicious circle is constantly in search of the same satisfaction.

To preserve the negative and movement, desire rejects the apology of the harmonious and reinstates its subjective incompleteness. In Hegel's monumental *Aesthetics* one finds a brief mention of Faust's subjective search, counterbalanced by the presence of the absolute, which makes Goethe's work "the one absolutely philosophical tragedy."[41] Faust is destined to encounter tragedy because his desire is still tied to subjectivity. The fact that Hegel defines *Faust* as a tragedy is an indication that the opposition between universal and particular has not been sublated; thus,

*Faust* is a tragedy even if its end is "happy" because the protagonist's salvation depends on transcendent powers. What is absent is the affirmation of the ethical order: Faust's salvation, as is always the case with Christianity, is stubbornly individualistic. Given his definition of comedy, Hegel could not have called *Faust* a comedy as Schelling did: "In comedy . . . it is subjectivity, or personality, which in its infinite assurance retains the upper hand."[42] Faust does not know assurance, he knows the "beyond" he is desiring. It can be said, then, that *Faust*, in the Hegelian context, is a comedy with an unhappy end and a tragedy with an equally unhappy end. Hegel's last word on this matter is that a "midway between tragedy and comedy"[43] is preferable; it is a compromise solution demanded by Hegel's version of modernity, an epoch in which individuality is unable to renounce itself. Having reached this point, it is better to abandon tragedy altogether since it does not correspond to the contemporary Zeitgeist. But desire is tragic, a fragment constantly in motion that does not believe in completion. Becoming is its distinctive character, the sort of becoming that is coming-to-be and ceasing-to-be,[44] the result of being and nothing which refuses, however, Hegel's final speculative triptych. Desire is the beginning, although not absolute, of being and nothing, which finds in Faust's inevitable death its resolution.

If it were possible to read the Hegelian logical circle as perfect reciprocity of being and nothing, we would be even further away from the reality of desire, but Hegel does not give equal value to them both on the question of becoming; having "started" with Being, he cannot but conclude that "the determinations [of Being and Nothing] are of unequal value."[45] Although logic and desire have little in common, desire exhibits its own asymmetries and eccentricity; if that were not the case desire could not stand, metonymically, for the whole individual, that is, be a symbol of its own incompleteness. At the same time, it is not possible to declare it off center without relating it to the whole, however undefined and nebulous, but still conceivable in intuition.

What, then, is the locus of desire? The question is whether it is found in the self or outside the self. If one does not believe in the actual existence of the devil, desire must be conceived of as inner and as being itself and other at the same time; it is, in short, self-transcending. By the same token, it does not coincide with the subject, even though, if there is a subject, it would not be such without desire. Without the "nowhere" of desire, art would lose the privileged viewpoint which differentiates it from the "here and now" of morality. If in the beginning there is desire and if desire does

not stop at any definite object, then the aesthetic must not find its justifi-
cation in the object itself, as has been done by appealing to beauty. Unfor-
tunately for this approach there is no aesthetic object per se. According to
Heidegger, it has become meaningless to speak of objects at all, and that is
why abstract art is legitimate, the effects of this void are so far-reaching that
modern art should find for itself another name.[46] An example of catachre-
sis: art that is no longer art, in search of a name and an author.

Yet, art has an object, or, better, it has art itself as its object. The self-
reference of modern and contemporary art does not need to be demon-
strated; witness the use of irony in Paul Klee, Max Ernst, Robert Musil.
The object of art is art itself; such a realization opens the way to many
unexpected and therefore provocative perils; it could not be otherwise.
The first danger is the vulgarity of popular art and *Kitsch*, due to the lack
of the aesthetic direction provided in the past by the idea of Beauty. Not
secondary is the danger represented by the constant changes in styles. It
would be preposterous to lament the swiftness of these changes; it is sig-
nificant, however, that with postmodernity a return to the past has taken
place in music and architecture. A perhaps gracious but uninspiring eclec-
ticism has taken hold of public squares and streets; the concession to col-
oristic ornamentation reveals that desire itself is lacking in thoughtfulness
and directives. Desire is looking back, a tendency that was already con-
templated by Hegel with his thesis that art must finally vanish. The search
for the new—an aesthetic category that finds no easy application and for
which rules cannot be given—is now hindered by a social and economic
fait accompli that results in desire's present impasse.

Faust's desire does not provide an eternal solution, but at least offers
a finite, temporary solution to the problem of nihilism's perpetuity. Desire
as destiny, therefore, but not in the sense that desire is one with being, desire
is comparable only with itself, while its "object" is both being and nothing:
being minus nothing and nothing plus being. In proclaiming only itself, it
produces fullness and emptiness. Given these conditions, it is not by chance
that desire finds an "object" on which to operate, and in particular the to-
be-contemplated aesthetic "object." But it is the mode and not the object
that determines what is beautiful; Heidegger rightly wrote: "[B]eauty is not
a property that is added to a being as an attribute. Beauty is a lofty manner
of being, which here means the pure arising-on-its-own and shining."[47]

By refusing any subjective interpretation of beauty, Heidegger
excludes desire and, with it, the significance of the myth of Faust. Faust
knows that he wants and knows that he does not want the first thing at

hand; he does not hesitate when it is a matter of declaring his desired object: beauty and knowledge in Goethe's and in Ferruccio Busoni's versions of the myth; Mephistopheles simply provides the "how." Heidegger would reverse such a statement and say that now we know the "how" but we do not possess any clear, objective destination. Unlike the metaphysical will, desire belongs to the phenomenological experience, but neither of them is deciphered by "simple" interiority. In any case, we should not be led astray by the claim that the will is the exclusive beneficiary of becoming: Faust, for instance, is overwhelmed by desire, not by the will, when he reluctantly surrenders his soul to the devil. Put otherwise: the will is blind, capable of aiming at just anything; desire is selective.

Human completion lies in its limits; this shows that desire's subjective aims cannot be completely realized even with the intervention of a superhuman being. This is most apparent in the rendition of *Faust* by Ferruccio Busoni. In Busoni's opera, the climax represents the death of the protagonist, a death which is all human, a natural fact; there is no evidence concerning Faust's possible salvation or damnation. Mephistopheles here is more an *alter ego* of Faust than a superhuman power; in fact, when Mephistopheles appears in the first act, he presents himself by saying that he is as swift as human thought, and this is what convinces Faust. The miraculous illusions accomplished by the evil force are not to be dismissed, but, even so, Busoni's opera is secular; Faust's final invocation to God is met with the silence of the sky, while Mephistopheles' last question: "Has this man met with misfortune?" reveals his own ignorance and confirms the exclusively human aspect of the desire to know. The indeterminacy of the finale tells us that only natural death is certain. Alternating sacred and profane music, Busoni remained within the traditional framework of the myth: Heaven and Earth, Sky and the Underworld, they all aim at their respective triumphs. For all that, we are assured that desire is consistent with its premises since it cannot tell us what awaits us; the question as to the very efficacy of desire is left open.

## THE DESPAIRING WILL

The many versions and the almost infinite variations on the theme of Faust bear witness to the centrality of this myth for Western culture. The fascination is not without reasons: *homo faber*, from the inception of metaphysics to technology, is also the *homo* of *Begierde*; Faust combines the two in a timeless impermanence.

Are there differences between desire and the will which permit us to distinguish them qua notions? Desire is first of all longing, duly romantic; the will, more sanguine, acts on desire, the latter representing a more primordial stage in comparison with the will. The will intervenes later in appropriating that which desire has already surmised, that is, its object which can be either the good or evil. While desire is not "blind" (let us recall the fundamental relevance of the gaze in Hegel's description of the encounter of the two consciousnesses), the will can be so if it is not mediated by desire which provides the will with the discriminating content typical of desire.

Desire is not subjected to the discipline of the universal; its encounters are not predetermined, and that is the reason why, strictly speaking, it cannot go astray—unlike the will. Without losing its subjectivity (its form), the will becomes conscious of itself in such a way that it replaces desire in the task of building its dominion. It is up to the will to establish the priority of the universal and we will see how in Thomas Mann's *Faust* the dominion of the concrete universal is symbolized in Adrian Leverkühn's will to power. Desire's aspirations, instead, although subjective, disclose a universality of a different kind: that of a structure impossible to silence, which, being fate itself, does not yield to fate. Faust relinquishes his will to Mephistopheles in order to salvage his desire. Either the will or desire must predominate. The only possible salvation for Faust depends on desire, but desire also condemns him to searching for an impossible completion. The alternative, to rely on the will, would mean to succumb to another type of irrationality, the one theorized by Nietzsche.

If the will becomes will to power, that is, the will to appropriate every aspect of being, it also becomes aesthetic will whereby universality should coincide with subjectivity. However, the right to particularize, accompanied by a fragmented universality, has a price: Nietzsche consciously appropriates the tragedy of the fragment and the subsequent clash with the commonly accepted values inherited by centuries of Christianity. Even though the domain of the aesthetic is only a perspective, it is still the perfect setting within which exert the will to power, but that does not mean that tragedy is being denied. Since tragedy constitutes the core of existence, the aesthetic also cannot ignore the centrality of nihilism. Artists' activity (for a Nietzschean art may be dead, but the artist is alive) and their products are a reaction of the aesthetic will to passive nihilism, that form of nihilism which accepts truth as correspondence of subject and object. That truth is destructive; thus Nietzsche's famous *dictum* affirms: "We possess *art* lest we *perish of the truth*."[48]

The will to power encounters art after having exhausted all the other possibilities, when at the height of nihilism its value is resuscitated out of despair. It is not a matter of being inclined toward a good use of the will (with its possible object, the aesthetic); Nietzsche does not talk of a good will or a bad will; this distinction does not belong to the Overman, or even to its diluted version and closest approximation; the Overman creates values, and the aesthetic is one of them, indeed a fundamental one. The sorry consequence of there being in fact a "beyond good and evil," represented by nothing less than madness, is overlooked by Nietzsche but not by Thomas Mann, who has his Faust destroyed by insanity. In comparison to Busoni's opera, Thomas Mann's *Doctor Faustus*[49] acquires its meaning not only from philosophical considerations, but also from historical ones. The surrender of Leverkühn's soul, anxious to accomplish extraordinary musical exploits, is intertwined with Germany's fate before and after the rise of Nazism; thus, Mann's text, describing the death of the insane composer, becomes an allegory of those years. If it were not for that, the work would not be convincing; Mann almost declares the perversion of art in a moralizing move that is epitomized by the respectability of the narrator, a person who is decent in his opposition to the dictatorship, who is devoted to his genial friend, but who cannot raise himself above a standard mediocrity. The quasi-identification of high art with evil at a time when it was despised and persecuted is problematic, even admitting the well-established association of genius and destructiveness. In Leverkühn's will, we detect only a detached interest in the world around him; this is an indication that he is the victim of his own will. It is Leverkühn who, having invited the devil, after a while feels comfortable in his presence even though his conversation dwells on the description of sickness and the "security of hell." The protagonist finally calls himself the obedient servant of the devil: they have a common will; the only rebellion on Leverkühn's part is timid and emerges when he is asked to renounce love. Desire, connected to Eros, is defeated at the hands of the will. Furthermore, the "deserved" final madness of the new Faust corresponds to Mann's silence on any possibility of utopia; damnation is found on earth, in the paroxysmal negation of reason, a weak candidate to oppose to irrational evil whose force lies in its irresistible fascination.

The necessity of narration must differentiate one character from the other, but the demonic power is in Faust himself, whose double nature does not invoke an absolute, transcendent Other; this would result ultimately in an admission of ignorance. As a structure, the Other reiterates

the reality of human finitude which is not to be integrated into the symbolic register in any other way except via the recognition of its destinal character. Desire, though, attempts to fill its own void and that of the absolute Other.

From the start desire's destiny is curtailed by the presence / absence of the Other, yet it insists on its particularity, accepting the risks of self-transcendence, the only way in which it can attain significance. In Lacan, as we have seen, immanence and transcendence coexist. The symbolic transcends the individual, whose sole aim should be that of approximating it rather than defying it. But desire and the will cannot be reduced to the role of incorporating what is given. Even if it is divested of any romantic connivance with the unknown and the mysterious, desire's irresistible inclination is the quest of the new—perhaps a utopian mission, but one that is renounced at the cost of exploring only a wasteland. On the contrary, it is the will that knows everything about the wasteland because that is its first encounter.

Desire activates metaphorical "behaviors," but even so the metaphors should be appropriated by desire itself without overstressing the objectification involved in any metaphorizing. The transcendence of the Other does not explain the Other's function as constituting the basis on which desire resists objectification. The gulf, in fact, widens, to the point where desire resigns itself to actuality. This yielding per se would not represent a defeat of desire if objectivity were inclusive of desire itself; instead objectivity is transcendent, making problematic any mediation; the ghost of nihilism is not overcome in any definite way. In this context, the nothingness of art rests on the paradox of desire and on the impossibility of the will to overcome that void which is the result of the absolute transcendence of the Other. Desire is destined to speak through that *flatus vocis* which is the subject.

It is at this juncture that Faust becomes the man who completes nihilism, indicating that a radical reversal has taken place: the subject, searching for the absolute Other, loses its correlate. Fernando Pessoa's version of *Faust*,[50] unfortunately unfinished, presents a man who is terrorized by the idea of the whole and the mystery of the universe; reason and the understanding do nothing to alleviate the horror of existence and death. Love is purposeless; so are action and intelligence. The chilling atmosphere permeating Pessoa's *Faust* is unmitigated; with obsessional consistency, the most recurrent word in the text is "horror," against which Faust is impotent. Absolutely incapable of loving or desiring, this sterile soul

fears that after death a perpetuation of horror and mystery will take hold of human beings; perhaps death will consign us to new forms of ignorance and dread. Other's people joy and laughter, everything that makes them attached to life, fail to affect him; on the contrary, they make him despise them; Faust is a doomed person for whom reality is dream and death is reality.

If desire has any meaning for him, it is the desire to reach beyond God, toward a transcendence even more absolute than the one handed down by theology; Faust is, therefore, in a state of desperate nescience. He burns his books; language itself is inadequate to express anything, including metaphors and symbols. Clothed with a Lucifer-like pride, solitary, beyond madness, led to kill, he declares himself to be devoid of a soul. Faust's knowledge does not admit any soteriology. Knowledge does not unveil truth; on the contrary, it discloses an even more profound mystery. His final desire is to perish.

One of Faust's destinies is to terminate in nihilism. Erudition, love, these are negated in the name of what is absolute, but the absolute remains hidden to humans, and is an unsurpassable enigma; when a boundless pride is unwilling to make concessions to finitude, all that remains is unmitigated desolation, and Faust becomes an example of a subjectivity that is ignorant of his own power. Not only knowledge is an impossibility; death may be the continuation of what has already been experienced in life, where action is deceiving and violent. Embracing a total reversal of the propitious search for knowledge and experience, Pessoa's *Faust* avoids and rejects any consolation that might derive from the outer and inner world. The world itself is not an object with its definite and determinate qualities that serve as a correlate of subjectivity; without an objective basis, the subject also precipitates into the void. This Faust is an abstract being who lives among abstractions, going as far as envying the madman, who at least is capable of laughter; for him redemption is inconceivable because subjectivity has run its course; as a consequence there is no irony either, the tragedy is completely nihilistic.

The transition from nihilism to irony is possible once the relative supremacy of the subject has been reinstated. Such a conversion presupposes that the world is reduced to a non-absolute dimension, and that the discrepancy between subject and world is no longer infinite and abysmal; thus, irony does not exclude nihilism, but is simply one of its mitigated forms. Irony discovers the world's finitude, which assures us that evil is finite also and that there is a limit to the worst—a viewpoint that does not

deny evil, but assigns to it a limited scope. Irony, with its re-emerging sub-
jectivity, turns the given upside down by putting back in place (actually,
reinventing a place for) finitude. This artifice aligns good and evil in such
a manner that the only "beyond" available is that of the subject itself; at
the same time the subject renounces transcendence, that is, the infinite
that would make it indeterminate.

The ultimate Faust, therefore, is not the one portrayed by Pessoa,
with its unredeeming nihilism, but rather the one imagined by Paul
Valéry, who does not have Faust either condemned or saved, and this is
why he is the symbol of that human ambiguity which is typical of irony.
Valéry's narrative, which incorporates both irony and gravity, is sympto-
matic of a state in which nihilism and its negation oppose each other; the
resolution is found in Faust's final refusal to be alive again after a fall from
the heights where he had met the Solitary, a madman almost reduced to
the animal state. Half resuscitated by the fairies, Faust rejects their offer
to return to life; confined to a place which is neither Hell nor Paradise, a
kind of Limbo where light and a relative darkness alternate, he is still free
to pronounce his last word, which was also his initial word: "Not."

The Nietzschean themes of Valéry's *Mon Faust*—the Solitary man
confined in the mountains, the danger of eternal recurrence—do not con-
trast with Faust's old age; aware of the nullity of knowledge and life, Faust
is so disillusioned that he dismisses his disciple by refusing to offer him any
advice or encouragement. Irony intervenes when the traditional presence
of Mephistopheles becomes a pretext for reversing the roles. It is Faust who
tempts the devil by declaring to him that he is by now divested of any
authority, without honor and credibility; the devil does not frighten any-
body anymore. Faust, old himself, wants to rejuvenate the devil, who, lim-
ited to doing evil, is after all a simple being, incapable of profound think-
ing and reflection.[51] Faust reproaches Mephistopheles for being nothing
but a product of tradition, pursuing a historical error. The refusal of
Manichaeanism on Faust's part convinces the devil to agree with him; they
will not sign a pact, also an outmoded and merely formal way to agree on
something; words will be enough, and Faust will write his *opus magnum*
which will be a combination of autobiographical events and imagination.

The irony present in the reversal of roles between the two characters
is not developed, since Valéry left unfinished the first part of the play;
however, the second part of *Mon Faust* corresponds to the first: the nega-
tion of both Hell and Paradise is also present in Faust's doubt about
whether he is alive or not after his fall from the mountain. To the denial

of the afterlife corresponds the affirmation of nihilism; Faust's "no" to life is in accord with the negation of desire: "But my haughty spirit has undone desire."[52] Desire's defeat is tantamount to declaring the end of life and also of art, but even though Faust does not want to be saved or condemned, he wants to be the one who decides his destiny. The process of secularization is completed: being neither man nor Overman, Faust dies willingly in the simultaneous affirmation and negation of the will and therefore of the subject which signals the presence of irony.

This taming of desire is something different from the decisions of the will; coming from Faust and not from a supernatural power, desire reveals itself to be mortal. Mephistopheles cannot rejuvenate it; Faust has already experienced everything. Still, this is not an admission of complete nihilism; in fact, when Faust encounters the madman, the absolutely solitary person, it is the madman who expounds the most convincing nihilistic maxims, and it is Faust who tries to object to them, arriving at the conclusion that a solitary madman is worse than the devil. Thus, Valéry's approach to desire is ambiguous. Desire is neither firmly appropriated, nor is it dismissed unreservedly; in the end it becomes an object of ironic indifference, and this is accomplished by an act of will. But at the end of its course, desire discloses its nullity.

The death drive not only destroys desire, but it also nullifies, *in mentis*, desire's previous accomplishments. The suspicion arises that neither desire nor the will can counteract the death drive; other forms of subjectivity are required to explain the very existence of art. Above all, a subjective legitimation of aesthetics seems insufficient to assure that nihilism can be overcome. Faust is a clear illustration of this point. Before we explore another route, a final word on Faust's myth will clarify the transition we are seeking. The death drive is a pathological manifestation of desire and in addition an indication of guilt. If Faust is neither meritorious nor guilty, as Valéry suggests, if he deserves a neutral Limbo, we are really in a no-man's-land which could not be the locus of the aesthetic. Since to create is also to destroy, Faust's inability to hate and to love leaves him, however, a thinking being. There is another possibility represented by objective thought. Subjectivity being unequal to the task of explaining the aesthetic, the aesthetic looks for proper theoretical explanation in speculative thought.

CHAPTER 2

# Art as the
# Organon of Philosophy

---

Even if one grants that the aesthetic is legitimized by desire and, therefore, by subjectivity, the question remains whether an objectivity of its own can be attributed to art. Schelling thought so. Without negating art's obvious ties to the sensuous, Schelling explains the meaning of art in speculative terms, via the deductions of the different art forms, and legitimates this explanation through a cosmological metaphysics. On this issue Schelling's initial declaration is revealing: "To construe art means to determine its position in the universe."[1] Aesthetics is inseparable from philosophy as a whole, therefore, its method must be philosophical, that is, based on intellectual, not empirical intuition. Consequently, the philosophical consideration of art does not stop at appearance, not even at the beautiful. Art is related to ideas and to truth, and its necessity makes it the legitimate child of the Absolute. The Absolute, in its identity, is the starting point, the recipient of everything that is potential and becomes actual through the interplay of the potencies, both real and ideal. Intuition is the instrument that leads us to knowledge of the polarity real / ideal, while the Absolute constitutes the ever-present background out of which the potencies with their informing interpenetration (*Ineinsbildung*) of infinite and finite reestablish their lost identity in the archetype of beauty. If the artist starts from the real, that is, the objective, aiming to arrive at the

33

ideal, then the privileged point of departure of the philosopher is to operate within the ideal or the subjective. And, since the ideal is the higher potency, philosophy finds itself in the unique position of approaching art starting from the vantage of the Absolute in explaining both art's content and its different forms. Indeed: "The philosopher possesses better vision within the essence of art than does the artist himself."[2]

The ideal is accessible to art through the archetypes to be found in each artistic form, and what counts is first of all the archetype of beauty which is symbolized in the works of art. Philosophy concerns itself with the whole which posits different determinations, the potencies, whose relations make them analogous to each other. Everything is present, albeit potentially, in everything. This is true both for art and for nature. When we are reasoning about one single "part" of the Absolute we must ground it in the Absolute, otherwise the particular potency under discussion would be devoid of essentiality. It would be erroneous to separate the potencies categorically, in the specific case of aesthetics the result would be a theory of art and not a philosophy of art.[3]

Philosophy and art are in a relation of mutual interpenetration, the two spheres stand on an equal footing, because in the final analysis the real, which is the concern of art, and the ideal are undifferentiated in the Absolute. Therefore, if the philosophy of art is possible it is also necessary; analogously, art's ideas are intuited objectively, making every artistic endeavor an intellectual pursuit rather than a sensuous one.

Schelling's unitary delineation of art's philosophical role is only in part disrupted by the interplay of the real and ideal potencies operating at different levels of actualization. Art in general develops its own nonidentity by "following the steps" of the Absolute. From this process the differentiation among the various arts, from the real to the ideal, emerges. Starting from this premise, Schelling cannot resist the temptation—a procedure common in his time—of placing the arts in a hierarchical order according to the predominance of the real or the ideal potency. The definition of art as the informing of the infinite in the finite, and the recurrence of the real and the ideal, together yield the "real" unity, constituted by the formative arts (music, painting, and the plastic arts), while the "ideal" unity characterizes the verbal arts.

The dichotomy continues within this first division. Since the Absolute is identity, the ideal unity will appear also in the real unity, and vice versa. But the first possible combination, at the lowest level of the hierarchy, is music, which stands for the real unity within the real. Music

"has only one dimension," writes Schelling in an graphic manner, it is the inorganic art par excellence;[4] while painting represents the ideal form within the real, and also their indifference. Architecture provides the unity of the previous two forms. Here the inorganic reappears, but this time in space. It is "solidified music,"[5] displaying rhythm, harmony, and melody. Architecture is followed by sculpture, the plastic art that more than any other within that subdivision reaches autonomy. To sculpture belongs the expression of reason. A parallel explanation applies to the ideal, verbal arts; one finds lyric poetry at the lower level, being mainly rhythmic and particular, lyric poetry encloses the infinite in the finite. In epic poetry the relation is reversed, since the finite is subsumed under the infinite, and so the universal predominates. Finally drama unifies the particular and the universal.

Admittedly, the Absolute is today almost universally considered an obsolete concept, especially when the Absolute is conceived of as ground for everything that is. Nevertheless starting from intuition, a sort of indeterminate whole is given. It is possible to "imagine" or to "think" the whole without ascribing to it any determination or quality whatsoever beside that of undifferentiated being. This is what is meant initially by "indifference," an indifference that points to the pregnant identity of real and ideal. A totality from which nothing can be extracted would be a barren concept, but here we witness something more than mere identity from which nothing can be derived. Identity means potentiality, in fact it has been said that Schelling's notion of the Absolute is predialectical and analogical.[6] Particularly difficult, then, becomes the problem of deducing differentiation and multiplicity from the original and primordial identity. One answer is that the Absolute is identity, but identity is not absolute; this asymmetry marks the transition from the one to the many, grasped by intellectual intuition.

Intuition comprises reason, and to reason belong ideas. The archetype is the model, the idea that presides over any artistic perfection. The need for a model results from art's composite nature; to account for an otherwise inexplicable "phenomenon" Schelling resorts to the necessary ideal. A hidden ontological argument is lurking here, to the effect that beauty, qua idea and ideal, is that which must be considered existent. This is an ontological argument, however, that does not necessarily imply perfection, since "beauty is the absolute intuited *in reality*"; at the same time, if God is "by virtue of his own idea,"[7] so is beauty. The archetype of beauty is separated from philosophy only by "the reflected nature of its

images"[8] and its function is to bring the ideal and the real into contact, so that beauty becomes universal truth and particular at the same time.

The enormous importance that art assumes in Schelling's early system of philosophy is further exemplified by his belief that, in partaking of truth, art establishes a relation with philosophy that is one of integration. Philosophy becomes objective through art, indeed, "philosophy is inconceivable without art."[9] Even more interesting for the contemporary reader is one of the consequences of a theory in which the potential predominates, namely, the conviction that art is based on the identity of conscious and unconscious activities within their respective domains, that is, freedom and necessity. But art's role as the organ of philosophy would remain undisclosed if art were not a form of truth, of identity (also of conscious and unconscious). From the ideal viewpoint truth and beauty are one because both unite the subjective and the objective; only their mode of intuition changes. This process is possible thanks to imagination (*Einbildungskraft*) which unifies what "in reality" has always already been one. The universe itself is God's work of art, and archetypal art is analogous to the divine creation since it reflects the beauty belonging to reason and to the ideas. The analogy tends toward identity in such a way that in the end God is "responsible" for the work of art: He is the source of the archetypes represented by and in art.

<center>SALVIFIC INTUITION</center>

These are the conditions for a philosophy of art that goes beyond aesthetics (that is, it is not limited to appearance); it is a philosophy because the interpenetration of art and intuition is given in its universality. The appropriate organ for attaining objectivity, that is, intellectual intuition, provides the way to attain, internally, ideas; to imagination, instead, is given the task of forming these ideas externally. Imagination gives us a "derived world"[10] in which the Absolute and the finite are united. However, the criterion for distinguishing between imagination and intuition is obscured when Schelling speaks of divine imagination in metaphorical terms: "Nature," he says, is "the first poem of the divine imagination."[11] One way to avoid the collapsing of the distinction is to attribute to intuition the unique capacity for knowing, but for Schelling intellectual intuition is just as productive as imagination is. If there are differences, they must be understood analogically, even though Schelling never discussed analogy at length so as to arrive at a theory of its implications.[12]

Imagination is justified when one is discussing art, it becomes more problematic when it is made the basis of the divine. Still, at the finite level I can intuit and imagine both the real and the ideal, and imagine the false. If the true is intuited intellectually and the beautiful is imagined (reflected) and intuited at the same time, then philosophy and aesthetics are at bottom convergent, echoing each other from two different points of departure. The belief that the universe is God's artistic product and that human creation, in its unconscious aspect, translates the archetypes into imaginative forms thanks to intuition is hardly convincing. This is because intuition does not necessarily present the original identity of the real and the ideal. Even so, the attempt to construct an aesthetics based on intuition and imagination is still valid. Indeed art is the most appropriate realm in which these "faculties" can find their legitimation. But for Schelling discarding the principle of identity would entail paying the high price of separating the aesthetic from philosophy, so that there would be no theory of art at all. Certainly, the move away from the philosophy of identity would require a revision of what it means for art to have an object (the idea, the archetype) and to be objective. The truthfulness of art would be put in doubt.

As reason and intellectual intuition are the custodians of philosophy, aesthetic intuition borrows the object from that sphere, appropriating the true, the sublime, and the beautiful. The two realms are therefore distinguished only by a relative division, not an absolute one. The ideal and the real, then, form a totality that can be called "All" by returning to the indifference of the Absolute—a regression which is not a convoluted retrogression, but a convergence and a possible completion. Since the Absolute is a point of departure and not a point of arrival, differentiation is difficult to elucidate. Moreover, by starting from the whole, Schelling makes it clear that the only way to knowledge is intuition, not analytical thought. Intuition is a tool for synthesis and, in consequence, is more apt to be thought of as posterior than as being capable of grasping the beginning of philosophy. It follows that intuition, in Schelling's system, leads to a contradictory state of affairs. His answer to these objections is that intuition provides a pre-synthesis, which will be displayed in all its potential until a future religious and historical completion is reached.

The rationality of intellectual intuition, when it is combined with aesthetic intuition, makes art objective. To produce art is to arrange truth and beauty in one unity. The quasi-identification of the true with the beautiful makes artists responsible in front of the philosophical community, which is

the appropriate judge of their works. The real and the ideal are at the disposal of both artists and philosophers, but only artists deserve the designation of "genius" because it is their "choice" of a specific art form which will determine the transition from the infinite to its finite realization. These particular forms include the whole within themselves because the universal is already both unity and multiplicity. Only chaos (the sublime) is absolute identity, the bottomless, dark ground. There is an absoluteness of form out of which separation is possible, but only if particular things form an absolute whole. The ideas themselves are at the same time particular and absolute, something that for Schelling deserves the name of "mystery." Each idea is an image of the divine, and, as real, is a particular that "materializes" itself in the gods, who signal the inception of art. Qua intuited actuality, the gods are the object of art, archetypes, and the mythology that ensues is the content of the first stage of art. Later art will become, with Christianity, allegorical.

Notwithstanding Schelling's conception of nature as real and his view of art as belonging to the potency of the real, art has for him a prominent intellectual significance which goes well beyond nature. In fact it is the preponderance of form and ideas which makes poesy "the formative element of the material or content [of art]."[13] Things could not be otherwise when art is seen as being symbolic. Defining the symbolic as the synthesis or unity of the schematic and the allegorical (the schematic being a mode of representation that intuits the particular through the universal, in which what dominates is the universal), Schelling declares symbolism to be absolute indifference, a return to the point of departure after the roles of imagination and intuition have been explicated. Among the arts, music, the most abstract of all, allegorizes in that it conveys the universal while starting from the particular. Painting schematizes, and the plastic arts are fully symbolic. The repetition (and informing) of each mode of representation in the different domains of nature, philosophy, and art points to Schelling's transcendentalism, which permeates all the spheres of knowledge. These iterations are the result of the deductive process, *conditio sine qua non* of there being symbols and particulars and not only indifference.

How the analytical moment is going to be introduced is an issue that needs particular attention in evaluating Schelling's philosophy. Given that the parts include the whole, that they differ from each other and from the Absolute according to the different positions of their respective potencies, it is impossible to go beyond the schematism through which the universal refers to the particular. But Schelling's intuitive and synthetic move goes

beyond schematism, since he reverses it to reach (via allegory) a further synthesis: the symbolic. Strictly speaking, therefore, there is no analytic moment in Schelling's theorizing, his philosophy is a sequence of extremely suggestive analogies. Art, the third potency, is more than art, it is also that side of philosophy which is objective and real. Conversely, philosophy is the intellectualization of poesy.

### MYTHS VERSUS MYSTICISM

Schelling assigns a privileged position to the artistic contents that are universal and symbolic. From this approach it follows that mythology and ancient Greek art are judged superior to modern Christian art. Also privileged are those art forms which synthesize the real and the ideal, because in this case meaning coincides with being.[14] Only on this condition is art symbolic and absolute. The search for completeness relies on the indifference of symbol which is partly meaningful and partly real. Symbolism and mythology (the representational side of the archetypes) go hand in hand to universalize the infinite. Where past and future are one, as is the case with mythology and the archetypes, there the infinite becomes that potential out of which the new emerges as one of its possibilities. Both the Absolute and mythology are poetic in themselves. The latter in particular springs from the intuition of the universe and, therefore, comprises a poetic rationality. It cannot be forgotten, in fact, that mythology was the beginning of philosophy. It is rather Christian art that is irrational, where the adjective "irrational" indicates a disjunction which in Schelling's mind will be restored to unity in a mythical future.

The interpenetration of infinite and finite reaches its apex in Greek art, both in essence and in form. Greek mythology is realistic rather than idealistic, and that fact itself justifies the superiority of Greek art, since the predominance of the real potency is what characterizes art qua art. Christianity detaches itself from nature to get closer to the ideal, in the process it elevates history and providence to revelation. With the priority of the universal, to the detriment of Greek beautiful particularity, Christianity makes it imperative to look at the world morally, from the viewpoint of a newly acquired freedom, but the antithesis between finite and infinite remains, since it is ontologically unsurpassable, given the essence itself of the infinite. The Greeks approached the infinite symbolically; that is, the finite was for them a symbol of the infinite. Christianity reverses the relation, yielding allegory. In the first case, the infinite is subordinated to the

finite, whereas in the second the finite has no value in itself, it sinks to appearance. Only a religious cult retains within itself symbolic actions, while Christian mysticism is to be viewed negatively as a state that ignores nature, or at least that sees it allegorically. What is gained, though, from nature's lost divinity is to permit the supremacy of ideas, the most important of which is the idea of subjectivity.[15]

As a consequence, true poesy undergoes a negative change, there are few mythological themes that flourish in the Christian world view. By the same token sublimity has been excluded, what remains is beauty. But this is a debatable conclusion, unless the sublime is defined in Schelling's terms as the informing of the infinite in the finite without loss of the infinite, and beauty is likewise defined as the informing of the finite in the infinite. We shall see how the sublime is present also in Christian art, especially as the infinite retains its undomesticated character. In relating the finite to the infinite, modernity made an effort to approach the symbolic. However, without the objectivity provided by the intuition of nature, there is danger of plunging into mysticism,[16] something that could be described as a form of objectless alienation.

Advocating a new mythology that would comprise "a synthesis of history and nature,"[17] Schelling projected into the future a utopian hope which is still waiting to be realized. His message was ignored by art's subsequent developments, which have evolved along the lines of the artificial. But Schelling's pronouncements leave artists free to accept or reject precepts from the philosopher, since if taken literally they would curtail poetic life. It would be futile to turn back to an epoch in which the symbolized finite took the shape of hubristic destiny. Yet, notwithstanding Schelling's high esteem for Christianity, he ascribed to the Greeks a superior mythology, preeminent because it is poetic through and through—poesy being defined as "the unity of the infinite and the finite in the *finite.*"[18] The mystic, in rejecting the finite, is definitely not a poet.

### AFTER SCHELLING

After having expressed an aesthetic judgment loaded in favor of ancient art, Schelling examines the possibilities of the future. Far from prophesying the end of art, Schelling invokes the beginning of a new mythology symbolized by new gods of nature, and a return to epic poetry. Art would become absolute, and the antinomies that had marked its course would disappear in the perfect symmetry inclusive of ancient and Christian art.

The chiasmus between the finite and the infinite will find its completion in time. A future synthesis will make their complementarity actual. The present division, though, avoids a categorical dualism, because the finite and the infinite are in themselves inseparable; they simply secure for themselves different meanings, as is apparent in art's diversified results. Only in these terms is future unification conceivable at all. History is far from completed; the fusion of subjective and objective is still to be reached. What makes Schelling's theory relevant today, albeit extremely problematic in its search for a mythical union with nature, is his attempt to explain art as the result of a universalizing intuition. In this context, the complete artist would be one who holds nature to be empowered with mythical aspects. Schelling's words have remained almost dead letter—unjustifiably so, if one considers his overall perspective inclusive of the unification of freedom and being, understood not as something already in our possession but as something to create.

To place completion in the future, rather than in a rational, idealized eternal present, is an act of faith. However, there is something mechanical and not really organic in Schelling's structures, like the recurrence of the dyads real / ideal, necessity / freedom, symbolic / allegorical. All these determinations spring from intuition quite automatically. It is notoriously difficult to base one's argument upon intuition (its solipsistic tendencies are well known), yet intuition remains an essential prerequisite of philosophy. Intuition in particular lends itself to the exploration of art by providing, if not its essence, at least the promise of a limited content. Therefore intuition is the privileged point of departure for making the aesthetic intelligible. But Schelling claims much more, that is, that the aesthetic is indissolubly tied to the philosophical, in that they share a common, analogous, albeit inverted structure within which intuition's role, a priori, is to be the instrument of any inquiry whatsoever.

The enormous burden on intuition is justified inasmuch as this faculty is intellectual and productive of objectivity, thus it is distinguished from imagination proper, whose role is confined to the aesthetic. If there is unity, if a systematic approach to philosophy and art is possible, it is because tautegorical (a neologism formed from "the same" and "allegorical") processes ensue from the Absolute. The Absolute, far from being an isolated Other, can be intuited in its full import while irradiating its hidden and dark light. It is not given in its entirety, and art itself, as a consequence, has not yet reached its completion. But art's place is assured from the start, since it combines the reality of archetypes and the ideality of

ideas; it objectifies them and so makes them its reflected content, but this content (if one wishes to make a comparison with Hegel) is subjected to a different development, since it circumvents the contribution of the concept. The different achievements of ancient and modern art are for Schelling the result of symbolic and tautegorical processes, cosmic and mythical, not of logical determinations. It follows that art cannot "die" either literally or metaphorically. Its eternal presence is guaranteed by the tautegorical process itself and by the eternal fecundity of the Absolute.

What is more disconcerting than anything else in Schelling's thought is his claim that art finds its place on the objective side of the philosophical spectrum. The justification for this stand rests on the view that art's domain is the real, although it also includes the indifference of real and ideal in some art forms. Within indifference, the real or objective alternates with the ideal or subjective in their respective transcendental roles. Alternately, they become the foundation of works of art. But now that both subjectivity and objectivity have become suspect, the question whether art needs a transcendental foundation can be asked anew. It is worth inquiring whether it is really the case that if art is deprived of its transcendental absoluteness it becomes arbitrary and unnecessary, as Schelling claims. Granted, a subjective foundation is sufficient to explain the existence of art, since it leaves its necessity unexplained. Schelling, instead, declares art to be objective because its objects are eternal even if historically given. If we eliminate this aspect and accept Heidegger's critique of the dyad subject / object, we must ask ourselves from a philosophical viewpoint what is left of Schelling's speculative thought. The aesthetic project remains conceivable even if objectivity is put aside in favor of the ontic dimension as theorized by Heidegger. This move signals the essential role of self-transcendence, but this time divested of the extreme subjectivity of desire.

To start with, Heidegger objects to the subject / object dichotomy when it is understood epistemologically and ontologically. Heidegger's approach changes everything. *Dasein* does not need objects or epistemological objectifications to be "by-things."[19] The elimination or putting aside of the object is the perfect solution to the Kantian problem of the thing-in-itself; in addition, Heidegger warns us that it is when the object loses any relevance that one can speak of genuine transcendence. The ontic dimension, though, retains a partial priority over the ontological, to the extent to which a residue of the analytic of *Dasein* maintains its relevance. On the other hand, "ontic transcendence is itself based on primal

transcendence."[20] Ontological transcendence precedes activity,[21] and that is why it is one with freedom, before any choice has been made. From the more modest *existentiell* viewpoint, transcendence becomes a specific act of self-transcendence, a phenomenon that Heidegger describes in the following way: "In transcendence Dasein surpasses itself as a being; more exactly, this surpassing makes it possible that Dasein can be something like itself."[22] A repetition of the Faustian theme lurks in Heidegger, who calls *Dasein* "excessive," "insatiable," with necessary links to temporality that make it, constantly, ahead-of-itself.

### PROSAIC MYTHS

One should value Schelling's insistence upon the relevance of myths in art. In fact, their presence is prominent also in the modern and postmodern age, to which we now turn to elucidate their inner coherence. These are secular myths that have abandoned the claim to a metaphysical validity. What can still be of use in Schelling's theory of art is, in fact, the need for mythology qua content. However, the notion of content also has been declared outdated by contemporary critics and philosophers, especially structuralists, who detect in it the refutation of their formalistic analyses. But if the content of art resides in mythology, a mythology deprived of its metaphysical foundation, one should pose the question of whether modernity has found a new mythology conducive to artistic expression in science, taken in its more general meaning. On this issue, Schelling invoked the philosophy of nature, but his nature and his science have been accepted with great reservation by the contemporary world.

Whether art still needs models or archetypes is a question that can be answered in the affirmative if we assign to myths an intersubjective function, rather than an objective function in Schelling's sense. In this connection, there is a science that has shown itself to be the perfect candidate for a new mythology, and that is psychoanalysis which has been used to interpret innumerable literary works. But one of the risks inherent in such a point of departure is the danger of reducing art to psychological factors and interpretations. On the other hand, sociological interpretations are inevitable for paintings and sculptures which use found materials as a way of "getting rid" of waste material, and thus discard aesthetic norms, such as beauty, that were the marks of an objective understanding of art. Alluding to the insubstantiality of present society, these forms indicate a propensity toward what is already given rather than being

an attempt at poetic transformation. "Immanent" is the adjective that best characterizes these works, the products of artists who cannot challenge the intersubjective world to which they belong.

Mythology could influence the current art world if, in contrast to the current view, the present were not considered to be fragmented. Instead, the ontological rupture, to which the subject has been condemned by the realization of its being a simple grammatical structure, has produced the "postmodern condition,"[23] whose artistic achievements are nothing but a compromise between the modern and the old. These artistic results constitute a further proof that the myth of the Overman has failed. Of course it is useless to "moralize" on this issue. On the other hand, a positive judgment concerning the collapse of high art into low art (typical of postmodernism) is hardly desirable. The process of popularization is evident if one notes that the museum has become a place that does not guarantee the presence of art, even less of beauty. When door handles are exhibited and the public is invited to touch the "artistic objects," allowing it to believe (falsely) that it can appropriate that which once was untouchable, we witness the meager results of the intersubjective approach to art, rather than a profound search for its conditions.

Thus, it is not the "concept of art" that is investigated in postmodernity, but rather its function. Typical is the fact that the I-Thou relation has been replaced by the I-You (in the plural), the "I" (the artist) is reduced to quasi-anonymity, while the "You" (again in the plural), with its overwhelming presence, makes problematic the distinction between their respective positions. Art has become the confusion and not the fusion of I and You. Fusion is the task of the sublime, but I disagree with Jean-François Lyotard that modern aesthetics proclaims a nostalgia for the sublime.[24] The sublime plays an important role in modernism, but the sublime is far from being nostalgic. It is instead the most noteworthy result of the emergence of the new in modern art. It is to be regretted that the sublime is absent from postmodern art, this hybrid which accepts a worn-out "We" in search of reassurance. The monstrosity of Philip Johnson's former AT&T building in New York City stands as one of the most pretentious mixtures of realism (its dutiful monumentality) and ingratiating sentimentality (the pinkish, superficial surface of the granite). Accessible and inaccessible at the same time, Johnson's building is a parody of the sublime; his ironic intentions are even more questionable in his so-called Lipstick building in Manhattan,

where the pink color predominates to the point of becoming a homage to futility. In these examples one can see the failure of art when it declares the nullity of objectivity to rely on the myth of everyman.

## ART'S FUTURITY

In the light of these considerations, reexamining Schelling's overall project helps us to understand art's objectives. In order to qualify as objective, art must rest either on a metaphysical ground or, minimally, on the marginalization of the subjective. In idealistic thinking the higher place is reserved for the subjective, and Schelling, unsurprisingly, assigns the subjective to philosophy. But art is philosophical and therefore truthful. It appropriates for itself that part of the real which particularizes itself. The Absolute, from its primordial oneness, has fragmented itself, leaving its mark on the archetypes and mythology. Objective art is possible because reason lets mythology pursue its independent course. The particular universality that is proper (and necessary) to art is due to the autonomy of mythology. Thus, art is first of all "realistic" even when it avoids empirical reality, it is "realistic" because it is imbued with the objectivity of the symbols.

The sharp opposition between symbolic and allegorical art marks the latter as being a more intellectual art than the former and, in addition, less permeated by the tragic. Allegory is to a degree disqualified on the ground of its incompleteness, in contrast to symbolic art, which is synthetic in nature. The criterion of good art is that it be as complete as possible, a standard which is hardly questionable even today, if one interprets "complete" in a strictly aesthetic, polyphonic sense, distinct from an impossible totality. Why allegorical art is to be considered "inferior" to symbolic art depends on the fact that it is less real in Schelling's sense. Allegory's "mistake" is that of starting from the particular,[25] while the goal is the futural apotheosis of the whole, a "new return" to symbolic art, in which schematism plus allegory form an identity. When the ideal prevails, as in the verbal arts, the results are more philosophical than in the formative arts, since the former operate through a medium that is also ideal. But this transition is insufficient to reverse the allegorical process, an event which would mark the advent of a new mythology.

Schelling shares with Hegel the idealization of Greek art. However, this is no longer of fundamental importance. The true question is whether that idealization rendered Schelling's aesthetic judgments sound or whether he felt on that account a nostalgia for the past. His advocating the

completion of art excludes a return to the past. As he sees it, the synthetic character of completion will absorb what is valid in modern art, including allegory. Schelling is the Hegel of the future, awaiting the Paraclete, the third epoch of the Johannean Church.[26] It will be objected that we need not wait for that prophetic moment; yet everything is already given in the potential. The new path that will be taken assures the future of art.

Instead, we are now witnessing the almost complete absence of myths in the world of art, due to the extreme subjectification of the aesthetic process and to the proliferation of their sociological statements; what predominates is the particular without the intervention of any allegorical process. Literality prevails at the expense of the philosophical dimension of art which, as we have seen, must include, beside the literal image, its objective correlate. In the example of the door handles, given before, one finds the absolute autonomy of the image which precludes any attempt at interpretation. In this way, the necessity of art disappears into the merely empirical.

### THE NECESSITY OF ART

The universal for which the philosopher is searching does not have to be conceptual, it is sufficient that it guide us toward the objective thanks to a particularized whole. Thus, for Schelling the forms of art are particulars within the particular, while the work of art is finite / infinite. It is a finite that results from the infinite affirming (and hiding) of the Absolute, the justification of which is the Absolute itself. Thus, Schelling can conclude the first part of his philosophy of art boldly declaring that "the philosophy of art is the construction of the universe in the form of art."[27] Art's appearance in the phenomenal world is a manifestation of the Absolute from which art derives its necessity. The necessity that materializes in the work of art is the product of genius, who is defined as "the absolute indifference of all possible antitheses between the universal and the particular.[28] Genius alone is capable of uniting poesy with art, the real side of art with the ideal, subjective side.

Schelling does not insist on beauty alone as being one with art; he is concerned with the real / ideal polarity because that is what justifies art's philosophical and necessary status. Without undermining the relevance of beauty and the sublime, Shelling attempts to provide a model for art that implicitly declares art more pertinent than the beautiful alone. This is the other side of Schelling's intellectual stance. This view is contemporary in

flavor, since the beautiful, in the sense of the harmonious, has almost vanished from our concert halls and museums. At least, when it appears, it is likely an indication that we are facing the art of the past. But what vitiates Schelling's position is his relying on a specific intuition of the Absolute. Intuition is of course legitimate, but when it is declared *the* faculty that decides what is objective several problems arise. Under consideration is the intuition that aspires to be valid beyond evidence. On this point Edmund Husserl writes: "a 'categorical intuition', an intellectual insight, a case of thought in the highest sense, without any foundation of sense, is a piece of nonsense."[29] However, there are universal intuitions that provide purely categorical concepts such as "unity," "relation," and so forth, but for Husserl these are still dependent on consciousness, whereas Schelling goes beyond such considerations. Consciousness, in fact, separates concept and object and only follows from the original identity of the Absolute.[30] However, experientially, the real and the ideal, object and subject, or being and presentation can be identical in self-consciousness[31] prior to any mediation, with the result that Schelling's notions become intelligible, provided that the synthetic act prevails over the analytic moment.

The second question concerns whether only intuition provides an objective view of art. To begin with, no objectivity is absolute. Especially in art the created object is the result of a self-transcendence that always borders on intersubjectivity. Schelling, however, denies the absoluteness of the object, since for him intuition is the universal vehicle that conjoins the real and the ideal potencies which will be separated by an act of freedom. In ascribing priority to the potential, the answer is to profess also the priority of intuition, since the potential is given only in intuition. The difficulty arises in making the transition from the potential to the actual. For Schelling this is a matter of the informing of the infinite in the finite, a "condescending" on the part of the Absolute to mingle real and ideal also in the "real" world. From the infinite principle descends a different kind of reality, which, finite as it is, is analogous to its infinite Principle. The infinite, therefore, is not absolutely transcendent in its identity with itself. As the source of the real and the ideal, it is intelligible, but the act of comprehending it can be as much indeterminate as the Absolute itself in its identity.

Now it is important to ask whether it is plausible to assert that art is explained in its necessity. "The necessary," Schelling writes, "is that which is posited in all time."[32] The double, chiastic movement between the infinite and the finite must have explanatory power if the ideal,

almost suprasensible aspect of art is to be incorporated into Schelling's system. This suprasensible component must, of course, be both theoretical and factual, considering that beauty, as everybody knows, is perceivable even though it cannot be touched. Ideally speaking, the beautiful owes its aesthetic value to the fact that it presents itself as unity. Beauty is not, therefore, due to an act of consciousness only. What is distinctive in Schelling is that the highest forms of art are those which, beside being unitary, allude to the infinite indifference of real and ideal. In the finite work one aspect will always predominate, but a preestablished harmony will forever remind us of the possibility of the ideal. Schelling's is a system that requires a hierarchy and does not allow the different forms of art to "compete in the market." The hierarchy of the arts is the necessary consequence of a systematic theory dependent on a transcendental methodology in which the ideal obfuscates the real. Translated into aesthetic terms, this is like saying that the objectivity and necessity of art tends, in its highest forms, toward subjectivity, which would make art one with philosophy in an approximate circularity. Art is objective in that, thanks to intuition, it produces spontaneously. Intuition, however, makes differentiation problematic at the intellectual and the aesthetic level, since what is at issue is the harmonious union of real and ideal.

The organic quality from which the diverse forms of art unfold makes the task of art one of "returning" to the primordial original identity, but this time finite. Art is the organ of philosophy in that it "reveals" the truth of tautegorical processes intrinsic to the potencies. Thus, philosophy and art are complementary, and truth belongs to both. Truth makes its appearance through the content of art, through the archetypes first and then through mythology—above all mythology that is archetypically concretized in beauty. The genius is the unconscious creator of a truth that elects beauty as its analogue. The artist traverses backwards the territory of the philosopher, that is, the artist goes from objectivity to subjectivity and the philosopher from subjectivity to objectivity, and both encounter the infinite. The task of the artist is even superior to that of the philosopher considering that the creative process is one of imprinting. Yet, a profound analogy unites them, and the necessity of the one is the necessity of the other, if one disregards the different instruments with which they operate, that is, aesthetic intuition and intellectual intuition, respectively. After all, the two types of intuition are analogous insofar as their function is to manifest the whole. Thus, art and philosophy rest on the same ground. The privilege

of the artist is to have access to truth without divesting it of its sensuous aspect. The prerogative of the philosopher is to situate art in the realm of knowledge. Strictly speaking, artists are oblivious of truth, or their relation to truth is unconscious, truth is revealed in the work of art itself: "The artists most fit to produce beautiful works are often those least in possession of the idea of absolute truth and beauty. They lack the idea precisely because they are possessed by it."[33] The still romantic dichotomy of conscious and unconscious from which the work of art originates lies at the root of the double life of the artist, who is obliged to serve two masters, that is, subjectivity and objectivity. But myths are not created by the artists themselves, they are created by the "universal intuition of the universe."[34]

There is discontinuity in art—a historical development that Schelling explains "structurally" via the progressions of the potencies. The different art forms are each self-contained, and if there are illuminating analogies or quasi homologies among them (for instance between music and architecture), the fact remains that these differences are due to the preponderance of the real or ideal potencies. Above all to prefer one or the other art is not a matter of taste because their aesthetic specificity derives from their internal (analogical) and external (structural) relations. It is a matter, in appreciating art and in philosophizing about art, of construing and elucidating what is seen, heard, or read in a manner as intuitive as that of the artist. Necessarily, the levels are different. The creator is considered superior even to the philosopher, but without philosophical reasoning (deduction) the product of the artist, while remaining objective, would be deprived of its absolute significance.

To say that art is objective is to maintain, among other things, that its inner structure is similar in every art form. Even the break between symbolic and allegorical art, though salient, is relative, it does not affect the deduction of the art forms. The ultimate purpose of art is found in the necessary multiplicity that reveals itself to be—philosophically—unitary and harmonic. Even a metaphorical view of art is insufficient, since metaphors are too limited to elucidate the abundance of mythological narratives. Metaphor is a technical device rather than a category capable of penetrating the complexities of the whole; it is a dispensable means for mythopoesis. It suggests a void that needs to be (ful)filled by language. In Schelling's theory of art the void is repudiated, even though the pleroma is still to come. Mythology and the archetypes, truth and beauty work together in the endless process of completion of the Absolute.

# CHAPTER 3

# Philosophy as the
# Organon of Art

## SIC TRANSIT

Diametrically opposite to Schelling's understanding of the Absolute is Hegel's. No transition can be given except the admission that one is the reverse of the other. But the consequences for art are remarkable. By categorizing art as actual, Hegel places art in the position of being absorbed by philosophy and so divested of its objective autonomy. Philosophy has often ignored art's autonomy or even presence, Hegel being the case in point when he finally declared art's end. What he meant is that art has little to teach to philosophy and that their interrelation in the long run comes to nothing. The "death of art," as it has been called, makes clear art's insignificance vis-à-vis religion and philosophy. Sublated into speculative thought, given its "compromises" with sensuous appearances, art has a problematic relation to the Concept, and the Concept cannot contain all art.

Art is an activity that cannot be reduced to philosophy; yet it is up to the philosopher to try to understand what art stands for. Hegel did try to understand it, but, given the absolute priority of thought in his system, he reproaches art for being representational and for being a defective instrument of knowledge. Art's specificity and meaning rest principally on the notion of beauty.

HEGEL'S TRIPTYCHS

Beauty is a "specific way of expressing and representing the true," there-fore, it must be understood by conceptual thought.[1] Truth means the totality and is, as a consequence, connected to systematology. But there will always be a residue in art that remains unexplainable; even less can art be confined to the reiterated triptychs which constitute Hegel's logic and aesthetics. There is something foredoomed in art which makes it a volatile human endeavor. Art is in its materiality subject to the erosions of time, but what is decisive for its "condemnation" is its inability to support the rationality of the system. Beauty is still a mere image[2] through which one grasps with difficulty the infinity and circularity of thought. Immediate, finite, it seems that art rests on a nothingness incompletely spiritualized.

In order to dismantle such a view it will be sufficient to negate Hegel's absolute point of departure. Hegel fails to repudiate the convic-tion that the present, qua actual, already displays everything there is to understand about the future. This is the famous affirmation of the ratio-nal / actual identity, whereby the Absolute is not too different from a cat-egorical imperative. Instead, if prominence is given to the potential, then, clearly, none of its expressions can ever exhaust it. Thus, Schelling can eas-ily avoid the problem of the end of art, as Hegel must, since for Hegel art becomes deficient in comparison to absolute rationality and is incapable of providing us with anything genuinely new. Hegel's gigantic effort leaves art in the realm of the finite, to which it certainly belongs, but also deprives it of a final philosophical purpose.

The question, then, is whether art is worthy of scientific inquiry or is instead hopelessly prey to contingency. Hegel's final answer is affirma-tive, notwithstanding the fact that art can be accused of being tied to feel-ing and imagination; and imagination, as everybody knows, gives us the possible and not the actual. The remedy, if we want to avoid condemning art and beauty to the realm of the frivolous, is to regard them both as expressive of freedom and, even, of the divine. Art is the mediating term between sensuousness and thought, "it points through and beyond itself,"[3] thus it is permeable to thought. However, to intellectualize it would mean to underestimate its sensuous, necessary aspect; in fact, spec-ulative thought ascribes a meaning to art, but this meaning, looked at carefully, is "beyond art." If a theory of art is necessary, its necessity lies in the expansionistic nature of thinking, which must include the examina-tion of what is, after all, a spiritual activity.

The Hegelian Concept can be extended to include art which is "a development of the Concept out of itself, a shift of the Concept from its own ground to that of sense."[4] We are faced here with a regression and an expansion, so that beauty, in order to be reached, must assume the "shape" of the Concept, must be inclusive of both the particular and the universal, but the universal is thought, and art can only verge on it. Thus its imperfection. It is only the Concept that can provide art with its necessity and make possible a scientific inquiry into aesthetics. The fact remains, though, that art is a transitory stage whose full justification is to be found in the *Science of Logic*. So Hegel can say that the Concept of art is taken up lemmatically,[5] since to demonstrate its necessity would mean to rethink his whole philosophical system. At the root of the specific Idea of art, the ideal, lies a paradox, namely, art is and is not the whole. So characterized, art should be allowed to transcend its own time, but Hegel's position denies that this is possible. On the one hand, art is ideal, and, on the other hand, it is excluded from the continuous development of the Idea. There is nothing new beyond romantic art.

Superior to nature, art springs from a spiritual activity that excludes imitation;[6] it can evoke feelings, but this is not its purpose. Taste is similarly insufficient to direct us to the artwork, for taste is superficial, it ignores art's meaning and can at most make us enjoy a single work. The major defect of taste is that it stops at the external, at the sensuous, and is incapable of understanding art, which must be evaluated according to its spirituality. Spirit's high conquests can look at the senses with some disdain unless they become the means to a higher unity. Notwithstanding Hegel's claim that art is situated in a middle position between sense and thought, it remains something external, relating at the same time to the two most ideal senses, that is, hearing and sight. Yet Hegel says: "In artistic production the spiritual and the sensuous aspects must be as one."[7] This unity is the effect of beauty. The concept of beauty is *sui generis*, actually an Idea, more enigmatic than the logical Concept in that it implies, by definition, the unity of the spiritual and the sensuous. It follows that the universality of the work of art is also *sui generis*. Detached from thought, beauty is exposed to externality, which is why there is no preestablished "how" that would teach just anyone to be an artist. The beautiful cannot be taught, and its spirituality, which *must* arise from the work of art if it is to be worthy of its name, is far from being subjective. If art, then, purifies us from the passions and mitigates them, this effect is secondary. What is essential is that art gives us truth in quasi-universal

form, suitable only to itself. This truth consists in the reconciliation of freedom and external nature. Mere subjectivity, as the dominant component of art, has disappeared.

### BEAUTY SURPASSED

With hesitation, Hegel affirms the scientific status of aesthetics. The reason there can be a science of art is more than pure subjectivity, the point where Kant left it, prey to subjective taste. Instead, art embodies spiritual freedom in its mission of self-understanding. No danger of nihilism here. On the contrary, art presents a concrete content (the Idea) which, constantly and predictably, yields norms for evaluating artworks according to their correspondence to the ideal. A result is the unfortunate and, in Hegel's time, common trend toward ranking art forms according to a criterion which, even though intrinsic to the theory, limits the freedom of artists who are therefore prevented from going beyond the post-established principle of harmony.

In this respect nihilism is more "malleable," leaving artists to confront their own drives and to disregard any "ought," except their own. But Hegel, although condemning it, did detect nihilism in the art of his time. In irony he saw a nihilistic principle that undermines the stability of the Idea. His argument against irony as a viable artistic means combines a moralistic position with a philosophical one. It is moralistic in that Hegel wants to affirm the values of morality and *Sittlichkeit* even in an area that is deaf to moral considerations. Hegel never forgets the *Sollen* of duty and reason reflecting on itself.[8] In irony the Concept is distorted, unrecognizable, or utterly absent, even masqueraded. The beautiful, instead, is somehow pure, even though art involves two complementary specificities, in that the sensuous object remains finite, but its meaning unequivocally pertains to the ideal. Thus, a criterion is already established for the hierarchical classification of the arts. Poetry will merit the first place because it is closest to the spirituality of thought. It is also "easier" to express ideas though the medium of language. With these conclusions Hegel has already determined the system of the arts, namely, first the Concept, then its corresponding Idea, then the prescriptive nature of aesthetics. Certainly an aesthetic theory, to the extent to which it incorporates a theory of beauty, is bound to differentiate the beautiful from not-art. Otherwise it would end up being indeterminate. Hegel, however, beside giving normative directives, tries to systematize (actually the two processes become

one) the beautiful, regarding it as something whose presence admits of degrees. This last point clearly emerges from Hegel's analysis of the different art forms, that is, symbolic, classical, and romantic.

Beauty must be actualized by the artist, but the Idea of beauty should remain immutable. Yet, each moment of the Idea, of the Concept, is relative if considered in isolation, but to call art "relative" is both an impossibility (given its concrete "existence") and a truth, and the contradiction is intrinsic to the position of art itself. Thus, art does not die a natural death; its death is decreed by consumption of its own content, which is violently appropriated by the successive stages. At the same time, its dissolution into religion and thought testifies to the fact that there is an insurmountable imperfection inherent in its form. Art's significance has never been that of the accomplished whole; art is one-sided, being tied to representation (one of its necessary components), art is destined to be dethroned by reason, that is, by absolute absoluteness. What dies at the higher stages of determination of the Idea and the Concept is art as such and beauty. Hegel says that art by definition is beautiful art, therefore, beauty and art should "die" together, at most leaving traces in memory. The beautiful is that which harmonizes with the Ideal, and although art without beauty is for Hegel conceivable, he would dismiss it as being devoid of meaning and content. By the same token, abstract painting would indicate for him a return, therefore a regression, to inorganic forms of life, colors notwithstanding. Consistent with his own dictates, Hegel, while appraising painting, reiterated his view that the portrait is the depiction of the highest expression of inwardness and, thus, the most deserving object of visual art, because the human face is the most distant from the externality of inorganic nature.

It would be mistaken to accuse Hegel of not having given us, and thus to the future, a theory of art that could foretell art's possibilities. What he can be reproached for, though, is the affirmation of the eternal return of the Concept into itself, a theory that excludes real novelty in the field of art. Yes, the Concept determines itself in time. However, it is difficult to avoid the conclusion that what is determinative is the constant reaffirmation of a structure destined to exhaust itself. But Hegel stood firm on his principle. In fact his philosophical conviction could be condensed by quoting Louis the XIV's statement: "*Après moi le déluge!*" or, if one prefers: "*Après nous le déluge,*" in view of Hegel's systematicity and collective priorities.[9] And the *déluge* did indeed come, with Friedrich Nietzsche and even before Nietzsche with Karl Marx. The consequences

for art have been critical, since art acquired its own significance and it was no longer seen as ancillary. But it is more interesting to recognize that from one form of nihilism (limited to the end-of-art theme) which was opposed to all other forms of nihilism, another one, more radical, was developed, and that from nihilism a revaluation of art came about.

Hegel gave art a meaningful content, but his final verdict put into relief art's negative side. Even so, a relevant theme within Hegel's view of art is the notion of harmony, a deterrent against the most extreme forms of nihilism.[10] Harmony, as a feature of art, can be considered peripheral; it is not the legitimate heir of the Ideal and of beauty; it is a premise, together with symmetry and conformity to law. Harmony is a "congruous unity which has set forth all its proper factors while yet containing them as a whole inherently one."[11] It is a matter of quality, but also a matter of abstract form. One finds harmony among colors and even in animals, in their movements; thus, harmony is related to nature, and that makes it spiritually undeveloped. It represents, however, a first step in the direction of free subjectivity, the completion of which is beauty.

Without the immanence (or quasi immanence) of beauty the art-work would be null and it would not be autonomous. But with the abandonment of Hegel's systematic philosophy it has become clear that the spiritual in art excludes the absolute immanence of the ideal and the real. Such an impossible combination, however, is what makes Hegel a visionary, and a shrewd one at that. He places all significance at the level of the Idea which informs the real, while the ideal becomes the criterion by which to judge every single atom of the world. To be an idealist means, in his specific case, to "discard" everything in order to reappropriate it in the eternally significant totality which has demonstrated itself to be the ideal and the Idea itself. Hegel starts from the Absolute to return to the Absolute which he never left. Espousing a panlogistic view, which declares the rational to be real (the rational being the unity of subjectivity and objectivity) and the real rational, Hegel was aware that he was embracing a totalizing view of philosophy. However, this often misinterpreted statement, which some took to mean that Hegel was trying to justify literally everything, finds its more than plausible explanation in the consideration that a rationality that is particular is no rationality at all. What Hegel was putting forth was simply a definition of what constitutes the rational and the real—an idealistic tautology, therefore, but one that includes difference. Art's destiny is to stop short of the completion of rational and real; at most art can aspire to be analogous to the full

expression of thought. The perfect univocity between art and philosophy will never be complete, even though Hegel's panlogism aspires to exactly that. The role of the Concept is unquestionably one of guaranteeing that the different aspects of reality conform to its triptychal structure. Art is included in that structure, but it will never be the model for explicating the function of the Concept.

If art is not the organon of philosophy, philosophy has nevertheless the right to intervene in its domain to legislate as to what is beautiful and what is unacceptable and to determine art's place in the overall economy of the system. There is another reason why aesthetics is possible, namely, art can be the object of rational discourse once its speculative possibilities have been ascertained by philosophical *fiat*. As philosophy is not beautiful, so art is only imperfectly philosophical. If it were eminently philosophical it would be one with speculative thought. Significant in this respect is the fact that the last stage of art is the romantic one, undermined by its own irony. Irony stands for the dissolution of its own premises, marked as it is by lack of substantiality. Hegel, in connecting the end of art with romantic irony (and the comic), ignores irony's other resources, that is, the possibility that irony may reject sentimentality and be critical. Sentimentality limits itself to negotiating with the infinite, which makes it a source of discontent. Criticism operates exclusively within the finite, from which it extracts the all-too-human awareness that truth can be destructive. By putting forth a contingent criterion for dismissing art, Hegel exhausts the already limited possibilities of art. But Hegel condemns irony because it repudiates truth and therefore challenges the veracity of the system as a whole. What is this truth, then, that can be banished by romantic irony? Truth has nothing to do with defining finite forms, being the whole Idea; the demand on art is that it must objectify and embody the Idea.

## THE ULTIMATE RATIONALITY

Art confirms and at the same time contradicts the totality, the absolute system. Art confirms it because no concept (I am referring here to the concept of beauty) can avoid being de facto absolute. It contradicts it because art, without being "other" like nature, nonetheless looks beyond itself, specifically to philosophy, without being one with it. What art does, though, is to become concrete through different art forms. Symbolic art, symbolized by architecture, has not yet appropriated the

organic and natural shape of living beings, thus symbolic art is a distortion which shows its incompatibility with the Idea and therefore also with the ideal. Yet, symbolic art is art because it is concerned with shaping matter into *some* determination, it is a partially achieved attempt at continuity. Symbolic art does not represent its object, but only hints at it with its massive inertia. It is unable to articulate the complexity of the Idea in its inner movement. Its truth is, as a consequence, deficient.

Classical art is all that symbolic art is not; in the classical form what prevails is the unity of form and content, that is the ideal, spiritual subjectivity which alone is absolutely meaningful and true. A perfect correspondence testifies to the predominance of inner life which dominates externality, but in such a way that the natural becomes ideal and the ideal beauty. In this meaningful presentation of the human body one perceives the concrete symmetry of individuality. It is the case that art here manifests what is most significant in meaning: objectivity and true absoluteness, that is, the ideal. But what is still unclear in art is the relation inner / outer. 'Inner' and 'outer' are here taken synecdochically, as exemplary of the dialectic character of art, but more than that, these notions lend themselves to the understanding of art, since the arts include the elements of externality. Although Hegel argues in favor of the perfect union of content and form in classical art, the complete coincidence between the inner and outer is problematic. The inner is different from the outer because the external side of art, its having to contend with a medium, will never coincide with pure thinking. There is an unavoidable discrepancy between the outer and the inner in art unless one postulates the total metaphysical immanence of thought (or expression) and reality. This is a plausible interpretation of Hegel's philosophy, however, if it is correct, it becomes impossible to justify the theme of the end of art.

The price that art pays for its actuality is that future self-transcendence is ignored. Moreover, the demands of the Absolute restrict art to the secondary role of beautifying a reality that is already, *ante artem*, meaningful. Art's function remains confined to the expression of the ideal, an all too temporal expression. Thus, the "death" of art corresponds to the rebirth of pure thought, and art dies twice. First there is the death of the work of art itself, due to the expected decay of its material substance or to the incomprehensibility of ancient languages for the vast majority of people, and then art dies a second time since it is an inadequate means of conveying the absolute meaningfulness of the Idea. Yet, the interpenetration of inner and outer must be as complete as possible if

we want a result that speaks to the public. In fact Hegel is far from advocating an esoteric view of art—art belongs to the people that have produced it, it is not the exclusive "property" of the artist.

## MYTHS AND THE SYMBOL

Hegel's systematic devaluation of nature runs parallel to another, namely, the devaluation of mythology. He regards mythology as the expression of a stage long gone, that is, the heroic age, but since it is beautiful, mythology is looked at with a maximum of nostalgia. Now that the rationality of civil society and the state has made us into ethical beings, at one with universality, heroism is superfluous. The ubiquity of the ethical restricts the borders of the poetic. Myths are now consigned to the universality of memory; they offer an ideal to be recaptured ideally. They are indeed universal in character, hence it was legitimate for an artist to resort to myth as content. The individuality of the heroes displayed what is active in the logic of the expressible ideal; but now heroes have died (as is art's destiny) a spiritual death.[12] Once mythology has been assigned a limited artistic role and a possible future has been discarded, only the present predominates in art. Hegel considers myths to represent a transitory source for artistic imagination. They are to be regarded as belonging to ancient art, in which the rational and intelligibility have not yet taken hold. After all "mythology is . . . in general only an idle invention of fables,"[13]—maybe fascinating, but external to the true content of thought. Myths are not profound as Schelling believed, surely they can be studied starting from the philosophical perspective and interpreted symbolically, yet Hegel never undertook such an extensive inquiry. In myths what prevails is imagination, this explains their coming to life in past historical times and this is sufficient to justify their existence, but one should refrain from thinking that myths stand for the completion of art.

Akin to symbolism, mythology has the defect of concealing what is implicit in the Idea. Also the symbol is intellectually poor, ignorant of spirit's future possibilities. It produces monsters, as in Asian art, with multiple arms, or the Sphinx, and abominations such as the combination of animal and human forms. Symbols are ambiguous and therefore often sublime, formless, grandiose in their expressions, measureless. In them the Idea transcends the artistic object, making impossible the required immanence of meaning and form.

It is almost a commonplace to attribute a symbolic structure and function to art.[14] What is meant by that attribution is that symbols

encompass all that art *is* and so the symbolization process assumes the role of a transcendental device. But looking at the symbol proper and not to the symbolic function, one comes to see that the symbol has a limited role to play in art. For Hegel the symbol, in contrast to the arbitrary sign, is an intuition that coincides "more or less" with its content.[15] Its mode of representation is not free. This is what made Jacques Derrida say that "through the symbol [spirit] is a little more exiled in nature."[16] Since the symbol is not arbitrary like the sign, symbolic art must make reference to something actually existing or thought to exist. But no movement, no development is present in symbolic art, notable as it is for its static character. If art extricates itself from this initial stage it is because it is vanquished, incapable as it is of developing beyond itself. In fact, art's forms develop thanks to the unfolding of thought, and the symbol is the first accomplice of the Idea in this project.[17]

In between reality and imagination, the symbol is neither arbitrary nor natural. The symbol conveys an affinity with freedom that liberates it from the constrictions of sensuous nature. Let us remember that nature is to be sublated in its negativity and must be "replaced" by spirit, to incorporate it into spirituality is an impossibility. Thus, the symbol is that type of sign which looks both to the past and to the future. It looks to a past represented by mythology and by a conception of the world still caught in the primal, undifferentiated unity of the absolute triad. It also looks to the future, since it hints at a liberation from this same unity. Thus, imagination is essential to symbolic art. Imagination intervenes every time it is a matter of linking meaning and shape.[18] Symbolism proper has its inception not in the Concept but in nature, and here lies the necessity with which it is clothed. To start from the meaning or the content would mean to start from what is already accomplished and spiritual. Symbolic art's route is altogether different, for it never goes beyond approximation but only illustrates the meaning itself. This happens in the symbolism of the Egyptians and in the sublime poetry of the Jewish people. By nature symbolism is implicit and esoteric; for this reason symbolic art does not have the clarity needed to attain beauty, since beauty stands for the freedom of a conscious subjectivity. Necessary as it is, symbolic art is not spared art's limitations, and its overall meaning is constantly in danger of collapsing into the other-than-itself.

As things stand, the symbol is a hybrid which is too weak to encompass substantiality and strong enough to make its impact on an art form that still struggles to identify itself. The powerful side of the symbol

comes forth when Hegel connects it to the sublime. It is here that symbolic art reaches its apogee. When meaning predominates and empirical externality is put aside, we witness an elevation of the inner life of spirit, an overcoming of the finite. This is what the sublime is.[19] Its negative and positive sides rest on the fact that the sublime first appears and also is incapable of appearing. Invisible and unutterable, or utterable but invisible, the meaning of the sublime has no recognizable shape. It makes its presence felt in poetry—like the poetry directed to the One of Persian pantheism or to the Jewish God, that God lacking pure spirituality. The Jewish God is pure transcendence, thus Jewish art is sacred, not simply symbolic in the strict sense of the term since in the symbol what predominates is the shape while in the sublime shape is banned or declared explicitly to be inadequate to the task of evoking God. The sublime is subsumed under the symbolic and not categorized independently because it tries to answer the same question that symbolic art raises, namely, What is the relation between inner and outer? The answers that they both offer are similar. The sublime declares more explicitly what in the symbolic is implicit, that is, the incongruity, the lack of correspondence between inner and outer. The symbolic, the symbol proper, looks for its completion in the external shape, trying to capture what is seemingly transcendent. The sublime, in an act of despair, consigns itself to transcendence and hopes to find there, in the beyond, an answer to the pressing question of meaning. The two modes strive to reach a meaning, a content that the Absolute has withheld.

## THE SYMBOLIC SUBLIME

The symbol is less than full signification, the symbol by itself offers only indications that something meaningful is at stake; it is both terrestrial and divine, and only that portion of art is symbolic which admits of the invisible and the inconceivable.

We will see in the writings of Edmond Jabès how the tension between being-of-other and being-for-other is compatible with finitude and with its negation. The sublime is related to itself first, but being unknowable, it confronts the other as transcendent. The sublime is characterized by being itself and other, half real and half imaginary. Like Kant's natural sublime, its artistic version does not point to a hypostasis. In order to be so reduced it would have to be immutable and semantically fixed. Its meaning refuses this interpretation. Being also "other," the

symbolic sublime prevents a definitive, permanent signification, it is ductile, potentially infinite. If it were otherwise, it would be a useless artistic creation. Therefore symbolic art is neither nihilistic nor decadent unless it renounces its intermediary position between sense and non-sense. Symbolic art is open to divergent meanings, and so is sublime art; it follows that religious art, to the extent to which it is dogmatic, cannot be sublime unless it hints at the possibility of heresy.

When the symbol insists on presenting itself as fixed, then it is dead, like the dead metaphors worn out by time. The need for interpretation is thus fundamental, especially considering that the artist's product is always and necessarily incomplete. In fact, what counts in sublime art is the dynamic to-and-fro between the esoteric and the exoteric, since with such reciprocity symbolism in art reaches its maximum point of sublimity. The symbol detaches itself from reality without requiring the death of the thing. Such negative outcome is overcome by the symbol's power to appropriate a reality that has not yet found its completion in part because it is intrinsically finite, and also because it must leave room for the other. There is a perfection in the incomplete which separates it from the perfection of the beautiful, the beautiful being self-contained and self-appropriating. The symbol, and with it the sublime, look beyond the already formed to shape a unity in the making. Perfection in the sense of the beautiful has ceased to serve art, it has become premeditated, and—what is worse—it pretends to be innocent. If art is to go beyond beauty, an encounter with the unknown is needed so that the unknown can sweep away all reference to established truths. For this reason the symbol in art is created together with the work.

A digression to illustrate the sublime at work is in order. And there is no better example than the emblematic poetry and poetic prose of Jabès, with its insistence on God's silence, the correspondences between the desert, nothingness, and death. Within this framework lies a deep anomaly, namely, the lack of correspondence between God and His Book, between the word and the ineffable. In accordance with the Jewish notion of transcendence, the Jewish God is forever aloof. Every doubt is permissible as to his existence, every question legitimate. It is the answer that is problematic. The person who has no doubts is to be pitied above all because s/he overlooks the impossible and yet attempted symmetry between the Book and the book, whose words are constantly in danger of collapsing into each other: "Every word is first of all the echo of a lost word."[20] The unknown is the infinite source of language and word, without this Nothing nothing

could take shape. It is in silence and thanks to silence (divine and human) that the possibility of the word comes forth.[21] Nothing is known of God, so the word augments the distance that separates us from Him in a necessary alienation productive of despair and desert sand. The ineffable is the source of our *docta ignorantia*. God, in plunging us into the void, is the source of that despair which helps to activate the word of the poet. What is sublime here is the attempt to say what cannot be said, that is, the incommensurable distance between the absolute divinity and the word of the poet. Yet, Jabès is convinced that what unites us is silence. Eternity remains veiled in ignorance, ready to be challenged by finite beings. To ask oneself whether Jabès points to atheism is to ask the wrong question. It is better to say that he would aspire to atheism were it not for the fact that God's absence is indispensable to the poetic word, which is another source of silence. The divine is unreachable and therefore sublime, it throws us into the midst of a nothingness from which the sage and the poet emerge as the only possible protagonists. The sage is a constant source of inspiration for the poet whose task consists in humbly uniting word and silence, whereas the sage's role is one of provoking the poet to think and rethink the desert we inhabit notwithstanding our doomed desire to share.

Hegel was justified in stating that the sublime is in search of an appropriate form of representation and in search of a meaning. Nothing corresponds better to Hegel's definition of the sublime than Jabès' art where we read that in the sublime "the Absolute withdraws from the appearance and the appearance falls short of the content."[22] In Jabès' case, the Absolute God is absent from the word and the word is forced to admit its impotence vis-à-vis the enigma, while the sought-after harmony is broken by that same word, which is caused in turn by God's silence. By the same token, representation (the content) is consciously rejected, even though the word, more opaque than transparent, has for him the task of covering the abyss, so that the abyss is experienced as "visible" and at the same time minimized by the word. Dissonance prevails between the words and the silence that hides inside the words. Mysterious like the rest of creation, the word opens up other mysteries and secrets, in fact the word is what is most secret. In vain the question tries to penetrate into the word, into God.[23]

The sublimity of Jabès' themes, revealing as it does the discrepancy between the sought-for divine and the pale resemblance of the human word, finds its exact correspondence in his style, which is a combination of prose and poetry. The poetry belongs to the divine and the prose to the human sphere. To write only in poetry would mean that the solution to the

paradox of God had been solved, that there was indeed an analogy, an affinity, between God and human beings. This is not the case, and that is why the question prevails over the answer. What dominates is the disquiet caused by the missed encounters between finite and infinite. The Concept would resolve this anomaly, but it has not yet made its "appearance," so that Jabès' work is marked by an insufficient concreteness; only partially free, his inner life is too constrained by the negative to find "true expression in finite phenomena."[24] Jabès' sublimity is closer to that described by Hegel than to that described by Schelling, who did not separate the sublime from beauty in absolute terms. For Schelling the sublime consists in the subjugation of the finite, but, paradoxically, it is reachable, since it belongs to the aesthetic appropriation of the macrocosm. Indeed the sublime is the first step "toward an aesthetic view of the world."[25] The finite in sublimity revolts against the infinite (the "book," as opposed to "The Book" in Jabès' poetry) which explains why the sublime has unsettling effects.

The pursuit of the infinite, a search that is understandable in terms of religious beliefs and also in terms of *hybris*, is sublime. Without *hybris* art would not exist at all, and the *hybris* that helps artists to overcome nihilism is sublime. More specifically, everything that displaces the self toward an endless quest is sublime. The search has no end, no matter how one strives for the final and absolute mediation of every single determination. In fact, such absolute result would correspond to the end of art and also to the end of literally everything—or, alternatively, to the circular repetition of the same. An infinite that is reachable is no infinite at all from the viewpoint of art. Such complete immanence is what makes art vanish before a more powerful mode of presentation. Hegel's sublime is both infinite and destined to find the other in classical beauty. The infinity of symbolic art, which for Hegel is never beautiful, is secured by the discrepancy between the symbol and its meaning, so that infinite sublimity stands for a displacement. Here Hegel is right, but he did not think of this displacement as constitutive of all art, just of a particular artistic form. Displacement is the only assurance that the sublime will preserve the lack of correspondence between universality and individuality, which, if this correspondence were absolutely mediated, would give rise to utopia and not to art. On the other hand, Hegel is no nihilist, the interest that his aesthetic theory arouses lies precisely in its being an affirmation of the spiritual value of absoluteness. His perspective makes art a failed attempt to include the Absolute within its sphere. But Hegel's view on this matter can be seen as a sublime attempt to understand art.

## THE CIRCLE

Hegel's examination of symbolic art shows an excess of rationalism, partially justified by the fact that not every symbolic expression is artistic and not every art form is symbolic. This is acceptable insofar as art is capable of evolving into other forms—for Hegel, the classical and the romantic. The question, however, is whether art really evolves. Surely primitive forms of art from prehistoric times are, in their own way, aesthetically crude. Artists' technical ability has developed, since artists learn and unlearn from those who have preceded them, but just by virtue of being a work of art every work stands on its own, unique and incomparable.

The central point of Hegel's aesthetics is the distinction that obtains between content (meaning) and form, and this is dependent on the logical analysis of inner and outer. Content and form are immanent in each other and stand in reciprocal relation to each other, accordingly, the inner becomes outer and the outer inner. In point of fact, the meaning of a work of art, what Hegel calls the "inner," or the "inward," that which needs explanation and interpretation in a philosophy of art, is immune from changes—at least if we want to say with Hegel that a universal aesthetic theory is possible at all. The form of a single work of art could be left to technical considerations of concern to the critic. But Hegel says something different. For him the philosophical interpretation of a work and of the age that produces it depends on the congruence of inner and outer. Thus, every work is necessarily a unity of which the philosopher takes full possession. Changes in art reflect the various emphases between inner and outer, but the logical structure remains invariant.

At this point the existence of beautiful, classical art emerges as the highest form of art. Yet, its purported eternity has given way to a fragmented art that does not take into account—or has rejected entirely—the notion that art is there to satisfy the ideal of beauty. Beauty, the serenity at all cost of the Olympic Greek statues, carries within itself its own demise. This is an indication that the freedom embodied in those statues was incompatible with the maximum of expressiveness or intelligibility. The integration form / content, individuality / freedom, which first appeared in classical art, gave birth to the sensuously beautiful, but what is in wait is "[t]he absolutely meaningful . . . the thinking, absolute, non-sensuous One."[26] Thus, art, whose concern is to annul the discrepancy between spirituality and nature, and to repudiate all deformities and contingent ugliness, is finally doomed because it cannot complete philosophy's function.

Still, classical art brings forth a unity unseen before, for in this art form the object is unnatural enough to allow meaning to emerge from it.

Far away from the externality of nature, beauty contends for primacy with the sublime, an unequal contest, for in the sublime meaning is even more separate from form than in the beautiful. Since, according to Hegel, there is no mystery to unveil, either in art or in philosophy, the sublime and the symbolic are ultimately judged to be ineffectual, with no affinity to concrete substantiality. Hegel's theory of absolute knowing impedes the understanding of sublime art, which is gloriously incomplete rather than incomplete by default.

Although it is indisputable that art is connected to religious beliefs and also to the civic and political ethos,[27] art dissolves itself when it embraces those nihilistic genres that are the satire and the comic. But also philosophy "destroys" art. Here art is not the organon of philosophy; rather the opposite: philosophy deprives art of philosophical significance. The ambiguity of Hegel's project in regard to art rests on the absence of a definite reconciliation between thought and its Other, nature, while the analogies and similarities of the logical process through which every transition "repeats" and includes the logical structure of the preceding one, discredit art's autonomy. Admittedly Hegel tries to give to the artistic ideal a conceptual structure, but this structure is vitiated by the presence of the sensuous, which is unsuitable for providing stable meaningfulness for art. It is not time that effaces art, it is eternity.[28]

The explanation lies in the fact that the Concept is necessary absolutely while the sensuous is not. The contradiction is explicit if we think that the content of art dissolves itself, while at the same time it is impossible to understand art until philosophy disowns it. Art becomes fragmentary because it goes through a process of secularization and forsakes the divine.[29] The comic launches the last attack on an art that has already rejected beauty, whose precarious existence was one with the ideal. However, Hegel holds in reserve another idea that makes art, possibly, perennial. This is the idea, supreme in Hegel's thought, that art exhibits a circular motion. In this specific case it is humor, the last stage of art, that "turns back, as it were, to symbolism where meaning and shape likewise lie apart from one another."[30] There are differences, of course. Humor creates its own content, and so the artist prevails over universality, whereas symbolic art still yearns for absolute transcendence. But this circularity is imperfect, and that is why Hegel finds fault in art. Its end is marked by nothing less than an "explosion." Apropos of Jean Paul's humor, Hegel

says that "nothing develop[s], everything just explodes."[31] Art dies, and the artist is born. The road is open for Nietzsche.

Hegel's philosophy manifests the endless, infinite reiteration of the substantial structure given by the Concept and the Idea. In the "end" the radical new is excluded from art and equally from speculative philosophy. The totality, the one and all, from which Hegel started, may not be false as Theodor W. Adorno claimed, however, within Hegel's framework, a step outside the totality would represent a form of nihilism, a fragile substitute for the eternal truth of the rational.

## CONCLUSION

Starting from the interpretation of historical theories of art with the purpose of discovering in them the themes and essential notions of the aesthetic domain, three possible loci of the aesthetic have been identified: the subjective, the objective, and the absolute. Their respective logic is different: the subjective approach rests on the conviction that the artwork is ultimately illusory if it were not for the fact that its appearance activates in the subject an inborn taste for beauty. We have seen this in Schiller, who limits the aesthetic field to an anthropologically based search for harmony. It has the merit of declaring art a superfluous need, but one that is nevertheless part of the activity of the subject. This activity consequently develops into a negative search not only for beauty but also for knowledge. The Faust figure illustrates the inner logic that emerges when subjectivity enters center stage. But Faust does not create works of art; a victim of his own double, he is the one who, after having reached the desired object, repudiates it as being extraneous to his own being. The emerging negativity, which is implicit in the desire for the new when it is brought to its ultimate consequences—that is, when the subject is forced to renounce itself—ends with the impossibility of discovering a determinate object. The subsequent contingency of art exposes art to the danger of nihilism. The necessity of art has not been demonstrated by the desiring, volatile subject of experience. As for a subjectivity that is unequal even to itself, its limits are surmounted by considering artistic form and content independently of any intrusion of the subject.

The limits of subjective aesthetics having been established, we have examined Schelling's indeterminate beginning which discovers, thanks to intuition, the objective necessity of art. This transition is made possible by the acknowledgment that aesthetic "objects" are real in the sense that

they are intuited in the finite. The role of the Absolute is that of pro-
ceeding from the potential to the actual; this process is never complete, so
that even the archetype of beauty, in signifying the unity of the Absolute,
remains dependent on a metaphysics of the infinite. The metaphysical
approach, in assuring the object of aesthetics, nevertheless casts a doubt
on the reliability of intuition when it is not anchored to experience in a
direct way. Experiencing the artwork in its totality becomes secondary vis-
à-vis the intellectual apprehension of beauty.

Beauty remained at the center of nineteenth-century aesthetics.
Hegel's absolute, as opposed to the objective account of art, aims at pro-
viding an exhaustive explanation of what is art and at uniting, in a per-
manent sensuous experience, beauty with its concept. By proclaiming the
priority of the actual, Hegel's implicit argument is that the potential can-
not give us beauty, as it cannot give us the infinite. Central to his argu-
ment for the completion of art is the perfection of its concept. However,
that same absolute standpoint puts the autonomy of art in danger, or at
least it makes it relative and negative, as opposed to that absolute view-
point within which it has nonetheless been placed. The contradiction is
resolved, not by adhering to the concept of beauty which is too self-con-
tained to account for the infinity of thought, but to that of the sublime.
The sublime points to a possible but temporary integration of the sub-
jective within the artwork which opens the way to future artistic devel-
opments.

# Part Two

# Art's New Truth

# CHAPTER 4

# Apprehending the New

Artists are suspicious of outside directives, even those derived from philosophy and art criticism. An example is Pierre Boulez's confession that he mistrusts ready-made aesthetic theories that ignore artists' new and original contributions.[1] Yet it remains true that philosophy sheds light on art by providing criteria (and thus additional significance) pertinent to the art world. In doing so, philosophy also tends inevitably to judge single artworks, artists, and historical periods. This is not a secondary task, as it may seem, considering that without these appreciations aesthetics would dwell on the indeterminate. Judging a work of art as relevant or not is a consequence of any theory of art. The relation of art to philosophy is unproblematic as long as there is reciprocity between the work and the theory. If it is otherwise, neither art nor philosophy has the last word; it is an indication that one of the two does not accept any guideline from the other, that one is ahead of or behind the other.

Aesthetics' function consists in expounding an inclusive theory within which to place the actual works of art. This makes the philosopher's judgment more authoritative than that of any other person, including the artist (even though the philosopher can learn from the artist). Philosophy clarifies the reasons for art and its place within the world, that is why artists can disregard philosophy only at great cost. There is another aspect of aesthetics that must be taken into consideration by the artist, and that is its inclusion of every art form, its tendency to systematize,

whether this is accomplished or only attempted, its providing a unitary explanation of aesthetic phenomena. Artists themselves are too limited by their particular domains to include the whole of art. They know, of course, how to create, but rarely, even if they are avid readers of aesthetic theories, can they extend their horizons to arrive at generalizations of universal import. They are certainly receptive to forms of art other than their own, but to them the definite, final word on art's significance is precluded. Artists may deny the possibility of such inclusive discourse or may find it uninteresting, nonetheless, philosophers and artists are sure to encounter each other, and at that moment the philosopher will honor the work of art, but will also maintain her / his right to interpret it.

Given these premises, it remains to be seen what is typical of art. The three approaches, namely, subjective, objective, and absolute, have left us with frameworks that do only partial justice to art's greatest value: the new. In particular, the absolute standpoint has revealed itself to be the most destructive of art's ability to renew itself. Now it is time to look again and in more detail at the means and modes of art in order to ascertain whether they can stand on their own and to what extent they contribute to art's autonomy. But, even before that, it is useful to take note of Wilhelm Dilthey's transitional and psychologistic approach, which will shed some light on the concreteness of art in its essential encounter with the artist. In introducing the notion of intersubjectivity, Dilthey opens the way to the contemporary scene in which meaning enters center stage.[2]

What predominates in Dilthey's approach is the notion of lived experience (*Erlebnis*), which he sees as the grounding principle of art. This procedure detects what unites the artist's creative process and the public's enjoyment of art; accordingly, the conditions for the possibility of art are found first of all in the universality and intensity of feelings, and subsequently in imagination. Art is not imitation; to accept the theory of imitation would leave music and architecture unexplained. If Vitruvius' argument to the effect that architecture originates from nature were right, columns would be but an artistic extension of trees. Instead, nature is distant from art; art necessitates, psychologically, the imaginative process and inner experience. Having its point of departure in and being constituted by the combination of will, feelings, values, and their mental associations, all juxtaposed in the fertile nexus of psychic life, art is nonetheless not considered immanent in these states; in relation to their reality art is placed "above." A considerable amount of empiricism hides a more profound principle: in the play of inner and outer, as far as art is concerned, it is the

transcendence of the inner which is victorious, but it is still an inner that becomes *apparent*. The introduction of history rather than myth testifies to the "reality principle" to which Dilthey subscribes. Since art, aesthetics, and poetics are free from any metaphysical mission, being confined more modestly to the sphere of psychological (but also spiritual) products, such a theory has the advantage, in principle, of putting the new on a well-deserved pedestal. The art of the past ceases to be normative, notwithstanding the fact that the psychological derivation of the work of art is subjected to the conditioning processes evolved from tradition.[3]

It is far from imperative for an aesthetics based on psychological reasoning to conclude by declaring art transcendent. The more specific notion of self-transcendence is sufficient to the task, especially if that notion refers to domains of experience that cannot be taken in isolation. In fact, self-transcendence indicates the chiastic overlapping of subjective and objective which, having its inception in empirical knowledge, surmounts the other-than-itself while assimilating it. Dilthey speaks instead of transcendence because art is not imitation and goes beyond the experience of "mechanical relations."[4] This is certainly true, however, it is misleading to call "transcendent" (in the strict sense of that term) something which is simply different from what was previously present and which was given potentially. If one were to accept this logic everything would become transcendent in relation to everything else. Difference is still part of the totality which is partially immanent to its determinations.

The fact that art differentiates itself from an empirically convincing reality, in this case experience, makes it, nevertheless, analogous to what is given. A discriminating sensibility must be present for the estimation of art—it can be painfully absent—but when this sensibility is actual it is itself another empirical fact whose complexity makes it akin to art in a quasi prefect reciprocity. This view, far from being a banalization of art, emphasizes instead that its bailiwick is limited by the impossibility of absolute otherness, which is excluded for the reason that art could never make it its own. Moreover, the reality that supposedly is transcended by art is reinserted in art's circuit, thus becoming an object of aesthetic experience, an experience that has all the elements of reality in the hermeneutic sense. Between art and reality, analogy mediates, not transcendence. To take this position makes art all the more relevant to the *Geistswissenschaften*. If art is distinguishable for being qualitatively and quantitatively different from other aspects of life (the creator's impressions are more intense and more copious), the result is that in the exchanges

between quality and quantity, art reaches an intrinsic subjectivity, not absoluteness. Dilthey professes a relativism capable of objective universalization without neglecting the individual's lived experience. As a matter of fact, these components form a dynamic circle that includes history and art. Consequently there are no absolute rules in art, what rules there are are destined to remain indeterminate, oscillating between an involuntary process and conscious activity. The role of unconscious creation is kept within limits in order to limit an irrationalism obtained at the expense of rules. Dilthey's recommendations occupy a middle ground between lived finitude and artistic expression. By the same token Dilthey rejects any absolutization of the concept of beauty. If there were absolute beauty there would be an absolute form with fixed rules, and art would not develop. No statement could be more anti-classical or more firmly committed to the new.

Beauty, the central notion of metaphysical aesthetics, is declared by Dilthey to be in life itself, and, given life's richness and variety, he must exclude "every universally valid concept of beauty,"[5] even though beauty is not illusory. Art's meaning derives, instead, from an "imaginative metamorphosis" which, starting from poetic moods, ends by producing aesthetic categories, one of which is beauty, to which the sublime, the tragic, the comic can be added. Reduced to a psychological category, but having an inner logic, beauty (whose locus is between the sublime and the ugly) arises when an object is psychologically adequate to the mind of the spectator. It is therefore connected with pleasure. It must be added that beauty is *filia temporis*; if that were not the case we would not see style changes, and an immutable classicism would pervade the art world. Moreover, if the new were not a central aspect of art, art would leave us indifferent.

Between inner and outer stable relations obtain which make possible the formation of natural symbols. However, that which springs from these relations cannot limit the style or the technique of artists, even though their range is always finite and partially determined by historical conditions. They produce, in turn, innumerable aesthetic principles which exclude the formulation of any fixed system. The multiplicity that punctuates history makes the nexus meaning / content non-universal. Universality belongs to concepts, to philosophy, and therefore concepts are excluded from the sphere of art. Life itself is beyond concepts, and, since poetry (and art in general) is an interpretation of life, art has the social function of providing meaning, which is always subjective and individual.[6]

The relevance of Dilthey's psycho-historical procedure, which he later modified, rests on his commitment to a relativistic and at the same time general notion of art. No absolute prominence is given to beauty—an indication that the twentieth century is near. The idea that the concept of beauty is specific to art is the typical prejudice of a rationalistic aesthetics that has lost its connection with the potentially new. Having abandoned metaphysics, Dilthey is free to examine *Erlebnis* from a historical perspective; *Erlebnis* retains its unfamiliar core—so much so, he admits, that the "condition of aesthetic intuition points to something unfathomable, a primal source of harmony, which is inaccessible to our thought."[7] Even granted this necessary ignorance art is and remains meaningful. Meaning is essential and, most important, it is accessible. It is the content of something that has the power to increase human vitality, within which feelings and images, inner and outer, are incorporated to form the aesthetic experience. Dilthey's subjectivism was later attenuated, but never completely abandoned, as his notion of Weltanschauung demonstrates.

Resolved to provide an empirical account of aesthetics without falling prey to empiricistic atomism, Dilthey created a partially speculative and partially empirical aesthetics which has the merit of paying great attention to the creative act, which he saw as originating in lived experience. He is remindful of the fact that artists imagine and also interpret—a trait that makes them comparable to scientists and philosophers. This overall project, with its abandonment of the objective and absolute, brought about the emergence of the intersubjective world-nexus; this fait accompli has made artists aware of the insufficiency of a merely subjective view of art. Even though Dilthey remained committed to a view that places in the forefront the artist's subjective process, he never underestimated the parallel, reciprocal interactions in which the artist is, willy-nilly, caught. Subjectivity per se is not evil, it is an essential component of the aesthetic act. However, the theoretician must be wary of its influence, since s/he aims at a more stable understanding of the artwork than can be achieved by mere imagination. Subjectivity is not prior, it is the result of the human ability to take possession, temporarily and *grosso modo*, of what surrounds us. Let us call it "reality" rather than nature. Art now relates to reality and no longer to a naive notion of nature's powers. Reality includes all those artificial aspects of lived experience which are part of our overdeterminate existence, within which, at each step, a finite but indeterminate number of possibilities encounters our subjectivity.

## THE HIDDEN TRUTH

Caught between subjectivity and objectivity, art is neither of them. Its modes and means are most relevant for determining what art is. These include the new above all and secondarily beauty. If we continue to speak of subjectivity and objectivity it is with the proviso that these terms are abbreviations, in the first case, for self-transcendence, which includes the subject of experience and its encounter with the other than itself, and, in the second case for the ontic presence of the work itself, plus the self-transcendence of the means it employs.

Art's objectivity indicates more than its being in the public domain. We have seen too many daubs in public places to be persuaded that location in an open square or in a closed space such as a museum or concert hall is sufficient to make an *opus* a work of art. The objectivity of the artwork does not even reside in its beauty, long misunderstood as constituting the focal point of any reflection on art. Beauty has been supplanted by the new, a particular type of new. The new in question, the artistic new, is *differentia specifica*, according to which the given is submitted to transmutations, metaphorical in the case of poetry, or otherwise formal, so that the new work is unrecognizable by referring to previous standards. It is, in short, a style that at first disconcerts and therefore may have little to do with the pleasurable, even though pleasure is one of the responses that it may generate.

Modernism, which from its inception has focused on the new, has generated surprise to the point of shock, and that is still the case in music. First of all the disappearance of beauty and, above all, at a deeper level, the presumed absence of accessible meaning, make modern art disturbing. Modernism seems to have developed out of tautological statements— not tautologies like 'A is A', but more like (paraphrasing Gertrude Stein): "art is art is art is art," at the third potency. The tendency toward nominalism implicit here would make the meaning of art immanent if it were not for the fact that art is grasped from both the subjective and objective viewpoints. More specifically, it is acknowledged that the artwork presupposes an artist who both objectifies and subjectifies, using a plurality of means with the aim of being innovative. Imitation is thus out of the question, whether it is mimetic or mythical. Tautological to the point of being always true, art is also a social phenomenon and communication. Art contains its elements in a unity that has nothing beyond itself, it cannot, therefore, be transcended, either by beauty understood ontologically

or by a truth derived from an external domain. Equally excluded is the moral perspective on what lies in front of us in the form of a composition, a painting or a poem.

The content of art is art, just as, in Hegel's *Science of Logic*, thought thinks itself. When Stéphane Mallarmé answered Edgar Degas, who had been complaining of being short of ideas for writing a poem, with the words: "It is not with ideas that you write a poem, it is with words,"[8] he was pointing out a tautological truth, but one that astonishes the naive listener. Objectivity is all in the word. Facing this sort of nominalism, it is easy to conclude that the object is no longer, that objectivity has run its course. I would rather say that it has been transformed, since from a logical and conceptual objectivity we have arrived at a semantically fragmentary conception of beings. Art was instrumental in this process. The quasi-tautological nature of the arts, by which is meant their autonomy, necessarily excludes all hierarchy among them, since there is no ground on which to found it. A better way to situate the arts would be according to the geometrical figure of a pentagon, with its five angles, that is, music, architecture, sculpture, painting, and literature (inclusive of prose, drama, and poetry), rotating at leisure and connected by segments that stand for the mixed art forms, for instance dance and opera.[9]

Nominalism does not banish truth from art: art has truth and tells the truth even though its meaning is hidden within the work itself. Traditionally art was considered truthful if it was founded on objectivity or absoluteness, but, if the objective side of art is considered null, then the question of its truth becomes linked to a form of aesthetic nihilism. This is far from being a compelling conclusion. Nietzsche's work provides the best illustration of a theory of art that disposes of truth and yet assigns to art one of the highest places among human activities. Fragmentary as it is, art is a value and, as such, is meaningful even though its messages may escape the many. The truth of art must be looked for in the legitimate commixture of the by now hidden subjectivity and a reality whose function is that of eluding both itself and the subject. Thus, art hides its truth on the subjective and the objective sides of the spectrum. We are confronting here a truth according to which interiority is as volatile and erratic as the subject itself. Truth is a construct such that it makes the equally fragmented subject oscillate between inner and outer. Dispensable as it is, the subject's self-transcendence paves the way for the "transcendence" of the work.

Art's truth lies in its chiasmic unity, not in being real; it does not present a substantialistic view of the artwork. The category of substance

has disappeared from philosophical discourse since Nietzsche, and con-
vincingly so. If there is an objective mode that is recreated in the artwork,
this does not depend on the identity of beauty and truth, of objective and
subjective, intuited in different ways. This identity has suffered a decisive
diremption, and now the objective and subjective sides of art are similar
only because they are meaningful, but their respective meanings point to
different dimensions of art.

### PHILOSOPHIC ART AND AESTHETICS

As the substantialistic side of art has disappeared to be replaced by
nominalistic truth, so also the expression of feelings has lost its status
as common currency in the attribution of meaning to art. A reversal
has taken place which no longer allows art to be the organon of phi-
losophy or art's truth to be associated with a content. It remains true,
however, that philosophy is a means of exploring art's prospects. The
process of intellectualization, particularly prominent now, makes the
artist of the present even more dependent on other disciplines than in
the past. Art resorts to philosophy. The issue is to determine why and
how. Philosophy's relevance has to do with artists being caught in the
grip of nihilism—a specific type of nihilism that pertains to the absen-
tee object; art and philosophy have gone hand in hand in banishing
any reference to the object, since the object no longer has any onto-
logical authority. It is evident, however, that philosophy still has the
responsibility of providing art with a framework ready to accept art's
independent creations. Art has rejected representation (if we want to
speak only of the visual arts), not because of its aggressive competitors,
that is, photography and cinema, as Arthur Danto claims[10]—these may
have been in many artists' minds, but the true reason for the rejection
is that objectivity was no longer philosophically viable. Consequently,
abstract art refuses the idea that what is manifested in a painting is
expressive of "something." Here Danto is right in denying that expres-
sion is a viable explanation of what art is, at the most what is expressed
in abstract art is the void that the subject has come to be. Similarly,
Boulez, when asked, "What did you want to express?" replied: "Noth-
ing."[11] Traces of the fundamental switch from the object to an aseptic
subject are noticeable in the rejection on the part of philosophy of an
irenic humanism worn out by its own universalistic expectations. The
price to be paid was at first a form of nihilism that discarded beauty, at

least a conception of beauty that had to do with harmony. Irony was another way of replacing regressive feelings with a critical stance.

The relation between art and philosophy can be humorously exemplified by an instance of conceptual art cited by Danto, who, however, draws a different conclusion from mine. At an exhibition there stands a table on which books by illustrious philosophers are placed.[12] It is intended as art, but it indicates ironically that the concept of conceptual art lies in the philosophical content of the books, not in the table itself *cum libris*. Not any book would have brought about the same effect, and Danto, in pointing out the commonness of books and the consequent problem of separating one ordinary object from another, thought of that table as metaphor for the relation of art to philosophy and disregarded the irony, a sign that art is looking for a philosophical substratum, juxtaposed and possibly intrinsic. We will see whether philosophy can keep this promise. The truth that the arts are influenced by "extraneous" doctrines is evident to anyone who has devoted any thought to such matters. The difficulties arise when it is a question of determining how and, perhaps, why this is so. Danto's example puts into relief one of the ways in which art indirectly (and thus ironically) answers to philosophy. Those books say: "Anything could be art, provided that it can be explained by philosophical means."

Philosophy invites attention from artists in three ways. First of all, philosophy lends itself to being absorbed overtly, that is, directly. For example, the motif of the "double," from the figure of the Unhappy Consciousness in Hegel's *Phenomenology of Spirit*, was very influential during Hegel's times. The work of E. T. A. Hoffmann is another illustration of this trend, of what Freud later called the "Uncanny."[13]

Second, there is a similarity between what philosophy does and what the arts do, namely, they both interpret, at different levels, lived experience. More specifically, philosophy adds to experience instruments that are characteristically its own, that is, the concepts necessary to rationality. The relevance of concepts for art is particularly evident in allegory where they proliferate, without detriment to the metaphoricity of language. The supposed stability of the concept as opposed to the dynamic character of rhetorical language is a false dichotomy, especially if one takes the concept to be experientially ductile. And at this juncture artists find a source of unlimited possibilities. Of course, philosophy is not mechanically applied to a literary text or composition, it is appropriated dynamically. Even the most avant-garde approaches to art, which take pride in

fragmentation, must reckon with these temporal exchanges. Not only is all art in time, art is time subjectivized and objectified simultaneously. In this context, time must be kept separate from history (which has come to mean, rightly or wrongly, a series of events, preferably monumental, provided with intrinsic meaning), because art in its temporal dimension *is* a searching and not a fact, it is also the subjectivization of the objective and the objectivization of the subjective.

The relevance of time in art does not exclude the complete dissolution of the artwork in time. The allusion is to what Danto calls "disturbational art," an art that is ephemeral and also one with life: "The disturbatory artist aims to transform her audience. . . . And she means to achieve this by some transformation of herself . . . the disturbatory artist sacrifices herself so that through her an audience may be transformed, perhaps only for a moment."[14] These words can be applied to the *exploits* of John DiLeva Halpern, who puts his life in danger by "bridging," something that he called "social sculpture." He climbs the Brooklyn Bridge with fireworks in his hands, with the intention of involving the public. He writes: "OUR view is that *anyone* with even the most discrete association to our project determines the project's final evolution in proportion and to a specific degree."[15] The danger mentioned by Danto lies in the present case in the fact that Halpern has been arrested more than once for trespassing. Here lived experience is extended to the point that time coincides with the art "object" itself. Equally essential is the explicit declaration that this type of art-event cannot do without the tacit intervention of the public; but the aim is, of course, to provoke the public so that it becomes one with the art-event.

The third way in which philosophy is of interest to contemporary artists is that it serves as a good antidote against the dangers of nihilism. Although philosophy may be "guilty" of nihilism, it is still in a position to provide the arts with a profusion of concepts and also with their critique, which can then be elaborated by art for its own ends. It would be unthinkable, today, to produce art that completely dissociated its own activity from philosophical discourse. Accordingly, Danto is right to claim that artists have a "saying" in what they create, but, to be precise, artists do not interpret their work, they explain it, by which is meant that they elaborate on the processes that have led them to their specific works. They do not have a monopoly on their philosophical significance.

The difference in question becomes clear when poetics is separated from aesthetics. In fact, artists have poetics at their disposal, not necessarily

an aesthetics. The present statement suggests that poetics can be philo-
sophically inspired and relevant. However, poetics is on the side of the not
yet interpreted signifier. What aesthetics adds is the signified (or lack of it),
which produces additional signifiers. The individual poetics of an artist per-
meates her / his work in its minute details, while the aesthetic signified
(which is other than the referent) intervenes in the signifying chain as a jux-
taposition. However, interpretation is not something that is artificially
superimposed on the artwork, the signifieds are not separated by a bar from
the signifiers, as Ferdinand de Saussure and Lacan would have it. Signified
and signifier go together, like the "two" sides of a Möbius strip. The art-
work, by acting as a signifier, activates the signifieds in an endless process.
Both multiply indefinitely in their reciprocal motion. Yet the difference
remains between the artwork and its interpretation. The individual poetics
of the artist functions as a mediator, and that is why poetics lends itself to
philosophical categorization, which means that artists *do* philosophy
unconsciously. If the connection between the work of art and its interpre-
tation were impossible, the work would be aesthetically nonexistent, even
when it is perceivable.

Aesthetic theory approaches the artwork indirectly, through its
poetics, which is quasi-philosophical, sometimes psychological, and
always stylistic. Each poetics is the product of the artists' self-transcen-
dence, which is the result of an indirect access to the "real." The signifiers
proposed by any poetics must not be understood as signs or symptoms of
a set of signifieds already structured in a theory. In the case of the artwork,
the artist and the interpreter may well operate within a new theoretical
framework. However, the interpreter retains a special authority over poet-
ics since s/he intervenes when the artwork is completed. I am aware of the
existence of "works in progress," always in the making. Their uniqueness
is due to their relation to time as incomplete but not unfulfilled. It is in
this alley that the interpreter's efforts are directed. The poetics of the artist
is a process of formation that develops through time, it can even be said
that art is time metaphorized and symbolized. Those in whom these
processes are deficient are artists whose style and poetics have never
changed, they are considered minor artists, and justly so. The interpreter,
being concerned with both signifiers and signifieds, enjoys a greater sta-
bility and permanence of method, which, however, is relative. S/he avoids
any reference to an objectified and reified notion of beauty, rather, s/he
functions like the linguist or the speaker who conceives of a given poetics
or work of art as an anaphora. Aesthetic theory refers to something said

or done before, whereas poetics addresses (implicitly and potentially) something not yet said (the aesthetic theory) cataphorically.[16]

These two terms ('anaphora' and 'cataphora') do not carry with them the implication that the relation between poetics and aesthetics is simply one of succession or precedence. The nexus is more profound, since 'anaphora' and 'cataphora' stand for connections that are indeterministic. They bring into focus the linguistic nature of art, whether it is narrative, musical, or visual. We are confronted with a specific unifying language (style) that separates (thus making autonomous) each of its forms without denying the legitimacy of mixed forms. These, and metaphor, find their justification in metabasis. While metabasis is prohibited in logical and strictly philosophical discourse and deductions, it is the very basis of poetic and stylistic existence. If a poet were afraid of transgressing the categorical boundaries of logic, very little would be left.

Aesthetic theory is, therefore, an extension of poetics, that particular dimension which arbitrates and positions art in its proper locus. This is, however, an incomplete truth, since poetics can influence the direction in which aesthetic theory evolves. It is also interesting to note that artists, confronted by Hegel's "death sentence" on art, have resorted more and more to theory. The intellectualization of art that ensued is a mark of art's vitality, even though it has meant a diminished role for artistic spontaneity. Spontaneity (not to be confused with improvisation) has never been, of course, the sole factor in artistic creation, but the reversal that has taken place is most apparent when we consider that science and art are connected together in the making of art. What art and science have in common is an apprehension, not of reality per se (that perpetually elusive concept), but of what stands for reality, that is, the metaphors employed to conceal it, to domesticate it even, to bend it to our purposes.

## THE EMERGING MEANING

Structurally speaking, art speaks, and its function is that of making us forget that truth is destructive. Plato must have intuited this function of art (as consolation) when he decreed its condemnation, since for him philosophy's supreme task was that of recollecting. Therefore, when considering art, there is more involved than disavowing the imitation of the imitation. Massimo Cacciari maintains that autonomy is essential to art, and that is why Plato condemned it, not because it is mimetic. Techne also is mimetic, and certainly Plato did not oppose techne. For Plato, forgetting

is, so to speak, the cardinal sin of anyone who thinks. Art may make us think, but first it makes us respond to something that is new, and, because it is new, it cannot make us remember.

In the case of art, the ontological status of the new consists in the existence of the work itself brought about by the imagination and fantasy of the artists who relate to their productions as a middle term between the not-yet (to recall Ernst Bloch's concept) and the actual. In order to reach this point, artists may utilize the beautiful, but what occupies their minds is the process itself. Contemporary artists have been disobedient to Schelling and Hegel in eliminating beauty from their aspirations, but they have accepted the idea of the true. This ideal truth binds science and art together, since science can provide a guiding principle for those who are dissatisfied with a notion of art as free-floating in the vacuum of indeterminacy. The connection between art and science constitutes a step toward the negation of nihilism, a danger deeply felt by artists who are searching for a meaningful resolution of their own intentions. It is more than permissible, at this point, to explicate philosophy's role vis-à-vis art, a role which goes beyond the systematizing of art by finding a locus it can inhabit. Philosophy's objective is to detect the instruments and categories that are essential to art. One of these is imagination, but logic and reason also play a role in the formation of the artwork. The points of departure for philosophy and art are similar, but they diverge when artists deform or distort concepts in order to invent the new. These concepts are still recognizable by the interpreter, whose aim is to bring them forth explicitly by negating in the process the immediacy of sensation.

Thus, mythology—qua preconceptual—is only one side of the aesthetic process, the side that is traceable to the emotional side of art. Mythology is that logic which develops into a collective intuition. Myths's capacity to convince rests on the convergence of factors and structures that are transindividual. Artists, to the extent to which they assimilate myths, now run the risk of losing their originality and ending up imitating pre-given structures (innovative artists do not imitate, they are imitated). It is a notorious fact that mythology changes slowly, unlike the phenomenological side of art. On the other hand, the logic employed by the artist also evolves with difficulty, and that is why revolutions in art are so rare. It is right to situate art where intuition and imagination expand, but when art's most elevated content coincides with mythology art does not produce new truths.

The attempt to replace mythology with history would constitute an impasse unless history is conceived of in logical terms. Hegel sought to

reach such a synthesis, but his trinitarian logic is historical only *in men-tis*. Clearly, myth and history so conceived are insufficient to account for the new in art, since the new is mainly thought of in stylistic terms. That may be appropriate in the case of Richard Wagner, for example, but then the difficulty arises of dissociating style from content—a most dubious operation as far as Wagner is concerned considering that he sought the perfect correspondence of the two in the *Gesamtkunstwerk*. This dissocia-tion would be a way to compromise on the search for the new. Instead, the new must concern the totality of a work of art. Art is a totality that presents itself as fragment, experienced as such by the public and by the creator. This happens because artists violate the essence and eternal forms of mythical entities and draw from the preexisting being only that which their intuition and logic demand.

I have said that philosophy intervenes in art, and art in philosophy. The mutual exchange, which is a more than casual interdependence, has its inception with philosophy's ascribing a meaning to art. The meaning in question is not necessarily an extralinguistic, ontological, or ontic being, considering that art, particularly modern art, has learned very well how to abstain from the "real." The "real" status of the referent excludes it from art and philosophy, whose truth is brought about by their respective processes. The meaning that art and philosophy search for in each other goes beyond the single work alone since meaning is dependent on the self-transcending process itself. To clarify the point one can imagine or build mirrors in which the artwork is reduplicated in myriads of images. These images (or interpretations) cross each other, and the crossing itself is the meaning of the work. This phantasmal illustration of the inner relations of the work of art suggests that the work's understanding is after all a possibility, and alludes to two fundamental determinations of art: appearance and mean-ingfulness complementing each other. Art and philosophy concur in tak-ing meaning to be intelligible if it relates to an intersubjective structure. This truth is valid also for a style that cultivates extreme condensations of meanings. Meaning surrenders to the requirements of a given poetics; there is no pre-given meaning to get hold of in a moment of poetic dis-content. And the referent is nothing other than the thing-in-itself, the residue of an interpretative process which leaves the artwork untouched. The referent is transcendence and, as such, exists in the imaginary sphere of the possible. The referent is that void which the artwork covers with lay-ers and layers either of words or of brushstrokes or of notes. But the absence of the referent, this mythical core, does not proclaim the absence

of significance. As contrasted to the referent, meaning is the resulting vector of that which encompasses it, that is, the work of art. Nihilism has no role to play here, if one understands nihilism as the nullity of artistic relevance. Additionally, the meaning of a determinate work is to be understood as always being hypothetical, the result of conjectures as to the nature of the interactions between the parts and the whole of a work of art.

Once reality is excluded from the world of art, it follows that its truth coincides with its meaning. This meaning is in time. Art is in time in a double sense, since it is conceived in time, and it has a history. Keep in mind, however, that its history is *sui generis*. If there is development it is due less to time per se than to the connecting and intersecting of developments drawn from something that is more than historical in character. These developments derive from the new, which, although it is in time, disavows time, seeing temporality in the strict sense of the term as the negation of its specificity. As additional works develop, they are more a rejection of previous accomplishments than imitation. Imitation denies art. This is true vis-à-vis both nature and philosophy, art does not duplicate philosophical premises or conclusions. Art absorbs philosophy as a means of securing form and of extracting at its source a more unitary view of what art is over and above the process of its execution. By accepting philosophy in its ranks, art does not become eclectic. Art knows how to keep its distance from philosophy by adding what is proper to art, namely, poiesis. Poiesis is not philosophy gone astray (as some analytic philosophers would like us to believe),[17] it is philosophy imbued with a second form, that is, appearance. The audible and the visible in art issue from a form that disavows a fixed structure. It is because the artwork is appearance that it is meaningful and polyphonic. Therefore it is unsatisfactory to speak of the content of a work of art *tout court*, the so-called content that has magnetized aesthetics is in actuality nothing but its phenomenological externality, it is one with its sensuous appearance.

It is possible to study art by appealing only to its sensuous aspects and ignoring its philosophical import. However, the main danger of this approach rests on the fact that it would treat the sensuousness of art (the audible and the visible), with its specific laws, as intellectually null. Art's sensuous aspects change substantially in meaning (let us think of music, where each interpretation is almost a world in itself) with the evolution (or involution) of each historical period. Even so, we must call our attention to the work's density, its philosophical importance. Needless to say, the artwork's sensuous appearance is what at first glance captivates, and

without it art would be null. Nonetheless, it must be accompanied by an underlying structure in order to be understood. Necessary but insufficient, art's sole empirical actuality is insufficient to elucidate its overall significance. In that fragmented totality which is art the synthetic moment must be present as self-transcendence. Self-transcendence is comprehensive but not exhaustive and it points to the new in a nonidealistic manner. The ghost in the machine of art, without undue embarrassment, turns out to be, not the metaphysical conception of beauty, but that which the artwork *does*.

### THE FUNCTION OF ART

The project now is to determine what art does and not only what art is. Leaving the structure behind so as to concentrate on function, one discovers very soon that art since Kant has been regarded as pleasure-giving. Nietzsche proposed an attenuated version of this theory when he declared art's function to be one of consolation. Pleasure and consolation are related in that both exclude the possibility that art will leave us indifferent. However, the adequacy of these two explanations (pleasure and consolation) was defensible when we could speak of art as being beautiful. Now that the concept of beauty is in question we must still extricate ourselves from the idea that art has at least one "useful" function, namely, that of giving pleasure. It remains to be seen what pleasure means. For psychoanalysis pleasure is neither frivolous nor insignificant. Indeed, pleasure is indirectly connected to Eros, to the search of stimuli (even if unpleasant) as opposed to the unpleasantness of lack of stimulation.[18] Regardless of how relevant pleasure is in the appreciation of art and of the new, art's main function must be found somewhere else, namely, in its link to truth. Art relates to truth in a specific, nonlogical and intuitive way. Art tells, or narrates the truth of self-transcendence without representing it *de re*. Moreover, it is truth without certainty, because the object of intuition constantly eludes us. If art were a completely disinterested activity, detached from the alienable truth of the subject, it would transpose us to a plane of sheer contemplation. Art would still be personally significant, but it could be accused of solipsism and frivolity.[19]

Another explanation than the one proposed by the theory of contemplation is found when the function of art is situated in its epistemological value, which coincides with the reciprocal self-transcendence of the "subject" and the "object." Now the notion of subject is under attack

on different fronts, nevertheless it is clear that the subject, conceived in a strictly relativistic manner, is far from buried. What the subject has lost is its metaphysical substantiality, not its phenomenological element. The subject is a cluster of functions, one of which is to select among the stimuli coming from the external world. In this process, what is lost is harmony, which suggest that the subject and stable syntheses must be kept separated. The subject is a disordered mode of being that encounters truth *après coup*. The subject is a matter of displacement, a mechanism that strengthens its dynamic character. If one accepts the psychoanalytic theory concerning the division of the subject into ego, superego, and id, one also acknowledges that each of these concepts has its own definite specificity, but so has the subject, which defines in an abbreviated manner the sum total of these preexisting and disparate functions. The subject is a posteriori, a logical possibility. It *becomes*. The possible changes in the subject clarify why one of its possibilities, art, carries with it a relative truth pertaining to the subject's self-transcendence. As a receptacle, the subject appropriates art when the illusion of the whole has disappeared. We witness here a reversal of the relation foreground / background, whereby the fragment (the subject) becomes secondary vis-à-vis the "transcendence of the object." In order to actualize itself, the subject, which otherwise would be *in potentia*, must respond to its own truth, and art appears at this crossing as the *verum factum*,[20] as that "artificial" product which makes the *verum* and the *factum* exquisitely novel.

Art may spring unconsciously from the subject, but what it produces is the transition from the self-transcending subject to the self-transcending work of art. Here is situated art's truth, and also the consolatory function of art. However, "consolatory" excludes a passive recognition that, after all, there is something beautiful in this world beyond that tragedy which is life. "Consolatory" in this context can mean only that art is part of a process that affirms existence, that accepts the nonconceptual and the pre-philosophical. Existence, although it is precarious, serves to elucidate the prior immanence of an undifferentiated subject in the process of formation. If what is at issue is creation, art and philosophy can be said to originate from a common source, which accounts for art's relation and proximity to truth.

The chaos from which art extricates itself helps us to identify one of art's functions, namely, that of unifying the inner and outer. Unity, which is intrinsic to art, can dispense with the identity of subject and object, which are always problematic and interchangeable, because the artwork is

itself a "subject" and not an object to be passively received. Yet, no ani-
mism or hylozoism is suggested by this statement. What is meant is that
the artwork has a function because, at least minimally, it has something in
common with its maker, since it incorporates her / his own vision. Para-
doxically, this state of affairs makes art autonomous, in proportion to the
autonomy of the subject. The underlying unity is therefore a unity out of
which an individual structure emerges. In art, structure and function are
inseparable albeit distinguishable. The structure corresponds to art's being
both form and unity, the function to the fusing together, to the point of
complete involvement (such is the case of the sublime), of the self-tran-
scendence of the subject and the artwork. So it is insufficient to say that
art is consolation, art is beyond consolation, so much so that it is the con-
sequence of the overcoming of the opposition pleasure-displeasure.

In this context the sublime assumes a fundamental role; the sublime
epitomizes in a dramatic way the "conflict" of pleasure and displeasure,
pleasure being limited to the beautiful finite. The effect is manifest to an
eminent degree in baroque art, a supreme example of which is the Chapel
of the Holy Shroud in Turin by Guarino Guarini.[21] Here the sublime dra-
matic effect is obtained thanks to the shading of the black marble of the
base inside the Chapel to the lighter gray of the six layers of segmental ribs
of the dome. One's eyes proceed in a vertical direction, as they are com-
pelled to do, given the small size of the Chapel, and stop finally at the sight
of the white Dove of the Holy Ghost. The sense of ascending toward the
sacred and the revealed mystery completely absorbs the observer, who has
the lasting impression of taking part in the rising process that has led the
architect to integrate the logic of the form with a mythical presence. On
the other hand, the predominance of the funereal, contested by the hope-
ful message, bears witness to the experience of the sublime. The fusion of
languages (architectonic and mathematical) and the invoked hope that the
Paraclete, as consoler, provides, come forth with the superabundance of
Eros once the meaning of the Chapel has been translated into secular lan-
guage. However, this union makes manifest the displacement felt by the
subject, torn between the lost sense of self and the acquired sense of com-
plete estrangement. The sublime is a most contradictory experience in that
what prevails is our surprise at the lack of transparency of a work which
reflects our own subjective lack of transparency. Pure pleasure is precluded
by the awareness that the experiencing subject is caught in a space that
does not allow any further expansion. At the same time, the space of the
Chapel and the observer become one, in one undifferentiated unity.

The Chapel of the Holy Shroud is sublime in its mystery, and it is mysterious because it is sublime. First of all, its space excludes all reference to the outside, which is almost tyrannically suspended by the inner configuration of the Chapel. It is not only space that predominates here, that would make the Chapel simply an interior. What makes it uncanny is that it throws us toward being-for-death. We are constantly reminded that this is a monument to the divine death of Christ transcending time and space. Moreover, the effect of surprise, typical of the baroque period, at the sight of the interior is enhanced by the two convex stairways leading to the Chapel, also black but relatively innocuous if compared to what is in waiting. No doubt, for Guarini, who was a Theatine priest, the Chapel forcefully and violently punctuated the triumph of the Christian faith in the Paraclete. Yet this triumph is so distant, so immensely transcendent, coming after a stunning interpenetration of ordered but enigmatic layers of ribs, that the sense of liberation is hardly convincing for the secular viewer. The uncanny sublime is translated here into space and time. The finitude of the man Christ is declared something temporal and spatial, constantly brought to mind by the mournful color. The work, in fact, is basically monochromatic notwithstanding the white dove. Salvation is itself a function of sublime art, beyond which nothing more can be said. Art stops at the experience of the sublime, whose main function is to put us in contact with the experiential and the intellectual resources of a subject destined to understand its own ignorance.

## NEUTRALITY

There is a danger that art deteriorate into moralism. This happens whenever the artist forgets that art's truth is never explicit, that is, that it never perfectly coincides with objectivity. Now, we want to separate the ethical and moral dimension from aesthetics, because combining them would establish an undesirable alliance, embarrassing in the face of political and demagogical powers. It would also be wrong in principle to postulate that art's function is to educate. The most inspiring works are those which challenge the mental status quo, preestablished values, and, when art elevates, it elevates those who are already disposed favorably to its magnetism. All this is certain, but the issue becomes important considering that some theorists condemn *l'art pour l'art* because of its social insignificance. Art has never convinced anyone reluctant to be persuaded in advance, however, if art were an end in itself in the strict sense of the word, it

would appeal only to those who admire the merely decorative to the detriment of truth. The decorative is everything that, without violating good taste, stops at taste, which is insufficient to give us high art. As far as bad taste is concerned, it is characteristic of old and contemporary art, although now it seems more pervasive than it once was, in virtue of the fact that the selection process is still in the making. It remains true that the present century has inflicted on us numerous examples of works that have little to do with good taste. It is indisputable that nobody has to attribute the name of art to just any example presented under that name.

To extricate the critic from this apparently insoluble dilemma, the notion of neutrality offers itself. By this term is not meant an aseptic notion of art, distant from everything that affects us. The term signals instead a neutrality between morality and immorality and between the beautiful and the ugly. According to this perspective, the beautiful and the ugly disappear under the notion of style, which, as Jean-Paul Sartre made clear, "must pass unnoticed."[22] Each work is a response to the *desideratum* of neutrality, which is nothing but its own implicitness. Therefore the question whether art should be committed or not evaporates under the aforementioned stylistic requirement. A similar principle applies to the question of good or bad taste, considering that an excess of good taste would reduce the artwork to being merely ornamental. Such a work would be futile.

The notion of neutrality goes a step further. It liberates art from the control of moralism, it introduces truth in art as neither destructive nor necessarily elevating or edifying. Neutrality so conceived is compatible with nihilism, except for the fact that nihilism is always attenuated by self-transcendence, self-transcendence makes the artwork the intersecting point of always incomplete metaphorical, allegorical, and symbolic processes. These processes are per se unrelated to the good or the beautiful, they sometimes invent it. One no longer faces naked nihilism, since art can be neutral and include a conception of truth as mediation between what is and what is presented as artistic elaboration. Art includes truth and becoming; the importance of becoming in art is in fact one of the reasons why perfection, the idea of Beauty, is barred from art. But the absence of beauty is not to be confused with the artistic supremacy of tragedy. Insisting on the ubiquity of the tragic would deprive art of the full range of possible ways of metaphorizing. After all, the tragic is related to what Lacan calls the "real" and is therefore closer to truth than to the symbolic, artistic mode. The real must here be understood as that which

cannot be symbolized, the point of resistance or limit that presents itself as an obstacle to linguistic and artistic development. Art therefore is truth, or truthful, but incompletely real (it is not confined to its material side), and it includes the symbolic without conforming to it. Although ordinary and spontaneous language is also symbolic, it lacks the significance of the intentionally poetic. In other words, art is never the result of total spontaneity (if that were the case children would be consummate artists). What is relevant in the work of art and the aesthetic act is their truth, which makes art accessible to communication without implying any ideal, univocal referent, be it subject or object (if art were univocal only scientists or idiots would understand it).

The criterion of neutrality forbids the work of art to be centered on the subjectivity of the artist. If it were so centered it would fail to resonate or it would resonate too much in its naiveté, it would be too close to the imaginary. Objectivity, or style, at the other end of the spectrum, will produce works that are neutral because they question the validity of subjectivity, even though the necessity of the aesthetic act is retained. Henceforth the "referent" will no longer be the subject, but what the agent has made of the symbolic material at his / her disposal. In like manner, the object disappears qua object, qua perfect assimilation of self-transcendence. This "exchange" is what enables us to say that the object of art is its potential plus its actual significance. From this process imitation, direct or indirect, is excluded, since what is created is different in kind from those forms of perceptual reality which constitute the quotidian aspects of life. Nothing has prepared us for the extreme, sublime novelty of the work of art, an impact that can reach the point of shock. This is the demonstration that the new is central to any discourse on art. It is essential to insist on the fact that, in relation to art, the new occupies an unexplored territory which denies nature's supremacy in favor of the artificial.

## ART AS THE ORGANON OF ART

Art is not alone in expounding the new, however, art alone pursues the new for its own sake. This observation reopens the question of the relationship between art and philosophy, in particular the question of whether philosophy can sustain the constant proliferation of the new and give it the stability of truth. It must be admitted that art is no longer the instrument of philosophy nor is philosophy the full instrument of art, but this newly acquired independence has brought about an increase in the

aesthetics of nothingness. Especially regrettable is the lack of cohesion and consistency in placing art in a philosophical context. On the other hand this independence has also brought about a range of perspectives unknown in the past and tenuously tied to philosophical concepts—art as utopia, as remembrance (Giacomo Leopardi and Marcel Proust), as tragedy, as uncanny. Art has become its own vehicle and its own justification. Just as philosophy has abandoned all metaphysical concern and the search for foundations, so art has faced its own nullity by avoiding a comprehensive world view that might have rescued it from nihilism. The fragmentation to which art has been subjected (and which is also its own doing) has led artists to embrace extreme forms of subjectivism, mitigated at times by the awareness that the crisis is generalized. Thus, art had no choice but to become its own organon, having given up any a priori contact derived from a theoretical perspective; this does not mean that artists have renounced theorizing.

If "art for art's sake" openly shows its deficiencies and shows its polished bareness, it is also true that art must go beyond any given accomplishment. A poesy in search of the possible excludes "reality," and with it the equivocal notion of imitation. Those poets who have renounced all contact with philosophical discourse are recluses dwelling in their own self-imposed isolation. Mallarmé declared that poets write exclusively for other artists, that poems are written and read with the understanding that they belong only to poets. What results from this extreme position is an unsurprising sense of impotence on the part of the poet whose exclusive ideal is the eternal, invoked mystery of the "science of the Word [Verbe]."[23] A poetry without external support other than language such as his can be considered decadent, but is saved by musicality through which the verse approaches the harmony of the "alphabet of the stars."[24] Poetic language needs no justification in art, just as rationality needs no justification in philosophy. One question, however, becomes imperative, and that is whether art is really self-sufficient, enclosed within itself. There is no doubt that art is autonomous, but self-sufficiency is a stronger requirement, since it presupposes that art is its own instrument, its own aim. In that case there would be no beyond, no overcoming of art. Nothing would come after art and Hegel would be disproved. Far from confirming nihilism, art's self-sufficiency would privilege its means to the detriment of preestablished ends. A doubt, then, is raised as to whether aesthetics is needed, or whether it is enough to rely on the poetics of the poet. Philosophy and art are compatible, but they employ different methods and their itineraries are different.

Art can ignore those logical processes which make philosophy a narrative of a sort, held together by a premise and a conclusion. Even though philosophy is far from presenting a monolithic continuity, it displays continuity in its search for rationality. Art, instead, in its most noteworthy achievements, relies on discontinuity (though without forgetting the internal unity of the single work). There is no rational mediation between Masaccio and the linearism of Piero della Francesca, what unites them is their emphasis on perspective, but one painter does not confirm or disprove the other.

In philosophy the presumed universal rationality of what must be explained or described prevails, therefore philosophers establish criteria for such explanations and descriptions. What aesthetics adds to philosophy so conceived, to art, to the individual poetics of the artists is a critical approach. Since the "correspondence" between theory and "object" is in this case out of the question, aesthetics is against a systematic approach. The twentieth century has amply demonstrated that art follows its own distinct path and it mistrusts a systematic philosophy whose intent is to declare the futility of art in contrast to the relevance of the concept.[25] Yet, aesthetics will not take into itself the task of assigning to art the non-locus of a protracted limbo. It has already been said that attention to artists' declared intentions when they formulate their poetics is a necessary but not sufficient condition for the clarification of art. When art declares its autonomy from philosophical speculation, it does so with the conviction that it is creating its own ground.

Art discovers its justification in doing. Instead of going back to art's historical beginnings, aesthetic theory must cooperate with art in displacing its own metaphors. Aesthetics is, therefore, a critical enterprise, whose mandate goes beyond taking a judgmental stand toward this or that work. Aesthetics redefines the place that art always tends, necessarily, to usurp by going beyond itself. At the same time, art uses everything that has already been transformed by history, philosophy, and science. The isolation of art that supposedly derives from the *dictum* "art for art's sake" is only nominal, since art always stands on its own. What emerges from this program is the contradictory confluence and concentration of the whole of reality in a permanent core which declares itself impermeable to outside influences. "Art for art's sake" is not a universalizable manifesto. It would be absurd to apply it to architecture, the art form that more than any other is tied to economic development or decline; if this motto were adopted by architecture the result could sanction only decorativism. Even

consideration of such a policy already undermines the concept of an art whose extreme self-sufficiency would lead to insolvency. Yet aesthetic theory must take the ideal of art for art's sake seriously for the simple reason that at the present time it is one of the few notions capable of countering the vulgar exploitation of art on the part of the cultural *attachés* of postmodern society. Mallarmé had already pointed out the dangers of vulgarization. He retreated into language, opposed the spontaneity of conversation in favor of the artificiality of poetic sound. The significance of his choice and his subsequent decision to be above the spirit of the age, resulted in the absolute priority of poetry: at the limit art is more a matter of religiosity than of aesthetics.[26]

To both poetry and music, the most striking examples of art as the organon of art, belongs an analyticity that renounces any outside intervention. In fact, precision is what makes art—any art—art, this analytic precision, which is also advocated by Robert Musil, assumes the aspect of a self-imposed imperative. Modern music, by "returning" to the analyticity of the baroque period, has repudiated the frequent descriptive excesses of romanticism. What has been gained is the affirmation of a poetics that rejects those external influences which would interfere in the expansion of the pure musical or poetic discourse. It is always dangerous to compare the arts to each other, only tenuous analogies can be established through this method—but the results can be fruitful first of all for those artists who tentatively explore new possibilities within their own medium suggested by what in another art form may already be well developed.[27]

High art has been forced to retreat into an ivory tower in order to avoid the collapse of the concept of art. The victory of postmodernism, which Hegel could have called "postmortem art," with its declaration of the collapse of high and low, is far from assured as long as the relevance of myth is unchallenged. But myth's role in art, together with its corollary, the explicit attachment to content, has been set aside both by postmodernism and by formalism. Now, as if to compensate, art itself and not its products has become mythical in the pejorative sense. Hence, art's sacredness and mysteriousness are indeed in danger, although they re-emerge in the work of all those artists who, facing the high / low dilemma, prefer to avoid the trap constituted by pleasure. These artists may be haughty, but more than anything else they are aware that art is forbidden to extend its influence beyond its own domain. Thus, a form of moderate nihilism underlies each attempt to define art as limited to a private perfection. How to overcome artistic limits, the nihilism implicit in the

artwork, is an issue that can find a solution if the conception of art as an end in itself is retained. Art is declared self-sufficient and, what is more important, the final arbiter for judging its own results. As a value, art is not in search of further justification, and the path inherited from the past has no validity beyond mere historicity. What must come forth from the work is its own disruptive power, disruptive for the conformist and more fundamentally for the artists themselves. Subjectivity responds to this necessity by hiding art's premises, by showing the final product as if it had emerged from a beyond that is also immanent. A conception of art that dismisses any outside influence beside the determination of the artist and that circumscribes art within its well-defined domain may be not only a symptom of decadence but also of its opposite. What has forced high art to withdraw into its present, well-delineated niche, is its strength, which refuses to compromise with the object of representation.

A step taken in full awareness of the difficulty of dispossessing the object of a centuries-old predominance has been taken by the avant-garde. The transition, though, has been gradual. From the futurists' undoing of the realistic form it can be deduced that the process was a laborious one. A displacement has taken place which is still challenged by the rear-guard's advocacy of an impossible return to representation. This displacement is far from arbitrary, it responds to a philosophical necessity, because the object is something imaginary which is never given in its entirety, not even *in mentis*. Thus, art results from the encounter between being and nothing, that is, the being of the material side, and the nothing of representation. The avant-garde has been able to reckon with a situation of apparent stalemate and respond to the challenge of philosophy. What has been gained by this movement is the elimination from art of all the false glitter that could have made it seductive.

As an end in itself, art accepts the possibility that meaning be attributed to it. Even though this conception of art lends itself, more than any other, to the misunderstandings of a nihilism as *end in itself*, the fact remains that art for art's sake is the best way to penetrate art's potentialities. Being confined within its own sphere, art acquires the significance and the freedom of a nonmoral imperative. Art's evocative power is its power to lead us into temptation. Art does this by putting aside beauty and leading us further into the unknown realm of the uncanny. The uncanny is tied to the aesthetic, to the narrative space, and to the sphere of the emotions. The uncanny has its place in the psyche, it is nourished by the feeling of fear and distress, the perfect equivalent of the sublime.

Familiar and unfamiliar, the uncanny is eminently ambiguous, and so lends itself to being associated with the aesthetic *locus suspectus*, where anything can be found and in which the esoteric may clash with an apparently innocent exterior. To say and not to say at the same time, to leave everything implicit, this is the function of the uncanny in art, marked by an obscure, solitary silence as significant as words. Freud himself seemed to be anxious to hand the uncanny over to the writer and the literary critic, despite his admission of its ineradicability. His desire to rationalize it leaves the aesthetic value of the uncanny untouched and unexplained. If taken seriously, as it should be, the intrusion of the uncanny would shatter the well-established notion that art is above all productive of harmony. It is important, though, to remark that the uncanny is not solely related to space. As Heidegger indicated, it is also related to time, since it permeates *Dasein*'s potentiality-for-Being in its relation to the silent call.[28] Leaving aside the distinction between authenticity and inauthenticity, on the ground that it is more appropriately applied in the ethical domain (and also because art is, so we hope, always "authentic"), it is time to relate art to the uncanny, above all in its sublime manifestations.[29] The sublime is not only the colossal, the erect, the petrified, as Derrida has described it.[30] The sublime has also the character of the uncanny, of time and space petrified. The sublime is uncanny because it goes counter to our ordinary ideas of space *and* time.

To extend the sublime to every single work of high art would contradict the very experience of the sublime, an experience that makes it impossible to distinguish among sense, intellect, and reason. Therefore, we prefer to restrict the sublime to very rare experiences. If the sublime is tied to the death drive and to the uncanny, as Freud would have it, then death and the sublime do not transcend us. Rather it is we who transcend them. In fact, death is immanent in our being, yet it is other, and in the sublime we put everything in question, including our being. It is doubtful, then, that Edmund Burke and Kant were right in claiming that the sublime is apprehended only when the spectator is not in danger. "[T]ranquillity tinged with terror"[31] is no terror at all, rather an intermediate state of disquiet.

The best illustration that the uncanny is close to the sublime is Olivier Messiaen's awesome composition *Et Expecto Resurrectionem Mortuorum*. Here the theme of death is present, together with faith in a beyond, which is, however, expected to be no less overwhelming than life itself. A secular reading of this work is possible. Diametrically opposed to

Gabriel Fauré's subdued *Requiem* and in addition to the presumed play-ful aspect of art, Messiaen's work constantly reminds us of inescapable death, with a violence seldom attained in other musical works. The theme of the final resurrection applies also, or can be extended, to the phenom-enal world, and that is what makes this composition eminently uncanny. An uncanniness related to time in the sense that the work's mode is related to a conception of time as finite and yet admitting of a beyond. "Mystical" is an inappropriate word to describe this powerful composi-tion, which is synthetic in character, as is to be expected since the theme encompasses the whole of the Christian faith in its relation to the human. Uncanny are the bells, the gongs, and trumpets with their lacerating finale, and equally uncanny is the sublime conception that carries to the extreme limit the already extreme theological belief in the end of the world, in a conflagration that, present in time, transcends time. Messi-aen's work convinces the listener that the experience of time first of all concerns our inner intuition and then presents itself as a synthesis of fini-tude and eternity.

The sublime dares to cross that threshold which is given by the pleasant. Other qualifications apply here, namely, the boundless, the pres-ence of a limit that defies limit—there is enough to exclude pure pleasure. It is better to say of the sublime that it is a kind of perverse (unnatural) pleasure in which what predominates is a disorienting, irrational, and unrepeatable sense of estrangement. It is extremely unusual for an experi-ence of the sublime to repeat itself with its initial force, and here lies its limit. In contrast to the beautiful, which always has a similar impact on us and which eventually is refined each time it is approached even in the same work, the sublime is perceived as such only the first time it is encountered. It is as infrequent as our encounters with death. In its prox-imity to the nothingness of the referential object (death is not repre-sentable), the sublime aspires to the divine without ever reaching it, but it gives the (false) impression that infinity has reached its limit, which of course is no limit. Contradictory as it is, the sublime fascinates for its incomprehensibleness, its inscrutable being. Mysterious and superb, it cannot be forgotten or forgiven for placing us before something that escapes complete intelligibility.

The notion of irrationality intrinsic to the sublime qua uncanny is in perfect agreement with a view of art turned upon itself like the con-ception of art as organon of art. Significantly, artists consider art a kind of secular faith, just as mysterious as actual religious faith. What has been

renounced by this move is the cognitive value of art. What has been gained is a self-proclaimed autonomy that trusts its own resources and leaves aside its sources. This notion of art is in accord with the sublime and demands faith in its immanent perfectibility, while the nothing that surrounds art is willed and accounted for. Only the creative act, rationally unjustified, justifies itself. In an art so conceived (we are here considering only literary forms) the verb predominates to the disadvantage of the substantive[32] with its referential, substantialistic tones. No references to a pre-given reality are allowed, almost as if art were play. But play is incompatible with the sublime. Therefore it is necessary to limit the role of play in art; play must be interpreted in a limited sense, and the comparison between art and play can only be carried out within well established confines. First of all, art, from the artist's viewpoint, would qualify as play bound to determinate rules only if the rules are not pre-given, for artists undo that which tradition has established before their entrance on the scene. It could be argued that the introduction of new rules is also part of play. However, in art the complexity of this task goes far beyond play as ordinarily understood, since it involves taking into consideration all, or almost all, previous cultural codes in order to modify them. Art's genesis may well be found in play, transcendentally this may be so. Yet, to reduce art to play would be like stating that the notion of aesthetics is derivative and far from being autonomous. Although art is something situated and elaborated historically, it is all but a secondary activity, dependent on secondary emotions or structures. At the origin of art there is art. This is what is claimed by anyone who conceives of art as a self-sufficient value. Yet, qua value, it has gone through periods of devaluation and valorization. History's developments alter the view the public has of art, its function, and its place in the hierarchy of values that predominate at a given time, but history cannot tell us what art is as such, and it does not determine the meaning of art.

Fragmentation is the necessary consequence of art understood as an end in itself. Thus, a conscious separation keeps art at a distance from any other activity, intellectual or otherwise. The fragmentation noted above is compatible with a perfectly assimilated nihilistic view of the world. But the conception of art as its own organon, although it arises in response to an external and internal state of affairs, is not entirely reactive. This view calls for the awareness, on the part of the artist, of the supremacy of art. Nihilism, implicit in the blurring of logical distinctions, is the ideal companion of art conceived as its own end. If, on the other hand, we look for a

different conception of art, what is encountered is the contemporary acknowledgment that art is ancillary, an activity among others, and thus, we stumble into another form of nihilism, one that concerns itself with an eclecticism detrimental to style. The dilemma has no simple answer. If one adheres to the first alternative, that is, art being its own end, one must be ready to dismiss the "world," in Lacan's words the "real," as being the impossible, or reduce it, more functionally and perhaps cynically, to a means that is transcended by art. But transcendence is never absolute, no matter how artists and their works embrace the notion of art for art's sake. This conception is always problematic, since it rests on the conviction that art can find its resources only within art. The void thus introduced, a vacuum that denies the fullness of being, is filled by style, which stands for the fulfillment of art. The second alternative, that is, art is ancillary, is also dangerous because if one takes art to be secondary, then the door is open to all kinds of aberrations, from concessions to popular taste to overt propaganda.

According to Gottfried Benn, *l'art pour l'art* has nothing to do with a mystical and esoteric principle. Art is the only oasis within nihilism, to be distinguished from pessimism, which is in itself "a legitimate spiritual principle."[33] Nihilism, for Benn, must be exploited artistically and thought of as a provocation. Afterward a constructive spirit, typical of art only, can express and appropriate mythopoetic discourse. Art functions as a guarantee against nihilism because it is the one activity that goes counter to the mechanization of positivism. Positivism has provoked a schism between the art world and science, has made them enemies of each other, and so any attempt to undo the schism will be a temporary truce. During Benn's time, positivism and science had to be opposed to the conception of art as expression. Ladislao Mittner elaborates by saying that expressionism turns upside down the symbolist ontology whose invisible reality was constituted by the soul. For expressionism "things exist in themselves, but no longer do they exist for man . . . they are incomprehensible and at the same time irrefutable . . . every solution is legitimate because all possible solutions coexist."[34]

For Benn, nihilism can be overcome only by pure transcendence, self-transcendence is insufficient, given the void that surrounds poetic creation. The poet must reach forward to the tragic, bearing in mind that antihumanism and antihistoricism are the sole answers to the dissonances of the times.[35] Poetry, specifically lyric poetry, is monological, it comes out of a laboratory. It is the result of observations that make use of the microscope, it pulverizes reality. Having renounced the whole, the totality,

poets are aware that by now their art is nothing but an archaic notion. What emerges is a poetry which, in its absoluteness and isolation, is directed at the few and which defies any comparison. Truth is inessential to poetry; what is fundamental is expression, but its repercussions are minimal. Poetry does not aim at improving humanity; it is not pedagogy; history ignores it: "works of art are phenomenal, historically ineffectual, without consequence in reality. Therein lies their greatness."[36] Here the sublime does not contend with nihilism for supremacy; being equal to each other, they both declare art's independence from any dogmatic way of thinking or of looking at art. Art for art's sake knows that its power resides only in its limits. Art is pure transcendence according to the aforementioned view, but even though poets are guided by the lyrical Ego, the Ego does not constitute a center. The Ego is a void that can hardly be filled in dialectical fashion. Yet nihilism has a function to perform, considering that at last it has reached the goal of generating art without justifying it. In fact, art is in no need of rationalization if its point of departure is absolute in the sense indicated above. Hegel did not foresee that the absolute view of art could be the consequence of nihilism, in Hegel's case nihilism in art was the final consequence of his absolute standpoint.

# CHAPTER 5

# From Artifice to the Will

## ART UPROOTED FROM TRUTH

What has preceded will serve as an introduction to Nietzsche's contradictory theory of art. On the one hand he denied value to art for art's sake and on the other hand he rejected any connection between truth and art. For Nietzsche the designation "false" applies both to low art and high art. Even though the separation between high and low became pronounced only after his time, Nietzsche nevertheless foresaw the dangers of an art insensitive to the uniqueness of style. Art is willed and desired, but contemporary art is suspicious of what is left of desire's subjectivity. Nietzsche used the notion of the universality of the will in order to move toward a metaphorical conception of high art. At the opposite extreme, low art rests upon signs and symbolic systems so commonplace that their products do not deserve the name of art. In both cases—that is, whether we start from symbols or from metaphors—art's relation to truth reveals itself to be problematic.

Symbolism, if understood as arbitrary, is removed from the common conception of truth. Truth must be declared unreachable when approached in a direct manner, for it is situated beyond and behind any logical category. High art is aware of this predicament, of the impossibility of attaining a universal, absolute truth, and yet it aspires to such truth through the act of self-transcendence, even though it cannot at the same time displace itself in absolute transcendence. If it could, any act of interpretation would be hopeless. At the opposite extreme, low art has

renounced truth, and yet persists in declaring that it has a hold on reality. Low art reappropriates ready-made symbols and in consequence devalues the role of imagination. One of the predictable results of low art is the predominance of eclecticism, all too apparent in those hybrids that compromise the essential unity of the work of art. The "truth" of these works is explicit, unworthy of being discovered, for these works lack any metaphorical interest. In postmodern art a ready-made symbolism proposes all-too-well-known forms with a stubborn disregard for the new, which is nothing less than the purpose of high art. Both symbols and metaphors synthesize, therefore they have a role to play in art; we will see in the following chapter metaphor's role in clarifying art's truth. As far as symbols are concerned, their truth is by now detached from any notion of beauty; they are not artistic per se, indeed they often represent an obstacle to artistic novelty.

Since artists are no longer dedicated to the idea of Beauty, which is criticized as being metaphysically ambiguous (the inadequacy and ambiguity of beauty depend on its having to carry the burden of the ideal and the sensuous), it is worth keeping in mind that the beautiful so conceived has been replaced by formal style without any direct reference to sensuality and by symbolic and metaphorical processes which do not correspond to any pre-given concept. This, at least, is modernism's message. And if one of the objectives of aesthetics is to discriminate between high and low art, then, if there is still room for high art, there is still room for philosophy as opposed to sociology.

### NIETZSCHE'S APPEARANCE

The reason art has turned away from truth is that it has not found a viable substitute for the metaphysical truths of the first half of the nineteenth century. The subject itself, suspected of all sorts of misconduct, from connivance with metaphysics to downright frivolity, has disappeared from art, carrying with it all notion of meaningfulness. Not even the Overman could assist us here, because the Overman is but an inflated extension of *Mensch*. Actually, Nietzsche oscillated between asserting a merely quantitative difference between Man and Overman and a qualitative one. At times he saw the two notions of Man and Overman as separated by a huge hiatus (Zarathustra limits himself only to announcing the Overman), and at other times he seems to find that a quantitative difference is sufficient for explaining decadence as opposed to the constant enhancement of life.

"Man" is the result of meaningless, bygone certainties, destined to nullity with the advent of the will to power. The Overman, on the contrary, is a being who is not yet, the usurper of the future when the future will efface history to announce eternal recurrence, new gods, and, consequently, a new mythology. The Overman is indeed a myth, no less fated than "Man." In the meantime, for those who are waiting, an immense void has penetrated everything from art to politics. Art has forgotten truth. Truth itself has become suspect, now that the Platonic separation of appearance and reality has been discarded.

Even so, art can still stand for liberation. Indeed it does, but under certain conditions. Nietzsche was aware (his judgment on Wagner proves it) that myths may coexist with vulgarity and so are insufficient for revitalizing art. However, from that long tirade which is *The Case of Wagner* not a single concrete recommendation for art emerges, except perhaps for the reference to *Carmen*, with its supposed *élan*.[1] Wagner, Nietzsche contends, sided with appearance, with effect. He was a decadent actor who reduced music to expression—a mistake such as this is no longer acceptable because it lacks authenticity, wit, and exuberance; Wagner's theatrocracy is beneath art. In addition (and this is a death sentence) his music is nihilistic. After the death of the beautiful and of God, art's purpose is to maximize the vitality of art, with the will to power at its center: "Aesthetics is tied indissolubly to . . . biological presuppositions: there is an aesthetics of *decadence*, and there is a classical aesthetics—the 'beautiful in itself' is a figment of the imagination, like all idealism."[2]

The truth of art is that there are two truths. The first is decadent and Christian, the other superhuman and affirmative. These can also be seen as two falsehoods, since it is not truth in the epistemological sense that Nietzsche had in mind. He was no longer pursuing this illusion. In the chaos of modernity, there are very few things to put in order from a Nietzschean perspective. In a world in which the subject is a fiction—along with causal relations, truth, and science—one of life's few redeeming features is art. And the advantage of art, including tragedy, which is the source of everything valuable and inspiring, consists in its being the only domain in which order, style, and unity have a legitimate place. Furthermore, art intensifies the Overman's will to power. If the pompous title "Overman" has any elevated meaning, that is, if it excludes the naked desire for economic or political power, that meaning must be sought in the work of the artist, who is no longer the genius of the romantic tradition, but is de facto the creator of aesthetic values.

The Overman declares the overcoming of nihilism, and with it the end of humanism, he shatters the illusion that "Man" is an end in himself and the final goal of a historical development gravitating around an ideal image. Outer and inner forces have reduced "Man" either to a spectator or to an aimless being devoid of any ethical or moral model. From "Man" nothing can be extracted other than the passivity of the masses and the morality of Christianity, which has made us too self-conscious and has weakened fundamental, vitalistic drives. The Overman, instead, is someone who acts according to the will to power, which is something completely different from consciousness. Consciousness is the object of education (*Bildung*), but nothing and nobody can teach someone to become an Overman. This notion of the Overman is the object of a prophecy— as if Nietzsche could not dismiss the teleological mode of thinking which has dogged Western culture since its inception. Although Nietzsche expressed violent disdain for everything traditional, at the same time his titanic attempt to overthrow established values, without imperiling the world of aesthetics, made it more precarious and difficult to build. Art is far from constituting a world, if by "world" is meant something unified, connected with tradition, and provided with a rationality of its own. And art has little to do with truth. Indeed, art is its resolute antagonist, since truth is destructive, whereas art is, after all, constructive, the preeminent and possibly the only antidote to truth.

The overcoming of nihilism is not secured once and for all and truth is far from being firmly established by any epistemology—a tragic outcome that, however, only remotely concern art, since art is remote from truth. This remoteness is not what makes art preeminently tragic; tragedy concerns the artist rather than art itself. Thanks to style, art is a transfiguration of the brutality of becoming, therefore, it has a redeeming quality, so that it puts an end to the artist's tragedy and establishes a salutary distance from life's tragic manifestations. Although the enigmatic split between artists and art can probably be bridged only by the Overmen, it is their burden to take this step over the abyss and to make it light.

To insist on Nietzsche's fascination with tragedy is indisputably right, but it is advisable to keep in mind the place that he attributes to lightness and laughter. If art's function is to cover up the horrors of life, its tragic and inescapable aspects, it is not surprising that considerable room should be made for gaiety and laughter. Art is after all the equivalent of a medicine to be administered *ad libitum*. The comic and comedy, however, are unstable remedies even though they procure relief. The

comic is merely the "transition from momentary fear to short-lived exuberance."[3] As far as comedy proper is concerned, it testifies to the end of myth and is, as a result, a symptom of mediocrity, a concession to popular taste. Tragedy also, however, can show signs of decadence. But, when it is correctly understood, the tragic presents itself as a corrective for nihilism. Therefore tragedy, like art in general, is never an end in itself, and since it cannot be eliminated, the tragic is utilized. In its broader sense the tragic is not meaningful per se; quite the opposite, it is tragic just because it is not meaningful. The will to power, which has no purpose in itself, can nevertheless impose a meaning on the tragic. Being the product of the will from which freedom is excluded, the "yes" to life has nothing rational in it, it is pronounced in spite of everything. Its value is therefore unquestionable, but always in danger of turning into its opposite. This precariousness depends on the fact that all reference to objectivity is excluded on principle.

Nietzsche never felt the need to resort to stoicism as a feasible solution to life's evils. For him art and life were, beyond question, beyond good and evil. To take seriously the questions posed by nihilism, a notion which is more comprehensive than the notion of pessimism, is to enter the domain of philosophical concerns. There are psychological ramifications to nihilism—the depressive states of those who have lost belief in desire, the inanity of previously felt values—but nihilism's true import, unavoidable in the contemporary arena, inevitable for those who have experienced the surrounding decadence, is to be sought somewhere else. Nihilism is a response to the impossibility of substantiality and objectivity, a metaphysical impossibility. In a note in *The Will to Power*, Nietzsche distinguishes pessimism from nihilism: "Pessimism as a preliminary form of nihilism;"[4] pessimism is a psychological state of mind instead of a philosophically elaborated notion concerning values. To see that pessimism is something altogether different from nihilism it is necessary to recognize that pessimism can be conquered by means of frivolous acts or mere things, namely, low art. This is not the case for nihilism, which, if it is to be conquered, requires high art and a philosophical understanding of life. Pessimism is a preliminary phase, comparable to subjective taste in the fields of morality and aesthetics. Now Nietzsche argues that, methodologically, priority must be given to the notion of nihilism because, even though pessimism can be more than a passing mood, nihilism goes beyond it in declaring, among other things, the death of Eros, and in exposing the separation between appearance and reality. What is in question is the value of

life, the status of values, and the negative answer given by nihilism concerning epistemology as well as ethics and aesthetics.

Nietzsche never overcame nihilism fully; this becomes clear especially if one considers his skepticism about the possibility of knowing. Knowledge is a matter of will, and, since the will is indifferent to the totality of being, Nietzsche, unavoidably, drew the conclusion that knowledge is fragmentary. He did so without nostalgia, indeed with awareness that the metaphysical problems will never be completely solved. At most we can declare our epistemological bankruptcy irrelevant. Nietzsche's philosophical reaction, instead, is to counterattack with the metaphysics of the Overman, eternal recurrence, and the will to power.

Nietzsche alludes to nihilism as a psychological state, but nihilism is more properly seen as a static view of culture and society as a whole. Given the lack of a meaningful totality and truth ("becoming has no goal"),[5] the question "for what?" arises spontaneously, but it is reason and not vitalism that has led to such questioning. Nihilism, however, strengthens our response to life; it is, in short, a "pathological transitional stage,"[6] but also normal in the sense of being predictable as long as the old metaphysical values prevail. Nietzsche has not escaped nihilism, as he himself admits; at this juncture nihilism must be used as a weapon to destroy philosophically that which is already meaningless, namely, faith in God, truth, and the beautiful (active nihilism). In this way nihilism is replaced by higher values—a full transvaluation. Clearly, then, the label "nihilist" is inappropriate to describe completely Nietzsche's position. The destructive moment that accompanies creation is far from being nihilistic. If Nietzsche could analyze the "world" only in order to destroy it, it is also true that he made amends for the loss of the old.

Nihilism is the expected response to the extinction of those values which in the past have held culture together, but for Nietzsche these had never been values at all, since they were heteronomous from the start. Above all, they need not be justified historically, the appropriate stand is to recognize how dangerous they are in the present. Nihilism, therefore, is to be recommended if it presents itself as a step toward final domination over becoming. Nietzsche thinks, however, that the age of nihilism has just begun, because modernity is only beginning, and so we should embrace the "tragic age," in which certainties are denied to us, in which the question of pleasure and displeasure has become a false question, since both pleasure and displeasure are means and are never worthy in themselves. Nietzsche says that one must look for a corrective in nihilism itself,

since, in understanding, and using it, we miraculously transform it into affirmation. The opposite path, that of negating the enormous relevance of nihilism from the start, would represent extreme defeat, because if nihilism were thus set aside it would be impossible to conquer it. Idealistically, it is a matter of self-awareness.

In entering the ambit of art, Nietzsche detects one cure for decadence, and that is Dionysus. There is indeed such a thing as decadent, romantic art, the ugly and the vulgar are proper to it. They stand for a "no" to life, to which beauty, being biologically valuable,[7] answers with a "yes." It is unnecessary to spend time in trying to define beauty; beauty, qua entity, does not exist, like truth, it is an imaginary construct. Between truth and art, therefore, there is no encounter. Art is unrelated to truth, but its use value in promoting life is priceless. The Dionysian mode is there to intoxicate us, and so we accept tragedy as a stimulant. In accepting tragedy's aesthetic relevance (this amalgam of the terrible and the "yes") what is obtained is the Dionysian, a mode which defies both pessimism and optimism. Thereafter any conception of art that identifies it with the pleasant is out of question. By the same token, feelings and expression are excluded, belonging as they do to the sphere of the reactive rather than the active. Nothing is left to be explored by truth, and art declares that truth is not the highest value. This being the case, truth is surpassed by art and by the will to power. In this context, art "does what it can" both to lessen life's diremptions and to stimulate. It cannot prevail completely because life's ambiguities are too ingrained to allow free rein to any stable mode of being. Even science, which threatens to displace art and which seems to have displaced religiosity, promising safe remedies for the unpredictability of becoming, is doomed to failure. It is debatable whether Nietzsche was a competent prophet on these issues. What is incontestable is his aspiration to combine the disorder of becoming with an equally disturbing philosophical position. Very little is stable in Nietzsche's thought, so much so that Giorgio Colli warns us not to read Nietzsche with the intention of finding contradictions: "Nietzsche has said everything and the opposite of everything."[8] In this chaos art retains, after all, the capacity to console, and, beyond that, it is one of those values which makes of its creators beings who have the privilege of transcending themselves. Here lies the significance of the Overman.

The concept of the Overman is the most provocative concept originated by Nietzsche. Yet he conceived of the Overman only as a potentiality for being. It is more a symbol of self-willed solitude and a

phantasm than a foreseeable reality. Since the Overman is thus situated in the future it is exceedingly difficult to point out its characteristics, there is no model one can invoke. One single indication, however, concerning the Overman can be stated with accuracy, namely, the ability to overcome nihilism once and for all. Nothing less than the Overman could possibly combine in one stroke the fullness of life, the will to power, the acceptance of eternal recurrence, and the creation of new values. Beyond this, the Overman is indefinable, leaving us to imagine how life would be if this new "race" were to dominate. The most tragic and extreme aspects of life pertain to the Overman, who is beyond good and evil, the perfect example of a person who combines the destructive aspects of existence with its constructive aspects.

Art itself, high art to be precise, arises as the result of our ability to expand and destroy. Each new style, each new vision is the outcome of the dismantling of previous stylistic connections, which are then replaced by different conventions and priorities. What emerges is something that contradicts already established criteria, each new style requires a new criticism. The *pars denstruens* must be as significant as the *pars construens*, even though they require two different processes, merciless deconstruction in the first case and will in the second. This combination involves both the suspension of the critical faculties and their retention. It is thus the prerogative of the few who are able to surmount the contradiction immanent in high art. Whoever arrives at this new criticism has succeeded in suspending nihilism.

The Overman is incapable of eliminating the reasons for nihilism, for these reasons are permanent, but the Overman will be able to make nihilism ineffectual. The artificiality of values, that is, their not being grounded in anything "superior," remains. What has changed is the subjective stand toward the nakedness of reality. Not even the Overman can remove the fact that the will to power and truth will be forever separated. "*Primum nocere*" is Nietzsche's motto, later weakened by the interaction between destruction and construction. Indeed, Nietzsche's refusal to give a prominent place to beauty, understood as something enduring, reflects his desperate search for the new. He found the new in the work of artists who are bound to destroy as much as they forge, and who therefore avoid any reference to any pre-given ideal. In thus deemphasizing the ideal of the beautiful, Nietzsche opens the way to an eccentric conception of art. He does not, however, want to rehabilitate the ugly. He found enough of it in Wagner.

## EXPECTED TRAGEDIES

The only thing that artists can take seriously is tragedy, thus spoke Nietzsche. Tragedy qua drama duplicates the tragedy of the artist. This preeminence of tragedy echoes the aura of the art of ancient Greece, but is based on the values each of us accepts. The issue of tragedy becomes actual again after the dismissal of Christianity, after the death of God. This is Nietzsche's conviction. In reality, Christianity has included tragedy in its world view, the symbol of the Cross is far from reassuring to attentive scrutiny. Nevertheless the Christian world has produced the *Divine Comedy* and tragedies only secondarily. The possibility of salvation precludes serious consideration of *amor fati*, which may even become suspect from the theological viewpoint.

Art is tragic and tragedy is art, both in lived experience and in fiction. If what Leibniz called "metaphysical evil" is something permanent, if the void surrounds and permeates us all, if, in short, the nihilistic view of life is justified, then tragedy would satisfy the need to find unmistakable correspondences to human experience. Tragedy would have cognitive value. But Nietzsche's point is different. Nietzsche's aesthetics accentuates the artificial over and above the natural, and so it would be misleading to conceive of the Overman or of art solely in vitalistic terms. Vitalism is more theatrical and artificial than any previous metaphysical fabrication.

What is of value in tragedy is its status as a mythical model that is futural. Thus, the statement that tragedy is unrelated to truth must be further qualified, since tragedy does not declare any truth. In effect it circumvents truth through its stylistic effects. This is an important addition that makes style the necessary mask on the already disfigured face of the Overman. Accepting this conclusion means that tragedy is *more* convincing than comedy. Leaving aside his later insistence on laughter and dance, Nietzsche never recanted his initial negative judgment on comedy. It is tragedy that provides us with truth, though not with a literal truth, which in itself cannot be defined in terms that would be analytically acceptable. Truth, in its broader sense, is everything that marks us. It comprises, therefore, history, science, and myth. It is usually called "reality," but a reality that must be conceived of as excluding the metaphysical dualism of appearance and reality. Tragedy and art are as dangerous as reality and truth, but they offer them to us transformed in an idealized manner, *even* for Nietzsche. Thus, tragedy's function is preeminently mythical.

Necessary to the overall economy of human thinking and being, Nietzsche mythicizes the tragedy of art so that it becomes a counter to the tragedy of life, at the same time he sees life as the continuation of the stage, and so both art and life are clothed with the aura provided by mythology. The artist and the philosopher are most aware of these ambiguities, their tragedies consist in being ahead of a given historical age, which is why artists and philosophers are closer than anyone else is to that myth which is the Overman. The Dionysian element, which is indispensable to any fertile human being (from this element s/he acquires the ability to overcome passive nihilism), is a vital and primitive force which finds perfect fruition in tragedy. Tragedy must be appreciated to the full, for, as Ernst Jünger warns us, those who turn away from tragedy, along with nihilism, have not understood anything in life.[9] Jünger calls nihilism a "fundamental power" from which there is no refuge; yet, nihilism and the tragic are what convinces us of the necessity of vitalism. The mysterious and perverse manner in which the tragic affects life provokes an instinctual reactive response. Here is found the mechanism of becoming, which opens up the possibility of further becoming. Nietzsche does not have to provide a rational justification for tragedy and art, or science and aesthetics, everything is included in *amor fati*, the realization that everything is given simultaneously.

Aesthetically speaking, tragedy is illusion, but not delusion as it is enacted. Nietzsche extends the fictitious to the inexorable, fragmentary, chaotic existence of the individual who prevails thanks to her / his *hybris*. This is the tragic outcome of a philosophy that refuses all mediation.[10] But this judgment may be considered moralistic, insufficient to solve the problem of nihilism and its consequences. Since the tragic is the essence of our being, the only values that can go counter to it are those which favor it, like a sort of homeopathic medicine. Thus the heroic, which is a profound pose, is destined to predominate. Contradicting Hegel, Nietzsche resuscitates tragic heroism and assigns it the place of honor in his philosophy. Even laughter, which is addressed to the absent God, distinguishes the Overman, or even its diluted version, and is a response to the tragic, both in art and life. Gilles Deleuze rightly sees the continuity between these two apparently opposite states: "The tragic is not to be found in . . . anguish or disgust, nor in a nostalgia for lost unity. The tragic is only to be found in multiplicity, in the diversity of affirmation *as such*. What defines the tragic is the joy of multiplicity, plural joy."[11] *Pace* Bergson, laughter is not didactic.

## RHETORIC FIRST

Far from being defunct, artists are nevertheless in danger of being romantic, decadent, of expressing feelings instead of creating style (expression is closer to life than to art). They can, though, approximate the Overman by accepting the tragic dimension which elevates them to the will to power. Always active, solitary, abnormal, sometimes morbid, artists display an excess of energy and will. They use everything for their own purposes and in the end they become prisoners of their own genius: "If one has a talent, one is also its victim: one lives under the vampirism of one's talent," and: "One has to tyrannize in order to produce any effect at all."[12] In exchange, artists create out of a sense of overfullness, destroying at once the present and their own nihilistic tendencies. The artist is a tragic figure to whom nothing is precluded, even the ugly acquires a redeeming quality. Only the decadent artist will avoid it: "[T]he feeling of *power* applies the judgment 'beautiful' even to things and conditions that the instinct of impotence could only find *hateful* and 'ugly'."[13] Artists' vitalistic response to the ugly and the terrible is what saves them from nihilism. What they add to their impulses is style, whose aim goes beyond persuasion. Style commands.

The tragedy of art is the tragedy of the artist, although artists are always ahead of their material. Nietzsche omitted the details as to the nature of this style; it is clear, though, that, despite his stress upon the Dionysian, Nietzsche rejected as a model for art any bombastic rendition of the artist's personal tragedy. Nietzsche criticized Wagner for his overstatements, and he would probably have disparaged Gustav Mahler's symphonies for the same reason. To surmount tragedy means to react to the danger represented by nihilism, so as to guarantee that in the future the reactive forces will no longer be needed. By including the ugly and the painful in art (at least as a possibility), Nietzsche shows that they have a role to play in the formation of the artist. Gone is the idealization of the beautiful, or even worse of Beauty, every aspect of life can be used for its enhancement. It is forbidden to say that art is diminished by the rejection of the beautiful and truth; being creation, art can do without any other justification.

The emphasis is on the future, thus, realism is excluded. By the same token, music is privileged by Nietzsche because it is the art form closest to becoming and to the development of time; music is itself an appendix to becoming. Similarly, metaphor in literature is bound to be disregarded. Metaphor has no prominent role to play in art since there is

little to metaphorize given that appearance and reality have lost philosophical relevance. *Zarathustra* is not a metaphorical work, it is allegorical. From chaos, constant becoming, any analogy that would connect fact or event with language is excluded. There is no transition from *A* to *B*, *A* and *B* remain confined to their own spheres. With allegory it is different. Allegory takes possession of the particular in order to ascribe to it a universal meaning; it is the true manifestation of the will to power. In metaphor one finds no universality, at the most there is only poetic, maybe lyrical, subjectivity. Even so, Nietzsche used metaphors in his writing; he employed them more to stress difference, however, than to show similarity—which prompted Witold Gombrowicz to say that "Nietzsche uses the pedal too much."

As mentioned, Nietzsche's work, especially *Zarathustra*, far from being in its essence metaphorical, provides a perfect example of allegory, as characterized by Northrop Frye, an allegory that uses images to provide "examples and precepts."[14] The fact that Nietzsche was addressing the few does not change this analysis. The advantage of allegory rests on the fact that it is better suited to disclosing the future, given its prophecy-like structure. Allegory is also more apt to signify the mythical than metaphor is. There is tension within allegory between past and future, perfectly elucidated by the image of the rope in *Zarathustra*. In metaphor the present prevails, witness the fact that metaphors are stated in the declarative mood. In metaphor also there is tension and expansion, but allegory adds an implicit "ought-to-be," which makes it the least nihilistic figure of speech. It also makes it controversial, open to criticism and to stereotyping—a destiny, though, which metaphor and all the other tropes share. For Nietzsche, metaphor does not coincide with the aesthetic, it is used for passing from one universe of discourse to another, for instance, for transposing scientific language into the language of philosophy, from one untruth to the next. Nietzsche's metaphors are expedients for circumventing that void which is truth. No one can do without such use of metaphor unless s/he is prepared to speak and write in the language of logic, exclusively employing well-defined and univocal symbols. Even if this were possible, the aesthetic implies something more than metaphor. Nietzsche's metaphors are meant to displace truth. Moreover, the aesthetic is not metaphorical per se, its function is broad, and it comprises art forms that ignore metaphor, such as music and architecture.

One author who limits the metaphorical in Nietzsche is Paul de Man. Without denying the presence of metaphors in *The Birth of Tragedy*

(once appearance is in place, it is displaced by a metaphor),[15] de Man says that what in the end prevails is a form of representation that denies representation. Truth "happens," it is, however, unutterable. Similarly, nature has been replaced, for good, by the will. The will is unrepresentable, but can be alluded to by metonymy and allegory, thus are created the figures of Dionysus and Zarathustra. Ours is indeed an age of allegory and metonymy, metonymy that de Man appropriately calls "blind,"[16] because it has acquired a tragic sense, given the loss of the subject as ground and essence. Allegory's point of departure is intrinsically non-universal. If it succeeds, it exposes more than it describes and can easily be used for moralistic (or immoralistic) purposes. Nietzsche used allegory immoralistically, without neglecting the pleasures of iconoclasm. What he discarded was irony, too supple an instrument for a philosopher whose aim was to glorify the metonymic dimension of appearance. An ironic art would be romantic and would also jeopardize the tragic dimension of existence, which is after all the source (but not the foundation) of art.

True, language is not tragic in itself.[17] However, this does not make it ironic, no matter how much one is ready to extend the meaning of irony, and even if we admit that the Socratic discourse was deconstructive. It must be kept in mind that Nietzsche renounced truth with an act of will, not so much because truth is ironic or unreal as because it is unbearable. Irony has no place in Nietzsche's thought, even though irony presents itself as one of the answers to chaos.[18] If irony is the consequence of superabundance, Nietzsche's response to the same state of affairs is the "joyous" acceptance of the tragic. What interferes with de Man's interpretation, with its emphasis on irony, is Nietzsche's adherence to the will to power, which excludes ironic reversal. Surely de Man speaks in deconstructive terms, according to which irony's necessity is assured, but he denies to Nietzsche's thought its tragic dimension. Irony of course can be tragic when it assumes the form of a duality that finds no resolution. Only in this case one can say that tragedy and irony coexist, but this is not the result of rhetorical language having taken the place of metaphysics. Rather this happens because we are "naive," that is, we give a meaning to events.

More promising than the consideration of irony is the consideration of allegory as pervading at least some of Nietzsche's texts. Allegory has the advantage that it universalizes starting from the particular. No other point of departure was possible for Nietzsche after his radical rejection of Hegel's universalism. Now the subject is no longer a substance, no longer a result, it is a fiction which (at most) is useful. If all this is accepted, the

road is open for Zarathustra, who is the emblem of a subjectivity that aspires to universality and denies it at the same time. Narrative allegory is overt in its own manner. It must be so if its *incipit* is to uncover the uncanniness of that same point of departure by means of linearity. Allegory has a beginning and an end; by exploring what has been left out by metaphor and irony, allegory forbids the reversal of meaning or of intention typical of irony. In art allegory, which is more cerebral than metaphor, has usually been perceived as too obscure in comparison to other rhetorical figures. Yet its possibilities are vast in that it allows the particular to expand. It can even be said that if allegory were left out of consideration, structuralism would be an absolute truth. In universalizing subjective experience, allegory goes beyond pure thought, and its meaning is not always easy to identify. Sometimes cryptic, it presents itself as the interconnection of symbols clashing with a beyond, that is, the universal which allegory aspires to secure. This beyond is anchored to the mainland of subjectivity. In conclusion, allegory stands for an expansion, which changes our notion of "concept," in that through allegory that notion becomes hybrid, impure.

### BEING AND ART: THE AXIS NIETZSCHE-HEIDEGGER

Whereas at the core of Nietzsche's theory of art one finds untruth and artificiality, with Heidegger one enters another realm, in which the new encounters art's other aspect, that of being truthful. The new and the true here form a dynamic unity, and so truth is given to us in the making, it requires the creation of a terrain all its own, or, as Heidegger puts it, truth finds its place between World and Earth. To the artwork is assigned truth, the truth of a thing and of the way that thing is differentiated from other things through being self-sufficient and not having the character of equipment.[19]

In distancing us from the practical, art brings us closer to truth. Art discovers the "what and how" of a particular being, reveals the essence of Being, and is, therefore, truth. "The origin of the art work is art. But what is art? Art is real in the art work."[20] Heidegger rightly refuses to define art or the beautiful, he characterizes art as a domain which is self-contained and which at the same time is related to its surroundings. A Greek temple, according to Heidegger's example, makes us aware of its spaciousness, both internal and external. The temple-work sets up a world, it expands its own space, but is restrained by the Earth that surrounds and shelters

it. In this contrast of inner and outer, the artwork turns out to be the repose of striving. Truth is no longer destructive, it is enigmatic, something that happens, like the artwork in the perennial game of concealment and disclosure, the Open and the Closed. Truth emerges from the work, like beauty, which also happens. Since not everything can be unconcealed and since not everything is already disclosed, truth is in motion, Heidegger even says that it is untruth-truth "insofar as there belongs to it the reservoir of the not-yet-uncovered, the un-uncovered, in the sense of concealment."[21] Heidegger's esoteric account of truth and art avoids the pitfalls involved in defining art and the beautiful. What is gained is that truth—the primordial disclosure—remains incomplete and therefore is left to time and history. The new has a more than considerable role to play in art qua creation,[22] however, art is not our own doing. On the one hand, the artists are creators, on the other hand, their work contains truth which, being an occurrence, is revealed to us rather than produced by human effort.

The paradox of subjectivity and truth finds an echo in the strife between World and Earth, through which the "repose" of the work of art, that is, its unity, manifests its forcefulness. The artwork is an event, not a thing is the strict sense of the term according to which stones and glasses are things. Art brings to us the World and Earth combined in a discordant circle inclusive of being. Since the work of art is one of truth's possibilities, it brings being out into the open, therefore to create a work of art is to receive Being. No concessions to subjectivity as an autonomous factor that determines the will are apparent here. Heidegger advocates a comparatively passive approach to works of art and to truth. Whereas Nietzsche distrusts truth and thinks it has a deleterious effect on humans, Heidegger responds to truth with a sober sense of awe, and does the same with the work of art. He remarks that to see the work of art as a "stimulator of experience" is to degrade it.[23] Art is placed in a self-sufficient sphere, which it shares with truth, and so art is declared, really, half autonomous. This is what allows Heidegger to say that art precedes the work of art and that art is "the setting-into-work of truth."[24] Imagination—that remnant of romanticism—therefore, has no prominent role to play in the formation of art, and is discarded in favor of poesy. Every art form tends toward poetry, which is the privileged art form since language is the vehicle that embraces the openness of Being. Language is poesy, and the encounter with poesy begins the discovery of the uncommon and exceptional, a leap that is ultimately unexplainable, coming from Being,

another riddle akin to the riddle which is art. What matters in art is nei-
ther its experiential dimension nor the pleasure it bestows; what counts is
that there is Being rather than nothing and that Being is ultimately
poetic. Heidegger's starting point seemed at first to be subjectivist. In fact,
it is the opposite and provides an unyielding answer to Nietzsche's "liqui-
dation" of art qua untruth.

If Heidegger fascinates more than he convinces, the reason must be
looked for in his verdict on the riddle of beauty. He is perhaps the last
philosopher to consider beauty in a manner so consistent with an aura.
Art is not destined to succumb, even though nobody can be certain that
the temporality connected with being will not bring about an extreme
reversal. Heidegger poses the question of whether high art is at the end of
a long path ending in technology, in that case the artwork would no
longer be a thing bringing forth the potentiality of being, but would be
instead a mere object of experience. In that eventuality, art would no
longer be uncanny, and therefore, in the language of *Being and Time*,
authentic, a true inexplicable call. Like truth, the work of art is placed
between Being and beings, mounted like a precious gem in the ontologi-
cal difference so dramatically elucidated by Heidegger. Art equals destiny,
this is what "the bringing forth of the true into the beautiful" implies.
However, its origin as techne must warn us that the revealing of art is in
danger: "Whether art may be granted this highest possibility of its essence
in the midst of the extreme danger, no one can tell."[25] With Heidegger
one always verges upon the sublime, in art and philosophy—the sublime
being danger itself.

If there is anything sublime for Nietzsche, it is the will to power that
becomes art, submissive only to form. It is difficult to reconcile the desire
for form with what seems to be the impulsiveness and spontaneity of the
will to power; but the appeal to spontaneity is deceptive. Even though the
will to power has little to do with rationality, it is not sheer spontaneity,
qua force and energy, it must give form to itself, if only because it sets a
goal for itself autonomously. Music is one of these goals, the perfect
medium for conveying the tragic message that there are no messages.
Nietzsche was aware that the will to power represented the beginning of
permanent tragedy, the zero point of beings ungrounded in Being. Hence,
his momentous attempt to overcome nothingness. Music is "false" like
every other art form, since nothingness cannot be refuted. Yet it is also the
true extension of the desperate need to deny nihilism. For Nietzsche
music is primordial, not language. The opposite is true for Heidegger.

Heidegger's stand in favor of articulated language culminates in his contention that art accentuates the possibilities of poesis. His entire philosophy discloses a poetic mode, which embraces both the emergence of Being and its utter uncanniness. This combination lends itself to exploration by poetic means, and so poetry turns out to be what makes possible the encounter between Being and language. Language is privileged because it conveys the told and the untold, while communication, expression, and a given content are kept in the background. Humans are not the initiators of language, language speaks, and humans respond; from the depths poetic language emerges, unexplainable by positivist or scientific means. Language calls us into presence and absence, thus it is not principally representational. In using mortals to speak, language does not properly belong to us, only speech does. What mortals do when they speak is a listening. This is the essence of poetic language, of which prose is a derivation deprived of resonance. This antihumanist position is justified, since humans are no longer the bearers of self-consciousness. On no account are they invested with any attribute that could make them masters. Heidegger places *Dasein* in a passive position, so much so that even in art imagination has no place. The mirror image of Nietzsche, Heidegger disregards the *hybris* of the Overman, replacing it with the priority of Being over beings. The consequences for art are clear and nebulous at the same time, considering that art is in constant danger of falling into the hands of the "they." Art belongs to, and is a consequence of, the leap that Heidegger invokes so as to draw near to Being, knowing that the ontological difference will prevent complete nearness.

The bucolic image of *Dasein* as the shepherd of being may sound obsolete, but what it conveys is the necessary attachment to Earth and World which produces the work of art. What Heidegger calls the "repose" of the art work is another way of saying that the artwork should convey harmony and unity.[26] There is no such harmony in Nietzsche's conception of art. Whereas Heidegger expounded the reasons why poetry deserves priority, Nietzsche resisted the potential sentimentality of lyricism, fully adhering to tragedy, and without blinking. In neither vision does neutrality have any place, at no point do either Heidegger or Nietzsche advocate indifference. Nietzsche accepts the tragic without ado; the beautiful, like truth, is eliminated from art, as an appendix belonging to the past, together with all the concepts that have plagued philosophy up to the definite transvaluation of values. Heidegger in response sets himself the task of resurrecting the beautiful from oblivion, so that the truth of the artwork

becomes beauty itself. Elevated by truth, being truth itself, the work speaks to us in the language of Being, which is one with silence and which responds to the reverberations of Being. The leap needed in order to value art is therefore similar to the leap of the philosopher who ventures beyond *ens* to arrive at Being.

The question of art's truth is answered via a detour if we think that Being, that which allows the Opening, lets art be. Art's historical dimension is the result of the event of Being, and each work always retains its event-like quality. Being dependent on temporality, Heidegger asks himself whether high art is still achievable. His answer is as ambiguous as his notion of temporality, which makes it difficult to separate completely high art from tradition. Consider the "futural being of the past" of which Heidegger speaks and the following quotation from an early work: "The past—experienced as authentic historicity—is anything but what is past. It is something to which I can return again and again."[27] But, as we know from the past, art transforms itself. That has always been the case.

A mechanistic world excludes the new, without which aesthetic experience comes to nothing. If monotony and repetition are actively looked for, it is an indication that the resources of high art have been undermined. Repetition is absent at the aesthetic level, and it remains to be seen whether repetition conceals something intrinsically tragic or sublime, beyond its sheer monotony. Nietzsche was convinced that it does, on the other hand he did not recommend repetition as an artistic style. Repetition has no stylistic value, and, furthermore, would be the most anti-Faustian attempt to master the unknown. At most the obsessional character of repetition lays bare the poverty of the social substratum in which the artist lives and in which society at large is implicated, but this sociological explanation does everything except telling us about the truth of art.

How to decide the question of art's truth or untruth is a philosophical issue. In order to circumscribe the problem let us presume that there is no escape from truth. To try to avoid it altogether in philosophical discourse and in everyday discourse as well would be tantamount to suffering a mental collapse worse than that of Nietzsche (*argumentum ad hominem* intended). Heidegger interprets Nietzsche's dictum "there is only art so that we do not perish of truth" as an anti-Platonic statement. By putting "truth" in quotation marks, Heidegger feels authorized to say that "truth" in this instance refers to the truth of supersensuous reality. His argument is the following. Art enhances life, it is will to power, and will to power is the ultimate metaphysical truth of Being, *ergo*: art is truth

and not mere consolation. Given that the will to power is, among other things, art and that art is will to power, truth for Nietzsche rests on the overwhelming, brute, and frenzied existence of which art is an elaboration, not the direct expression. Art is untruth, then, if one means by 'truth' that which is primordial. Heidegger's analysis is an attempt to contain Nietzsche within the philosophical tradition, to round off the corners of his most iconoclastic pronouncements. Thus, he connects truth and art in one metaphysical point. "Art, particularly in the narrow sense, is yes-saying to the sensuous, to semblance, to what is not 'the true world', . . . to what is not 'the truth'."[28] However, appearance has lost for Nietzsche any validity from the moment in which the transcendent "true world" has been unhinged. The inference, therefore, is that art impugns truth and supersedes it. This does not make art transcendent. Unless one interprets Nietzsche's thought as an unlikely attempt at transcending appearance, it must be recognized that art is inessential from the viewpoint of truth. The antagonism art / truth has its justification in the fact that truth does not enhance life, even less adorn it, on the contrary it makes us prone to accept nihilism as the final response to aimless becoming. This is so because supersensuous truth weakens sensuality and also because sensuous truth is something to be feared, precisely because it is tragic in a way that art tries not to be.

If there is any metaphysics in Nietzsche's *opus*, it concerns the conviction that the will to power is a truth, that it gives form to life. However, the will also inaugurates the new meaning Nietzsche was searching for, and the Overman is the crown of our aesthetic evolution. But the Overman is the "Man" of the future, therefore, meaning is deferred to a later date. In the meantime truth will always be somewhat false if it is excluded that truth implies a form of knowledge of ourselves. Art is still *verum factum*, what it makes known are emotions together with the fragmented *Gestalt* of history and culture. Emotions, history, and culture are dangerous, and art can be dangerous too. Let us not interpret the presence of feelings in the aesthetic experience as a concession to sentimentality. Nietzsche did not have in mind Bartolomé Murillo's maudlin paintings of children as representatives of an art productive of rapture (*Rausch*). In privileging the Dionysian, Nietzsche is praising laughter, not innocent, beautiful smiles.

Heidegger identifies beauty with the supreme importance of ascending beyond ourselves (rapture). Consistent with his overall interpretation, Heidegger nevertheless oscillates when facing Nietzsche's more than exuberant texts, he tries to retain beauty's composure and significance beyond

Nietzsche's own statements; reluctantly Heidegger says that when Nietzsche used biological language he did so only to make himself understood by his contemporaries.[29] I refuse to think that Nietzsche, a haughty philosopher, lowered himself to speak down to his contemporaries in the language of biology if he did not believe that such language at least approximated his own manner of thinking. Like Freud, he united knowledge derived from the body with the emotions; art itself testifies to the fact that they are combined, so that a form of truth must be assigned to feelings. It is imperative, then, to contradict Nietzsche's claim that art and truth are irrevocably situated on different planes. When he opposed truth to art what Nietzsche meant by truth was not only Platonism, but, more fundamentally, the univocal truth of scientific inquiry, from which art must keep its distance. When Nietzsche considered truth, he was also speaking of the tragic lack of form, to which our first reaction is to be passive. The solution to tragic passivity or nihilism is to be found in the will to power, so art becomes a kind of weapon engaged in a battle of feelings against feelings.

Artists operate within the sphere of the pathological; this is a pathological state of a specific type, since art and innovation stand for the overcoming of mere subjectivity. Heidegger writes: "Rapture as a state of feeling explodes the very subjectivity of the subject. By having a feeling for beauty the subject has already come out of himself; he is no longer subjective, no longer a subject."[30] Nor is the beautiful objective. Once stability has been excluded, the conclusion must be that art itself is becoming, and is, therefore, a form of truth which has gone through new stylistic and formal elaborations. Nothing is univocal here, and so truth is as difficult to attain as untruth. However, Nietzsche did not say that "there is only art so that we do not perish of falsity"—an indication that we can at least glimpse at truth. Since truth is equivocal, perspectival, and nonessential, it is always problematic. It is that same becoming which has already proved itself to be impossible to comprehend in its givenness and that makes art neither subjective nor objective.

## ART: THE TRUTH OF THE NONEXISTENT

How wrong and how right are Nietzsche and Heidegger in relation to art qua truth is still to be determined. In art there are as many truths as there are styles and art forms. Whoever thinks that the time of eternal Beauty has run its course, together with the idea that art is a product of imagination, has grasped a historical truth, that is, a relative truth. The creation of a work of

art is not wholly contained within the consciousness of the subject, but the interpretation of art must be a conscious act. The interpreter has a method, while the artist has an individual style. Approached in this manner, aesthetics already constitutes the overcoming of nihilism, even though the danger of falling back into it is always present. Nietzsche knew this when he declared himself to be, at times, decadent. Nietzsche provisionally situated the work of art at the center of conflicting forces, that is, the sensuous and the eternal. In the battle, truth (qua eternal) vanishes, leaving the work free to overwhelm us. The "true," then, is rather the impossible convergence of sensuous and nonsensuous. Without being nihilistic, Nietzsche is skeptical, since neither style nor the beautiful guide us toward being and being is never attained. Thus, truth and art are situated at different levels, truth must be conceived of in static terms, whereas art never ceases to be dynamic, rhythmical. It is clear now why Nietzsche, given these premises, places music in a very high position. The will to power is above all rhythmical; the alternation of elation and "depression," the high and the low, the allegro and the adagio, announce that pulsation (its first characteristic) is best achieved by music.

When Nietzsche wrote that art is will to power and, hence, is creativity, he started from the viewpoint of the artist, but he left at the level of a sketch his view of the nature of creativity, an issue that psychoanalytic thought researched more thoroughly than he did, as a result of its exploration of the unconscious. Even though psychoanalysis dismisses the notion of the Overman, this discipline has the instruments to arrive at a clarification of what constitutes creativity. Without speculating about the psychology of the Overman, it is sufficient to say that the Overman may appear to be the best candidate for the title "genius." But the Overman, beside being the creator of the art of the future, is also the one who harbors within the self the desire for power for its own sake, and therefore considers externality as nonexistent. Strange as it may sound, the creator is a more problematic figure than Nietzsche leads us to think. In this respect, it is essential to take into account the surrounding milieu of the artist rather than situating her / him in the perfect and absolute isolation of the Overman. There must be, following these connections, at the limit, the illicit intervention of negativity, in the absence of which no results can ensue. True, Nietzsche recognizes the antithesis truth / art and its repercussions in his overall view of the creative process, on the other hand, absorbed as he is in the "centrality" of the Overman, he underestimates those external factors which necessarily interact with the artists without determining them completely.

In a noncommonsensical way psychoanalysis fills this gap. In particular its Lacanian interpretation shares with Heidegger the view of the priority of language over any other form of expressive comportment. Lacan was influenced by Heidegger's view that truth evokes rather than expresses being, but for Lacan being is essentially lack and negativity, whereas Heidegger still seeks to disclose Being. After Heidegger, the panorama becomes broader. If beauty is what shines through being, any aesthetic form has its justification, and we can give credence to any art form even if it is not strictly linguistic. Still, language assumes the role of privileged medium for revealing what otherwise would remain hidden, that is, the significance of Being in its anti-nihilistic function. For Lacan, nihilism is excluded, not simply condemned moralistically. It is excluded after an existential leap comparable in the ontic realm, to the leap advocated by Heidegger in the transition from beings to Being at the ontological level. At this point, the need for self-transcendence decisively emerges, even though Heidegger avoids any endorsement of imagination or of aesthetic intuition understood as disinterested; Heidegger makes it clear that disinterestedness is excluded from the existential or any other domain. What we have, instead, is care and the fourfold of Earth, Sky, Divinities, and Mortals.

In the absence of a metaphysical strategy that guarantees a permanent victory over nihilism, we are left with the oscillating constancy of becoming. Art is also this oscillating, and even the thought of eternal recurrence, although sublime, has repercussions on our subjectivity. It did not persuade Heidegger exactly for this reason. The question becomes whether nihilism is intrinsic to art or whether it originates elsewhere. The answer will determine what are the limits of art, considering that art is torn between two challenges. If nihilism is intrinsic, art is no longer a self-transcending activity. If nihilism is exterior to art and then permeates it, the escapist is right to treat art as ultimately devoid of relevance, with its sole function to provide a fictitious, transitory, and passive pleasure or acceptance. Instead, the escapist is wrong because art is one locus of mutual recognition.

In trying to justify art in the contemporary world we must be ready to provide art with a philosophical meaning, beyond nihilism. This is a difficult task, since nihilism has pervaded art and also philosophy. Heidegger has "solved" the issue of nihilism by appealing to the abyss and the consequent leap that would allow humans to go through, once and for all, the narrow passage of metaphysics. The non-oblivion of Being would

indicate a going beyond technology, and thus, the rejection of technology would represent a first step toward art. However, as Véronique M. Fóti says: "Art cannot be straightforwardly naturalized, because it marks the technical detour or supplement through which *physis* contemplates and completes itself."[31] Both technology and the poetic are forms of disclosure and destiny, beyond which stands Being.

If one considers the difference between *ens* and Being, one realizes that nothingness is also a "given," but if one stops at metaphysics one will never understand the essence of nihilism identified with the forgetting of Being. At this point, it is clear that nihilism is external to Being, yet art could not exist without glimpsing into the not-yet explored abyss of Being. Before that step was taken nihilism was essentially something intrinsic to art because the ontological difference had fallen into oblivion. However, the future does not promise the overcoming of nihilism, on the contrary, since the future relies on tradition and historicity, the past is bound to arbitrate among the three dimensions of temporality. There is no circle that can mediate between *ens* and Being.[32] Heidegger espouses anomaly,[33] and art is this anomaly caught between nihilistic metaphysics and Being. Mediation, the sought-for alternative, does not concern Being, it would not even necessarily assure an a priori harmony, since self-transcendence has no bearing upon the transcendental sublation of two opposites but can operate only in full cognizance of the distance between mediating points.

Art is there to demonstrate that nihilism is external to the pursuit of the new, and to introduce the new, starting from the non-mimetic interpretation of the eternal return, is relatively easy. Nietzsche, in fact, considers art as something still unexplored. However, it would be a mistake to say that art represents a new value. The past centuries are there to testify that the arts have been promoted and sought for by the ruling classes, what changes with Nietzsche is the consideration of art as an end in itself, not at the service of some Maecenas or other. And it is no coincidence that shortly after Nietzsche's death, at the beginning of the twentieth century, a new type of art exploded. Nietzsche opened the way to a reversal of aesthetic criteria by his insistence on a poetics of the Overman. His influence in this field is enormous, considering that after Nietzsche the sentimentality of the romantics is gone, and experimentation starts to assume the well-known proportions of modernism. The man who said "We Europeans" was aware—all too aware—that political, aesthetic, and scientific upheaval lay ahead. His personal tastes in art are at bottom irrelevant, and if his logical thought is indeed deficient, it must be said that

Nietzsche firmly defended the autonomy of the aesthetic while at the same time rejecting the pitfalls of historicism. This defense has great merit, considering that what had kept at bay the emergence of a nonhistorical conception of art had been the misrecognition of tragedy. By the end of the nineteenth century historicism had been exhausted, the artistic patrimony had been consigned to the museums. Unfortunately, by combining together in a closed fashion the tragedy of the artist and the view of art as will to power, Nietzsche finally equated the tragic and art, thus contradicting one of his assertions, namely, that art represents a consolation from tragic becoming. Perhaps no other outcome was possible after the refutation of Platonism.

Art and truth are incompatible, but art makes self-transcendence possible, and truth is anchored in the plane of nihilistic immanence. One must ask oneself at this point how self-transcendence operates, whether it involves the will or whether other mechanisms are at work. First of all it must be noted that self-transcendence does not imply an intellectual, rational act, not even an act of intuition. No matter how it can be rationalized *post factum*, it remains a spontaneous process and the only door open for the overcoming of nihilism. Nihilism can be conquered by the act of "choosing oneself," as Heidegger invites us to do without guilt,[34] releasing that potentiality for being which belongs to *Dasein*. Thus, art comes forth from the appropriation of the self inasmuch as art, from the viewpoint of the creator, is the optimal forum to "demonstrate" the uniqueness of the individual. True, art is irreducible to personal idiosyncrasies, there are higher requisites for its unfolding, such as a given structure and parameters that channel the contingent flow of associations. The interplay between these factors will determine the final result. If 'subject' and 'object' are considered improper terms for characterizing this process there are reasons, since the object is too confined to its own immobility, and the subject is too self-conscious to allow the true appropriation of what is potential. Likewise, a work of art is not an object. Even when it represents one, it cannot be one because its dynamic character requires the double intervention of the artist and of the observer or listener. To so reduce it could tempt us to limit art's significance to preservation. And in fact Hans-Georg Gadamer adopts tradition as that which is "always part of us";[35] This statement represents a step back if compared to the self-assurance of the artist who professes that tradition is the mannerism of somebody else.[36]

It is premature to remove the subject to a position of inconsequentiality, its overdetermination can still explain the crisscross that makes the

artwork possible through the convergence of conflicting forces. This is why, without the dynamic aspect of the work of art, we would have an empty assemblage of signs. Moreover, if we, together with art, have more than one destiny, then, the subject, however displaced, can claim one of its "rights," namely, to interrogate and to respond. Even as will to power art develops in a habitat, and art does not succumb to chaos. How this can happen many find mysterious, inadequately explained by a combination of structural factors. That is why the recourse to myth is so tempting. Nietzsche, in concentrating his attention on art qua creation, as opposed to art as something to be admired, created his own myth of the Overman. Like every utopia, that of the Overman tries to replace the void or lack intrinsic to truth with a magnified image of that same truth.

## THE SUBLIMITY OF NIHILISM

Elevating history and tradition is not the way to defeat nihilism, it would serve only to postpone it. Now, nihilism remains to be explored in its ramifications to see whether it fosters art or whether it silences it.

If nothingness follows from being, still it cannot be confined to the mere nonexistent; "nothing" is a function of thought. Aesthetics, like any finite endeavor, is imbued with negativity, otherwise aesthetics would be equivalent to the eternal, another form of nothing. The recognition of an ontological void, of the absence of pleroma, is precisely what allows art to posit changeable structures and consequently to acquire changing meanings. Nihilism itself avoids declaring the impossibility of meaning, since meaning has its inception in an act of will based on the potential nothingness of subjectivity. Art, however, has no privilege in telling us what the world means; ethics and morality do that in a more effective way. Also, art does not represent the world for us, to do so it would have to submit itself to the world instead of imposing its own view either in an a priori or an a posteriori manner. The work of art operates starting from the zero point of indeterminacy and this is why it can be said that art is a priori. It is also a posteriori because art necessitates an active will. The will denies nihilism, but is itself nihilistic. The assertion that Western thought from Plato on has been the reflection of a will ready to negate value to the world makes reference to a form of nihilism that has little to do with contemporary nihilism, which must of necessity recognize the role of negation in the will itself. Unqualified nihilism would deny any role to the will itself. The will starts from nihilism—this is its precondition—but the will

is also under conscious (or unconscious) control and, therefore, divides itself into desire and its negation. The consequences of this division are evident in art and in the artist: art displays its relative necessity by originating from the awareness of the deficiencies of the negative, of the zero point. Art has its beginning in human finitude, without finitude, which is the negative of the positive, art would be unimaginable, like the materiality which sustains it and which makes it understandable.

If art is to be explained in negative terms now more than in the past, this is due to the failure of a metaphysical justification of art. Artists have always looked to philosophy and science to assure that their works are rooted in thought. The desire to articulate belongs to the artist essentially, and the way to do it rests on the articulate power of philosophy. Especially with the rise of iconoclastic modern art, the need to utilize philosophy has become urgent. Philosophy has only an incomplete framework to offer art (hence the partial correspondence between the two) with which to "complete" itself. But philosophy can, at least potentially, analyze every work of art with the intent of making it transparent.

Another function of philosophy vis-à-vis art is to prevent complete acceptance of an aesthetics of nothingness, which necessarily would disregard any meaning that art may convey. Contrariwise, categorizing art products, which has been characteristic of nineteenth-century aesthetics, would be to bring the process of rationalization too far, since contingency is unavoidable in matters of self-transcendence. The tendency to classify, though, is still present, notably in the trend of giving a name to every school of painting, of music, and so forth, which reflects the fact that, even now, the need to put some order in the field of art is still felt. In fact, the aforementioned fashion has become more prominent now than in previous epochs when the succession of different schools did not display the contemporary, accelerated rhythm. Moreover, what has changed now is the overall structure in which art has become significant. If deductions have lost their authority, it remains true that aesthetics needs the parameters of a theory. The locus of art has been identified as the constant oscillation between nothingness and being, inner and outer, with self-transcendence at its nucleus. The necessity of these parameters is relative in that they fluctuate in time, they are far from possessing the fixity of a metaphysical circumference. If metaphysics has completed its course and if nihilism is the response to its vanishing, then what must be done is to consider the resulting void within which subjectivity is forced to make endless reference to itself. The history of philosophy, which is the scene of

a constant, at first latent, nihilism, has revealed subjectivity to be that striving which is unable to account for its own doings.

The consequent rise of rhetoric, a symptom of the definite alienation from the real, has led to the reevaluation of the baroque[37] and of the paranoid structure of the Ego. The baroque announces the nothingness of substance and the triumph of an erratic Ego, whose resources depend upon a false transcendence, marked by the same obsessive character of the Ego. Thus, the Ego projects its own misapprehensions onto a transcendent void. Jean Racine's tragedies, as interpreted by Roland Barthes, are symptomatic of the lack of any referent outside the self other than a terrifying knot of hopeless outcomes. Chasing their own tails, Racine's noble characters—in contrast to his simple down-to-earth servants, who always think there is a way out from tragedy—reject the empirical world in order to live in a constructed cultural world that is imbued with insanity. The Ego is prisoner of its own misapprehensions. A glorious nothing awaits these characters whose tragic death forebodes the end of the subject understood as the source of rational discourse. Barthes writes: "Language is never a proof. The Racinian hero can never prove himself: we never know who is speaking to whom. Racinian tragedy is merely a failure that speaks itself." And further: "To avoid speech is to avoid the relation of force, to avoid tragedy." This is an impossibility, since in Racinian terms there is no "escape, transcendence, forgiveness."[38] Baroque art represents a step toward the annihilation of the subject and with it of those structures that supported objectivity in the past. The baroque world is one in which tragedy indicates the defeat of both subjectivity and objectivity, without any superior order to which to appeal. The mechanisms are all internal, but their inner consistency is doubtful. Given the separation of inner and outer, it is not surprising that Racine's paranoid discourse is combined with the most impeccable use of language, a formal perfection that can be ascribed to the self-contained nature of the inner.

This is sublime art, in which the relation between artists and their work is one of negation, in the sense that artists find an incomplete Self in their ramifications and products. By the same token, the character, the canvas, or the composition, do not stand in a relation of whole / part with the artist. Both product and producer are parts, unfinished and incomplete unities. Given this, what gains the upper hand is style, considered neutral in comparison with any emotional content that the artwork may conceal. Of course, there are parallels between the style and the material of the artist. The style corresponds to the adopted Weltanschauung which in turn

approximates the universal demands of an epoch. There is nothing generic or mystical about these correspondences. The interrelations between artist and the work are filtered through the artist's sensibility and the idealized (or not idealized) views that the cultural and social milieu puts forth in its characteristic nonrational manner. At the same time artists, exactly because they are forced to question their Self, can identify a realm of ideas immanent in their sentiments. The immanence is not absolute, neither is transcendence. If transcendence were absolute, silence would be the most appropriate approach to art, and if immanence were absolute, it would be impossible to avoid the most extreme form of solipsism. A middle ground would be the best antidote for nihilism, it would make possible a prescriptive aesthetics. Nihilism can be defeated either through a regression to an all-knowing subject or through a desire that is oblivious of its own limits. In the first case, the subject would clash against necessity, and so the danger of nihilism could re-emerge at any moment in the form of cynicism. In the second case, there is a higher probability that nihilism could be kept at bay because desire is that structure which aims at its own negation without ever reaching absolute negation.

Since nihilism's desolate "meaning" is the consequence of a metaphysical thinking that objectifies beings, to think Being, as opposed to beings, to the extent that this is possible, still leaves us within nihilism but does change its significance. The nihilism derived from the thinking of Being, as contrasted to the active nihilism of the will to power, retains something absolute, since it urges us to go beyond any conceivable goal. Yet, Being becomes meaningful because it represents a refuge from the spatiotemporal dimension of subjectivity. As long as Being remains concealed, nihilism will prevail, camouflaged by an act of will—an inadequate subjective-metaphysical act since it distorts the essence which lies more deeply in the default of Being. To overcome nihilism would be tantamount to overcoming Being in its default, whereas to overcome Being is an impossible undertaking which would undermine human beings.[39] Thus, the notion of nihilism vacillates between metaphysical thought and its negation. Nihilism is a derivation from the history of Being in its withdrawal and the result of the metaphysical thought that ignores Being. If philosophy remains confined to the ontic, Being remains unthought. Such a pervasive expansion of the notion of nihilism, inclusive of almost all philosophy, must necessarily bear consequences in the aesthetic sphere. In order to comprehend what these repercussions are, let us consider, as Heidegger does vis-à-vis Nietzsche, that nihilism can

be seen as being simply a psychological state; soon this becomes a more "substantial" nihilism, which tries to deny metaphysics—that is, in Heidegger's terms, the whole of Western history. This transition occurs because human beings need a basis on which to evaluate, and, once the original form of nihilism takes hold, it is overcome by a reaffirmation of metaphysics in the form of will to power. Will to power means that being and values are combined, this is active nihilism which has moved away from the passivity of those who declare art to be unattainable. Nietzsche's "ecstatic nihilism," linked as it is to new values, can be utilized to explain the effect that sublime art has on us. Heidegger writes: "Insofar as the supreme powerfulness of the classic-ecstatic, active-extreme nihilism knows nothing outside itself, recognizes no limits over it, and acknowledges nothing as a measure, classical-ecstatic nihilism could be a *divine way of thinking*."[40]

There is no better way than this to declare that the sublime is close to those extreme cases where the boundary of being is discerned as providing at least one possibility: that of the complete experience of art.

# CHAPTER 6

# The Nothingness of Art

## THE REPERCUSSIONS OF NIHILISM

Since it permeates our being, history, and philosophy, nihilism is not a transitional state or phenomenon. When nihilism concerns our attitude toward being it has serious consequences, if it isolates us from being and makes being unapproachable for us, there is no remedy for the proliferation of its effects. One possible consequence of a thoroughly nihilistic standpoint can be a return to the past, in that case nihilism is revealed as constituting the ultimate regression. Nietzsche feared such a return. His thought is projected into the future and aspires to a radical break. Heidegger, however, denies that there is a break in Nietzsche's thought, he discerns continuity in the metaphysical affirmation of the will and the technological appropriation of the earth. The consequences for aesthetics and art are well defined: either art will become the only space within which non-nihilistic access to Being is possible, or else art as will to power will have, more modestly, the therapeutic function of keeping under control the nihilistic tendencies of the Overman. In the second case, nihilism is included within art as its proper "foundation." This approach is precarious, considering that art is indeed autonomous, but this autonomy makes art an escape from the seriousness of production. Thus, art acquires freedom and independence, along with its therapeutic function, but at the cost of becoming frivolous. In both cases art is destined to recognize that nihilism is its appropriate basis and point of departure.[1]

All this translates into the necessity of the sublime, the only possi-
bility now if art is to be taken seriously, notwithstanding Tafuri's state-
ment to the effect that sublimity is "sublime uselessness."[2] The nihilistic
feeling produced by the sublime is a residue to which preeminent impor-
tance must be given, yet the sublime is inclusive of the beyond, and this
is precisely because the sublime, as Kant made clear, does not correspond
to any object. It is, thus, from the start a "beyond." The beyond of the
sublime is *our* beyond, even though to master it by an act of will is incon-
ceivable. The sublime is an invention resulting from the self-transcen-
dence of a subjectivity which cannot be halted (brought to a standstill) by
any objective correlative. Thus, there is constant and considerable danger
of falling prey to nihilism. The sublime reminds us that the beyond, just
like the feelings that it activates, is precarious. The beyond is even dan-
gerous, because where it lies anything can happen.

But art is not only a matter of feelings, although feelings are
inevitable as the work of art is approached. Nor is it science, for it would
be hopeless to objectify something that rests on the negation of apodic-
tic knowledge. Art, although it tells the truth, is far from demonstrating
anything, not even the necessity of nihilism. Its power depends on the
overturning of necessity, so that it can be transformed into the "quite
possible." Qua possible, art puts the necessary aside as something to look
at with suspicion. When art joins with the necessary, uninteresting
results come about, realism being one of them. If we take the example of
the painter Josef Albers, we note that his different versions of *Homage to
the Square* are not realistic in the literal sense. Their linear presentation
defies the absoluteness of its geometric truth, because when the viewer
changes position the lines are perceived as slightly moving; in other
words, the symmetry is not absolute, an indication of the coloristic
refinement of the paintings. Even so, the canvas would be more provoca-
tive if the painter had arranged the four sides of the square not in the
proper order, as a square, but in disarray, one detached from the other,
and still called it "square." Had he done so, the result would have been
critical irony, an irony that dissolves the certainties of objectivity in order
to reverse the meaning of that same objectivity by using it as a pretext to
challenge its very possibility.

Irony is only a possible component of art and it is far removed from
the sublime. Psychologically speaking, the sublime cannot be ironic
because it demands total involvement on the part of artists, their commit-
ment to the hidden "beyond" of our mental fabric. And, philosophically

speaking, the sublime cannot be ironic because its overdetermination can be analyzed only if irony's dual structure is rejected. Irony is doubly determined, for it moves back and forth within the "I-you" structure of discourse. Nevertheless, like the sublime, it resists any stable interpretation. The sublime requires (and is the consequence of) the appropriation of the whole cognitive and sentient human apparatus, it declares the conquest of nihilism, since nihilism operates at the level of a cognition that has exhausted its possibilities. The new of the sublime (and there would be no sublime without the new, which is why postmodern art is so far away from the sublime) challenges the constant reiterations of nihilism, at the same time nihilism resists the sublime's questioning about the validity of nihilism's critical stand. It must be admitted that, to this extent, the sublime is precritical.

Art, even if confined epistemologically and sensuously to its own sphere, measures up to the unlimited, more so than any other human endeavor. The task of aesthetics, then, is to understand the anomaly which is art, leaving the door open to that which limits absolute immanence. The recognition that art necessarily transcends an immanent explanation does not imply that it transcends human capability, it is situated above the all-too-human and below the divine, for it is the product of the interchange between perception and materiality. A parallel can be seen in the relation between art and aesthetics, considering that art is, relative to aesthetics, material, and aesthetics makes explicit the intellectual processes implicit in the work of art. No matter how one persists in calling it divine, art does not aspire to transcendence; if it did it would be neglecting the sensuousness that is essential to art. Art mitigates this necessary requisite by presenting it not as a limit but rather as a possibility of creation.

## UTOPIA AND NIHILISM: THE TWO FACES OF THE AESTHETIC

Art is the imaginable. As such it displays an affinity for the utopian where by "affinity" is meant that expansionism which unites one with the other. Art, however, is also actual, and so one of its real possibilities is that of nihilism. We have here two possibles which may go hand in hand, since nihilism leads to the nullification of art qua value, not qua intrinsic possibility. Calling art an "intrinsic possibility" is tantamount to saying that it allows us to neglect the given in favor of the imaginable. Thus, art can be utopian although utopia need not be art. Utopianism is concerned

with forming imaginary castles (more or less disenchanted) or with imposing order, in a compulsory manner, on an idea of progress already undermined by history's imperfections. The view that utopianism is different from the aesthetic[3]—since utopia discards everything that is superfluous and promotes everything that is uniform and pedantic—is applicable to a conception of utopianism that concerns only *homo politicus*, but not to art, whose aim is to transform the actual into the possible and the possible into the actual. Utopians want to build, and what they fear most is disorder and the unforeseen. But we know from Valéry that there are two things we must be afraid of, namely, order and disorder. It is better, then, to advance in both these directions simultaneously.

Even from a negative characterization of the utopian spirit one can deduce that art after all takes seriously the traits of utopianism. The unity necessary to every artwork springs from a utopian desire to endow matter with meaning. Like utopianism, art is mainly artificial, since it has renounced the notion of the purposefulness of nature. Looking closer, one finds that meaning is superimposed upon what is in the process of being created and not upon what is already given. At the same time, utopia is distant from art, whose purpose is to offer an indefinite, always expanding, view of the new instead of presenting a fictional perfection which is to remain the same for all eternity. But an additional trait makes art and utopia similar, considering that they both project into the future. Utopianism acquires an additional meaning if it is viewed as one of the possible categories in which art can be situated. As a possibility that becomes actual only by being ideal (i.e., art actualizes a form that exists nowhere else), art is the unique locus in which utopianism gains some degree of reality. Once the political sphere has been excluded, utopianism reflects the hope, present in art, that art can make us forget that we have something to forget.

This process is evident both in the sublime and in beauty where the specific combination of matter and mind, all in favor of mind, facilitates the apprehension of what lies beyond matter. But beauty is more serene and consequently unlikely to cross into that territory which is called the "inner." In beauty one observes the regularity and symmetries of the artwork, therefore beauty is also less in accord with the producing Self. For this reason, the beautiful is also less likely than the sublime to be considered close to nihilism. Nihilism is finally superseded by the conviction that we are witnessing, not a remaking of objects, but instead a remaking of oneself. The sublime imposes on us the feasibility of such a project,

thus, it is distant from the mythical, unless the mythical takes into account the dynamical dimension of past and future.

For Lacan ethics is connected to a structure that makes room for desire, which is a mythical concept with romantic overtones. In Lacan's view, art is part of the symbolic register, but myth, because it is pregnant with well-established meanings, is ill suited to a conception of art that takes into consideration art's potential for decadence, as well as its potential for renewal. Utopia is not mythical—witness its partial novelty— while what is utopian in art is its function of looking to the future, in contrast with the main function of myth which is found in the reiteration of what is considered timeless. This may seem a reductive view of myth, but, if we want to continue to explore the new, we must consider myth's alliance with the already-expressed, deprived moreover of irony. One of the advantages of myth, however, is its necessary distance from any form of nihilism. On the other hand, myth's capacity to elicit a response at the aesthetic level produces little more than a conditioned response, lacking spontaneity. Thanks to myth, one proceeds on a sure path, without dangers. That is why, in our own time, if myth is taken to be the basis of art, it produces only variations on a theme; however these variations can be ironical and as such subversive of the timelessness of myth. The relation between utopianism and nihilism can only be opposition, considering that utopianism expands and nihilism contracts. There is no artwork which can combine the two. On the opposite side of the spectrum, utopianism, when it is in league with the sublime, indicates a surplus of meaning. The sublime so "circumscribed" generates anticipation. There is something soteriologic in the sublime which makes it similar to utopianism, but not necessarily ascetic, nor necessarily dependent on the ideal of progress.[4] The sublime is expansion that even works against the beautiful, since the sublime surpasses beauty's harmonious sense of symmetry between the inner and the outer.

## RENOUNCING THE BEAUTIFUL

The rise of nihilism has forced the present time to part with beauty. Art can be recollection, utopia, tragedy—none of these necessarily entails any inclusion of the beautiful, which appears now as an intruder on the scene of aesthetics. The beautiful is no longer considered vital because it is too superficial to rival the depths of the unconscious or to make us understand history. The idea of the beautiful, which is not a modernist concept

and is even less a postmodern one, has been fulfilled by the art of the past;
now it may even cause embarrassment. Thus, Hegel was right when he
proclaimed the end of *fine* art. Valéry was adamant on this point: "Nov-
elty, intensity, strangeness, in a word all the *shock values* have supplanted
[the idea of beauty]."[5] The fiction of the beautiful has disappeared, after
having been negated by history. Philosophy must recognize this fact,
which is probably irreversible, without falling prey to the skepticism of
those who think that aesthetics cannot give an account of what art is. In
comparison to the study of techniques, composition, and invention, the
field of aesthetics explains what is possible and what is impossible in mat-
ters of art. Confined to the area of the possible, art must renounce the
metaphysical constructions of the past, which are seen to be erroneous
since their objects defy definition.

"Beautiful" is a kind of ancillary qualification, like pleasure, which
can be absent from the perception of the work of art (pleasure is, after all,
a matter of subjective taste). The burden of aesthetics, then, is to under-
stand something that was produced with no specific end in mind and
whose value rests on its being situated far away from other, nonpoetic,
modes of dealing with reality. Beauty itself does not concern an age that
has learned to do without it, it remains a philosophical ideal beyond defi-
nition. But it is too soon to resort to the ugly as a viable alternative. The
ugly is of interest to aesthetics only because it is the contrary of the beau-
tiful, there is a sphere containing neither that has usurped the place once
held by beauty in nineteenth-century aesthetics. The reference is to the
modality of the possible, derived from Aristotle, according to whom
"poetry *tends* to speak of universals."[6] The possible includes the false—it
can be either true or false—and so, after all the changes that art has under-
gone since the second half of the fourth century B.C., aesthetics concerns
itself with the possible without regard to any consideration of intrinsic
truth. The universality of art is shaken by the non-universality of subjec-
tivity, which is now free to misrepresent even itself. The proliferation of
ironic and humorous art as opposed to beautiful art, which Hegel foresaw
with great clarity, demonstrates that art's meaning is sought in opposition
to absolute values, including beauty. Irony's advantage over absoluteness is
due to the multiplication of the possibilities of the possible. By "distorting"
the world, irony expands the temporal and spatial references to actuality
(the true at all costs) which as a consequence becomes irrelevant.

If beauty has indeed become a burden, there is still room for an art
that declares itself immune from the conditioning of tradition. This is

pure abstract art, an art that looks at actuality with suspicion—in short, high art. To describe this art, it is sufficient to contrast it with postmodern art, whose specific aim is to reiterate the fragmentary nature of actuality by juxtaposing the *same* fragments in a futile pastiche which is within everybody's reach. Given the unavailability of any foundation that would justify an art devoted to the beautiful, postmodern art decides in favor of recapitulation. It is the mimesis of itself. To explain, or, better, to approach high art, which postmodern art is not, we must consider its necessary lack of an objective foundation. If philosophy persists in declaring that art is necessary, a priori necessary, the untruth of art is excluded, but its truth is made to rest on metaphysical considerations that have been dismantled by nihilism. The complementarity of truth and untruth "limits" art to the possible, without lowering it to the level of the utterly contingent. Art's modality attains actuality following the intricate path of mental processes born out of indeterminacy. The transition from potentiality to actuality may not be a necessary step, but, once the will has appropriated the potential, the possible becomes mediated and mediating. Thus, the possible springs from the disorder of the indeterminate to arrive at the organization of the work of art.

When the will intervenes, the potential becomes its ally, ready to produce. Valéry stressed the relevance of the will when he said that art coincides with its formation[7] and that poietics reveals, more than any philosophical theory, the inner secrets of the work of art. Poietics is a technique comparable to that of the engineer, which yields something quite unlike ordinary language, or prose; it is so autonomous that nothing else seems to be required for the understanding of art. Without reducing aesthetics to the passive admiration (even though admiration is never completely passive) of the work of art and to a *post factum* report, its meaning, as distinct from poietics, must be found in its relation to truth. Art's distinctive type of truth is our best point of departure if we are to secure for art its proper philosophical significance. It remains to be seen how this truth must be understood in order to include the new.

UNPRECEDENTED FORM

If truth is necessary, logically and epistemologically, and if art is limited to the possible, its truth must rest on an imaginary apprehension of what can, in the future, contribute to the expansion of reality. Nevertheless, as Edward Casey has shown, imagining and creativity may differ. There are

cases in which imagining is "banal and repetitive, manifesting an impov-
erished and threadbare character," and at other times the creative act does
not seem to imply any sort of imagining.[8] Even so, the imaginary and
imagining stand for the beginning of an action; this is why art *is* the mak-
ing of art, is poiesis. These considerations seem to dissociate art from the
merely potential imaginary and place it decisively in the sphere of the
symbolic. But although art itself is symbolic, and infinitely so (when
Valéry says that a poem is never finished, he emphasizes its linguistic
affinity with the signifying chain), it needs the mediation of the imagi-
nary and its universalizing subjectivity. Art's unique truth resides in defy-
ing both the symbol and the image, and in including both.

It is not the case, then, that we expect all judgments of taste to be
accepted by every human being. We expect instead that art's value will be
recognized as belonging to the sphere of subjective mental constructs. Art
is fully symbolic only when it becomes an object of study, but, first of all,
like the imaginary, art speaks to our perception. Art harbors within itself
our imaginative, active capacities which are the basis for further interpre-
tations. Consider in this connection the act of remembering. Memory is
in part an imaginary reactivation of a past which does not necessarily
entail all the attributes usually ascribed to the imaginary, and yet it can
precede the externality of language. Additionally, memory contributes to
the evaluation of art when art brings to us sensations of pleasure or dis-
pleasure. In these cases, truth should be disregarded, since one cannot
ascribe truth to fleeting impressions. But, this view is debatable. The sen-
sations that art evokes are not ephemeral, they are legitimate, even though
they are only one component of art, and perhaps not the most evident.
However, to invoke neutrality at this point is to resort to the primacy of
form and to sublate feelings of pleasure or displeasure. Such neutrality
cancels out the understanding of art qua feeling. It is dissimilar to the
negation of the negation precisely in that, epistemologically, the two
moments of form and feeling are kept separate. This happens because the
work of art would evaporate qua source of knowledge as soon as it was
perceived if form were to lose its privilege. Form must not be identified
as the correlate of a finished, self-contained object. Form in art corre-
sponds to its forming, a process which is never completed and which, in
its existence, approximates the nonexistent.

Art does not deserve to die because it is saved by a formal truth—a
truth accessible to memory, even though art does not disappear into the
recesses of memory, as if it were a thing of the past. Art is perfectly able

to pave the way for different and new occurrences which, in their turn, will manifest art's ultimate goal, that of having no ending.[9] The ideal of pure art is never reached; in this consists the self-transcendence of art, which shows that there is no end to the means used to create artworks. The artwork offers itself for immediate gratification, but the initially immanent process must become an intrinsic formal tension which alone is the mark of worth. Thus, the artist, the work, and the receiver are involved in a similar process. Artists separate themselves from their work once the maximum of tension has been attained, and so do the receivers.

Finitude insinuates its limits (in the plural, and let us remember that form is also a limit) both in the artist and in the work. But an aesthetically conscious art brings with it the certainty that art tends toward the unbound. This unbound aspect is usually called the "ideal," the unreachable utopia whose function is to prepare consciousness for the unknown. Pure or absolute poetry, as advocated by Valéry, is such an ideal, impossible to achieve given the impurities of languages and irrationalities, which are tied to practical goals. Pure poetry is far apart from prose, and ideally it would merge with music.[10] We are facing here one of the many illusions that are needed for initiating a work of art. Such illusions concern above all the absolute truth of art. Art's worth may have been already accepted by society at large, and thus derived from something partly extrinsic, but its truth must be reinvented in every work since it points to a perfection unknown to any other creation of the mind. The truth of art resides in its tension, in pretending first of all to obey the dictates of the immanent real and, second, to assent to the illusions of the imaginary. The result is something that is always in transition, moving back and forth between immanence and transcendence. Paraphrasing Lacan, we can say that between the real and the imaginary there is art. Here we discover the locus of the potential, its priority and privilege which has been characterized as the perennial source of the new.

The new *is* because art has dismantled preestablished structures, which had been conceived of as eternal and immutable, and is able to give rise to forms (by "form" is meant a living, unified, and unique whole) which have little to do with the remoteness of a structure. A structure is thought of as necessary, the object of science, and the sine qua non of any norm. Form violates the norm and unmasks it. An art that does not do this remains tied to the preexisting—and therefore abortive—notion of beauty. Surely, art also knows the restraints of form, but form and structure are two separate notions. A structure is something external to which

one must submit in order to avoid chaos—but artists are not overly afraid
of chaos, which is the source of their own self-transcendence. Form,
therefore, is the result of a fight to the death with the inert, and what
emerges is style. John Cage wrote on this issue: "Structure is properly
mind-controlled. [It] delight[s] in precision, clarity, and the observance of
rules. Whereas form wants only freedom to be."[11] Structure is *outside* art.
If it were internal, art would be nothing more than the miniature repro-
duction of the outer, or imitation. This line of reasoning presupposes that
the outer is something already organized, ready to impose on art its own
*imprimatur*. Art resists this attempt at domination by creating form,
which has the power to overturn the premises of the outer structure. This
is another way of saying that art, at least modernist art, may have more to
do with criticism than with life, even though it appropriates life in order
to remind us of the limits of order. It finds itself, therefore, engaged in a
double battle against structure and against complete spontaneity. Art
exposes and challenges at the same time any structure that constitutes art's
limit. By doing so it avoids a direct contact with that which would con-
strict art's search for the new. Qua spontaneity (whose danger lies in that
it can pave the way to naiveté), art is a doing which asks us to be accom-
plices with poiesis.

   This is one of the reasons why art conveys a sense of familiarity sep-
arate from sentimentality. However, the opposite impression must also be
considered, that of not being familiar, of being, metaphorically speaking,
a "thing of the past" or a thing of the future. In order to activate the new,
art needs to exclude from itself any universal structure that would block
attempts to speak to us in an overdetermined manner. Nothing is more
repetitive than a structure encompassing "reality," on the other hand, it
is not "reality" that art overthrows, but literality. This fact demands an
inquiry into the nature of metaphor and its "rival," allegory, in order to
discover what is the relationship which holds between them and also
which of the two tropes can legitimately aspire to penetrate art's formal
symmetries and asymmetries.

## METAPHOR

It is customary nowadays to thank rhetoric for every bit of meaningful-
ness or lack of meaning that one can find. In particular thanks are due to
metaphor, which has become a frequent point of departure for the under-
standing of art. With the exception of Deleuze, who claims that art has

nothing to do with figurative language, philosophers and critics have had recourse to metaphor, thought of as the main trope, in order to explain art, hoping to find in metaphor a unitary framework that would include something which is not quite real and which is at the same time intelligible. The meaning and definitions of metaphor have become so broad that it is almost impossible to contain its range and apply it only to linguistic phenomena as Aristotle did. According to Aristotle, "A 'metaphor' is the application [to something] of a name belonging to something else."[12] This definition of metaphor is already comprehensive, so much so that it authorizes many "linguistic games," the first of which is the breaking of that logical imposition that prohibits metabasis or labels it, in Gilbert Ryle's terminology, a category-mistake.[13] Art's freedom would consist in crossing this line, but it would be a freedom that pertained to the verbal arts and only peripherally to the formative arts, where representation and icons are more appropriate means of organizing the artistic material. If one limits one's research to poetry in order to ascertain the import of metaphorical discourse, it must be said that without metaphor poetry would be a poor, desolate thing indeed, barely worthy of admiration, even though there are poetic examples that involve no metaphor. Therefore the controversy is not about whether metaphor is permissible or whether it can be abused. The project becomes to understand the function of metaphor in the overall discursive economy of art. Such understanding will clarify the question about the ontological status of art.

Metaphor's function is to make implicit the explicit and to make explicit the implicit through a comparison or parallel. We are all familiar with dead metaphors, those so worn out that they leave the impression that nothing has been said that goes beyond the expectations of the average reader. Thus, aesthetic metaphor is submitted to a value judgment based on the view that the power of metaphor lies in the abolition of everyday discourse. We value those metaphors which can accomplish this since they uncover the latent possibilities of language, and with it semantic value. Because of this, metaphor urges us to take sides. Lacan used metaphor to account for the transition from the real to the symbolic order, thus for him metaphor becomes a tool and not an end in itself. But metaphor lends itself to extraterritorial deviations, accepting or tolerating extra-linguistic referents. This is why some metaphors are called justified or unjustified, "good" or "bad." Ideally, however, the linguistic metaphor stands for the subjective suppleness of language. What is meant is that the linguistic metaphor incorporates and translates the original substantive

(which by itself would be artistically null in its phonetic presence) into additional phonetic associations or semantic resonances without leaving the plane of language, which is immanently neutral until such transformation takes place. It follows that metaphor is synthetic and analytic at once. It is analytic in that it dissects the potentialities of language before reaching its definite state. In other words, it is poietically analytic (it subdivides and specifies), and it is aesthetically synthetic in that its overall effect is to introduce a new construct. Metaphor is analytic also because it proceeds by similarity and difference, selecting among phonemes and sememes. This step is symptomatic of the transition to metaphor's synthetic dimension. Metaphor is semantically synthetic because it adds a plurality of meanings to scattered linguistic elements. In addition, it is creative of the new, without adventuring into the absolutely null and void. By the same token creative metaphor, having its inception in language, has at its disposal an instrument that is both commonplace and boundless. What metaphor accomplishes through this medium is something that prima facie subverts the primary function of language which is to communicate directly some state of affairs.

To do without metaphors would be to limit the number of the functions of language and also to nullify the analytic and synthetic components that generate sense and nonsense. In order to differentiate sense from nonsense one must be willing to distinguish between grammar and semantics. Grammar alone can produce a well-formed sentence that is meaningless, but when we form a sentence that is grammatically correct such as "this house is animated," we find ourselves in a different domain, free to determine whether the sentence is meaningful or not. Literally this sentence is problematic since houses are made of stone or bricks, incapable of animation. It becomes interesting only when it is interpreted metaphorically. Whoever is competent to decide about the meaningfulness of such sentences has mastered language.

We must ask now, albeit briefly, which interpretation of metaphor best explains the various aspects of art when art is thought of in terms of the radically new. It has been suggested that metaphor cannot be considered fully creative if it is understood according to the "comparison theory." This particular interpretation of metaphor is based on an implicit comparison or even a proportional analogy (implying four terms) between the tenor and the vehicle. Carl Hausman claims that metaphors create their own object, that an explanation based on comparison is inadequate because metaphors rest also on dissimilarities. His point is that the

metaphor's analytical aspect must be taken into account, and at the same time the great relevance of its synthetic aspect must be recognized. Hausman prefers to call this latter aspect "integration" because he wants to emphasize the moment of diversity rather than the moment of similarity. It is good to remind the reader, however, that a comparison is never a full identity, some difference is always implied, even though that difference may be tacit. Metaphor's esoteric and recondite aspects convince Hausman that metaphor can be studied theoretically but not analyzed, that is, fully explained.[14] He is certainly right if he is affirming that, once analyzed or paraphrased, metaphors lose their aura. But his thesis that they cannot be analyzed implies a contrast with the view that metaphors are not simply synthetic. Hausman concedes that the moment of similarity and the moment of difference concur to the formation of a metaphor, nevertheless he minimizes the role of analogy in favor of ontological integration.

To reconcile Hausman's theory with the comparison theory, or at least to draw them closer together, is a possible task. The comparison, via analogy, is first understood as bringing out the similarity between terms: "This house is animated as the people who inhabit it are animated." The difference among the four terms is then to be found in the fact that "animated" is predicated differently of the house than it is predicated of the people living in it. We are confronted with an analogy that depends upon previous knowledge of the four terms, but which also originates a new meaning. An analogical theory of metaphor is compatible with metaphors being creative, although they would not necessarily turn out to be creative in the strong sense that Hausman attributes to them, namely, that metaphors create their own new ontological object. Analogies are subjective, and the objects they create are more likely to be "subjects" than theoretical objects. While Hausman takes the meaning of the metaphor to be immanent, he denies that its ontological referent is immanent as well; in this space, half empty and half full, we find metaphor, which is never absolute and always ontologically tentative. No doubt metaphors are semantically productive, one must therefore investigate the relation between semantics and ontology. For Melandri this is a form of complementarity. For Hausman it is a form of integration between metaphorical expression and its referent, the referent being the ultimate point of resistance beyond which a metaphor cannot go.[15]

Metaphor shows its power to abolish everyday discourse when it reveals something that had previously remained unthought. It provides more than some new linguistic toy. According to Hausman, it generates

an object, a referent which can be an event, a conception, an expression. A referent is that *quid* which makes metaphors inventions and formed by two types of object-referents. The first is the "immediate" one (meaning), created by metaphor, and the second is the "dynamical object" (real) which controls the plausibility of the metaphor and which therefore is a center of resistance, something negative but nevertheless interpretable.[16] This extra-linguistic feature runs the risk of suffocating the freedom of the creative act. Hausman, eager to establish an aesthetic criterion for the aptness of metaphors, maintains that the referent is the limit, the obstacle, even, but which functions as a center of relevance. All this seems to indicate a departure from Hausman's main thesis that metaphors are radically creative of insights. On further scrutiny one finds that the object is both created by the metaphor and also dependent on extra-linguistic factors. In view of this conclusion, it is no longer clear whether metaphors are dependent on conditions that have little to do with their creative function. And it is no longer clear whether the "created" object or referent excludes a comparison between two or more state of affairs. After all, in creating themselves, metaphors do not create their own limits, they are subject to external criteria. In our view it is better to say that metaphors create their intentional objects while disregarding the supposed coherence of the world understood realistically, as establishing objective limits. Art, especially surrealism, has taught us to do that. The overall meaning of metaphor, independent of its internal form, remains new. Therefore metaphor can be explained as some new combination or implicit juxtaposition of meanings (or signs, symbols, signifiers) subversive of the explicit language.

It is doubtful that a metaphor can gain from referring to a limiting referent, at least from the poetic viewpoint. Such referents transcend the linguistic domain, they are distant from the poetic hypothetical worlds that expand the indeterminate. Finally, such referents are situated below, not above metaphors, being pre-given points of departure and not of arrival. In the example "the house is animated," the signifier "house" acts as a starting point, which acquires a new meaning thanks to the metaphorical act. The result consists of a parallel that does indeed individuate a unique object, but also qualifies adjectivally and so "demolishes," the commonplace object, the house. The transformation creates an imaginary referent opposed to any pre- or post-conceived connectedness or orthodoxy. Metaphors spiritualize the obstinate real, in so doing they overturn the world of objects by excluding the referent and approaching

it at the same time. One of the fundamental merits of metaphors is that they banish any dualism between signifier and signified (concept). However, referents qua individuals pose the problem of transcendence; also important is the recognition that meanings can be expanded, suggesting that self-transcendence is the propulsive force behind art, its inception and also its philosophical significance. A world without self-transcendence would be a world of structures only, in which a language without semantics is supreme. Such a reductionist view would omit to consider that dialectic is the result of the circularity between structure and function. A structure without function is something dead, and a function without structure is something nonexistent.

The relevance of metaphors for art lies in the fact that, being creative of meanings, they put into relief the symmetries and asymmetries of the aesthetic domain, as demonstrated by the fact that metaphor is never either simple identity or difference. Additionally, one must guard against the outright identification of aesthetic with linguistic metaphor. We concur with Paul Ricoeur when he says that aesthetic metaphor is "the stylistic effect of metaphor," something altogether different from the scientific metaphor.[17] Aesthetic metaphors, by superimposing on the real the frailty of language, are attempts to overcome the inexorable void left by the Absolute. In partial disagreement with Lacan, we can say that metaphors are redemptive to the extent that they limit the eternal recurrence of the same. In doing so they counteract nihilism, which, it must be admitted, has at least the function of making us aware of the *nihil* without which no response would be possible. However, nihilism per se does not create and, consequently, does not destroy. But its power is of great relevance if we consider that in the aesthetic sphere it leads to artistic acts, in reaction to the extreme meaningless of matter. The fact that nihilism can be *used* in order to arrive at an active "building on nothing" opens the way, in the case of art, for a transition from mere sensation to meaning. And meaning is itself a metaphor for that which we do not know. This consideration opens the question of a possible connection between metaphor and metaphysics.

Metaphor may ally itself with metaphysics and form illegitimate hypostatizations instead of maintaining its linguistic neutrality. In that case, metaphor refers to an underlying reality with the purpose of explaining it. For instance, Nietzsche's *dictum* "The world is will to power" is a metaphor. If it were otherwise, Nietzsche's perspectivism would vanish[18] and the result would be a monistic metaphysics. Metaphor may perhaps

open a plane in which reality is alluded to (the signified) and whose signifier is only apparently free to develop into the signifying chain. Something similar happens in Lacan's theory of metaphor, which places signifier and signified on different planes. But unless signifier and signified are on the same plane we will face a dualistic and asymmetrical theory of metaphor in which the signified is stifled. Such an approach would diminish the poetic potentiality of metaphor and force the philosopher to look for other ways in which meaning could retain its allusive character and art manifest its difference from literal truth.

### SUBLIME ALLEGORY

It is commonplace to define allegory as extended metaphor, but what exactly it extends remains to be seen. Descriptively speaking, allegory's dominant trait resides in imposing a rhythm on its material, while the role of metaphor is to connect signifiers in one composite unity. Compared to metaphor, allegory shows a marked discontinuity. In metaphor the difference between what is implied and the surface theme underlies a subjective universality (and this is its limit). Allegory, on the other hand, accepts as a *fait accompli* the scission of subject and object; thus, it is more constrictive than metaphor. The freedom associated with metaphor seems to be a personal and private concern, but this freedom is partially illusory. A more substantial freedom is found in the capacity of metaphor to go beyond the given in order to shape it according to semantic rules always in motion. This is the reason why metaphor is usually placed at a higher level than allegory. The impression that allegory gives of being mechanical is responsible for its devaluation, which in our eyes is unjustified if we think that in painting it can rise to the national dignity of Eugène Delacroix's revolutionary *Liberty Leading the People*; in literature and narrative in general it can be so subtle as to go unnoticed. In this "propositional symbolism"[19] it is the conception that predominates, giving to allegory a philosophical significance that is only adumbrated in metaphor. Keeping in mind that allegory has its inception in the particular and reaches the general, we can say that it dominates the restricted territory of intellectualization.

There is a possibility of mediation between intellectualization and art, and that is given by allegory. Allegory, as Angus Fletcher's erudite work shows,[20] is generally considered a derivative form of art even though its practitioners include such figures like Dante Alighieri and Edmund Spenser. The importance in allegory of causation, ritual, and cosmic

image relates it to philosophy, while its daemonic character, its sublimity, and its obscurity make it akin to those artistic manifestations which exclude sheer immanence. Opposed to mimetic and naturalistic art, allegory is usually thought of as dwelling on formal rigidity, as lacking beauty while stubbornly insisting upon the uncanny. Thus, readers or observers are left with little possibility for expanding their imagination.

Both allegory and the sublime detach themselves from empirical or natural boundaries. Allegory can be described as an alteration of the accepted distinction between lower and higher, whereby everything becomes "higher," insubordinate to the object. Also, the sublime is not simply a subjective feeling, if it were completely subjective, the sublime would disappear in the undifferentiated. Instead it is powerful, because of its capacity to convince us of the nullity of nothingness. It achieves this result suddenly, it takes us by surprise, and it discloses the existence of the cosmos, arranged, as Fletcher notes, in a hierarchical manner.[21] The relevance of allegory for aesthetics is shown by the fact that it assigns to the sublime a prominent place. In addition, allegorical narratives imply a process of rationalization which is opposed to myth.[22] With all this, the uncanny and the daemonic hint at the defeat of both subject and object. This defeat paves the way for the reevaluation of the sublime and of allegory. From the aesthetic viewpoint the question is whether allegory can be considered beautiful, and the answer is in the negative, but this response should not be alarming, since beauty is not a necessary attribute of art. Allegory can even be called antipoetic, if by "poetry" one means the metaphorical proliferation of images to the detriment of a comprehensive view of art.

What makes plausible the unity of the sublime and allegory is that both imply a process of intellectualization of the work of art. At first sight, it may seem that the sublime escapes intellectualization, but in reality it is imbued with artificiality, resting, as it does, on the "impossibility" of nature. Indeed Kant connects the sublime with reason, and we know that the use of reason is regulative and not constitutive. Let us specify. The "outrage on the imagination" which is the sublime is self-produced;[23] nature is not sublime *stricto sensu*; nature can be reduced to a mathematical formula, the sublime cannot be. The sublime is reached at the expense of science. In the sublime symbolism and symbiosis attain such heights that any mathematical formula is transcended, even when mathematics has helped to create it. For instance, architecture requires the use of mathematics, but its significance and whatever sublimity it may have is found in the transport that its unperceived formulas inspire in the spectators.

It is unnecessary to subscribe to a transcendent world view to grasp the sublime. A secular, nonmythical view is equally effective in leading us to descend into that subjective universality represented by profundity. In fact, the significance of the sublime is to be sought in the negation of a nihilism that declares the world already completed. Acceptance of that declaration would lead to the view that nothing could be added to an already made world, not even art. Nihilism develops from an awareness of the *nihil*, but a similar result is reached if the dogma of unchangingness is accepted. Art, especially the sublime, is there to belie this dogma, but in order to go beyond nihilism a bridge between the empirical and the imaginative is also needed. Nihilism proper denies that imagination has any role to play, just as it denies the consistency of empirical discourse. Thus, no connection can be established between imagination and fact. In a way, Kant attempted to reconcile the two, imagination and fact. However, his answer is regarded as not giving imagination enough freedom from the laws of the understanding,[24] thus minimizing the creative origin of art, with the danger of reducing it to mimesis, or at least to something close to mimesis. Perhaps, then, the bridge is not worth building if the result is a return to the imitative theory of art.

Another road is opened when allegory is introduced as the means to keep the "real" at bay without disfiguring form. This is so because allegory harbors within itself the formal characteristics of both the understanding and reason. On this issue, Fletcher speaks of allegory as making "an appeal to an almost scientific curiosity about the order of things."[25] Nihilism is excluded for exactly this reason. Moreover, Fletcher emphasizes the existence of common points uniting the sublime and allegory. For him the "oceanic involvement," the cosmic interest, the difficulty of comprehension, the step beyond sense experience, and the distortion of nature are common to both.[26] Even though the romantics took into consideration the connection between allegory and the sublime, they devalued allegory in favor of symbolism and mythology. What they lost in consequence was the exploration of a possible access to the rationality and abstractness of art. What they gained was belief in the almost religious role of art, reinforced by the view of art as creation. In this manner the rise of nihilism was postponed.

Allegory has brought us back, again, to the question of the sublime and nihilism, that is, whether nihilism can be considered an aesthetic possibility. If the notion of aesthetics is limited to the beautiful and the sublime only, then nihilism must be excluded from the aesthetic sphere and

it would be better confined to the bizarre and the ugly. The traditional resistance to the ugly is also a consequence of moral preoccupations. Following these, "beautiful" and "sublime" are adjectives different from any others and they are entitled to a special place in aesthetics. Indeed the beautiful is essential to art, just as virtues are intrinsic to morality. Kant tied the aesthetic judgment to what pleases and has general validity, he commented only in passing on the ugly. Yes, artists can represent death, wars, and illness, but they cannot represent what elicits disgust. If they do that, the object represented turns out to be indistinguishable from the ugly natural object. They commit, so to speak, the sin of realism, which prevails over detachment.[27] Kant ignored the possibility that artists could dwell on the ugly for its own sake or present it ironically. Marcel Duchamp's famous urinal was intended to shock, and it did cause a stir among the well-adjusted visitors to the gallery. The question of whether this object is to be considered a declaration of war directed against our senses or the ironic expression of a latent cynicism, is irrelevant in this context. The fact remains that with that gesture the artist had gone beyond the idea that the beautiful is the sole legitimate representative of art. What Duchamp did was also to negate the sublime, to exclude it from artistic consideration. What emerges in its place is the sense that a familiar object has been displaced (literally and metaphorically) and has become the focus of artistic concern; a deliberate act reveals itself as an act that can be repeated indefinitely.

It remains to be asked whether the sublime still confronts the contemporary aesthetician with an obstacle worthy of consideration. If, as it once was believed, the sublime is "confined" to the magnitude of nature, to the violently colossal, to might, and if mimetic art is by now marginalized, then the question arises whether the sublime is destined to regain prominence. The answer is that the sublime remains one of the few resources left to the aesthetic, to high art. What distinguished the sublime is not only the grandiosity and monumentality of its "inspiration" but also the peculiar relation that it establishes between the themes of a work of art and its specific Weltanschauung. The latter must be inclusive of subjectivity and intersubjectivity, so that the private and the public forge a generalizable unity. At the same time, contrary to the accepted view on the sublime that the person experiencing it must find herself in a non-dangerous position, it must be said that the sublime puts into question the objectivity of what is presented and, as a consequence, its correlate, subjectivity. On the opposite side of the spectrum, the acceptance of the

everyday paves the way for an art that places itself at the level of the average spectator or listener. Postmodern artists justify this attitude by invoking either democratic principles or the nullity and irrelevance of art understood as elevation, they conceive of art as simple play characterized by chronic simplicity. Of course play can be complex and elevating, but when the complexity of play is reduced to a subjective consciousness without subject, this paradox produces an art whose principles deny every principle. In the sublime there is no play. The factor differentiating the sublime and play is the sense of risk which prevails in the sublime. Unlike irony, the sublime rejects play in favor of an uncontaminated solemnity. The sublime cannot accept the playful because doing so would mean to come too close to mere adornment. It is a risk that the sublime cannot run. The sublime takes seriously the possibility of the simultaneous involvement of all the components of the relation subject/object. In so doing it contradicts that same distinction since it produces an awe inseparable from the totality. Moreover, the sublime surpasses beauty and its nonambivalent pleasure in that in beauty a distance is established between the "perfection" of the presentation and the corresponding reception on the part of the spectator. There is no distance in the sublime between the perception and its overall meaning, that is why one can say that the sublime may be compared, at the limit, to a psychopathological experience.

There is nothing incongruous in the sublime if we admit that, contrary to Kant's belief, the sublime is more than a matter of "disposition of soul"[28] on the part of the subject, which cannot be predicated of the object. We must recognize also that the sublime contains an act of knowledge—an act of knowledge which is of course *sui generis* and which individualizes the artwork as being more than an object of admiration. It is unavoidable that the sublime becomes an "object" of knowledge not transcendentally but concretely. Art is knowledge because knowledge is art. Kant's effort to separate reflective judgments, to assign them a nonconstitutive use and at the same time to ascribe to them universal validity, is admittedly subjective. As Kant proceeds from the first *Critique* to the third, a progression toward idealism manifests itself. In that process subjectivity assumes the critical role of discriminating between what constitutes beauty and what the sublime.

The opposition subjective/objective is resolved by Kant in favor of the subjective. The sublime is related to an idea; properly speaking, it cannot be said that an object, either natural or an artifact, is sublime. Intuition and imagination contribute to the subjectivity in question. Concepts,

which are the means by which objects are known, are excluded. Thus, art, in particular the sublime, does not teach us anything, its sphere is that of disinterested aesthetic judgments which have their inception in the manifold phenomena given in experience. The sublime, vis-à-vis the object of sense, is accessible to an intellectual approach transcending the empirical, and, at the same time, puts us in a contradictory state in which imagination and reason lead toward the abyss and toward conformity to law.[29] The sublime is aggressive and violent, negative and positive. There is no doubt that the sublime explored by Kant is connected to the greatest being, that *aliquid quo nihil majus cogitari potest.*[30] On the other hand, the consequence of this comparison is that the sublime is in itself contradictory, with no resolution in sight. Yet, the negativity of the sublime does not end in despair. If that were the case the feeling of the sublime would have to be accompanied by a sense of impotence, which Kant de facto denies, since the sublime can inspire a sense of human superiority when facing nature. However, the sublime forces us to confront the unutterability of what lies behind it, in other words, the infinite. The contrast between finite and infinite typical of the sublime makes the sublime a most interesting aesthetic "notion," in comparison to which the beautiful seems unproblematic. When contradictions are included in a notion, no adequate definition of that notion can be given, only a description that will momentarily satisfy reason. But reason is knowledge of both the negative and the positive, and therefore reason helps us to understand the sublime.

Hegel recognizes the negativity and positivity of the sublime. It is negative because it is not *stricto sensu* symbolic, that is, it makes no reference to externality. It is positive in that the sublime, being distinct from appearance, rests on absolute substantiality and not on subjective reason. Since the negative and the positive alternate with each other in quasi-parallel fashion, the sublime partakes of both. The negative, however, has priority in this exchange. Complete resolution in positive terms would consist in the transformation of the sublime into something perfectly intelligible, instead it maintains the aura of indecipherability. Hegel says: "This outward shaping which is itself annihilated in turn by what it reveals, so that the revelation of the content is at the same time a suppression of the revelation, is the sublime."[31] Note that this is not a definition in the Aristotelian manner, involving a specific difference. It is a dynamic description of what the sublime involves. This is a matter of substantiality, whereby simple appearance remains in the background. The subject has no part in it, only an absolute subject could contend with it.

The negative is an essential component of the sublime, either because its objectivity cannot be grasped completely or because it makes us surrender, subjectively, to our own indeterminacy.

One is tempted in this case to speak of a nihilistic experience. The feeling aroused by the sublime is one of bewilderment, it reminds us that art is a combination of the possible and the actual. The possible is far from paving the way for nihilism, but the resources of the sublime go so far as to instill in its listeners or viewers the awareness of a negative that transforms itself into the positive. The positive is here related to the possible, while the "actual" infinite of the sublime is that which secures the shattering uneasiness of the negative.

We return now to a point made earlier, namely, that the sublime is a matter of the possible which releases us from the actually given. The utopian moment therefore is present in the sublime, both exhibit the indeterminacy of any given shape while presenting themselves as eternally incomplete. Jean-Luc Nancy insists on the role of totality in the sublime. His conclusion is that this totality "is *beyond everything*."[32] We want to add to this consideration that the sublime also points to a possible unity, to a utopian conception of art in which the end (of art) gravitates toward incompleteness. This is also the beginning of a different art in which continuity is displaced in favor of discontinuity, so that, if there is harmony, it is only *in mentis*.

At this juncture the return of allegory is legitimized, for allegory makes the absent manifest and the manifest absent, entrusting it to a possible temporality. Metaphor, instead, derives its meaning from an atemporal present rather than from the future. And the sublime combines the atemporal with temporality in such a way that atemporality *becomes*.

## THE AESTHETICS OF NEGATIVITY

If one admits that art and beauty have some characteristics in common, but that they can be unconnected to each other, one is left with the question of what they have in common and whether art may be indefinable because of the indefinability of beauty. Hegel ultimately recognized that art exhibits its truth in a dynamic and meaningful manner (hence the relevance of *Darstellung* in his aesthetics); yet, beauty itself (i.e., the concept of beauty) is something static and therefore prey to metaphysical misunderstanding. After centuries of philosophical inquiry, what we have now is the awareness that the beautiful cannot be confined to any category.

The beautiful—or rather the aesthetic object—stands alone in dangerous proximity to nothingness, and this is why art points to an endless, infinite task. Hegel, the philosopher of the actual infinite, confined art to the finite, but now that the infinite seldom makes its appearance in philosophy, art still retains the right to search for—or at least to point to—the infinite. The infinite in this case is something negative, it is the mystery that Hegel denied to the work of art. Just because art is not reason, it can expand beyond the restrictive boundaries of any given structure. We take this to mean that nothingness is the best "category" in which to locate the realm of aesthetics.

The affinity between the negative and art, between art and nihilism, is part of a more general identification of philosophy with that which is only partially determined. It is possible, then, to locate the work of art in the ephemeral sphere of the "not." The current state of the arts suggests that this road is open to art. The pervasiveness of nihilism and the relativism in which present culture finds itself make plausible an inquiry into the ultimately ineffable and ungraspable, into the want of identity. The attempts of Joseph Beuys to reevaluate any object or pencil scrabble on a white page constitute an invitation to every person to become an artist. They are also symptomatic of the collapse of high art which is typical of postmodernism. The subsequent "democratization" seems opposed to the nihilism diagnosed and condemned by Nietzsche, in reality it is a symptom of a masked nihilism which conflicts with the demands of the grand style—where by "style" is meant, subjectively, the formal intransigence of the artist. Postmodernism is indeed nihilistic in the sense that it has lost faith in style and considers it, at most, as an addition which demonstrates its imperceptible difference from what surrounds it. But art can aspire to something higher. Thus, it is impossible to say that art remains confined to the present. This is the road that leads to the end of art, to the reiteration of the same until all content is dissolved. If art has taught us anything in the course of the centuries it is that its finitude is other than the ontic finitude. Nihilism has provided the occasion to evaluate art from a different perspective. As something that is to be overcome, nihilism paves the way for a dialectical reversal. A reversal of nihilism, independent of the absoluteness of the infinite, is conceivable through irony, but also through the mediating point between the zero of nothingness and the one of the infinite. In this middle "space" one encounters art and philosophy.

In order not to dissolve into nothing, after having lost the object which was its traditional content, art must secure for itself a form. In

fact, abstraction in painting signals the triumph of form. Paul Cézanne, Wassily Kandinsky, and cubism, all attest to the search for a determinacy which must reckon with objectivity understood as that which can be measured and calculated. In fact, Kandinsky drew the circles with a compass and the lines with a ruler.[33] The other middle ground, irony, as we admire it in Paul Klee, affirms, instead, the relevance of contrasts. The philosophical significance of such art rests not only on the fact that an ideal objectivity has become obsolete, but also on the fact that art has learned that negating one value can mean to affirm another. Thus, irony does not coincide with nihilism, rather it puts the absoluteness of values to the test without negating their pertinence. Something is destroyed in irony, but not form. In order to destroy form, artists would have to demolish all intelligible thought. Certainly, attempts to relativize everything, to declare the ubiquity of nihilism have been made. Nevertheless the negative does not have the power to destroy absolutely because it is distinguished from nothingness; but it is also true that the negative is a mechanism irreducible to a methodology.

If today we find ourselves in a philosophical swamp, this is due to the fact that philosophical thought disregarded the pertinence and value of the negative. After Hegel and Nietzsche this statement may sound irreverent, and yet, even Nietzsche tried to extract from the nihilism of previous philosophy the quasi-omnipotence of the will to power, pretending not to see that the negative aims, by itself, both at its own resolution and at its own perpetuation. Nihilism is for Nietzsche the basis out of which positivity is reached; once tradition has been discredited as nihilistic, thanks to another nihilistic act, then the road is open to the utopian view of an Overman whose role is to reduce the negative to a tool controlled by the Overman himself. If this is the final result of metaphysics, one can only hope that this biological impossibility (impossible up to now at least) will be in a position to solve the enigma of history, as Marx once thought that communism would do. Fortunately history and art, as the permanent dimension of the temporal, have little use for metaphysical certainties, and in the specific case of art negativity translates into rebellion against the beautiful. The history of art is a constant wavering between a negative point of departure and a point of arrival that nullifies previous assertions and beliefs. The lack of a final resolution surely indicates that beauty can be dispensed with. The rejection of the beautiful and the harmonious has paved the way for a new conception of art where discontinuity prevails. Such a development is conceivable thanks to the notion of the end of art.

This end is other than the end envisaged by Hegel, it depends on the ironic reversal of Hegel's notion of fine art. If art as beauty and content is dead, artists will reclaim it by declaring beauty null, in theory and in practice. The negative reiterates the necessity of art, not its demise.

Like art, philosophy begins with the indeterminate. Whether the indeterminate is bound to develop into determinacy is not a matter of total immanence, otherwise the proclaimed result would be an inflated tautology, stretched to its ontological limit. Indeterminacy, here the zero point, is the source or bottomless well from which values are extracted. Nihilism in art would be an indication that philosophy too had gone bankrupt. The question remains whether nihilism has actually been as pervasive as Nietzsche wanted to demonstrate. If Nietzsche's interpretation of Occidental philosophy is accepted, it follows that nihilism can indeed be viewed as including a meditation on art, although the hierarchy of values would be found to be different from what it was in past ages. Going back to history could bring with it a revaluation of tradition also in the domain of art. To avoid this risk, history must be defamed unless it is approached critically. Even though tradition has its place in the museums and archives spread throughout the world, it was not Nietzsche's intention to elevate tradition to the point of declaring it sacred. In the course of its development, nihilism has brought about qualitative leaps, which can be traced in art history, concerning both art's themes and technical innovations. In order to attribute these changes to nihilism one must understand nihilism as negating the ontological priority of actuality. Thus, nihilism comprises the potentiality-for-Being which is essential to the comprehension of art. The negative enters here as the necessary endless search for the new which must reckon with the nothingness of each beginning. Creation is ex nihilo, to the extent that it privileges the future and does not idealize the past. Thus, the point of departure of art is negative, but negativity does not necessarily imply an aesthetic of nothingness, the ability to explore further ("We err forward" said Musil) points to the truth of style. In order to have an aesthetics of Nothing it would be necessary to advance a step further, that is, to proclaim that all ontology has disappeared from philosophical discourse. And artists would be more than ever alone if they repudiated philosophy as a basis for additional understanding.

We have said that a fracture has taken place which is marked by the emergence of the fragment from a generalized void. The emptiness of meaning, the absence of a framework in which the subject (a nothingness

itself) could elude its finitude and silence, all this convinces artists to reject irony and to be consumed by silence.[34] Schelling never had to ask himself whether art is such a void, and one can still accept his view that the artwork is the product of unconscious activity and therefore a form of "objective nothing." Art can be considered objective even in the present age precisely because it originates in unconscious forces that are not, strictly speaking, subjective, the unconscious being the receptacle of our mythical apprehension of reality. The present statement is not meant to minimize the role of imagination and fantasy, which remain subjective as long as they are uncontaminated by objectivity. They are purely ideal, abstract, soon to give way to their objectifications which are not necessarily mythical.

Nietzsche tried to revitalize myth by transforming the legend of Dionysius into a mythical Overman. Nietzsche's effort, instead of succeeding in developing a communal mythology, has turned out to be an isolated effort, which is tantamount to saying that its failure is, from the mythological perspective, complete. It will be argued that Nietzsche did intend Dionysius and the Overman to introduce an elitist ideal—true. Nevertheless one must emphasize his aspiration to change the way the world is thought of. This is to say that Nietzsche's monumental ambition is to be taken seriously. However, after his devastating critique of Christianity, he could not propose a return to a mythical form of thinking without losing the coherence of his initial project. There is thus a reactionary streak in Nietzsche's philosophy, even though the Overman is the "Man" of the future.[35] The introduction of yet another myth, not timeless but rather projected into the future (I mean the Overman), shows that myths can indeed try to break with the past.

Schelling also ventured into the future with an apparently timid attitude (his work *The Ages of the World* remained unfinished) and promised a visionary philosophy.[36] Schelling's undertaking to distinguish the new from the old, retaining at the same time a unitary perspective, is impressive. The search for completeness actualized in the symbolic forms of antiquity, together with the quest for a future wholeness whose general destination is outlined, is, however, a self-contradictory project common to all visionaries. For myths and archetypes, if taken beyond their function in art, identify a path that has been constantly belied by historical events. The modern tendency inclines toward irony, the least archetypal mode. Irony turns upside down the meaning of myth, ridiculing it or making it the scapegoat of a past long gone.

Irony is a mode and as such must conform to its form, but irony as a whole excludes a mythical (ruled-governed) interpretation of the aesthetic, since it is too volatile, dependent on a fierce subjectivity. Northrop Frye speaks of the mythos of winter, inclusive of irony and satire, and he acknowledges that the practice of irony is an indication that "conventions are getting worn out."[37] One wonders whether with the mythos of winter all myth has evaporated. In that event, Hegel may have been right in proclaiming irony the last stage of an art that has lost philosophical pertinence. The mythical and archetypal approach to art makes art's autonomy problematic, at the same time it makes art communicative. The artistic product is judged, in its objective-subjective reality, by the tools provided by compositional rules. This means that the work of art requires a set of rules if it is to be potentially communicable. The formal unity of the artwork, which no longer embodies the congruity of the whole, but which is, rather a formal consistency accompanied by subjective variations, predominates in today's art. This unity is important, since the artwork is also the product of spontaneity, and spontaneity differs from the objectivity so laboriously sought by philosophical tradition. Experimental works seem to contradict both the subjective and the objective side of art; nevertheless, even music, which is usually considered a subjective art, is a sequences of organized sounds. Music is a language which, although it does not say anything,[38] is in effect intersubjective, once the interpretative code has been identified. A "private language" would be a language nobody listens to. Such a language could be beautiful in the sense that beauty rarefies as much as it condenses, but that would only demonstrate that the beautiful is defective in terms of compatibility with expansion.

## CONCLUSION

A few words are needed to crystallize the concepts behind the second part of our work. First, the role of subjectivity, which now appears to be negative more than an established fact. While discussing the discrepancy between philosophy and art, especially if the former insists on objectivity and the latter on subjectivity, we have established that art's full meaning cannot be identified in either of them alone. The truth of art, essential if we want to understand its place among human activities, rests on the new, but this fact must not make us oblivious of the dangers represented by the new. The ontological void of which the new is an aspect can lead to nihilism; even when meaning is reached, this meaning can

still be considered a fictional entity, or simply hypothetical—a construct; yet it must be a true construct because it corresponds to art's function. Thus, art's function is not only one of giving pleasure or of consoling us, but also one of establishing the truth of art's specific unity. Because of this, some have been led to believe that art for art's sake is the only possible answer in deciding art's meaning. The partial truth of *l'art pour l'art* rests on the autonomy of art; yet, art for art's sake can be, and often is, the response to a nihilistic view of the world. To counteract such nihilism (the result of the isolation of art), the sublime intervenes by negating every a priori conception of art. This rare phenomenon denies harmonious beauty and is the most convincing proof of the indispensability of the new in art.

In the second chapter, the problematic connection of truth and art has been considered following Nietzsche's perspective. High art is the only concern here, and its tragic aspect is one with the overcoming of nihilism. The consequences are, if not clear, at least in part foreseeable: given the prominence of style, due to the lack of an adequate content, it was inevitable that art, subsequent to Nietzsche, would resort to rhetoric, since he did not clarify what this style could be. Of course, it would have sounded like an injunction and an invitation to imitate it if he had done so. The reevaluation of rhetoric is the appropriate answer to the nullity of the "real" and reaffirms the artificiality of art which was "lost" in the century of metaphysical aesthetics. We have also seen that Heidegger's answer was of a different nature: subjectivity has run its course, and in order to reestablish the truth of art it becomes necessary to declare Being itself poetic with the consequence that the beautiful is resuscitated from oblivion. In the same way, the sublime acquires a new prominence, with the result that beauty and the sublime become less easily distinguishable, in that both depend on the rapturous essence of Being. However, to declare subjectivity extraneous to art is not a solution to its complete understanding; even leaving tradition aside, subjectivity is still relevant to the meaning in art, understood as radically finite.

In chapter 3, we have seen how the danger posed by nihilism is counteracted by the view that art has something in common with utopia. This is especially true of the sublime, the most "accessible" means of overcoming nihilism. In fact, one of the consequences of nihilism has been that beauty has been replaced by stronger demands in terms of art, so that the truth of art has become the untruth of metaphysics. Art denies stable structures and alternates between the explicit and the implicit. This is why

metaphor plays an important role in art. Its synthetic aspect depends on metaphor's symmetries, whereas its analytical moment puts into relief its asymmetries; in this way an overdetermined meaning is created. A step forward toward abstraction is represented by allegory, which is more "rational" than metaphor but also more artificial. Therefore, it is more distant from the mimetic view of art and closer to the sublime, whose negativity is a further indication of the priority of the possible over the actual. This is another way of saying that art is not limited by the present. As a matter of fact, nihilism, although negated, has at least taught us to go beyond any pre-given ontology.

# Part Three

# Subjective Aesthetics

In the beginning will be the new

CHAPTER 7

# The Role of Subjectivity

## ART: IMAGINING THE TRUE

Following Schelling, as we have done in the first part of this work, as he searches for a transcendental aesthetics centered on the subjective act of the artist, we find, in the end, an objective production. Subjectivity cannot warrant a stable point of departure, even less a stable point of arrival. But, since transcendental philosophy is limited by subjective intuition, it can rely only on art to represent objectivity in its original unity.[1]

Why art is "condemned" to objectivity, and why this suggests a tragic outcome for art, is due to the fact that art is first of all an objectification which incorporates the unconscious element. Unable to free itself from this power, the work of art is mysterious. What is mysterious in art—an aspect which has often been recognized, especially by the artists themselves—is its intransigence in matters of unity. Never quite transparent, either to the interpreter or to the artist, the work may be misinterpreted as an inessential product. If we are to reverse this judgment, it will be necessary to view the artwork as essential in that it conveys meaning, which depends for its credibility on imagination, sensitivity, and interpretation. The first consequence of this approach is the recognition that art is more than *consolatio*, it is more than a mere symptom of an imperfect grasp of the reality principle. Never being completely neutral, art is tragic because its own meaning is elusive. Intuition and imagination may well provide a sense of the infinite, the indeterminate, but at the same time they confine art to the role of

*ancilla,* in danger of losing its cognitive role. Hegel's philosophy is the case in point because his aesthetics ends with a repudiation of art's ability to extend itself beyond its specific, immanent means.

If art is conceived of subjectively, things reveal a different side. The Self is seen as an unstable receptacle of sensations and perceptions, and the reflexivity of which it is capable carries with it the awareness that the world is likewise unstable. What a subjective conception of art adds to our understanding is the experience of the precariousness of any attempt to define art except in terms of contingency.[2] But contingency, beside calling for activity, is nihilistic and ultimately tragic. Thus, the question is whether an activity such as art, which involves the whole of human experience, can really be considered inessential, unnecessary, even from the point of view of subjectivity. The tormented ironist knows better than anyone that art responds to an inner need to redo the past. In Richard Rorty's words: "All an ironist can measure success against is the past—not by living up to it, but by redescribing it in his terms."[3] This is a difficult task, since it carries with it the need to objectify subjectivity and to re-subjectify subjectivity, which is one possible definition of the aesthetic act. In other words, the ironist, after her / his encounters with the other, unleashes all the potentiality-for-Being that is attainable in a finite world.

Even if the aesthetic act is limited by subjectivity, its necessity and meaningfulness is assured. The necessity of art springs from that propulsive force which has been identified in self-transcendence, by means of which any radical separation between subjectivity and objectivity is banished. Self-transcendence is the *causa sui* or the *hybris* that refuses to be restricted to the domain of mere subjectivity. The Self, while recognizing otherness, appropriates it to the extent to which otherness is reducible to knowledge and perception, with the addition of imagination. The result, the work of art, will thus be mimetic when it affirms the isomorphism between being and language or between being and subject. Imagination and fantasy, however, will not allow metaphysics to have the last word, therefore art cannot be totally mimetic, and the residue is what is most valuable in art, that aspect of art which is neither immovable nor incapable of transformation.

Art's dynamic aspect is due to spontaneous imagination, which so changes the meaning of art that it becomes impossible to retrace the separate contributions of the subject and of the other. An art that would stop at stability is unthinkable, without movement art would leave us cold, it would not move us. We have come then to the truism that art is creation.

In order to clarify the notion of creation, the distinction between imagi-
nation and fantasy must be explored again. Imagination is partially
mimetic and representational, and thus incapable of fully exploring the
possibilities of art. The difference between imagination and fantasy is sim-
ilar to the difference between the given and the other. Fantasy is other
than imagination. Whereas imagination is contained within the limits of
the subject-object dichotomy, fantasy rejects the myth of realism, a myth
which should concern art only peripherally. Still, art involves imagina-
tion, the first step toward fantasy, whose aim is to disturb that "harmo-
nious banality"[4] which would impoverish art and also the world. The rel-
evance and the necessity of both imagination and fantasy is demonstrated
by their being strictly connected with intuition. With the act of intuiting
a representation comes to the fore, which is then contradicted by fantasy.
A building, for instance, in its abstraction from nature, can be the prod-
uct of fantasy. The frequent appearance of buildings in allegories testifies
to the fact that both painted allegories and architecture adopt an aesthetic
conception which has put aside any analogy to nature. In the end archi-
tecture only imitates itself.

Imagination is more docile than fantasy, more suited to a simple
elaboration of interpretations already given. It is closer to the beautiful
than to the sublime. The point is to recognize that through imagination
only part of the possible comes to the fore. On the other hand, with
pure fantasy one runs the risk of estrangement from the human world.
Pablo Picasso's contorted human bodies are, needless to say, the result of
fantasy and not of imagination because they portray "something" that
corresponds to a nonexistent, unimaginable object with the simple
means of common perception. Nevertheless, perhaps the best examples
of art, or at least the most reassuring ones, are the result more of imag-
ination than of fantasy. Yet, fantasy deserves prominence because it
raises the issue of nihilism by questioning the viability of the given. To
ignore that issue would mean to take for granted the fundamental role
of the new in matters of art. The relation of fantasy to nihilism is one
of acceptance/defiance.

But fantasy defeats nihilism through its ability to negate what is
simply there in its incomprehensible banality. Fantasy must be conceived
of as an activity productive of artworks which goes beyond wish fulfill-
ment. Imagination indeed is more likely than fantasy proper to confine
itself to fruitless mental acts. People who fantasize in the common, psy-
chological sense of the term are not generally creative of different worlds.

They artlessly submit the existing world to their own private wishes without the addition of any desire for a concrete outlet. Theirs are nihilistic acts that have no part in the formation of the radically new. But to affirm that only fantasy can defeat nihilism would be misleading, considering that fantasy is *one* aspect of the aesthetic experience. Nevertheless fantasy remains a powerful component of any work of art. Were art to surrender to the all-too-real it would disappear. Imagination, even though it is less compelling than fantasy, is also essential to art. Through imagination art attains a dubious ontological status but also provides a corrective to that set of rules and symbolic interactions which encloses the human community. Imagination regards these rules as something peripheral, no more than an expedient on which the old is based. These rules are not nihilistic, but they provide a structure too narrow for containing art. Art is something whereby all pre-given structure is negated; if it were otherwise it would coincide with the practical, an unending activity based on an unquestioned set of rules which are seen as insurmountable.

Art, instead, has its inception when the validity of practical rules is put into question. Art proceeds to dismantle the *idées reçues* by appealing to the destructive side of imagination and fantasy, positively, it attacks moralism in order to proclaim its own legitimacy. Even imagination, which is always mimetic, is free and relates to the real spontaneously, thanks to a conscious appropriation aimed at exploring its possibilities.

Mimesis is never pure. It is possible to conceive of mimesis not as simply imitation, but as discovery and invention. It is "free imitation,"[5] then, an imitation that negates itself; as such it is easily transformed into fantasy, whose imitative process is a "beyond." The freedom of fantasy, without being absolute, is close to the freedom that produces dreams when the predominant mechanism is displacement. The work of imagination, in contrast, is similar to condensation, for it assembles pre-given images in a partially determined and overdetermined representation.

Fantasy, on the other hand, has its raison d'être in the distance that obtains between the real and the ideal. Banishing either imagination or fantasy, making one the instrument of bad or of good art, privileging one over the other, would be futile. Imagination, being both mimetic and productive, is by itself capable of uniting the suspicion cast on the given and aspiring to the new; this side of the imagination affirms art's objectives.

The province of aesthetics is distant from all those other activities which are limited intersubjectively. The first step away from those activities is due to imagination, and the distance is widened by fantasy. When

Messiaen integrates the sound of birds in his compositions, he is being mimetic. At the same time his imagination is put aside in those compositions which are not programmatic. But when John Cage "allows" outside noises to interfere with his music, he enters the domain of fantasy and of "the inverted world." Something new has been introduced into music which negates the traditional distinction between noise and sound. Even though the street noises are "realistic," a music that includes them at random is no longer following the canons of imagination. Granted that the absolutely new is a fiction of the imagination, it is necessary to insist on the fundamental importance of the new whenever we speak of the relevance of art. The instruments available to arrive at this objective, as we have seen, are imagination and fantasy. Imagination alone is insufficient, especially if one understands by "new" something more than an unusual assemblage of discrete parts; imagination can put together the most disparate styles, but the result may not be new in the purist sense of the term, if it is applied mechanically.

From fantasy one expects something more than a report on the given, one expects the unsettling of the established order of things, if there is such an order prior to art. Art would be null, nonexistent without the possible as a source of the new. Imagination, more than intuition, is the instrument available for discovering or inventing the new, since imagination actively explores the possible on which it depends ontologically, it is one with the condensation of meanings and signifiers. In order to imagine, the mind has to extend the actual in a spontaneous metaphorical act, so as to recreate the possible. With fantasy things are otherwise.

Fantasy displaces, deforms the immanent object almost to the point of unrecognizability. Its "possible" is further removed from the actual because of its betrayal of mimesis. Fantasy does not recreate, nor does it respect the given, it is an anomalous act in the service neither of reason nor of the understanding, even though there is indeed something intellectual in fantasy, if one considers that it is a form of synthetic abstraction. However, in admiring (or condemning) an artwork, we seldom activate our fantasy. It is rather imagination, memory, form, and associations that come to the fore. A correspondence between imagination and fantasy in what has been objectified in the work does not imply the same correspondence in the observer or listener. In order to understand art it is unnecessary to incorporate it, even the sublime captivates us to the point of making us oblivious, paradoxically, of the work itself.[6]

The sublime belongs to a conception of art which, while affirming aesthetic significance, surpasses even subjectivity. The sublime pertains to that in-between sphere where subjectivity and objectivity lose ground. That is because the sublime holds fast to fantasy, an additional in-between zone that forges the new and repudiates or disdains ontology. Not everything is auspicious in the sublime—Kant knew this well. We respond to the sublime with uneasiness because we see through it to the precariousness of being and nothingness. In relation to the sublime, negativity must be interpreted as a state that encompasses the perception of otherness while being itself other. Being also can be other and, thus, symmetrical with negativity. This symmetry explains why the sublime forbids us to "take sides" in favor of either the subject or the object. Fantasy shares a similar fate, being other than itself, it is incapable, ontologically speaking, of deciding between the finite and the infinite. If at last it opts for finite being, this is not a concession, it occurs because fantasy depends on determinate or less-than-determinate intuitions.

The aesthetic act, while counteracting nihilism, generates forms that no raison d'état can permanently annihilate, notwithstanding various attempts in that direction. It is unnecessary to mention Plato's distrust of art, which has been commented on ad infinitum, it is more relevant now to grasp the reasons why art, particularly its postmodern version, has been marginalized and thought of as just one of many enjoyable activities, and why this has happened without the intervention of any authoritarian decree. A form of nihilism vis-à-vis the more profound meaning of art has taken hold, according to which the new is suspect or considered a mere subsidiary that encourages us to think of every aspect of history and reality as irrelevant intrusion. Jean Baudrillard claims that we live nowadays in a world in which events no longer have consequences.[7] This universal indifference, due to the bombardment and the ubiquitousness of signs and symbols, has contaminated art, seen as one event, one fact like any other, a source of pleasure requiring no effort. But imagination and fantasy do demand effort, and therefore pleasure assumes of necessity a non-primary role. If the new is disappearing from art, this regression makes high art obsolete and imagination equally so. Imagination and fantasy have been tamed, particularly in the age of "transaesthetics," as Baudrillard calls it, that is, the age of the proliferation of aesthetics, characterized by a lack of boundaries delimiting the world of art. It follows that both the beautiful and the ugly have evaporated in a radical agnosticism,[8] in total indifference. Since there is nothing more to see, to understand, to

admire or to do, art has no choice but to abdicate, in order to reappear as a mere contributor to the generalized *horror pleni*. Like any other human endeavor, art has acquired a neutral status whereby the ugly and the beautiful have canceled each other out. It is to be expected, however, that the ugly will predominate to the exclusion above all of the sublime, that transient *Schein* which is too weak to contradict the other than itself.

## NEW SENSATIONS

Baudrillard's synthetic a posteriori judgment is relevant to our discourse because it denies any role to aesthetic sensitivity. What is to be gained from this perspective is the recognition that the death of the Ego is an event to be welcomed, because it makes possible the revival of experience. The Ego was not vital to the creation or appreciation of art, since the Ego had always been a construct, the sum total of the subject's evidence in synthesizing itself and the world. Its abstractness has been replaced by the idea that what thinks is thinking itself, while the phenomenological subject is subjected to what is other than itself. Art, then, can be seen as the other which eludes total comprehension because it is the doing of an estranged subject. The door is open for decadentism, which must not be misinterpreted as modernism. In modernism, in contrast, one finds an attempt to save art from falling prey to the temptations of subjectivism. Decadentism is characterized rather by the complacency of the dissolving subject, destined to die but still vigilant. Its sentimentality, the confused aspirations of a morbid sensitivity, the refusal of the sublime, are all repudiated by modernism with a virulence directed against those who disclaim the fundamental importance (in art as in everything else) of knowledge.

Left to itself, the subject is both misleading and misled, and the symbolic structure that allegedly encloses it must also redirect it to include countless languages (*langages*) and sensations. This is the meaning of the self-transcending subject, which puts aside Lacan's funereal metaphor of the Name-of-the-Father in order to embrace a form of active nihilism which confirms the surmountability of any given structure. Nihilism favors the process of becoming, and that is why it includes the self-transcending subject, which can therefore emerge also as experience of the other. The subject having been transformed, its immanence is condemned to disappear. Hegelian as it may sound, this view differs from the theory of sublation in that the self-transcending subject is not conceived of in substantialist terms. Qua permanent displacement, the activity of

the subject is irreducible to the perpetuation of itself in the eternal recurrence of the concept. Thus, the process envisioned by Hegel can "understand itself" to the point of reaching the *telos* of absolute reason. At the same time, otherness and subject in Hegel coincide.[9] Even in the *Phenomenology*, the separate subject is finally included in the "we" that belongs to a different type of subjectivity, which forges the Absolute by surrendering to absolute negativity. There is no true self-transcendence here, since the object, the other, is part of the process itself. There is no tragedy either, for the Hegelian comedy (to be sure, divine) is to be read irreverently, making it a comedy at which we can laugh.[10]

Tragic or comic, the subject qua concept has, in Deleuze's words, "fulfilled two functions, first a function of universalization . . . [and s]econd . . . of individuation."[11] The process of universalization has already been questioned by Nietzsche, who nevertheless was still searching for a process of individuation; unable to find it in *Mensch*, he hypothesized the *Übermensch*, who is *telos* without subject. Applying these considerations to aesthetics, we can say that individuation belongs to the artwork itself. It is the work that is unique, the result of a distinctive process in which the subject annuls itself in order to come to terms with truth. It can be said, then, that aesthetic experience (inclusive of sensation and sensitivity) is a necessary but not sufficient condition for the production and evaluation of art. Vague as it may seem, the notion of aesthetic experience nevertheless points to one component of art, because without sensation the ontological status of the artwork would vanish. But an extreme subjectivism, if it has ever been advocated, is to be condemned on the basis of the concept of self-transcendence, which actualizes the work through aesthetic experience. The sensuous appearance of the work is an empirical a posteriori which concentrates in a chiasmus-like manner the subjectivity of the artist and the objectivity of the aesthetic act. Idealism, in its absolute or solipsistic version, fails to grasp the whole of the artwork, since it reduces it to an inner apprehension. However, the mind is formation, and therefore idealism can teach that there is a logic of art as well as a psychology of art.

In respect to music's mathematical constructions, architecture, and painting, art's logic rests on the compatibility of its parts, and this is what leads us to say that a given work shows unity or does not. Art's logic, then, beside being one with meaning, is a matter of negativity and positivity, the necessary but not sufficient condition of art which complements aesthetic experience, the legitimate but turbulent heir to art's

logic. It would be preposterous to say that art absolutely disrupts order, even the new obeys a newly invented logical and mental organization. The destructive moment is necessary, and that is what makes tradition a questionable criterion for the evaluation of art. Tradition is the mark of an acquiescent and reasonable, but not perforce rational subjectivity,[12] hesitant in matters of self-transcendence, and as a consequence incapable of producing new art.

Here Nietzsche's recommendations are pertinent, since without the intervention of a radical critique of values there is no possibility of rising to the new. Nihilism intervenes as a corrective to tradition in making clear that nothingness, like the potential, is and is not, that therefore it can be transformed into being. The function of the new is to explore the ontological possibilities offered by the actual through a process of selection and critical appraisal. This is both a receptive and an active process, always involving the element of selection. The new is an aesthetic category precisely because it proposes a combination of elements (the new is never simple) that is intelligible and experienced accordingly. The unity it affords is eminently an aesthetic experience, even though it is familiar to the theorizing of philosophy. The new provides the means whereby art comes to fruition.

It follows that Hegel failed to do justice to art since he omitted the new, which he called, with some contempt, the "original," that is, a deviation from the norm. His whole philosophy, dynamic as it is, allows for no variation, with the consequence that art dies for lack of vitality, reduced to repeating and to reproducing the old in different guises. Paraphrasing Cacciari, we can say that Hegel provided an ontological proof of the end of art. Without the new there is no art, only facts.

Art has meaning precisely because it contradicts facts and replaces them with the unexplored. An art that is subservient to facts, that recognizes only the *Wirklichkeit*, is doomed in advance to appear obsolete. On this account, the task of aesthetics is to find the parameters implicit in works of art and to accept the emergence of the new. This is a task that rejects extrinsic criteria which would subordinate art to ideology. The history of aesthetics shows that the most cogent theories in this regard are those which do not try to make of art a means to a pre-given philosophical end. Even so art has philosophical relevance, art induces philosophy to question the priority assigned to epistemology and to be suspicious of theories that take into account only the eternal logical structures of thought (the truth of art is experiential). Forms are present in art, but they

are such as to go beyond the restrictions of pure thought. Metaphors are a case in point, considering that their undulating nature shows that logic leaves an empty space that can be filled by figurative or ontologically ambiguous ways of relating to truth. Art is "all" here, in the unity of self-differentiating signifiers. Its rejection of absolute unity and univocal thinking differentiates art from philosophy, which attains the goal of conceptualization only when the manifold is reduced to "the night in which all cows are one cow."[13]

Artists are aware of the unity of their vision and of the multiplicity of experience needed in order to attain that vision. Even Nietzsche accepted this precondition when he said that active nihilism is the negative that does not imply negativism. In summary, art does not cover an intermediate territory, it is not in transit to absolute knowledge—that would make it a means that could be dispensed with. Art is independent of the constrictions of metaphysics, even though it partakes of the uncertainties of becoming. Only becoming affirms the endless proliferation of the new, in becoming phenomenon and ontology converge, producing, negatively, a plurality of "objects." Art, therefore, harbors within itself a certain kind of nihilism, the kind that, being relative, yields to the formation of the new.

## HERMENEUTICS

The concept of subjectivity is not essential for the understanding of art. This is what Gadamer says when he criticizes the view of art as lived experience and as the result of aesthetic consciousness. The work of art, especially the sublime, is capable of provoking the paradox of a "mute word." Yet, the artwork speaks, but in so doing it silences its impossible objectivity, that is why interpretation becomes essential. If it is indisputable, as Susan Sontag claims,[14] that a piece of art is allowed to mean nothing (and here its freedom resides), it is also true that such semantic neutrality can be inclusive of a more general meaningfulness pertaining to art as a whole—setting aside for the moment the isolated, single work.

Art's incompleteness made Hegel condemn it to the past. On the other hand, later thinkers have found that the value of art resides in its incompleteness. To recognize this point is to avoid the metaphysics of pleroma. Totality is excluded, since even if art may appropriate the results of science or of any field of knowledge, it cannot objectify them. On the contrary it subjectifies them in the aesthetic act, making them a

part of the whole that is given in precarious intuition, imagination, and fantasy. This fact makes the work of art potentially infinite, allowing an endless number of potential interpretations. Yet, it is also finite and therefore objective, but its objectivity is unstable, like its ideal, subjective meaning. Intuition provides these meanings, and this is why interpretation of a work of art is always deficient in terms of objectivity. This truth can be summarized by saying that art is confined to the finitude of a subject that knows what it does not know and does not know what it knows. Art recognizes this irony; consequently one purpose of aesthetics is to understand art's value as only approximating an harmonious truth. The true object of aesthetics, then, is the predilection for unexpected culminations.

How art is to be interpreted if there are no permanent canons by which to judge it is the question that must be answered. The danger, the great temptation of postmodern aesthetics, is to culminate in sociology, just as Hegel's ethical philosophy was said to dissolve into sociology.[15] Sontag's insistence on "banning" interpretation is therefore understandable, but unacceptable. Sontag is correct in rejecting the old distinction content / form; she is less correct in connecting interpretation to the notion of content. Content has been traditionally the reserve of the critic looking for a clear ontology for works of art, but content—of which Sontag says, with reason, that it constitutes a hindrance[16]—must be distinguished from meaning. Sontag's defense of style against content does not exclude meaning, which includes the style of the work. It is content that has lost its aura because it has been unmasked as ideology. But to say that interpretation represents a domestication of art as Sontag does would be defensible only if interpretation were to emulate art. This is not the case, since interpretation first of all functions as mediation between art and thought. If one claims that art is irreducible to thought since it is sensation and that it is susceptible only to visceral apprehension, what would be missed is style. Style is not only something grasped in an emotional ecstasy, for there is something epidermic and yet transparent about it as well. To think of style as the consummation of the work of art is to think of it as including the whole work.[17] But why should meaning be excluded from the aesthetic evaluation of art? Ultimately Sontag recognizes that content cannot be isolated from style even though it is posterior to style, and that is why, consistently, she attributes epistemological value to the art work: ". . . the knowledge we gain through art is an experience of the form or style of knowing

something, rather than a knowledge of something (like a fact or a moral judgment) in itself."[18] The object of knowledge is in this case left undetermined because what matters is the experiencing Self.

This totality which is style must be qualified. Sontag, in attacking interpretation, ends up by saying that, after all, only the single work of art has meaning, in that it displays a style which is individual and idiosyncratic, whereas art as a whole is meaningless. To say that it is meaningful would be to apply speculative criteria reminiscent of an outdated and indefensible metaphysics. It seems improbable that Sontag wanted to push her argument this far. Such a suspicion is bound to arise, however, from a text that focuses on the impoverishing role of hermeneutics. To focus on style is a universal way of approaching art, but it remains subjective if style is taken to be the medium that isolates and contains. Style must be seen as the immediate totality of both understanding and imagination. If style is something absolutely necessary to art, then it is necessarily subject to evaluation which must be done by interpretation. To admire art at the sensuous level is commendable but insufficient, if art is to be explored further, then meaning is intrinsically attached to it. Sontag writes that a work of art is free to mean nothing. Certainly, aesthetic theory and the public must respect the wish of the artist to declare war against meanings, even to defy art's raison d'être. Art may direct itself toward that path which nullifies its content. Content, and not meaning, is the equivalent of expression, therefore artists have the right to profess their nihilism in this respect. However, interpretation resists such reductions because it has the means to analyze any given content or lack of it.

Sontag reproaches interpretation for not being art, for reducing the work to the content. She implies that when content predominates it is more likely that a uniform view of art will take hold. There is some value in her approach, considering that style is more elusive than content, because content is easier to objectify in formulas. Content can always be brought to point to a conception that would subsume art under an extraneous category. These are the dangers.

Hermeneutics, however, is not structuralism, it is ready to recognize art as a historical process, distinguished from history but at the same time influencing history. Such an interchange avoids the dualism conscious / unconscious which would make the work of art a hybrid of the visible and the permanently invisible. Moreover, the invisible part of the work of art is not the idea of Beauty, or some pale semblance of it, or a definite content, it is that "not-yet" aspect from which hermeneutics extracts art's

philosophical relevance. Hermeneutics can advance without the notion of beauty, which, strictly speaking, is only a point of reference whose historical role has been eclipsed by a desire to abstract from an object (the beautiful) that had become too visible. The being of beauty has been explained either transcendentally or speculatively. Now, historically defeated, beauty is nevertheless worthy of historical consideration, and this is what Gadamer does with his defense of tradition. Gadamer is sensitive to the beautiful, but he is uncomfortable while facing modernism, which he tries to bring back to the impossible continuity of beauty. Even so, his historicizing is noteworthy since it allows us to relate to the past and also to venture (albeit cautiously) into the present and future, hoping that the recognition of the work of art will reside in its being the bearer of meaning, given its ontological value as presence.

Gadamer does not identify content with meaning;[19] he sees the meaning of a work of art as its unity plus its identity. Clearly, this calls for a hermeneutics of the individual work, the interpreter, or spectator, and the work are brought together immediately. We find here a dynamic conception of interpretation and art, within which "there is in principle no radical separation between the work of art and the person who experiences it."[20] The reasons for this are to be found in the continuity between the two processes of sensing and understanding, the result of using symbols in art. Whereas meaning is positioned between immanence and inexhaustibility, each interpretation is finite. At the center of the work of art one finds its meaning, inclusive of the organization of the work, its autonomous mode of being, and temporality. What is remarkable in Gadamer's account is the coexistence of immanence and transcendence, identified in play.[21] Not only artists transcend themselves through their meaningful play, but the works also transcend their own factual existence in displaying their meanings and in offering them for contemplation; they open up multiple possibilities.

Less acceptable in Gadamer's thought is his insistence on the continuity of tradition (artists know better on this issue) and his consequent neglect of the sublime in favor of beauty. Gadamer's devotion to the beautiful is an indication that he intends to take a middle position. However, the serenity of such a view is belied by the experience of the sublime. Perhaps Gadamer has avoided taking the sublime fully into account because he did not want to carry to the extreme the surplus which is, by his own admission, necessary to art. Now, the sublime is excess to the highest degree, it displaces the metaphorical beautiful while extracting from it its

extreme resources. Since it displaces the beautiful in this way, the sublime can hardly find a place in an aesthetics of harmony and continuity, devoted moreover, to the notion of mimesis. Although revised to exclude mere imitation, mimesis for Gadamer has to do with representation *in general*, with an orderly and proportionate representation.[22] In the sublime, in contrast, the idea of order is shattered, and its fragments assume the relevance of an unaccountable whole. Nevertheless, the partial rehabilitation of allegory, based on Gadamer's criticism of aesthetic consciousness (which is exclusively involved in symbolism) and on allegory's being connected to the *Logos* (which makes it a "hermeneutical figure") situates Gadamer close to contemporary sensibility. Allegory's displacements make hermeneutics an essential task. The different levels of meaning present in allegory, with meaning played one against another, leave the spectator with questions, and invite an intricate collaboration between what is revealed and what remains unsaid in the work of art.

Interpretation provides the tools by which art is opened to communication.[23] Thus, the possibility of meaning goes counter to the nihilism of those who declare the nonexistence or the outright impossibility of any value ascribable to art and use the infinite as an excuse to put aside the potential. In Melandri's words: "The infinite does not exist, or . . . if it does, [it] is not utilized."[24] Everything must originate from the finite, and art is the first human activity to multiply and transform the finite into specific experiences (*Erfahrung*, in Gadamer's words) to be admired. Even the sublime, strictly speaking, does not entail the infinite, since the sublime uses the finite and elevates it to imponderability. In recognizing this characteristic, one sees the parallel between the sublime and nihilism. Nihilism is the terrain out of which the sublime emerges in its full relevance. The sublime, anchored as it is to the perceivable, far from drawing us close to the infinite, reminds us that the infinite is illusory. The lack of a specific semantic value of the sublime and of nihilism excludes any form of mimesis, even the form advocated by Gadamer whose attempt at resuscitating the concept of mimesis by shifting its meaning from imitation to transformation[25] leaves open the question of the sublime.

The sublime is indeed a matter of style, and style has no correspondence in any object, however transformed—the sublime discloses the indeterminacy of the object. Furthermore, the sublime appropriates indeterminacy in order to alter the significance of the not-yet-seen, of the not-yet understood. Here one grasps the diffuseness, even the plenitude, of that *nihil* without which the sublime would be completely knowable and

thus reduced to non-art. Given this approximation of art to the *nihil*, one must ask the question of how the sublime, and art in general, can be a form of knowledge. Gadamer ascribes to art an ontological truth and a historical meaning, and the subject becomes an inessential intruder in that event which is art. The *nihil* is in itself the negation of being, but that negation, and with it the nothing, are created, just as, according to Christian doctrine, being was created, and created out of nothing. The nothing finds its place in a dialectic of pure thought, but also in the realm of art, where it acquires the prominence of the sublime and becomes the "object" of interpretation. The sublime is this nothing which subjectifies and objectifies itself out of sensuous paroxysm.

## THE UNCONSCIOUS SUBJECT

Let us not think that the subject, invoked here, coincides with a substance that would remain hidden were it not for its productions. The subject in question is bound to appear and disappear in its attempts at stability. Such stability is beyond its reach and is illusory, as the artwork is not. The subject is indeed nothing other than its productions; it does not, strictly speaking, create any reality. Fichtean idealism fails to grasp the relevance of what lies beyond the subject's reach, providing that "beyond the subject's reach" indicates the nothingness of the subject itself. In this sense art, and in particular the sublime, are creations that are constantly threatened with disappearance, but never do disappear because what is embodied in a work of art exceeds the precariousness of subjective tensions. Art is and remains nonsubjective precisely because a precarious subject makes it so through the aesthetic act. But to say that truth transcends art can be misleading on two counts. First, it implies that the work of art perpetually escapes us, second, it fails to acknowledge that the work embodies the intentionality of the artist. It is true, however, that the artwork is the result of a subjectivity which has put to use the teachings of nihilism. In this context, nihilism is the outcome of the self-abnegation of the artist as subject. It is unnecessary to resort to Lacan's theory of the split subject which is at the mercy of symbolic intersubjectivity, condemned to endure the unconscious in order to realize what is at work in art. There is some truth in this theory, but the fact remains that the unconscious explains only one aspect of the artistic process, not its final result. The unconscious is *not* everything, if it were, art would be a chaotic enterprise devoid of style. The unconscious adds to art and interpretation, but does not make them. The occurrence of

metaphor as an unconscious mechanism is far from giving us the finished work, and that is why psychoanalytic interpretations of art leave something to be desired, if they are not altogether misleading. (Consider Freud's attempt to interpret Leonardo da Vinci.) Lacan in particular poses more difficult questions, since he tried to "rationalize" the unconscious by making it homologous to language. After all, language is articulated, and so is the unconscious. The function of the subject of the unconscious is to produce symbolic mechanisms, but, since it is split between metaphor and metonymy (two devices that reach a precarious unity in full speech (*parole pleine*), a metaphorical elaboration of metonymic desire), the most that can be expected is a Platonic evocation of an imaginary unity. Yet, it is safe to say that Lacan's "full speech" is a sublation of sorts, allowing, as it does, the comprehension of symbolic acts.

The Lacanian subject of the unconscious has a significant role to play within the aesthetic domain, but only if the aesthetic is kept separate from the ethical dimension. From subjectivity something more can be extracted than an ambiguous collusion between the two dimensions, namely, the capacity to see beyond and to see through the already given structural determinations of intersubjectivity. The new must be included. The desiring subject, split as it is, does more than just reshuffling the cards. The subject so qualified invents the new by appealing to desire and by fleeing the chessboard to which the Law would like to limit it. It does not matter if an almost infinite number of moves are legal; the genius will find that move which will make her / him a dangerous advocate of the new. S/he reaches this point because subjectivity is permeated with negativity. Otherwise it could hardly act and would stagnate in an atemporal limbo. But it is not the subject (either collective or singular) that progresses; it is desire, which bursts forth by negating the structure of which it itself is part. We must admit that desire operates in an environment of cultural objects already given. It is no less true that it can escape the limits of the given—although, to be sure, at a high price. Lacan's tension between the static metaphoric symbol and its resolution in equally metaphoric but singular actions reflects every structural theoretical program. On the one hand, we have the historical sediments that have crystallized into unconscious oblivion, on the other hand we have the uncertain but salutary poiesis of transgression. Through the negativity of the subject, works of art become familiar and extraneous.

The work of art is anomalous, forcing the public and the artist alike to defer to the force lying at its source. Thus, the work of art is irreducible

to an act of narcissism, nor is it completely assimilated into what used to be called its "content." An aesthetic that takes into account only the content is easily confused with the ethics of the symbolic on which it is partially based. For art, according to Lacan, is not independent of the whole, it is the mimetic product of a signifier so insistent that it leaves no doubt as to its existence. Art's function, then, is to evoke and not to communicate, and so the repetitiousness of the message (the phallic signifier) excludes any real participation except a narcissistic gratification.

The way out of such a closed system can be found in an aesthetic theory that adopts a nominalistic view of art, as opposed to Lacan's symbolized "realism." By "nominalism" is meant an approach that does not declare the signifier to be ultimately an irremovable signified. In the end Lacan's theory breaks down the distinction he initially sought to keep, namely, the arbitrariness of the signifier. Nominalism secures the initial neutrality that is necessary if art is to be interpreted, if the message is too explicit art is degraded to the level of a commonplace. And it would be inaccurate to say that nominalism makes interpretation impossible, actually it makes it necessary and frees it from pre-given superimpositions. Interpretation *is* a superimposition, which is productive and inventive of meaning. The meanings so produced are *for* interpretation and are provoked by the work of art's openness to the not-yet-known. Also, in adopting nominalism we make abstract art more intelligible. The shock it used to produce is attenuated, since mimesis no longer represents an obstacle to our inventive capacity. In the end, it must be recognized that the shock value arises from the immediate presence of the work of art and from its interpretation, considering that interpretation makes the work signify beyond its presence. The dynamic quality of artworks (which demands a beyond-beauty) is the result of formal tensions, these are subsequently neutralized so as to appear aesthetically viable. The role of self-transcendence is clear at this point, since we see the static equilibrium of matter being transformed, in the work of art, into a subject-object which, strictly speaking, is neither subject nor object. Absolute subjectivity (or subjectivism) is too limited to account for the interactions that obtain between style and meaning, although style is particular to each individual artist, it also possesses the externality of an accomplished fact.

Nietzsche was correct in making style the mark of the artist and of the work of art, and Nelson Goodman too recognizes that style is a necessary condition of art's existence. According to him, in style are concentrated "certain characteristic features both of what is said and of how

it is said, both of subject and of wording, both of content and form."[26] Style comprises in a unity what is intrinsic and extrinsic, form and content. These fusions make the work of art a symbolic artifact integrating the "what" (the thematic complexity) and the "how" (the form). In style what is said is just as important as what is not said, thus, the subject qua artist and the "what" dissolve in preparation for another type of subjectivity, that of the interpreter. Not only do artists transcend themselves in forging works of art, but the public, also, and specifically the interpreters, transcend the initial neutrality of the work qua work when they are engaged in what is ultimately a value judgment. Reading, looking at a painting or a sculpture, listening to music are all acts of indirect communication. They exclude an acquiescent absorption on the part of the public either of the subjectivity of the artist and of the externality of the work, each act is a recreation and, therefore, also a relative misunderstanding of the works themselves. Direct access is not to be regretted as if it could be a panacea, a key to appropriating the work of art. The indirect road is preferable, and also unavoidable, since a work of art is a-logical in its consequences. Even artists may be unaware of the implications of their works, because they are themselves the result of a historical and ahistorical sensibility. Thus, it is said that desire progresses more than human understanding. The subject is incapable of comprising all the possibilities given in history, history and the subject are caught in their own respective disorders. To determine more precisely what is at issue in art from the viewpoint of the subject it is necessary to realize that the unity of the artwork is something other than that of the subject, which is divided into consciousness and the unconscious. The symmetry between work and subject is never complete, therefore the specific recognition that art demands, and deservedly so, is always defective and indirect. It is not a matter of subject and object mirroring each other. On the contrary, the subject is fragmented in the artwork, and the artwork displays, in its unity, traces of subjectivity.

    It is instructive in this context to consider the sublime. The sublime is the best demonstration we have of what the subject (inclusive of its conscious and unconscious aspects) is capable of achieving in terms of negating itself. The sublime annihilates the certainty of the subject even of being a mere symbolic entity; it transports the subject to that limit where comprehension is obtained at one's own expense. Yet, it may not be all that sinister if the subject has already accepted its own extraneousness, then the fascination of the sublime will be less violent. In an age in which

everything seems objectifiable, the sublime resists such regimentation and ordering, and since it does not refer to any discernible object, it is compatible with the notion of artistic neutrality notwithstanding its impact on the sentient Self. What is left to the admiring reader or listener is to acknowledge the sublime's unparalleled abstraction—beyond good and evil, Nietzsche would say—and that is exactly the case, because in "the beyond good and evil" is found the extraterritoriality typical of the sublime. All this is no outright nihilism, for nihilism negates, and therefore believes that there still exists something to destroy, namely, the given. The sublime outlasts nihilism, and it does so by reaching its maximum effect on first appearance. Afterwards we devote the same attention to the sublime that we devote to the beautiful.

Modernism in art had been an attempt to demonstrate the misconceptions present in the dichotomy subject / object. Nihilism, which emerged at the same time as a reaction to the lack of correspondence between subject and object, did not finally prevail, the reason being that modernism replaced the traditional value of beauty with the new values of form and style. Modernism, in its first inception, was thus the result of a crisis. What had to be accepted was the notion of an out-of-reach subject, no longer consciously active. The discoveries of psychoanalysis were in this respect a determining factor, since psychoanalysis taught us that the rational Ego dies,[27] to be replaced by the dynamic forces immanent in both the vital impulses and the destructive ones. The consequent process of mourning produced what is usually called "decadentism," particularly evident in the literary and poetic spheres. In the end the crisis was overcome by recognizing that form and style could sustain a new conception of art, or that commitment to an outside cause was necessary to save consciousness from oblivion.

Another route was to appropriate and distort those very structures which had made possible the formation of a meaningful language. This was the task of the avant-garde, which made the subject surrender to form. A task that was possible only because the subject is form itself, but a form that cannot know itself.

## THE INEFFABLE

Even if we were ready to accept that art is mimetic, art would still be partially incomprehensible. Art qua ineffable is indispensable, without this quality art would be banal. The ineffable persists in the esoteric allusions

of an art uprooted from reality and truth. When Pessoa in his *Faust* mentions an unqualified and pervasive horror, he is addressing the whole, the bearer of an unthinkable truth so threatening and silent as to be abortive. Truth is not for everybody, those who succeed in transposing it into art are the Overmen who have overcome the limits of insanity. And post-insanity is now postmodernism.

Much has already been said about the postmodern condition in the grips of which the only remaining possibility is that of exchange. In this historical context, Lyotard says that artists "must refuse to lend themselves to . . . therapeutic uses."[28] They should stop reassuring a debilitated and already anxious public. Thus experimentation is desirable, whether it is viewed with suspicion or not. As a matter of fact, experimentation is expanding if we think that a generalized neo-avant-garde has invaded every corner of the world and has become in this way academic. Lyotard is right, though, when he says that art "present[s] the fact that the unpresentable exists"[29] in the "form" of the sublime which carries no knowledge and no consequences. Schematizing, Lyotard defines modern art as that sublime art which is nostalgic about the existence of the subject (the unattainable) and whose purpose is procuring pleasure. Postmodern aesthetics, instead, has eliminated the pleasure of the form and "invent[s] allusions to the conceivable which cannot be presented."[30] This is an avant-garde position. However, Lyotard minimizes the divergence between modernism and postmodernism. Since it is evident that art, duly submitted to time, excludes absoluteness (it would be wrong to think that time and history do not leave their mark on the artwork), postmodernism takes into account this fact and translates it into a deterministic facsimile whose permanence is constantly in doubt. Taking history into consideration, a history deprived of any teleological meaning, puts us in a precarious position, it makes us all the tightrope walkers of becoming, as Nietzsche well understood. After all, art is still possible whether the subject is its determining factor or not, and whether the beautiful, having fascinated even the more obtuse part of the public, has declared itself to be eternal or contingent.

Given this "background," aesthetics must be conceived of as interpreting that *quid* which is the work of art produced by the process of self-transcendence. No return to an impossible all-knowing subject is implied here. The Faustian motif put forth in the first chapter must instead be interpreted as the result of an active force and movement internal to the subject (understood as the merely contingent receptacle

of such forces). Also, by being transindividual, this force makes possible the absorption of the new and the old. The interaction of these factors is far from reproducing the status quo. If becoming has any meaning it must be sought in the interplay of conscious and unconscious motifs, that is, the new and the old.

Since the discovery of the unconscious, we have become aware that the unconscious functions as a catalyst. Consequently, the work of art can be seen as that which includes within itself the resolution of the internal contradictions of subjectivity. In other words, to define art requires that we define the unconscious and consciousness. The unconscious is not a deus ex machina operating on its own; it is not an ontological, real object. It is a function, and, just as that which is produced through consciousness affects the unconscious, so the reverse obtains, that is, the unconscious affects consciousness. In brief, the unconscious is a mediator—an overbearing mediator, to be sure, but still something that leaves room for consciousness. And if the unconscious is not an object, so its complement, consciousness, is not a subject.[31] The unconscious indicates a "loss of objectivity," since "once it has been established that the object is self-contradictory, it can be identified only negatively: we can only say what it is *not*."[32] Schelling, however, was right when he attributed to the unconscious a role in the overall economy of his thought and to say that what is unconscious functions as the intermediary between subjective and objective. Nature is per se unconscious, while the Absolute, qua unity and identity, consists of both consciousness and the unconscious. In art these considerations lead to the tentative awareness that finite and infinite coincide, at least ideally. Considering the role of the unconscious, art has acquired an additional meaning, making art more problematic and ineffable than ever. Art, being also the result of the difference between subjective and objective, is not just a perspective among others; and one possible philosophical assessment of art rests on the fact that lack of absolute objectivity does not lead to catastrophe, even though it has cost us the loss of beauty.

Surely, the sublime can take the place of beauty; having been from the start subjective, the sublime has emerged now as the sole artistic possibility. In truth though, considering the actual artworks produced at the present time, we are witnessing a decline in the dimension of the sublime. Yet, in order to speak meaningfully of aesthetics, this "object" is necessary. The alternative, postmodern art, has taught us only what was already known, namely, that images, sounds, and words have ineradicable repercussions on

art's symptomatic fabric, the making of art becomes a reflection, a symp-
tom, of society at large. For psychoanalysis also art is a symptom, but it is
interpreted differently. Art is symptomatic of unconscious forces expressing
themselves through material symbols. Thus, psychoanalysis, by making ref-
erence to something conceived ontologically, puts forth the object in order
to explain, or interpret, the content of an artwork. This content is the
unconscious itself which has passed through all the inconveniences of dis-
continuity. In this respect Lacan is instructive. Art is the result of symbolic,
unconscious activity which can make all of us poets, though not necessar-
ily good artists. When the metaphorical use of intermingled signifiers
evokes the inexpressible other that is within ourselves, one speaks poetically,
not yet artistically.

Poesy's disadvantage over art is that it is private, but it compensates
by being a meaningful, albeit finite, metaphor. Also, poesy partakes of the
unconscious, which is and remains a negative notion even when it is
"objectified" in the work of art. The work of art is a continuation of that
negativity established for the first time by the unconscious. But the art-
work transgresses even the constraints of the unconscious, with the con-
sequence that its symbolization goes beyond the limits of the Law. If it
were otherwise art would become self-referential, and second, it would
recount the endless, structural conflict between metaphor and metonymy,
which, *nota bene*, seems to be placed outside time. Therefore, what can be
called the "content" of art becomes a form antagonistic to another form,
so much so that metonymy and metaphor try to exclude each other. This
is the same as saying that there is no content and no object in an art so
conceived, except for the reverberations of evocative forms excluding
every contact with intuition.

Is this nihilism? If nihilism is defined as the "total loss of semantic
aura, allusiveness, and allegorical mobility,"[33] then, Lacan's theories shut
the door on the aura of subjectivity, undermined by a radical finitude out-
side of any utopia. What Lacan does, however, is to reinstate the priority
of symbolism, which can be interpreted as instituting a *post-mortem* aura.
Following Cacciari's line of reasoning, which connects fulfilled nihilism
with utopia, one is obliged to recognize the impossibility of aura. The loss
of the auratic unity is demonstrated particularly well in architecture,
where the rationalization project of the twentieth-century's metropolis, in
which logocentrism has come to predominate in its presumed absolute-
ness, means also the annihilation of tradition and symbolism. The sym-
bol, in Cacciari's view, is transformed into the invisible, but the road that

started with nominalism has led to a contradiction between utopia and the project. The will to power of rationality and autonomy cannot reckon with temporality, with the contingent, utopia then is forced to reintroduce symbolism, which was at first set aside by the process of scientific geometrization. Modern architecture is nihilistic because it mythifies the will to power to the point of justifying "the interminable productivity of technique"[34] which, in turn, stands for the negation of value. After such a devastating analysis, there remains no room for either subjectivity or self-transcendence, the transparency of the project has eliminated, maybe once and for all, the possibility of the thinking subject. No nostalgia is advisable or possible, since, as Cacciari says, "the crisis is structural" to the system. The project is the antithesis of the subject who cannot emerge as autonomous. However, the subject is a symbolic "entity" which is perfectly capable of assimilating those linguistic structures which will make it vacillate between metonymy and metaphor and between project and utopia. Because of this the possibility (some would say the probability) of misunderstanding is inherent in art; this not necessarily negative fact is the result of art's overdetermination which opens the way to a multiplicity of interpretations.

Nihilism does not coincide with the possibility of misunderstanding, even the equivocation potentially intrinsic to the artistic act negates nihilism. To the objection that the act is per se nihilistic, the only answer that can be given is that it corresponds to an additive *nihil*. Moreover, the void to which art is one answer is pervaded by the dialectical movement of a negativity that appropriates itself. The process is partially conscious, the unconscious exchanges roles with the conscious, with the consequence that they interact chiasmatically. The interaction results in a clash, leaving little room for a perfect sublation (harmony). The *nihil* has accomplished what would have been impossible without its "intervention," namely, art has freed itself from the constraints of beauty. Before the unfolding of nihilism art was of a different sort, it was devoted to the beautification of a world that was considered from the start already endowed with beauty.

However, there has always been another trend, opposed to harmonious art. Numerous examples can be brought to mind. Suffice it to mention the art of the late Renaissance, which, along with the beauty and composure of its portraits, produced the disorder of the sculptures at Bomarzo in Lazio, erected in the park of Vicino Orsini around 1564, representing monstrous animals and giants. It is inappropriate, then, to identify the art

of the past as always embodying harmony. Yet, even in the presence of these anomalies, aesthetics has concentrated on the symmetries and proportions of works of art as if those attributes constituted an "ought." In aesthetics the "ought," borrowed from ethics, makes art overly rational and excessively narrow in scope. In the end it deprives it of the freedom to contradict and question rationality. Now that the "ought" applied to aesthetics is disappearing from our vocabulary, we are left with eclecticism and with the resurgence of nihilism, nihilism that Hegel had already seen inaugurated by romantic art. What once was form, with its rules, has become style, and style in all its nominalistic purport has been transformed into a subdued anarchy. What is still with us now is the ineffable, that element which separates art from the commonplace.

## TRAGEDY AND COMEDY

The question that confronts us following the rise of nihilism is twofold: whether the existence of art is indicative of tragedy or of comedy, and whether this division within art is destined to be resolved. Initially, Nietzsche had no doubts concerning the first question, for him art is tragic because everything else is tragic. The eternal recurrence of the same, the transvaluation of values, they all "reassure" humankind that the time of facile feelings, of scripts that offer abundant opportunities for playing, is over. Later Nietzsche introduced lightness and laughter in his discourse, but his is a tragic laughter, derived from the conviction that tragedy precedes awareness of the comic. The second question concerns the issue of whether nominalism or neutrality can save us from both tragedy and comedy, whether it can provide the occasion for overcoming both viewpoints. The aesthetic is the result of the tragic, which, both metaphysically and phenomenologically, addresses the essence and meaning of our being. Comedy avoids this standpoint by relying on a phenomenological, playful frivolity that is oblivious of lofty principles. When comedy prevails one can stand assured that nothing definite has been said or uttered concerning ultimate truths. Comedy is more skeptical than tragedy, it is also more nihilistic, since it puts into question those values which draw us close to the divine or which make us worthy of esteem. Comedy banishes the Overman and any sense of destiny, whereas tragedy dwells upon it. These observations are true if the comic is seen in isolation from the tragic, but Nietzsche refused such a stand. He held, rather, that the tragic becomes comic by the "simple" intervention of laughter.

Comedy, broadly understood, encompasses a whole Weltanschauung comprising the most diverse artistic genres. In painting this mode is explicit in the works of Paul Klee, whose joyous levity finds its counterpart in the meticulousness of the execution. Klee's is a kind of comedy that only touches upon action, and rightly so, since to resort to action would mean to run the risk of encountering tragedy. In the painting entitled *Comedy* (1921), Klee's comedians are the best possible comedians because they are "at rest," such imagery avoids the often lamented vulgarity (at least potential vulgarity) of comedy. Their repose, though, is negated in part by their precarious equilibrium, we see that the central figure is unbalanced, her feet resting on an even more unbalanced figure. The other figures (whose sex is left to the imagination of the viewer) are slightly separated from the "protagonist" who seems to be dancing and eager to hold in her hands a recalcitrant hat. The colors of the painting are sober, as are those of the background, shading from green to yellow. The background itself is a series of horizontal lines, darker on the upper-central part of the canvas—an expedient that puts into relief the lighter colors of the human figures. The horizontal lines symbolically indicate the rational and severe negation of comedy; they represent its antithesis. But the final affirmation is in favor of movement, since the overall impression of the painting is one of mild distress. By alternating movement with rest, Klee is telling us that comedy cannot dispense with its opposite, that is, the rational; this is what makes the comedians in the canvas hesitant vis-à-vis action. They even doubt the very possibility of comedy, and in so doing it seems that they are waiting for the spectators' permission to go ahead with their show.

Comedy is transgression and, therefore, always on the brink of falling into the void, it is certainly close enough to catch a glimpse of it. The void can be vital, if by "vitality" we mean the inherent danger and precariousness of every human endeavor, which acquires value in proportion to its danger. At this juncture it is possible to establish an affinity between the comic and the sublime, for in both experiences there is risk of tragedy. Truth is near, and this truth is not comical, it is tragic, since it teaches us that human beings are bound to a destiny that contradicts any positive anticipation. Tragedy is the result of the clash between the human and the nonexistent, providential deity.

Both tragedy and comedy are aesthetic modes that can be appropriated by every art form, but it is more interesting to recognize that art itself can be viewed either as comedy or as tragedy. Schiller sides with

comedy, for him art is play. Nietzsche sides with tragedy, for tragedy is more appropriate for acknowledging the contradictory drives at work in our "double brain," one part looking for constant stimulation and the other in need of peace.[35] Play is less forceful than tragedy, since it is levity, whereas art is tragedy transformed into words, sounds, and colors. The more life intrudes into art and the more art intrudes into life, the more striking is the correspondence between art and tragedy. That art is intrinsically tragic is a conviction derived from the recognition of the minor role of beauty in art, both as idea and as *telos*. Likewise, art is detached from morality and from usefulness; all these are now seen as deficiencies. Finality now speaks for something different, namely, for the culmination of art in tragedy.

The useful and the moral pacify. This is their function, and that is why art, as tragic, runs the risk of falling into a marginal position vis-à-vis its more effective opponents. The tragic, in contrast, defines the role of art, which is to demand from both the artist and the public a commitment to its tenets. This commitment involves the recognition that art is alone in providing its specific *telos*. This judgment denies any romanticism, it is rather the acknowledgment that art is close to the nihilism it wants to negate. But even when tragedy prevails, this is not enough to convince us that art must confine itself to admitting its failure vis-à-vis pleasure. If we ascribe to art the task of providing *consolatio*, we must admit that consolation is different from pleasure, for pleasure implies a partially active role on the part of the public, and consolation is a pale substitute for enjoyment. The issue of pleasure should not trouble us: since Freud, the opposition between pleasure and pain has been explained away in favor of a combination and constant transformation of the two, and not only in pathological cases.[36] A tragic, even tragicomic view of the world of art accepts this ambiguity as fundamental and as heuristically fruitful, since it puts into relief the abundance of art's aims and at the same time recognizes the finitude of its triumphs.[37]

Hegel, once more, represents the divide, in denying a logical role to the beautiful, he exposes it to a necrosis with no appeal. An aesthetic without beauty as its foundation is nihilistic, but not yet tragic, since irony and comedy provide the corrective to the tragic view. What is meant is that the tragic lies at the basis of irony and of the comic. Nihilism is not properly tragic; it is, rather, the void negated by tragic pathos. As a point of departure first, and of arrival afterward, the tragic

counteracts nihilism, whose influence would expand indefinitely if it were not for the meaningfulness of the tragic. Given this advantage, art, unable to seize beauty in its serene vanishing, appropriates the tragic as its own. Once these considerations are accepted, it follows that nihilism and tragedy go in different directions, since to the former belongs a whole Weltanschauung, to the latter the awareness of the human finitude. Nihilism, once it has come to the surface, proclaims the universality of tragedy, seen as no longer tied to the suffering of the isolated person but as pertaining to the whole.

Paradoxically, the nihilist is capable of laughter, since tragedy generalized requires a final detachment. Laughter is this detachment and it is destructive, whereas tragedy demands empathic participation. Thus, we find an alternation of tragedy and comedy, for their positions are interchangeable. The comic can play the transcendental role of grounding the distinction between tragic and comic—this happens when the comic coincides (by approximation) with nihilism. Inversely, the tragic can play that same role when its impact is temporally dissociated from the comic, then we have first tragedy proper and then a resolution (this is Hegel's answer). The relevance for aesthetics of tragedy, comedy, and irony (irony being the precarious fusion of the first two) is to be sought in their universality, and therefore in their capacity to present themselves as possible components of each work of art. These modes or mythical components—mythical in the sense that, without mythologizing, they present themselves as an alternative to the lack of meaning, are compatible with a final neutrality or nominalism.

At first glance there is nothing neutral in tragedy, comedy, or irony. However, a neutralizing effect is operative in the apprehension of these modes. Irony in particular, which involves detachment from the absoluteness of values, is closer than the two other modes to neutrality since it abandons the purely tragic and comic visions in order to put itself at the service of a neutralizing synthesis. It does so by having the tragic and the comic clash and collapse into a sequence of irresolutions. For instance, by general admission Paul Klee's paintings are ironic because Klee knew how to reverse the two realms of the human and the scientific in favor of neither, pointing now to the one, now to the other. There is a lot that is indistinct in irony as it has been described in the literature, first of all its paradoxical nature, which makes it possible for irony to say that $A$ implies $B$ and $B$ implies $A$.

This accounts for its horizon's being so vast as to appear infinite. Among the possibilities of irony one finds its ability to function either as background or as foreground for the tragic and the comic. In both cases it neutralizes their metaphysical propensities, which are in evidence when they refuse to metaphorize their preconditions. Also the tragic and the comic may be inclusive of neutrality. In the tragic neutrality is reached via catharsis, whereas the comic neutralizes the predominance of any signified or signifier by equating the two levels of discourse and eliminating the hierarchy usually associated with them.

Irony's role in art, given its neutrality vis-à-vis tragedy and comedy, is to resolve the opposition between nihilism and escapism. Whereas nihilists can be artists who are committed to their art and at the same time declare its limited significance (hence their irony), escapists ignore irony and any aesthetic ambition. They are unable to say whether what they have in front of them is art or not, relying instead on the authority of the museums or the theater to guide them through art. Escapists are unwilling to understand that art is something to fear. The sublime, for one thing, is beyond their comprehension, and they consequently retreat from it. The nihilistic aspect of art, instead, unsettles the quotidian conceptions of the "they" because it speaks of a possible annihilation of truth. To look for a sanctuary in irony is to bring to light the new, to perturb what remains of the semantic and ontological convictions of the past. This means that if critical irony is rejected, what remains is to devote oneself to the surface of things, here the status quo acquires its peculiar significance, and its name is historicism or tradition.

### SUBLIME SUBLIMITY

What goes counter to tradition is the sublime, whose subjective character has been elucidated in these pages, where it has been said that subjectivity is the *definiens*, not the *definiendum*. Concerning the sublime an analogous approach is justifiable. But let us remind ourselves that the sublime is or can be subliminal and therefore ineradicable from the mind. Conservation and restoration are the imperatives in the case of beauty. In the case of the sublime one must rely also on what is eminently fleeting, yet lasting in recollection. In order to reach its maximum the sublime must exclude even tragic irony which it ultimately abhors. Instead elation and wonder are the states of mind typical of the sublime which, as we know, cannot be induced or evoked on command.

## CONCLUSION

It is time now to conclude and summarize the theses that have been put forth in these pages. The first consideration concerns the fact that a subjectivist evaluation of art is unavoidable, even considering that art is truth. This particular truth tells us that art is, first of all, experiential. Although the "artistic object" is undeniably present in its givenness, it would be devoid of meaning if it were not for the fact that an intentional subjectivity intervenes to evaluate it also in its "objective" form. However, we must be clear as to the limits of subjectivity, since art is the result of an aesthetic act which is nonsubjective. The truth of art, therefore, lies in those evaluations that take into account both style and the potentiality for meaning hidden in the artwork. This process is particularly evident in the sublime, which never exhausts its potential, so much so that it merits to be called the most compelling, significant, and highest point art can reach. To restrict art into a definition is thus impossible; the most that can be done is to put forth different categories and examine them as to their heuristic value. We have discovered the new, first of all, as one essential component of art; this aspect has an objective, ontological, and even an experiential value. If subjectivity is unavoidable in matters of art, it cannot be forgotten that its correlate helps to form the basis of what is artistically valid. Art, and with it aesthetic theory, is limited by both the objective and the subjective dimensions. This encounter between "equals" produces the constant transformations typical of high art and establishes the locus of art. It is a locus lacking absolute stability, and this is why it gives us the ontologically new, whose role is to shake old convictions and rules.

Being neither necessarily beautiful nor ugly, art has a cognitive value that depends on the opening of a free ontological space within which subjectivity operates without detriment for logical truths. In this case, truth is more experiential than strictly epistemological. It follows that the best tool available to understand art is interpretation. Interpretation, which is always an approximation, intervenes to acknowledge that art, devoid of truth, would be reduced to simple (or complex, for that matter) sense and perception. These are insufficient elements, considering that an art so reduced would be, to a large extent, unintelligible. Instead, art is intelligible even when it is not mimetic, a characteristic that is particularly evident in the sublime. With the experience of the sublime, the subject encounters its own negative limit (both conscious

and unconscious), so that it cannot know absolutely. There is always something indeterminate in the sublime which shows that a persistent element of art is the ineffable.

We have seen how the sublime is a direct response to nihilism. In negating it, the sublime stands for a culmination beyond which art cannot go; if art were to go beyond, it would encounter that same nothing from which it was trying to escape. Faced with nihilism, there are other possible answers to which art can resort: tragedy, irony, and comedy. Tragedy is that response which affirms nihilism's right to enter our consciousness in order to sublate it through stylistic means. Irony combines together and neutralizes both the tragic and the comic. This additional complexity makes irony that particular accomplice of nihilism which adds to it all the ambiguities and the uncertainties of becoming.

As we have proceeded, we have discovered that art's main purpose and meaning reside in the truth of the encounter between a subject always in the making (and thus a nonsubstantialistic subject) and an objectivity which is equally elusive in that its metaphysical essence is unknowable. Art adds to these parameters the supplementary meaning of something that, being new, makes room for style and content. Style makes art, but it can also become a fruitless end in itself. If style were not assisted by a content understood as the expression of an elusive "object" of thought, the imaginative process of the artist would end in a vacuum. These processes depend more on the modality of the possible than of the actual—so much so that realism is excluded as a viable alternative to high art. Additionally, realism would delimit art to a combinatory of preestablished and preidentified referential components that would deny the new. The new, as it has been described in these pages, confronts this problem by declaring itself to be neutral vis-à-vis any ontological *ens*. Thus, the way is open to an expansion of aesthetic experiences, the ultimate beneficiaries of style. Also, to determine what is significant in art, one must consider whether the new has found expression in a unitary form. Yet this form must not be such as to constrain the potentiality for meaning; in other words, the artwork may overstep that same form in such a way that a definite structure is unable to contain it. This is why art can be called that activity that defies the given; an art that avoids this "responsibility" is destined to remain ineffectual.

One of the tasks of aesthetics, besides expounding the categories that explain that recurring event which is art, is to reject those attempts that deny the intelligibility of the new. And, as we have seen, the new is

ultimately the result of a subjectivity which displaces itself in order to leave room for truth. The resources of the new, by which is also meant the potential, are almost infinite; the artists themselves are aware of this and enjoy the privilege of experimenting with their own resources. A timeless modernity is all here: Faust, the emblematic figure of Western culture, has learned "how" but also "when" to venture into the new. By the same token, no philosopher can deny the relevance of an activity intended for the few and / or the many.

# Notes

## Chapter 1

### THE BIRTH OF AESTHETICS

1. Friedrich Schiller, *On the Aesthetic Education of Man—In a Series of Letters*, trans. Elizabeth M. Wilkinson and L. A. Willoughby (Oxford at the Clarendon Press, 1967), p. 197.

2. Ibid., p. 103.

3. Ibid., p. 157.

4. Ibid., p. 69.

5. See Enzo Melandri's notion of complementarity between empiricism and rationalism in *La linea e il circolo—Trattato logico-filosofico sull'analogia* (Bologna: Società editrice il Mulino, 1968), pp. 762–763.

6. Schiller, *On the Aesthetic Education of Man*, p. 139.

7. Ibid., p. 125.

8. Jean-Paul Sartre in 1948 will appeal to the *Cité des Fins* to describe the relation that is established between the freedom of the reader and the literary work of art. See *Qu'est-ce que la littérature?* (Paris: Gallimard, 1972), p. 325.

9. Schiller, *On the Aesthetic Education of Man*, p. 197.

10. Ibid., p. 195. The Aristotelian theme of mimesis, so successful as to have become commonplace, is still present in Theodor W. Adorno's *Ästhetische Theorie* (Frankfurt am Main: Suhrkamp Verlag, 1970), and in Hans-Georg Gadamer, albeit in the latter with some qualifications. See Hans-Georg Gadamer, *Truth and Method*, trans. Joel Weinsheimer and Donald G. Marshall, 2nd ed. (New York: Crossroad, 1990), pp. 113–115. Gadamer connects art with play and imitation; play is itself imitation, which in turn is representation and recognition. Mimesis is in this case the antidote to a theory of aesthetics based on fantasy.

11. Schiller, *On the Aesthetic Education of Man*, p. 57.

12. Ibid., p. 111.

13. Ibid., p. 103.

14. Ibid., p. 47.

15. Ibid., p. 197.

16. Edward S. Casey, *Imagining—A Phenomenological Study* (Bloomington and London: Indiana University Press, 1979), p. xv. Casey favors "imagining" over "imagination" in order to stress activity; he retains the substantive imagination to indicate "the complete phenomenon, composed in each case of an act phase and an object phase." I will privilege the term "imagination" while discussing Schiller, the term he himself used.

17. Ibid., pp. 127–173.

18. Schiller, *On the Aesthetic Education of Man*, p. 167.

19. Gianni Vattimo, *Le avventure della differenza—Che cosa significa pensare dopo Nietzsche e Heidegger* (Milan: Garzanti, 1988), in particular the third essay: "Nietzsche e la differenza," pp. 71–94.

20. Heidegger opposes any reductive, biological interpretation of Nietzsche's thought. He is right to the extent to which biology and metaphysics operate on different conceptual and methodological planes. This does not mean that the two tendencies are absent in Nietzsche. See *Nietzsche*, ed. David Farrell Krell, 4 vols. (Harper-SanFrancisco, 1991), 3:39–47.

21. Ibid., 2:57.

22. Ibid., 4:202–203.

23. Georg Hegel, *Hegel's Phenomenology of Spirit*, trans. A. V. Miller (Oxford University Press, 1977), p. 388, and p. 400.

24. Martin Heidegger, *Being and Time*, trans. John Macquarrie and Edward Robinson (New York and Evanston: Harper and Row, 1962), p. 226: ". . . our immanent perception of Experiences [*Erlebnissen*] fails to provide a clue which is ontologically adequate."

25. Manfredo Tafuri, *Ricerca del Rinascimento—Principi, città, architetti* (Turin: Einaudi, 1992), p. xix.

26. Jacques Lacan, *Le séminaire de Jacques Lacan, Livre VII, L'éthique de la psychanalyse—1959–1960*, ed. Jacques-Alain Miller (Paris: Éditions du Seuil, 1986), p. 370.

27. Mikkel Borch-Jacobsen, "*Les alibis du sujet (Lacan, Kojève et alii),*" in *Lacan avec les philosophes* (Paris: Albin Michel, 1991), p. 307.

28. Ibid., p. 310.

29. Pierre Boulez, *Le pays fertile—Paul Klee* (Paris: Gallimard, 1989), p. 127, and p. 87.

30. Experiments have been done revealing that a person understands more than s/he can actually express in language.

31. Jacques Derrida, while discussing Lacan's interpretation of *The Purloined Letter*, criticizes him for privileging the triadic structure rather than a quaternary schema. See "The Purveyor of Truth," *Yale French Studies* 52 (1976):31–113, 48.

32. Jacques Lacan, *Écrits* (Paris: Éditions du Seuil, 1966), p. 381.

33. Lacan, beside his famous "*ça parle*," also mentions "it thinks." Jacques Lacan, *Écrits—A Selection*, trans. Alan Sheridan (New York: W. W. Norton and Company Inc., 1977), p. 193.

34. Martin Heidegger, *The Principle of Reason*, trans. Reginald Lilly (Bloomington and Indianapolis: Indiana University Press, 1991), p. 48.

35. Enzo Melandri, *Contro il simbolico—Dieci lezioni di filosofia* (Florence: Ponte alle Grazie, 1989), pp. 65–66.

36. Ernst Bloch, *The Principle of Hope*, trans. Neville Plaice, Stephen Plaice and Paul Knight, 3 vols. (Cambridge, Massachusetts: The MIT Press, 1986), 3:1011–1022.

37. Ibid., 3:989–993.

38. Ibid., p. 1018.

39. Friedrich Wilhelm Joseph Schelling, *The Philosophy of Art*, trans. Douglas W. Stott, Theory and History of Literature, vol. 58 (Minneapolis: University of Minnesota Press, 1989), p. 242, and pp. 277–278.

40. Schelling notes that "The subject as subject cannot enjoy the infinite as infinite, yet it is a necessary inclination of that subject." Ibid., p. 276.

41. Georg Hegel, *Hegel's Aesthetics—Lectures on Fine Art*, trans. T. M. Knox 2 vols. (Oxford at the Clarendon Press, 1975), p. 1224.

42. Ibid., p. 1199.

43. Ibid., p. 1232.

44. Georg Hegel, *Hegel's Science of Logic*, trans. A. V. Miller (New York: Humanities Press, 1969), pp. 105–106.

45. Ibid., p. 105.

46. Heidegger, *The Principle of Reason*, pp. 33–34: "That in such an age art becomes objectless testifies to its historical appropriateness, and this above all when non-representational [*gegenstandlose*] art conceives of its own productions as no longer being able to be works, rather as being something for which the suitable word is lacking."

47. Ibid., p. 57.

48. Friedrich Nietzsche, *The Will to Power*, ed., and trans. Walter Kaufmann and R. J. Hollingdale (New York: Vintage Books, 1968), p. 435, paragraph 822.

49. Thomas Mann, *Doctor Faustus—The Life of the German Composer Adrian Levenrkühn, as Told by a Friend* (New York, Vintage International, 1992 (1948)).

50. Fernando Pessoa, *Fausto—Tragédia Subjectiva* (Lisboa: Editorial Presença, 1988).

51. Paul Valéry, "*Mon Faust*," *Oeuvres*, II, ed. Jean Hytier (Paris: Gallimard, 1960), 1.2.

52. Ibid., p. 402.

Chapter 2

ART AS THE ORGANON OF PHILOSOPHY

1. Schelling, *The Philosophy of Art*, p. 23.

2. Ibid., p. 6.

3. Ibid., p. 16.

4. Ibid., p. 109, and p. 161.

5. Ibid., p. 165.

6. Melandri, *La linea e il circolo*, p. 1074.

7. Schelling, *The Philosophy of Art*, p. 40, and p. 23.

8. Ibid., p. 29.

9. Ibid., p. 30.

10. Ibid., p. 37–38.

11. Ibid., p. 202.

12. See Friedrich Wilhelm Joseph Schelling, *Ideas for a Philosophy of Nature*, trans. Errol E. Harris and Peter Heath (New York: Cambridge University Press 1988), p. 19.

13. Schelling, *The Philosophy of Art*, p. 45.

14. The defect of meaning is that, by itself, it is unidirectional; it separates image and concept, and, consequently, does not provide objectivity.

15. Schelling, *The Philosophy of Art*, p. 67.

16. Ibid., p. 75.

17. Ibid., p. 77.

18. Ibid., p. 81.

19. Martin Heidegger, *The Metaphysical Foundations of Logic*, trans. Michael Heim (Bloomington: Indiana University Press, 1984), p. 129.

20. Ibid., p. 153.

21. Ibid., p. 184: "The genuine phenomenon of transcendence cannot be localized in a particular activity, be it theoretical, practical, or aesthetic."

22. Ibid., p. 182.

23. Jean-François Lyotard, *The Postmodern Condition: A Report on Knowledge*, trans. Geoff Bennington and Brian Massumi, vol. 10: *Theory and History of Literature* (Minneapolis: University of Minnesota Press, 1984).

24. Ibid., p. 81.

25. See Paul de Man, *Allegories of Reading—Figural Language in Rousseau, Nietzsche, Rilke, and Proust* (New Haven and London: Yale University Press, 1979), p. 116, in which de Man opposes "historical" to "allegorical," the teleological to the repetition of "a potential confusion between figural and referential statements."

26. Friedrich Wilhelm Joseph Schelling, *Philosophie der Offenbarung*, 14 vols. *Werke*, (Stuttgart / Ausburg: J. G. Cotta'scher, 1856–61), vol. 14, lesson 37.

27. Schelling, *The Philosophy of Art*, p. 103.

28. See Friedrich Wilhelm Joseph Schelling, *System of Transcendental Idealism*, trans. Peter Heath (Charlottesville: University Press of Virginia, 1978), p. 227.

29. Edmund Husserl, *Logical Investigations*, trans. J. N. Findlay, 2 vols. (London: Routledge and Kegan Paul, The Humanities Press, 1970), 2:818.

30. Schelling, *System of Transcendental Idealism*, p. 135.

31. Ibid., p. 24.

32. Ibid., p. 150.

33. Friedrich Wilhelm Joseph Schelling, *Bruno, or On the Natural and the Divine Principle of Things*, ed. and trans. Michael G. Vater (Albany: State University of New York Press, 1984), pp. 131–132.

34. Schelling, *The Philosophy of Art*, p. 52. See *Philosophie der Mythologie, Werke*, vol. 12, in which Schelling denies that China has ever produced a mythology, and therefore has never generated true art.

## Chapter 3

## PHILOSOPHY AS THE ORGANON OF ART

1. Hegel, *Hegel's Aesthetics*, vol. 1, p. 91.

2. Georg Hegel, *Hegel's Philosophy of Mind*, trans. William Wallace and A. V. Miller (Oxford: Clarendon Press, 1971), p. 294, paragraph 559.

3. Hegel, *Hegel's Aesthetics*, p. 9.

4. Ibid., p. 12.

5. Ibid., p. 24.

6. Richard Dien Winfield argues that a mimetic theory of art is intrinsically metaphysical and edifying, that it cannot distinguish the artwork of a genius from an artifact; it does not explain the individuality of the work of art and its "measure of reality remains something to be discovered, rather than constructed." See Richard Dien Winfield, *Systematic Aesthetics*, 1991, p. 1–3 of the manuscript kindly provided by the author.

7. Hegel, *Hegel's Aesthetics*, p. 39.

8. Kierkegaard used irony as an instrument to contest systematicity. For him irony denies the concept, that is, the universality of philosophy. This step marks the beginning of an existential appreciation of irony whereby it is "reduced" to a free standpoint in life, opposed to any pre-given form of objectivity. Søren Kierkegaard, *The Concept of Irony— With Constant Reference to Socrates*, trans. Lee M. Capel (Bloomington, Ind. and London: Indiana University Press, 1968), p. 274.

9. Jacques Derrida said that "It is always an 'I' that says 'We'." Keynote Address, "For the Love of Lacan," given at The Colloquium "Law and the Post-Modern Mind," The Benjamin N. Cardozo School of Law, Yeshiva University, New York, NY., September 26, 1993.

10. Benedetto Croce, *Ariosto* (Milan: Adelphi Edizioni, 1991).

11. Hegel, *Hegel's Aesthetics*, p. 140.

12. Philippe Lacoue-Labarthe, "Sublime Truth," in *Of the Sublime: Presence in Question*, ed. and trans. Jeffrey S. Librett (Albany: State University of New York Press, 1993), p. 79; he speaks of an "agony of art."

13. Hegel, *Hegel's Aesthetics*, p. 309.

14. See Ernst Cassirer, *An Essay on Man—An Introduction to a Philosophy of Human Culture* (New Haven and London: Yale University Press, 1962), in particular p. 143.

15. Hegel, *Hegel's Philosophy of Mind*, p. 213, paragraph 458.

16. Jacques Derrida, "*Le puits et la pyramide*," in *Hegel et la pensée moderne, Séminaire sur Hegel dirigé par Jean Hyppolite au Collège de France (1967–1968)*, ed. Jacques D'Hondt (Paris: Presses universitaires de France, 1970), p. 50.

17. Richard Winfield, in separating from Hegel's aesthetics what is systematic and what is historical, states that nothing prevents an artist from creating symbolic or classical art at any given time. True, but the problem remains of the relevance of such art for the contemporary public and the intrinsic value of the three different forms of art.

18. Hegel, *Hegel's Aesthetics*, p. 351.

19. Ibid., p. 362.

20. Edmond Jabès, *The Book of Shares*, trans. Rosmarie Waldrop (Chicago and London: The University of Chicago Press, 1989), p. 44.

21. Ibid., p. 39.

22. Hegel, *Hegel's Aesthetics*, p. 339.

23. Edmond Jabès, *The Book of Dialogue*, trans. Rosmarie Waldrop (Middletown, Connecticut: Wesleyan University Press, 1987), p. 51.

24. Hegel, *Hegel's Aesthetics*, p. 362.

25. Schelling, *The Philosophy of Art*, p. 88.

26. Hegel, *Hegel's Aesthetics*, p. 429.

27. Winfield's *Systematic Aesthetics* gives prominence to the ethical, but also moral content of art without subordinating to them art's autonomy, thus salvaging art's perennial existence.

28. Gilles Deleuze and Félix Guattari have revived the theme that art is sensation, perception, and affects, in contrast to philosophy, which is conceptual in nature; thus, they place art and philosophy in separate, noncontiguous spheres. Existing on its own, art does not have to justify itself before philosophy; there is no logical or illogical referent to which art must capitulate. See Gilles Deleuze and Félix Guattari, *Qu'est-ce que la philosophie?* (Paris: Les Éditions de Minuit, 1991), p. 156. These authors connect art to the impersonal becoming in which territory and deterritorialization prevent art from being representational. Isolated from religion and philosophy, art is innocently atheistic, midway between immanence and transcendence; finite art gives us back the infinite and, in doing so, renounces any referent (p. 183 and p. 186). We add: including beauty.

29. Hegel, *Hegel's Aesthetics*, p. 587.

30. Ibid., p. 601.

31. Ibid., p. 602. In a different context Melandri singles out an endemic difficulty in Hegel's thought in which "the actual infinite explodes in the finite and destroys . . . multiplicity." See Enzo Melandri, "*I paradossi dell'infinito nell'orizzonte fenomenologico*," *Omaggio a Husserl*, ed. Enzo Paci (Milan: Il Saggiatore, 1960), p. 85.

## Chapter 4

### APPREHENDING THE NEW

1. Pierre Boulez, *Boulez on Music Today*, trans. Susan Bradshaw and Richard Rodney Bennet (Cambridge, Massachusetts: Harvard University Press, 1971).

2. Wilhelm Dilthey, "The Imagination of the Poets: Elements for a Poetics," trans. Louis Agosta and Rudolf A. Makkreel, in *Poetry and Experience, Selected Works*, eds. Rudolf A. Makkreel, Frithjof Rodi, vol. 5 (Princeton, New Jersey: Princeton University Press, 1985), pp. 91–91.

3. Ibid., p. 54. See also Massimo Cacciari's *Dell'inizio* (Milan: Adelphi edizioni, 1990), p. 317, and p. 325. Tradition is antinomic since it implies both becoming and becoming's permanence; tradition is discontinuous; it renews itself through periodical catastrophes.

4. Dilthey, "The Imagination of the Poet: Elements for a Poetics," p. 108.

5. Ibid., p. 128.

6. Ibid., p. 170.

7. Dilthey, "The Three Epochs of Modern Aesthetics and Its Present Task," trans. Michal Neville, in *Poetry and Experience, Selected Works*, eds. Rudolf A. Makkreel, Frithjof Rodi, vol. 5 (Princeton, New Jersey: Princeton University Press, 1985), p. 188.

8. Quoted in Paul Valéry, "Degas dance dessin," *Oeuvres* 2:1208.

9. Particularly in the present age we witness an overlapping of art forms. Paintings that protrude from the canvas such as Robert Rauschenberg's "Combine paintings," musical compositions that resort to visual components such as those of John Cage, and Pina Bausch's theater which incorporates dance and speech. These innovations manifest the playfulness of art when it explores the territory beyond a given horizon. Jenny Holzer also has exploited the possibilities of integrating architecture and language. Her installation at the Venice Biennale of 1990 presents a series of irreverent aphorisms carved in a marble floor reminiscent of Italian palaces and churches. Her Guggenheim Museum installation was even more striking in its utilization of spiral architecture to flash electronic signs in its interior.

10. Arthur Danto, *The Philosophical Disenfranchisement of Art* (New York: Columbia University Press, 1986), p. 118.

11. Boulez, *On Music Today*, p. 166.

12. Danto, *The Philosophical Disenfranchisement of Art*, pp. ix–x.

13. Sigmund Freud, S. E., *The Uncanny*, 17:217–256.

14. Danto, *The Philosophical Disenfranchisement of Art*, p. 131.

15. John Di Leva Halpern, leaflet of the artist, *Art Corporation of America, Incorporated*, "This cop is carrying a work of art," 1979.

16. For the concepts of anaphora and cataphora, see Karl Bühler, *Theory of Language—The Representational Function of Language*, trans. Donald Fraser Goodwin, vol. 25 of *Foundations of Semiotics*, ed. Achim Eschbach (Amsterdam / Philadelphia: John Benjamins Publishing Company, 1990 (1934)), pp. 137–140, and pp. 438–451.

17. See Alfred Jules Ayer, *Language, Truth and Logic* (London: Victor Gollancz, 1946).

18. Freud, S. E., *Beyond the Pleasure Principle*, 18.

19. See Jacques Derrida, *L'archéologie du frivole* (Auvers-sur-Oise: Galilée, 1973), p. 90. In discussing Condillac, who defined the frivolous as the useless, Derrida identifies the frivolous with the tautological. This rehabilitation of the frivolous is connected to the impossibility or ineffectiveness of representation: "Frivolity is born from the swerve of the signifier, but also from its withdrawal into itself, in its closed and nonrepresentative identity. Therefore one avoids frivolity only by running the risk of nonidentity."

20. Giambattista Vico, *The New Science*, trans. Thomas Bergin and Max Harold Fisch (Ithaca: Cornell University Press, 1948).

21. Subsequent to writing this chapter, the Chapel was destroyed by fire in April 1997, probably by arson.

22. Jean-Paul Sartre, *Qu'est-ce que la littérature?*, p. 32.

23. Stéphane Mallarmé, *Oeuvres complètes* (Paris: Gallimard, 1945), "*Symphonie littéraire*," p. 262.

24. Mallarmé, "*Quant au livre—L'action restreinte*," p. 370.

25. Jacques Taminiaux, for one, establishes a comparison between Plato and Hegel on the one hand, and Aristotle and Kant on the other. Plato and Hegel have in common the speculative approach to philosophy, which leads to the condemnation of art, instead of starting from judgment, which results in a positive aesthetics. See Jacques Taminiaux, *Poetics, Speculation, and judgment—The Shadow of the Work of art from Kant to Phenomenology*, ed. and trans. Michel Gendre (Albany: State University of New York Press, 1993), pp. 1–19.

26. Mallarmé, "*Offices—Plaisir sacré*," p. 388.

27. Boulez's *Le pays fertile* is partly devoted to discovering analogies between painting and music.

28. Heidegger, *Being and Time*, pp. 319–325, paragraph 57.

29. See Lacoue-Labarthe, "Sublime truth," in *Of the Sublime: Presence in Question*, pp. 94–95.

30. Jacques Derrida, *La vérité en peinture* (Paris: Flammarion, 1978), pp. 136–168.

31. Edmund Burke, *A Philosophical Enquiry into the Origin of our Ideas of the Sublime and Beautiful* (Oxford, New York: Oxford University Press, 1990), p. 123.

32. Enzo Melandri, *Le "Ricerche logiche" di Husserl—Introduzione e commento alla Prima ricerca* (Bologna: Il Mulino, 1990), pp. 196–197. The object is expressed through a special semantic category: the substantive; to the verb, in a complementary fashion, belongs its own semantic category, derived from the intentional act of meaning.

33. Gottfried Benn, "World of Expression," in *Primal Vision*, ed. E. B. Ashton (New York: A New Directions Book, 1971), p. 109.

34. Ladislao Mittner, *L'espressionismo* (Rome-Bari: Laterza, 1965), pp. 31–32.

35. Benn, "The New Literary Season," *Primal Vision*, pp. 39–45.

36. Benn, "Can Poets Change the World?," in *Prose, Essays, Poems*, ed. Volkmar Sander, trans. Joel Agee (New York: Continuum, 1987), p. 101.

### Chapter 5

### FROM ARTIFICE TO THE WILL

1. Nietzsche, "The Case of Wagner," in *The Birth of Tragedy and The Case of Wagner*, trans. Walter Kaufmann (New York: Random House, Vintage Books, 1967). Massimo Cacciari, *Krisis—Saggio sulla crisi del pensiero negativo da Nietzsche a Wittgenstein* (Milan: Feltrinelli Editore, 1976), p. 103.

2. Nietzsche, "The Case of Wagner," p. 190.

3. Nietzsche, *Human, All Too Human—A Book for Free Spirits*, trans. Marion Faber (Lincoln and London: University of Nebraska Press, 1984), p. 115, aphorism 169.

4. Nietzsche, *The Will to Power*, p. 11.

5. Ibid., pp. 12–13, aphorism 12.

6. Ibid., p. 14, aphorism 13, and p. 17, aphorism 23.

7. Ibid., p. 423, aphorism 804.

8. Giorgio Colli, *Dopo Nietzsche* (Milan: Adelphi Edizioni, 1974), p. 196.

9. Ernst Jünger, *Über die Linie* (Stuttgart: Ernst Klett, 1980), paragraph 22.

10. Stephen Houlgate, *Hegel, Nietzsche and the Criticism of Metaphysics* (New York: Cambridge University Press, 1986), p. 193. Houlgate, writing about Nietzsche's theory of tragedy, describes "[t]he total identification of the tragic and the heroic" which corresponds to the isolated individual.

11. Gilles Deleuze, *Nietzsche and Philosophy*, trans. Hugh Tomlinson (New York: Columbia University Press, 1983), p. 17.

12. Nietzsche, *The Will to Power*, p. 431, aphorism 814, and p. 437, aphorism 826.

13. Ibid., p. 450, aphorism 852.

14. Northrop Frye, *Anatomy of Criticism—Four Essays* (New York: Atheneum, 1967), pp. 90–91.

15. Paul de Man, *Allegories of Reading*, p. 91.

16. Ibid., p. 102.

17. Ibid., p. 116.

18. Friedrich Schlegel, *Dialogue on Poetry and Literary Aphorisms*, trans. Ernst Behler and Roman Struc (University Park and London: Pennsylvania State University Press, 1968), p. 126, p. 131, and p. 155.

19. Martin Heidegger, *The Origin of the Work of Art*, trans. Albert Hofstadter, in *Poetry, Language, Thought* (New York, Harper and Row, 1975), p. 29.

20. Ibid., p. 39.

21. Ibid., p. 60.

22. Ibid., p. 62: "The establishing of truth in the work is the bringing forth of a being such as never was before and will never come to be again."

23. Ibid., p. 68.

24. Ibid., p. 71.

25. Martin Heidegger, *The Question Concerning Technology and Other Essays*, trans. William Lovitt (New York: Harper Torchbooks, Harper and Row, Publishers, 1977), p. 35.

26. Véronique Fóti notes that Heidegger's view is close to Hegel's conception of tragic reconciliation. See Véronique Fóti, *Heidegger and the Poets—Poiesis, Sophia, Techne* (New Jersey, London: Humanities Press, 1992), p. 73.

27. Martin Heidegger, *The Concept of Time*, trans. William McNeill (Oxford and Cambridge: Blackwell, 1992 (1924)), p. 19E.

28. Heidegger, *Nietzsche*, 1:74.

29. Ibid., p. 113.

30. Ibid., p. 123.

31. Véronique Fóti, *Heidegger and the Poets*, p. 102.

32. Gianni Vattimo interprets Heidegger's thought as still imbued with nihilism, given that Heidegger's Being does not propound a return to Being as ground and luminosity. Gianni Vattimo, *Al di là del soggetto—Nietzsche, Heidegger e l'ermeneutica* (Milan: Feltrinelli, 1984), pp. 60–61.

33. See Melandri, *La linea e il circolo*, p. 72, which states that the later Heidegger has renounced analogism, which is still present in *Being and Time*. See p. 71: "Anomaly cannot be a hermeneutical principle. Hermeneutics requires that the code be obtained by induction from the message; while anomaly, by introducing the code from the outside, independently from the message and from the decodifying operation, makes interpretation either superfluous or impossible." (My translation.)

34. Heidegger, *Being and Time*, p. 334.

35. Gadamer, *Truth and Method*, p. 281.

36. Pierre Boulez, comments in "The Making of the Ring: A Documentary," written by John Ardoin (Philips Video Classics, 1980).

37. See Lacan, *Le séminaire, livre XX, Encore* (Paris: Éditions du Seuil, 1975), pp. 95–105.

38. Roland Barthes, *On Racine*, trans. Richard Howard (New York: Performing Art Journal Publications, 1983), p. 59, p. 16, and p. 40.

39. Heidegger, *Nietzsche*, 4:223.

40. Ibid., p. 56.

Chapter 6

THE NOTHINGNESS OF ART

1. See Taminiaux in "Art and Truth in Schopenhauer and Nietzsche," *Poetics, Speculation, and Judgment*, pp. 111–126, and pp. 124–125. Taminiaux tells us that "We, in the modern age, have art in order not to die from the type of truth that was claimed by Socrates and Plato" (pp. 124–125). How can that be considering that Nietzsche was convinced of having demolished those same truths? It is more likely that Nietzsche felt that art could serve as a source of consolation from the truth of his own theories.

2. Manfredo Tafuri, *Progetto e utopia—Architettura e sviluppo capitalistico* (Bari: Laterza, 1977), p. 3.

3. Raymond Ruyer, *L'utopie et les utopies* (Paris: Presses universitaires de France, 1950), p. 35.

4. Ernst Bloch thought differently; his utopian philosophy aims also at the political and economic spheres. His rediscovery of the possible, though, is completely justified: this is the modality that allows art to change means, forms, and horizon.

5. Paul Valéry, "Théorie poétique et esthétique," in *Oeuvres*, ed. Jean Hytier, vol. I (Paris: Gallimard, 1957), pp. 1240–1241.

6. Aristotle, *Poetics*, trans. Richard Janko (Indianapolis Cambridge: Hackett Publishing Company, 1987), p. 12, 51b5. (Emphasis added.)

7. Paul Valéry, "Première leçon du cours de poétique," in *Oeuvres*, 1:1350.

8. Casey, *Imagining*, pp. 185–188.

9. Valéry, "Fragments des mémoires d'un poème," p. 1472.

10. Valéry, "Poésie pure—Notes pour une conférence," p. 1463.

11. John Cage, "Forerunners of Modern Music," in *Silence* (Hanover, New Hampshire: Wesleyan University Press, 1973), p. 62.

12. Aristotle, *Poetics*, 57b7.

13. Gilbert Ryle, *The Concept of Mind* (Chicago: The University of Chicago Press, 1984 (1949)), p. 16 ff.

14. Carl R. Hausman, *Metaphor and Art—Interactionism and Reference in the Verbal and Nonverbal Arts* (New York: Cambridge University Press, 1989), p. 29.

15. See Hausman, p. 200 and Melandri, *La linea e il circolo*, pp. 1005–1019, in which it is stated that every semantics produces an ontology, but the "object is always virtual" (p. 1018).

16. Hausman, *Metaphor and Art*, p. 216, and 230.

17. Paul Ricoeur, *The Rule of Metaphor—Multi-disciplinary Studies on the Creation of Meaning in Language*, trans. Robert Czerny with Kathleen Mclaughlin and John Costello, SJ. (Toronto Buffalo London: University of Toronto Press, 1981), p. 108.

18. Ofelia Schutte, *Beyond Nihilism—Nietzsche Without Masks* (Chicago and London: The University of Chicago Press, 1984), pp. 76–104. In particular, see p. 77.

19. Tzvetan Todorov, *Symbolism and Interpretation*, trans. Catherine Porter (Ithaca, New York: Cornell University Press, 1982), p. 115.

20. Angus Fletcher, *Allegory—The Theory of a Symbolic Mode* (Ithaca and London: Cornell University Press, 1964).

21. Ibid., p. 245, and p. 248.

22. According to Enzo Melandri every allegory is analogical (but not vice versa) and is differentiated from symbol, metaphor, and myth. Allegory requires a triadic schema: *explanandum-explanans-explanatum* where *explanandum* does not coincide with *explanatum*. The symbol is a necessary component of allegory. But the symbol, which serves to differentiate allegory from myth, differs from allegory in that it is also metaphorical, and metaphor, like the symbol, is comparable to a concept, whereas allegory is comparable to a proposition. Melandri, *La linea e il circolo*, pp. 97–104.

23. Immanuel Kant, *The Critique of Judgement*, trans. James Creed Meredith (Oxford at the Clarendon Press, 1986), p. 91.

24. Rudolf Makkreel, *Imagination and Interpretation in Kant—The Hermeneutical Import of the* Critique of Judgment (Chicago and London: The University of Chicago Press, 1990), pp. 46–47.

25. Fletcher, *Allegory*, p. 69.

26. Ibid., pp. 245–278.

27. Kant, *The Critique of Judgement*, p. 54 and pp. 173–174.

28. Ibid., p. 98.

29. Ibid., p. 106, and p. 107.

30. Derrida, *La vérité en peinture*, p. 157, and p. 151: "[The sublime] presents inadequately the infinite in the finite and it delimits it there violently."

31. Hegel, *Hegel's Aesthetics*, p. 363.

32. Jean-Luc Nancy, "The sublime Offering" in *Of the Sublime: Presence in Question*, p. 39, and p. 50. Nancy's statement goes in the same direction as ours since it leaves indeterminate the *quid* of the sublime.

33. Boulez, *Le pays fertile*, p. 126.

34. An example is Jabès' insistence on silence, which for him is also the silence of God. Here subjectivity has vanished in the objectivity of the desert, and objectivity has disappeared in the silence of the subject-God. See Jabès, *From the Desert to the Book—Dialogues with Marcel Cohen*, trans. Pierre Joris (New York, Station Hill Press, 1990), p. 77.

35. Cacciari objects to an interpretation of Nietzsche that would stress his aestheticism and utopianism; the will to power, so often associated with the Overman, stands for the demise of the subject and for a rationalization process dictated by need. Cacciari, *Krisis*, pp. 56–69.

36. Friedrich Wilhelm Joseph Schelling, *The Ages of the World*, trans. Frederick de Wolfe Bolman Jr. (New York Morningside Heights: Columbia University Press, 1942), p. 83.

37. Frye, *Anatomy of Criticism*, p. 103.

38. Cage, *Silence*, see p. 3 and p. 10: ". . . if something were being said, the sounds would be given the shape of words."

## Chapter 7

## THE ROLE OF SUBJECTIVITY

1. Schelling, *System of Transcendental Idealism*, p. 232.

2. See Richard Rorty, *Contingency, Irony, and Solidarity* (New York: Cambridge University Press, 1989). Rorty's pragmatism functions only as a placebo for the illness of the subject. It is therefore impossible to subscribe to Rorty's dictum: "If we take care of freedom, truth can take care of itself" (p. 176).

3. Ibid., p. 97.

4. Friedrich Schlegel, *Philosophical Fragments*, trans. Peter Firchow (Minneapolis: University of Minnesota Press, 1991), p. 11, fragment 95.

5. Schelling, *System of Transcendental Idealism*, p. 49.

6. Cacciari, *Dell'inizio*, pp. 49–51. Cacciari detects the nature of the sublime in the *Schein*, illusion, the void, and in subjective necessity, leaving behind the earth in which dwelling is not granted anyhow. The sublime breaks "the link between sensibility and understanding." What lies beyond appearance is the void.

7. Jean Baudrillard, *La transparence du mal—Essai sur les phénomènes extrêmes* (Paris: Galilée, 1990).

8. Ibid., p. 30.

9. Massimo Donà, *Sull'Assoluto—Per una reinterpretazione dell'idealismo hegeliano* (Turin: Einaudi, 1992), p. 44: "To produce the other qua 'nothing' means for the subject to declare its own originary nothingness."

10. See William Desmond, *Beyond Hegel and Dialectic—Speculation, Cult, and Comedy* (Albany: State University of New York Press, 1992). According to Desmond, dialectic is rescued by laughter with which it shows a virtual affinity (p. 282). For Cacciari, instead, the whole Hegelian theo-logy is tragic, truly staurologic. The death of God is a priori, in the beginning, so much so that Cacciari speaks of an "ontological proof of the death of God" (Cacciari, *Dell'inizio*, p. 192).

11. Deleuze, "A Philosophical Concept . . . ," *Topoi*, 7 (September 1988): 111.

12. Gadamer, *Truth and Method*, p. 281. Gadamer says that "tradition has a justi-fication that lies beyond rational grounding."

13. Melandri, personal oral communication, 1967.

14. Susan Sontag, *Against Interpretation* (New York: Doubleday, 1986), p. 28.

15. See W. H. Walsh, *Hegelian Ethics* (New York and London: Garland Publishing, Inc., reprint 1984), p. 55. For a different analysis see Gillian Rose, *Hegel Contra Sociology* (Athlone, London: Humanities Press, New Jersey, 1981).

16. Sontag, *Against Interpretation*, p. 5.

17. Ibid., p. 17.

18. Ibid., p. 22.

19. Hans-Georg Gadamer, *The Relevance of the Beautiful and Other Essays*, trans. Nicholas Walker (New York: Cambridge University Press, 1986), pp. 20–21.

20. Ibid., p. 28.

21. Ibid., p. 46.

22. Ibid., p. 36.

23. At this juncture differences between artists and interpreters become unavoidable. Artists, while explaining their works, de facto pinpoint that which remains hidden even from them. Their authority rests in part on the fact that they have temporal precedence over what they have accomplished, in part on their sensitivity and knowledge. The interpreters add their own sensitivity and culture; however, a generic pluralism must be avoided; interpretations help to form the work of art; without them a confused sensuous presence would predominate.

24. Enzo Melandri, *L'inconscio e la dialettica* (Bologna: Cappelli Editore, 1983), p. 54.

25. Gadamer, "Poetry and Mimesis," in *The Relevance of the Beautiful*, p. 121.

26. Nelson Goodman, *Ways of Worldmaking* (Indianapolis: Hackett Publishing Company, 1988), p. 27.

27. See Richard Boothby, *Death and Desire—Psychoanalytic Theory in Lacan's Return to Freud* (New York and London: Routledge, 1991).

28. Lyotard, *The Postmodern Condition: A Report on Knowledge*, p. 74.

29. Ibid., p. 78.

30. Ibid., p. 81.

31. See Melandri, *L'inconscio e la dialettica*, especially p. 20, and also pp. 25–26. For Melandri "The substantive trait of the unconscious, that which ontologically ought to make it a 'substance,' is called into question by its own subliminality. Also the substance is subliminal as compared to its sensible properties, but it is identified as a moment of *intelligibility*" (pp. 25–26). (My translation.)

32. Ibid., p. 51 and p. 53.

33. Massimo Cacciari, *Architecture and Nihilism: On the Philosophy of Modern Architecture*, trans. Stephen Sartarelli (New Haven and London: Yale University Press, 1993), p. 201.

34. Ibid., p. 209.

35. See Roberto Dionigi, *Il doppio cervello di Nietzsche* (Bologna: Cappelli Editore, 1982).

36. Freud, S. E., *Analysis of a Phobia in a Five-year-old Boy*, 10:34–35,

37. Tragicomedy is not a false compromise, witness Samuel Beckett and Giorgio Manganelli's *Hilarotragoedia* (Milan: Adelphi Edizioni, 1987).

# Bibliography

Adorno, Theodor W. *Ästhetische Theorie*. Frankfurt am Main: Suhrkamp Verlag, 1970.

Aristotle. *The Complete Works of Aristotle*. Edited by Jonathan Barnes. 2 vols. Princeton, New Jersey: Princeton University Press, 1991.

Ayer, Alfred Jules. *Language, Truth and Logic*. London: Victor Gollancz, 1946.

Barker, Stephen. *Autoaesthetics—Strategies of the Self After Nietzsche*. Atlantic Highlands, N.J., and London: Humanities Press, 1992.

Barthes, Roland. *On Racine*. Translated by Richard Howard. New York: Performing Arts Journal Publications, 1983.

Baudrillard, Jean. *La transparence du mal—Essai sur les phénomènes extrêmes*. Paris: Galilée, 1990.

Benn, Gottfried. "After Nihilism." *Prose, Essays, Poems*. Edited by Volkmar Sander, translated by Joel Agee. New York: Continuum, 1987.

———. "The New Literary Season." *Primal Vision*. Edited by E. B. Ashton, translated by Eugene Jolas. New York: New Directions Books, 1971.

———. "World of Expression." *Primal Vision*. Edited by E. B. Ashton. New York: A New Directions Book, 1971.

Bloch, Ernst. *The Principle of Hope*. Translated by Neville Plaice, Stephen Plaice, and Paul Knight. 3 vols. Cambridge, Massachusetts: The MIT Press, 1986.

Boothby, Richard. *Death and Desire—Psychoanalytic Theory in Lacan's Return to Freud*. New York and London: Routledge, 1991.

Borch-Jacobsen, Mikkel. "Les alibis du sujet (Lacan, Kojève et alii)." *Lacan avec les philosophes*. Paris: Albin Michel, 1991.

Boulez, Pierre. *Boulez on Music Today*. Translated by Susan Bradshaw and Richard Rodney Bennet. Cambridge, Massachusetts: Harvard University Press, 1971.

————. *Le pays fertile—Paul Klee*. Paris: Gallimard, 1989.

Bühler, Karl. *Theory of Language—The Representational Function of Language*. Translated by Donald Fraser Goodwin. Vol. 25 of *Foundations of Semiotics*. Edited by Achim Eschbach. Amsterdam / Philadelphia: John Benjamins Publishing Company, 1990.

Burke, Edmund. *A Philosophical Enquiry into the Origin of our Ideas of the Sublime and Beautiful*. Oxford, New York: Oxford University Press, 1990.

Cacciari, Massimo. *Architecture and Nihilism: On the Philosophy of Modern Architecture*. Translated by Stephen Sartarelli. New Haven and London: Yale University Press, 1993.

————. *Dell'inizio*. Milan: Adelphi Edizioni, 1990.

————. *Krisis—Saggio sulla crisi del pensiero negativo da Nietzsche a Wittgenstein*. Milan: Feltrinelli Editore, 1976.

Cage, John. *Silence*. Hanover, New Hampshire: Wesleyan University Press, 1973.

Casey, Edward S. *Imagining—A Phenomenological Study*. Bloomington and London: Indiana University Press, 1979.

————. *Spirit and Soul—Essays in Philosophical Psychology*. Dallas, Texas: Spring Publications, Inc., 1991.

Cassirer, Ernst. *An Essay on Man—An Introduction to a Philosophy of Human Culture*. New Haven and London: Yale University Press, 1962.

Colli, Giorgio. *Dopo Nietzsche*. Milan: Adelphi Edizioni, 1974.

Croce, Benedetto. *Ariosto*. Milan: Adelphi Edizioni, 1991.

Danto, Arthur. *The Philosophical Disenfranchisement of Art*. New York: Columbia University Press, 1986.

de Certeau, Michel. *Heterologies—Discourse on the Other*. Translated by Brian Massumi. Vol 17. Theory and History of Literature. Minneapolis: University of Minnesota Press, 1986.

Deleuze, Gilles. *Nietzsche and Philosophy*. Translated by Hugh Tomlinson. New York: Columbia University Press, 1983.

————. "A Philosophical Concept . . ." *Topoi* 7 (1988): 111–112.

————. *Le Pli—Leibniz et le Baroque*. Paris: Les Éditions de Minuit, 1988.

Deleuze, Gilles and Félix Guattari. *Qu'est-ce que la philosophie?*. Paris: Les Éditions de Minuit, 1991.

de Man, Paul. *Allegories of Reading—Figural Language in Rousseau, Nietzsche, Rilke, and Proust*. New Haven and London: Yale University Press, 1979.

Derrida, Jacques. *L'archéologie du frivole*. Auvers-sur-Oise: Galilée, 1973.

————. "Pour l'amour de Lacan." In *Lacan avec les philosophes*. Paris: Albin Michel, 1991.

————. "Le puits et la pyramide." In *Hegel et la pensée moderne—Séminaire sur Hegel dirigé par Jean Hyppolite au Collège de France (1967–1968)*. Edited by Jacques D'Hondt. Paris: Presses universitaires de France, 1970.

————. "The Purveyor of Truth." *Yale French Studies* 52 (1976): 31–113.

———. *La vérité en peinture*. Paris: Flammarion, 1978.

Desmond, William. *Art and the Absolute—A Study of Hegel's Aesthetics*. Albany: State University of New York Press, 1986.

———. *Beyond Hegel and Dialectic—Speculation, Cult, and Comedy*. Albany: State University of New York Press, 1992.

Dilthey, Wilhelm. *Poetry and Experience. Selected Works*. Vol. V. Edited by Rudolf A. Makkreel and Frithjof Rodi. Princeton, New Jersey: Princeton University Press, 1985.

Dionigi, Roberto. *Il doppio cervello di Nietzsche*. Bologna: Cappelli Editore, 1982.

Donà, Massimo. *Sull'Assoluto—Per una reinterpretazione dell'idealismo hegeliano*. Turin: Einaudi, 1992.

Escoubas, Éliane. "Kant or the Simplicity of the Sublime." In *Of the Sublime in Question*. Edited and Translated by Jeffrey S. Librett. Albany: State University of New York Press, 1993.

Fletcher, Angus *Allegory—The Theory of a Symbolic Mode*. Ithaca and London: Cornell University Press, 1964.

Fóti, Véronique M. *Heidegger and the Poets—Poiesis, Sophia, Techne*. New Jersey, London: Humanities Press, 1992.

Freud, Sigmund. *The Standard Edition of the Complete Psychological Works of Sigmund Freud*. 24 vols. Translated by James Strachey. London: Hogarth Press and the Institute of Psycho-Analysis, 1966–1974.

Frye, Northrop. *Anatomy of Criticism—Four Essays*. New York: Atheneum, 1967.

Gadamer, Hans-Georg. *Heidegger's Ways*. Translated by John W. Stanley. Albany: State University of New York Press, 1994.

———. *The Relevance of the Beautiful and Other Essays*. Translated by Nicholas Walker. New York: Cambridge University Press, 1986.

———. *Truth and Method*. Translated by Joel Weinsheimer and Donald G. Marshall. 2d ed. New York: Crossroad, 1990.

Goodman, Nelson. *Ways of Worldmaking*. Indianapolis: Hackett Publishing Company, 1988.

Hausman, Carl R. *Metaphor and Art—Interactionism and Reference in the Verbal and Nonverbal Arts*. New York: Cambridge University Press, 1989.

Hegel, Georg. *Hegel's Aesthetics—Lectures on Fine Art*. Translated by T. M. Knox. 2 vols. Oxford at the Clarendon Press, 1975.

———. *Hegel's Logic—Part One of the Encyclopaedia of the Philosophical Sciences*. Translated by William Wallace. Oxford at the Clarendon Press, 1975.

———. *Hegel's Phenomenology of Spirit*. Translated by A. V. Miller. New York: Oxford University Press, 1977.

———. *Hegel's Philosophy of Mind*. Translated by William Wallace and A. V. Miller. Oxford: Clarendon Press, 1971.

——— . *Hegel's Philosophy of Right*. Translated by T. M. Knox. New York: Oxford University Press, 1967.

——— . *Hegel's Science of Logic*. Translated by A. V. Miller. New York: Humanities Press, 1969.

Heidegger, Martin. *Basic Concepts*. Translated by Gary E. Aylesworth. Bloomington and Indianapolis: Indiana University Press, 1993.

——— . *Basic Questions of Philosophy—Selected "Problems" of "Logic."* Translated by Richard Rojcewicz and André Schuwer. Bloomington and Indianapolis: Indiana University Press, 1994.

——— . *Being and Time*. Translated by John Macquarrie and Edward Robinson. New York and Evanston: Harper and Row, Publishers, 1962.

——— . *The Concept of Time*. Translated by William McNeill. Oxford and Cambridge: Blackwell, 1992.

——— . *An Introduction to Metaphysics*. Translated by Ralph Manheim. New Haven and London: Yale University Press, 1959.

——— . *The Metaphysical Foundations of Logic*. Translated by Michael Heim. Bloomington: Indiana University Press, 1984.

——— . *Nietzsche*. Edited by David Farrell Krell. 4 vols. HarperSanFrancisco, 1991.

——— . *The Origin of the Work of Art*. Translated by Albert Hofstadter. In *Poetry, Language, Thought*. New York: Harper and Row, 1975.

——— . *The Principle of Reason*. Translated by Reginald Lilly. Bloomington and Indianapolis: Indiana University Press, 1991.

——— . *The Question Concerning Technology and Other Essays*. Translated by William Lovitt. New York: Harper Torchbooks, Harper and Row, Publishers, 1977.

——— . *What Is a Thing?*. Translated by W. B. Barton Jr., and Vera Deutsch. Chicago: Henry Regnery Company, A Gateway Edition, 1970.

Houlgate, Stephen. *Hegel, Nietzsche and the Criticism of Metaphysics*. New York: Cambridge University Press, 1986.

Husserl, Edmund. *Logical Investigations*. Translated by J. N. Findlay. 2 vols. London: Routledge and Kegan Paul, New York: The Humanities Press, 1970.

Jabès, Edmond. *The Book of Dialogue*. Translated by Rosmarie Waldrop. Middletown, Connecticut: Wesleyan University Press, 1987.

——— . *The Book of Shares*. Translated by Rosmarie Waldrop. Chicago and London: The University of Chicago Press, 1989.

——— . *From the Desert to the Book—Dialogues with Marcel Cohen*. Translated by Pierre Joris. New York: Station Hill Press, 1990.

Jünger, Ernst. *Über die Linie*. Stuttgart: Ernst Klett, 1980.

Kant, Immanuel. *The Critique of Judgement*. Translated by James Creed Meredith. Oxford at the Clarendon Press, 1986.

———. *Observations on the Feeling of the Beautiful and Sublime*. Translated by John T. Goldthwait. Berkeley: University of California Press, 1991.

Kierkegaard, Søren. *The Concept of Irony—With Constant Reference to Socrates*. Translated by Lee M. Capel. Bloomington and London: Indiana University Press, 1968.

Kojève, Alexandre. *Introduction to the Reading of Hegel—Lectures on the Phenomenology of Spirit*. Edited by Allan Bloom, and translated by James H. Nichols, Jr. Ithaca and London: Cornell University Press, 1980.

Kris, Ernst. *Psychoanalytic Explorations in Art*. New York: International Universities Press, Inc., 1952.

Lacan, Jacques. *Écrits*. Paris: Éditions du Seuil, 1966.

———. *Écrits—A Selection*. Translated by Alan Sheridan. New York: W. W. Norton and Company Inc., 1977.

———. *Le séminaire de Jacques Lacan, Livre VII, L'éthique de la psychanalyse—1959–1960*. Edited by Jacques-Alain Miller. Paris: Éditions du Seuil, 1986.

———. *Le séminaire, Livre XX, Encore*. Edited by Jacques-Alain Miller. Paris: Éditions du Seuil, 1975.

Lacoue-Labarthe, Philippe. "Sublime Truth." In *Of the Sublime: Presence in Question*. Edited and translated by Jeffrey S. Librett. Albany: State University of New York Press, 1993.

Lyotard, Jean-François. *The Postmodern Condition: A Report on Knowledge*. Translated by Geoff Bennington and Brian Massumi. Vol. 10. *Theory and History of Literature*. Minneapolis: University of Minnesota Press, 1984.

Makkreel, Rudolf. *Imagination and Interpretation in Kant—The Hermeneutical Import of the* Critique of Judgment. Chicago and London: The University of Chicago Press, 1990.

Mallarmé, Stéphane. "Du Parnasse contemporain." In *Oeuvres complètes*. Edited by Henri Mondor and G. Jean-Aubry. Paris: Gallimard, 1945.

Manganelli, Giorgio. *Hilarotragoedia*. Milan: Adelphi Edizioni, 1987.

———. *La letteratura come menzogna*. Milan: Adelphi Edizioni, 1985.

Mann, Thomas. *Doctor Faustus—The Life of the German Composer Adrian Levenrkühn, as Told by a Friend*. New York: Vintage International, 1992.

Marx, Werner. *The Philosophy of Schelling—History, System, and Freedom*. Translated by Thomas Nenon. Bloomington: Indiana University Press, 1984.

McCormick, Peter J. *Modernity, Aesthetics, and the Bounds of Art*. Ithaca and London: Cornell University Press, 1990.

Melandri, Enzo. *Contro il simbolico—Dieci lezioni di filosofia*. Florence: Ponte alle Grazie, 1989.

———. *L'inconscio e la dialettica*. Bologna: Cappelli Editore, 1983.

———. *La linea e il circolo—Trattato logico-filosofico sull'analogia*. Bologna: Società editrice il Mulino, 1968.

———. "I paradossi dell'infinito nell'orizzonte fenomenologico." In *Omaggio a Husserl*. Edited by Enzo Paci. Milan: Il Saggiatore, 1960.

———. *Le "Ricerche logiche" di Husserl—Introduzione e commento alla Prima ricerca*. Bologna: Il Mulino, 1990.

Merleau-Ponty, Maurice. *L'Oeil et l'Esprit*. Paris: Éditions Gallimard, 1964.

Mittner, Ladislao. *L'espressionismo*. Rome-Bari: Laterza, 1965.

Musil, Robert. *Precision and Soul—Essays and Addresses*. Edited and translated by Burton Pike and David S. Luft. Chicago and London: The University of Chicago Press, 1990.

Nancy, Jean-Luc. "The sublime Offering." In *Of the Sublime: Presence in Question*. Albany: Sate University Of New York Press, 1993.

Nietzsche, Friedrich. *The Birth of Tragedy and The Case of Wagner*. Translated by Walter Kaufmann. New York: Random House, Vintage Books, 1967.

———. *Human, All Too Human—A Book for Free Spirits*. Translated by Marion Faber. Lincoln and London: University of Nebraska Press, 1984.

———. *Human, All-Too-Human—A Book for Free Spirits*. Edited by Oscar Levy and translated by Paul V. Cohn. 2 vols. New York: Russell and Russell, Inc., 1964.

———. *The Will to Power*. Edited and translated by Walter Kaufmann and R. J. Hollingdale. New York: Random House, Vintage Books, 1968.

Pessoa, Fernando. *Fausto—Tragédia Subjectiva*. Lisboa: Editorial Presença, 1988.

Ricoeur, Paul. "The Metaphorical Process as Cognition, Imagination, and Feeling." In *Philosophical Perspectives on Metaphor*. Edited by Mark Johnson. Minneapolis: University of Minnesota Press, 1981.

———. *The Rule of Metaphor-Multi-disciplinary Studies on the Creation of Meaning in Language*. Translated by Robert Czerny with Kathleen Mclaughlin and John Costello, SJ. Toronto, Buffalo, London: University of Toronto Press, 1981.

Rogozinski, Jacob. "The Gift of the World." In *Of the Sublime: Presence in Question*. Edited and translated by Jeffrey Librett. Albany: State University of New York Press, 1993.

Rorty, Richard. *Contingency, Irony, and Solidarity*. New York: Cambridge University Press, 1989.

Rose, Gillian. *Hegel Contra Sociology*. London: Athlone, New Jersey: Humanities Press, 1981.

Ruyer, Raymond. *L'utopie et les utopies*. Paris: Presses universitaires de France, 1950.

Ryle, Gilbert. *The Concept of Mind*. Chicago: The University of Chicago Press, 1984.

Sartre, Jean-Paul. *Qu'est-ce que la littérature?*. Paris: Gallimard, 1972.

Schelling, Friedrich Wilhelm Joseph. *The Ages of the World*. Translated by Frederick de Wolfe Bolman Jr. New York Morningside Heights: Columbia University Press, 1942.

———. *Bruno, or On the Natural and the Divine Principle of Things*. Edited and translated by Michael G. Vater. Albany: State University of New York Press, 1984.

————. *Ideas for a Philosophy of Nature.* Translated by Errol E. Harris and Peter Heath. New York: Cambridge University Press 1988.

————. *Philosophie der Mythologie. Werke.* Vol. 12. Stuttgart/Ausburg: J. G. Cott'scher, 1856–61.

————. *Philosophie der Offenbarung. Werke.* Vol. 14. Stuttgart/Ausburg: J. G. Cotta'scher, 1856–61.

————. *The Philosophy of Art.* Translated by Douglas W. Stott. Theory and History of Literature. Vol. 58. Minneapolis: University of Minnesota Press, 1989.

————. *System of Transcendental Idealism(1800).* Translated by Peter Heath. Charlottesville: University Press of Virginia, 1978.

Schiller, Friedrich. *On the Aesthetic Education of Man—In a Series of Letters.* Translated by Elizabeth M. Wilkinson and L. A. Willoughby. Oxford at the Clarendon Press, 1967.

————. *Essays.* Edited by Walter Hinderer, Daniel O. Dahlstrom and translated by D. Dahlstrom. New York: Continuum, 1993.

Schlegel, Friedrich. *Dialogue on Poetry and Literary Aphorisms.* Translated by Ernst Behler and Roman Struc. University Park and London: Pennsylvania State University Press, 1968.

————. *Philosophical Fragments.* Translated by Peter Firchow. Minneapolis: University of Minnesota Press, 1991.

Schutte, Ofelia. *Beyond Nihilism—Nietzsche Without Masks.* Chicago and London: The University of Chicago Press, 1984.

Sontag, Susan. *Against Interpretation.* New York: Doubleday, 1986.

Stern, J. P. "Nietzsche and the Idea of Metaphor." In *Nietzsche: Imagery and Thought—A Collection of Essays.* Edited by Malcolm Pasley. Berkeley and Los Angeles: University of California Press, 1978.

Tafuri, Manfredo. *Progetto e utopia—Architettura e sviluppo capitalistico.* Bari: Laterza, 1977.

————. *Ricerca del Rinascimento—Principi, città, architetti.* Turin: Einaudi, 1992.

————. *The Sphere and the Labyrinth—Avant-Gardes and Architecture from Piranesi to the 1970's.* Translated by Pellegrino d'Acierno and Robert Connoly. Cambridge, Massachusetts, and London: MIT, 1987.

Taminiaux, Jacques. *Poetics, Speculation, and Judgment—The Shadow of the Work of Art from Kant to Phenomenology.* Edited and translated by Michel Gendre. Albany: State University of New York Press, 1993.

Todorov, Tzvetan. *Symbolism and Interpretation.* Translated by Catherine Porter. Ithaca, New York: Cornell University Press, 1982.

Valéry, Paul. *"Art et esthétique." Cahiers* II. Edited by Judith Robinson. Paris: Gallimard, 1974.

————. *Mauvais pensées et autres.* In *Oeuvres* II. Edited by Jean Hytier. Paris: Gallimard, 1960.

————. *"Mon Faust."* In *Oeuvres* II. Edited by Jean Hytier. Paris: Gallimard, 1960.

————. *Théorie poétique et esthétique.* In *Oeuvres* I. Edited by Jean Hytier. Paris: Gallimard, 1957.

Vattimo, Gianni. *Al di là del soggetto—Nietzsche, Heidegger e l'ermeneutica.* Milan: Feltrinelli, 1984.

————. *Le avventure della differenza—Che cosa significa pensare dopo Nietzsche e Heidegger.* Milan: Garzanti, 1988.

————. *La fine della modernità.* Milan: Garzanti, 1991.

Vico, Giambattista. *The New Science.* Translated by Thomas Bergin and Max Harold Fisch. Ithaca: Cornell University Press, 1948.

Walsh, W. H. *Hegelian Ethics.* New York and London: Garland Publishing, Inc., 1984.

Winfield, Richard Dean. *Stylistics—Rethinking the Artforms After Hegel.* Albany: State University of New York Press, 1996.

————. *Systematic Aesthetics.* Gainsville: University Press of Florida, 1995.

Young, Julian. *Nietzsche's Philosophy of Art.* New York: Cambridge University Press, 1992.

# Index

# PLAN A NEW WEBSITE
# IN 90 MINUTES

*Crescentia Cook*

658.022

First published in 2007 by Management Books 2000 Ltd
Forge House, Limes Road
Kemble, Cirencester
Gloucestershire, GL7 6AD, UK
Tel: 0044 (0) 1285 771441
Fax: 0044 (0) 1285 771055
Email: info@mb2000.com
Web: www.mb2000.com

Printed and bound in Great Britain by 4edge Ltd of Hockley, Essex – www.4edge.co.uk

British Library Cataloguing in Publication Data is available

ISBN 9781852525415

# Contents

# 1

# Understanding the Basics

*A brief explanation of the internet – Connecting to the internet –
What is the World Wide Web? – The internet and business – The
web development process – Domain names –Web hosting*

## A brief explanation of the internet

Most of us use the internet every day to search for information, send
emails, play games, do our banking, order goods and download
documents, music or films. It is becoming a major part of our lives
and we can connect to it not just through our computers but also
from our televisions and mobile phones. Wireless, satellite and
digital technology means that we can access it from nearly anywhere
in the world for our entertainment, to communicate and to get
information. We tend to take it for granted and most of us have
never stopped to think about how it works.

Internet stands for "International Network" and is a global
network of millions of computers following certain protocols to talk
to each other.

During the 1960s much of the initial technology for building a
computer network was researched and developed and by the end of
that decade there were four computers connected together as part of
the US Department of Defense project ARPANET (Advanced
Research Projects Agency Network). The internet, primarily
developed for academic institutions, scientists and the government,
has been evolving ever since.

Since the general public were given access to the internet in the

1990s the internet has expanded beyond anyone's wildest expectations. This is partly due to the fact that the internet is not run by any organisation. This has allowed the internet to grow organically, as anyone can build a computer with the correct software (a 'server'), and link into it.

## Connecting to the internet

Unless your personal computer is a server, no-one in the internet community would care if it broke down. Your PC is just an access point to the internet and you need to connect through it using a telephone line and a **modem**. The messages sent by your computer are digital whilst the messages sent through telephone lines are analogue. Modems turn the information they are sending into analogue for the phone lines, and the information they are receiving back into digital format for the computer.

You will need to be given access to the internet by an Internet Service Provider (ISP). Some of the most common ones are Virgin, AOL, Tesco, BT and Orange. An ISP allows you to have access from your personal computer to their computer network and their network connects you to the internet.

To view anything on the internet you will need **browser** software. A browser translates the code that web pages are written in and displays them in a friendly way for you to view. Internet Explorer and Safari are common types of browsers.

Have you ever noticed that at certain parts of the day, or if there is a newsworthy story, it can be difficult to get onto the internet? That is because the system becomes overloaded. America starts to go online around 2-3pm in the afternoon and there is a definite reduction in speed of access to the internet when this happens. Similarly, a newsworthy item can mean that your ISP's server or the server that hosts the website with the story can become overloaded when lots of users try and connect to it, which also slows things down.

The phone line and modem you use to connect to the internet can

affect the speed of your access too. A broadband connection is much faster than a dial up connection (and much cheaper for any kind of sustained use).

# The World Wide Web

The World Wide Web is the sum of all the information on the internet held on the web pages that can be viewed through your browser. Hypertext links connect the web pages to each other and clicking on these links leads you from one page to another.

# The internet and business

Fast, powerful computers, at reasonable prices, make the internet easily accessible to most people either at home, the office or school. The growth of the internet has been phenomenal and has many benefits for business.

- Emails allow you to keep in contact with your staff, customers and suppliers.
- Business websites can be used for the promotion and sale of goods and services to potential customers ('e-commerce').
- Online payment-processing facilities have further aided the growth of e-commerce.
- Online banking facilities provide 24-hour financial account management capability.
- Video conferencing and online meeting technology allows you to meet with people in different locations and give them access to presentations and information on your computer.
- Intranets allow you to communicate internally with your staff.
- Extranets allow businesses to share information securely with suppliers and customers.
- Internet marketing through websites and internet advertising creates a broader client base.

# The web development process

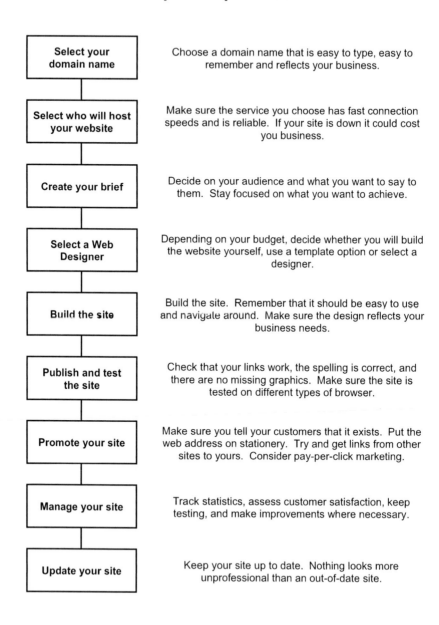

| | |
|---|---|
| **Select your domain name** | Choose a domain name that is easy to type, easy to remember and reflects your business. |
| **Select who will host your website** | Make sure the service you choose has fast connection speeds and is reliable. If your site is down it could cost you business. |
| **Create your brief** | Decide on your audience and what you want to say to them. Stay focused on what you want to achieve. |
| **Select a Web Designer** | Depending on your budget, decide whether you will build the website yourself, use a template option or select a designer. |
| **Build the site** | Build the site. Remember that it should be easy to use and navigate around. Make sure the design reflects your business needs. |
| **Publish and test the site** | Check that your links work, the spelling is correct, and there are no missing graphics. Make sure the site is tested on different types of browser. |
| **Promote your site** | Make sure you tell your customers that it exists. Put the web address on stationery. Try and get links from other sites to yours. Consider pay-per-click marketing. |
| **Manage your site** | Track statistics, assess customer satisfaction, keep testing, and make improvements where necessary. |
| **Update your site** | Keep your site up to date. Nothing looks more unprofessional than an out-of-date site. |

Starting a small business is not easy. There have always been a lot of things to consider, including accounts, advertising, legislation, sales and maybe even employment law. To make things more difficult, today's world of IT means you may even have to think about what computer to buy, what software to use and if you should have a website.

If you have never had a website then the web development process may be unclear to you and if you are considering e-commerce there are additional tasks you will need to undertake to ensure that the development and launch of your website is a success. The diagram on page 10 identifies the main steps that you can expect to take in the development of your website, and the chapters in this book will elaborate on what you should be considering at each stage.

# Domain names

All computers across the internet are assigned a unique identifier called an IP address. IP addresses are used like street addresses so other computers can locate them. An IP Address may look something like: 56.234.22.12 and is not very memorable. Can you imagine someone trying to find your website with an address of numbers? To make it easier to locate your website you will need to register a domain name that you can assign to your IP address so, instead of a meaningless number, people can enter something like *yourcompany.co.uk* to find your website.

---

**The domain name you choose is the representation of your business on the internet, so it is important to get it right.**

---

When buying a domain name all sales are final; if you make a mistake you can't change your mind and you don't get your money back. Make sure the domain name you use is:

- Short and concise.
- Easy to remember.

- Easy to spell. As a rule don't use dashes as this confuses people.
- Appropriate for your business. Your domain name does not need to be your company name; it could be a keyword that reflects the business that you are in. If you sell craft products it could be artgoods.co.uk.
- Make sure the name is still sensible when converted to lower case. Examples are *therapistfinder.com* (a therapist network) and the programmer's site *expertsexchange.com*.

## *Structure of domain names*

A domain name can have the characters a-z and numbers 0-9 with no spaces. Hyphens (-) can be used in the name but not at the beginning or end of a name.

A domain name always has two parts: the name and what is known as the domain level extension (also known as a 'top level domain'). Originally there were only six top level domain extensions: .com, .edu, .gov, .mil, .net and .org. ICANN (*internet Corporation for Assigned Names and Numbers*) has responsibility for managing the domain name system and additional top-level extensions are added from time to time. These are the most common forms at present:

- **.ac:** academic
- **.aero:** aviation organisations
- **.biz:** business
- **.com:** commercial organisations but unrestricted
- **.coop:** cooperatives such as credit unions and rural electric coops
- **.edu:** for post secondary level educational establishments
- **.gov:** for governments and their agencies
- **.info:** for information sites, unrestricted
- **.int:** international organisations established by treaty
- **.jobs:** for employment related sites
- **.mil:** military
- **.mobi:** for sites about and supplying mobile devices

- **.museum:** museums
- **.name:** individuals, by name e.g. Fred Davis
- **.net:** for network structures but now unrestricted
- **.org:** originally for organisations not falling within the other top level domain categories such as charities, trade-unions, professional institutes but now unrestricted
- **.pro:** professionals e.g. lawyers, doctors, accountants etc
- **.tel:** for services involving connections between the telephone network and the internet
- **.travel:** for travel agents, airlines, hoteliers, tourism bureaus, etc.

Unrestricted top level domains mean that anyone can register a name with that extension. Top level domains can also be country codes such as *uk* or *fr*, but they are usually associated with a sub category i.e .*co.uk* or .*org.uk*.

If the domain name you would like to use has already been registered it may be available with an alternative extension; if the .com version of your domain is already taken, the .co.uk name might still be free. Some companies will register several domain names at the same time i.e. both .*com* and .*co.uk,* so that people will be able to find them whatever extension they use. Another reason to register several domain names is if you know that people frequently misspell your company name or a word that you are using in your domain name. It would be sensible to register the misspelt version as well as your correct name.

If the domain name you want is being used, but there is not a website associated with it when you type in the address in your web browser, you may be able to buy the name from the owner.

## *Registering domain names*

There are several companies who are authorised to register domain names but there is only one master database maintained by Internic (www.internic.net). Nominet is the internet registry for *.uk* domain names (www.nominet.org.uk). Both these sites have a WHOIS search engine that allows you to check who owns a particular domain name.

When you register a domain your name, company name, address and payment details are recorded in the database along with the domain name. Domain names are purchased for a set period of time, usually 1-10 years, during which you own the right to use the name. The person who has originally registered the name will be given the option to renew the registration on payment of a renewal fee. If this option is not taken then the name becomes available for someone else to register.

The cost of registration will depend on the company you choose to register with, the duration of the registration you are purchasing and the top level domain. *.com's* are more expensive than *.co.uk.'s*. You can expect to pay anything from £10 to £35. The company you choose to host your website may register your domain name for free with their hosting facility but you need to check what happens and what you need to pay when it is time to renew. If you want to register a name yourself then there are many companies on the internet who register domain names. Whichever company you select make sure you are clear on:

- The duration of the registration.
- The price.
- If you are buying your name with a hosting service, make sure the contract allows you to transfer the name in case you have problems with the hosting company.
- Ensure that the contract states that *you* own the domain name and not the registrar.

# Web hosting

In order for people to see your website you will need to put it on a server. A server is a computer that is connected to the internet 24 hours a day. You will either need to get your own server, which can be costly and requires technical expertise, or you can use the equipment and expertise of a web hosting company.

There are two types of hosting that you can choose:

- **Shared server hosting** is the most common type of hosting used. It is suitable for smaller websites or e-commerce sites that have a limited product range. With shared hosting you will share your server with other websites. In the past shared hosting has had a bad name and could be unreliable. These days, because of the competitive nature of the market, you will get a secure and reliable connection to the internet at an affordable price. Shared hosting services can also include hit counters and shopping carts.

- A **dedicated server** is usually chosen by organizations with very large sites, who have the technical expertise to manage and operate a server. In this case you buy or rent the entire server for your sole use. The server is housed at the hosting company but you will get remote access to configure it. You save money on internet connection, security and network administration costs.

If you would like to have a dedicated server but don't have the technical expertise in your company, you can pay for a **managed service**. There are different levels of management you can buy. A fully managed service usually means that you will be completely hands off in the maintenance of the server, with your provider managing upgrades to the software, operating systems, security and performance of the server.

---

**One thing you do need to check no matter what level of service is provided, is the backup and restoration process, if anything does go wrong with the server.**

---

15

## *Choosing a hosting company*

To choose a hosting company you need to consider:

- How much **space** you will need on the server to host your website and any database or other files connected with the site. If you feel your site will grow in the future then make sure you can expand the amount of space available at a later date.
- **The response times of the server.** You will often be given the choice of a linux server or a windows server. Linux servers generally run faster and are more secure but if your web developer is planning to use ASP scripts or a database you will need to use a windows server. The activity and number of sites on the server can also affect the server's performance. If you have a lot of graphics, video, audio or expect your site to be very busy then you will need a server with a high bandwidth.
- **Reliability.** If the server is down then your site is down. Servers need to come down sometimes for maintenance and upgrading but aim to get a company that has at least 99% uptime and can back up this claim; some allow access to their server monitoring software statistics that will verify their uptime.
- **Technical Support.** You may be with your web hosting company a long time so you need to feel secure in the knowledge that they will be there to support you if you need help. You should be able to contact them by phone and email. Make sure that support is provided during your working hours if you are using a hosting service from another country. Some hosting companies provide 24/7 cover at an additional cost. Check what you are getting in your contract.

---

**You can test the efficiency and knowledge of the support you will receive *before* you buy by contacting the company and seeing what type of response you get.**

---

- What **additional features** does your web hosting company provide? Will you get email accounts? Does it support the software or scripting you want to use on your web pages? Have you got access to transfer your files onto the server? Strange, but some companies restrict access. Will you get statistics of up time and visitors? Can you transfer your domain name?

> **As a small business avoid companies that provide 'free' hosting. Usually this means having banner ads on your website that will make it look unprofessional and support is non-existent.**

## Who provides web hosting?

Your **Internet Service Provider (ISP)** may provide web hosting for free but usually this is in the form of a member's area and you will need to use web address forwarding from your domain name to the hosted website – i.e. you register your domain name and also register a forwarding address which re-routes people entering your domain name in their browser to the actual website address you have been provided by the ISP. Using web forwarding makes it difficult for search engines to list you properly and should be avoided.

**Specialist hosting companies** are often the best choice as they have various ready-made plans for different types of site requirements. They have the expertise in dealing with hosting and usually have an established support process for their clients.

# In summary

- Understand the development process and what tasks you will need to do at each stage.

- Think about a suitable domain name and have a few options in case the one you want is not available.

- Consider registering more than one domain name with different extensions or if misspelling of your name is common.

- Establish whether you need a shared server or a dedicated server, and evaluate the market to make sure you get the right package for your needs and that you will be able to upgrade it as your requirements change.

$$\underline{\overline{2}}$$

# Planning Your Website

*The benefits of having a website – Establishing your audience –*
*Planning your content – Starting a relationship with your*
*customers – Writing your website design brief*

## The benefits of having a website

When I started in IT the internet didn't exist. I can remember my
friend in the IT department showing me excitedly how he could
access information from museums and universities in America.
Whilst he could see the potential of the internet, I said to him
flippantly, 'Brilliant, but what use is that to me?' Nowadays, millions
of people all over the world use the web every day to find
information, look for services and shop online. Consequently people
are constantly surprised if a firm or business doesn't have a website.
But, does that mean a website is really something you need?

If the only reason that you are thinking of having a website is
because all your competitors have one, then think long and hard
before you proceed. Having a good website will take a lot of
planning and preparation BY YOU, and if you feel there is no real
benefit then you may not be willing to put in the effort that is
involved. The more time you spend planning your website the more
relevant it will be to your business and the development process will
be a lot smoother.

> **A bad website could do more damage to your business then no
> website.**

So what are the benefits of having a website?

- It will let people find out about your services and products, out of office hours and without them having to phone you. This may encourage them to get further information or buy some goods.
- It can provide better communication with existing customers. You can use it to keep existing customers informed, for example letting them know about discounts, promotions or new products and services. You can provide them with support using "Frequently asked questions" pages, user guidelines, technical specifications or special user areas with information that can reduce support calls. Customers who feel valued and cared about are more likely to provide you with repeat business.
- It can provide a new channel for sales and distribution, helping your business grow.
- You can publicise how well you are doing by listing high profile clients or having testimonials from existing customers.
- You can provide maps and directions showing how to find you.
- You can use the website as a window to display a portfolio of your work.
- You can provide press or trade information about your company.
- A website extends your market from local to national and even international. People use the internet to extend the choice of products and services they use from just local suppliers.
- If you allow an area for customer feedback, the suggestions could help you develop your business and supply new products that meet the needs of the market.
- It is dynamic; you can keep a website up to date with information at a fraction of the time and cost of updating brochures or other printed material.

---

**In a nutshell a website will provide your company with 24 hour advertising around the world at a fraction of the cost of other forms of advertising.**

---

New and existing customers can access information about you at their convenience, keeping them informed, creating good relationships and a potential market for your business.

### Think about the image of your company

You need to decide whether your website reflects you as a company today or where you want to be in a few years time. The majority of the people on the internet won't know who you are so you can project any type of image and you can emphasise any particular aspect of the company that you want. If you own a pub opening a new restaurant or getting an entertainment licence you will want to promote it on your website today as a 'coming soon'.

You want to give the image of a company who can be trusted to provide a good service and who care about their customer. This can be as simple as displaying a logo showing affiliation to a trade body or a clear policy on refunds if goods don't meet required standards. Out of date information on your website will give the impression that your company is sloppy or overworked which could put off potential new customers.

Having said that, don't get too carried away with the 'me' bit of your website, unless of course that is what the people who are visiting it really want to know about!!

## Establish your audience

Now that you've decided that a website can bring some benefits to your company you have to decide who you think will be using it. The type of information you need to provide on your website will depend on why people are visiting it. Typically the people who access your website could fall into one of these groups:

- New customers checking out what you provide and how much it costs.
- Existing customers wanting some help on how to use a product or advice on the best way to do something.
- Suppliers or contractors deciding if you are the type of company with which they want to work.
- The media wanting to find out more about your company (for example, if you have been involved in some charity work or sponsorship).
- General users who are seeing what goods or services are available locally.
- Web users who have stumbled across your website by chance, usually because it has come up in a search.
- Researchers – students, librarians, webmasters and competitors who are investigating the services and products you supply.

Each of these groups will have a different reason to be in your site and may need different information.

Find out as much as possible about your target audience. You may already have done much of this research when planning your general marketing strategy.

- How old are the people you want to attract?
- What's their educational background?
- What web access facilities are they likely to have?
- Are they likely to be experienced users or novices?

---

**Know your audience, so that you can structure the site content to meet their needs and expectations.**

---

## Plan your content

You may already have brochures and leaflets advertising your products or services and feel that these can be used as a basis for

your website. Sometimes they *can* be used, but more often than not you should start again when you think about the content of your website.

Reading from a computer screen is up to 25% slower than reading written text, so people tend to scan the pages on the screen picking up headlines. Users don't like to scroll through masses of text so you need to make your words count and use simple sentence structures.

Not all the groups listed in the previous section will apply to your business. If your website is for more than one group decide which one takes priority. For example, your website may be primarily set up to provide support for your existing customers, but you also want to tell new customers what sort of services you provide. In this case the main focus of your website could be to provide users a login area where they can access their own details and the progress of their work together with technical documents. Details of your services may be elsewhere on the site. Conversely, if the site is for the benefit of new customers you will want to focus on the services or products you provide and have a different area or page for existing customers.

Once a user enters your site you have about 20 seconds to make an impression. It should be quickly obvious to the user what your site is about.

## *Provide the relevant information*

Think about the groups that are relevant to your business and try to imagine the type of information they will want about your products or services. What sort of issues do you repeatedly have to explain to new or existing customers? How will you capture their attention and what makes you different from your competitors? Think about the information you look for yourself on the internet when you are looking for goods or services. Consider having a tagline that highlights the main message of your company in one sentence and have this on every page, as a user does not always enter your site from the home page.

When I am looking for someone to provide a service – perhaps a

solicitor or accountant – I usually search the net or check the telephone directories for potential suppliers and make a shortlist. I then look at their websites to see what sort of services they provide and compare them to what I need. The appearance of the site will influence my perception of whether they seem professional and friendly. Similarly, if I am going to see a new client I will have a look at their website to find out as much as I can about the history of the company, the company ethos, whether they are a high-tech cutting edge company or a family run business. People can and do read a lot about your business from what you provide on your website so content and design is very important.

> **A site shouldn't be all things to all users. Stay focused on your customer and your company's main goals. Let them know the benefits of using your products and services.**

Do you want the site to be interactive?

An interactive site makes the user feel more involved with the business. Interactivity can take the form of mini-surveys or an area that customers can leave feedback such as a guestbook. A building firm may have an online calculator to estimate materials or a hotel may include a currency converter. Holiday sites could have an area where people could upload photographs of their holiday. If you provide a lot of information then you may want to provide some way a user can search the information using keywords. If your business is relevant you may want a forum or newsgroup where people can ask questions.

If you do decide to have an area where people can leave comments or questions then you should make sure resources are in place to ensure negative feedback is dealt with swiftly and questions answered. Ignoring them will reflect badly on the company and imply that you don't care.

The degree of interactivity you have on your website should take into account the experience of your audience in using the internet. Sites that will attract novice users should limit the degree of interactivity as this could confuse them and put people off using your site.

# Start a relationship with your customers

Customers buy when they are ready to buy. Not when you are ready to sell.

Use your website to start a relationship with your customers. A successful website is one where customers return to use it, so you need to think how you can encourage your users to come back.

This can include **company news**. This needn't be work-related. It could cover personal achievements by a member of staff, a marriage, or birth. For small businesses with a lot of customer contact, it could make your customers feel more part of the business. It could also contain news items relevant to your industry that may be of interest to your clients, for example if they have to change working practices.

You could include pages with **hints and tips**. For example a site for a hairdressing salon may have an area explaining how to do particular hairstyles. Garden centres could provide seasonal information on what should be planted. The site could incorporate a glossary that explains jargon used in the industry.

If your business has links with the local community you may want to include **local community news**. Sites for hotels may want to include details of local tourist attractions and upcoming events.

You could consider using **links** to other sites that are associated with you or your market that users may find interesting.

Ask your customers if they would like more information and collect their contact details so that you can send them promotions, newsletters and marketing information.

Here is a list of the type of typical information normally found on websites to help you start planning your content.

- History of the company and how and why it was established. This should reflect the values and attitude of the company.
- Details and experience of key staff. This may sway the decision of someone looking for an expert in a certain field.
- Services that you provide.
- Product information. This may or may not include online shopping.

- Maps and directions.
- Opening times.
- Contact details. This can include email addresses and telephone numbers of internal individuals such as the accounts or sales department.
- Job descriptions and vacancies.
- Service level agreements, refund policies and delivery arrangements.
- Details of awards and industry recognition.
- Client lists.
- Portfolio of work. This could be photographs of completed projects for an interior designer, decorator or architect.
- Company news.
- Frequently asked questions.
- Technical specifications and user guides.
- Discounts and promotions.
- News items relevant to your industry.
- Discussion forums.
- Booking forms.
- Calendar of events or appointments.
- Feedback forms that allow people to give feedback either about the site or services.
- Search facilities.
- Hints and tips.
- Glossaries.
- Competitions.
- Community pages. Local news, attractions and events.
- Price lists.
- Links to other sites.
- Forms for signing up for mail shots or further information.

## Write your design brief

A web design brief is your document that tells your web designer what you are looking for, what you wish to achieve, what market and

audience you are targeting and any other related information important to your website.

Although it takes time and thought to write one, skipping this step will not make things any quicker. You will need to know this information when it comes to choosing and discussing what you require with a web designer so it will pay you to have a brief outline of what you want, even if it is just a one paragraph description.

A design brief will consist of some or all of the following subjects:

| | |
|---|---|
| **Company Profile** | This should be a brief summary of your business and include<br>• What you do<br>• Services/products you sell<br>• Number of staff<br>• How you fit into your industry sector<br>• Your traditional market<br>• How you see your business developing in the future |
| **Existing website details** | If you have an existing website then include what you like or dislike about it, whether it achieves its goals and why you are redeveloping it. |
| **Aims and objectives for the website** | What do you want the website to do?<br>• Information only<br>• E-commerce<br>• Generate enquiries<br>• Obtain information<br>• Display your work |
| **Target audience** | Is this existing customers or new customers?<br>• Do you have details of their age, sex, location?<br>• What web access facilities do they have?<br>• Do certain sections of your audience have special requirements i.e. visually impaired, deaf?<br>• Is it likely that they be accessing your |

| | |
|---|---|
| | website on hand held devices? |
| **Design** | • What visual message do you want to project? Do you want to come across as a high tech company who follows the trends or one that has a more cautious dependable approach?<br>• Has your business already got a corporate style and is this to be reflected in the website? |
| **Structure** | List the pages that you want to see on your site. This can change after discussion with your web designer, so be prepared to be flexible.<br>• Company profile<br>• Client list<br>• Press releases<br>• Contact details<br>• Enquiry form<br>• Product information<br>• Portfolio |
| **Functionality** | Provide details of any additional functionality that you want.<br>• A password protected user area<br>• Content management system<br>• Search engine for your content<br>• Guest book<br>• Downloadable documents<br>• Videos, music<br>• Flash content |
| **Deliverables** | Apart from building the website what other services do you hope your web designer can provide?<br>• Domain registration<br>• Hosting<br>• Copywriting<br>• Database development<br>• Search engine optimisation and registration<br>• Animation, video or sound |

|  | |
|---|---|
|  | • Provision of graphics and photographs<br>• Marketing<br>• Training<br>• Site statistics |
| **Timetable** | When would you like the site to go live? Is this date flexible or does it coincide with a product launch or other event? |
| **Maintenance** | How often do you think your site will need to be updated? Do you require a content management system or will you return to the web designer for updates? |
| **Budget** | Your estimated project budget. |
| **Contact Details** | The name, position and full contact details, including the email address of anyone who will be able to help with enquiries. This person should be someone who can make decisions and sign off the project. |

# In Summary

- Consider who you want to attract to your website, the information they want and make sure the website is focused on their needs.

- Plan your content. Ensure that the benefits of using your products or services are clearly presented and visible.

- Have a good idea of the image you want to portray of your business. Highlight the areas that distinguish you from your competitors.

- Check out the sites of your competitors, what do you like about them, what can you do better?

- Start a relationship with your customers. You want them to remember you, return and use your products or services.

- Collect contact details on your visitors that you could use to send promotions, newsletters etc.

- Write your web design brief.

# 3

# Time to Plan

*Take a few minutes to think about what you would like from your website.*

1.  Write down suitable domain names for your website.

    ……………………………………………………………………

    ……………………………………………………………………

    ……………………………………………………………………

2.  What do you consider the main purpose of your website should be?

    ……………………………………………………………………

    ……………………………………………………………………

    ……………………………………………………………………

    ……………………………………………………………………

3.  What is the main purpose of your business? How do you see the site supporting this?

    ……………………………………………………………………

    ……………………………………………………………………

    ……………………………………………………………………

    ……………………………………………………………………

4. Why are you different from your competitors?

......................................................................

......................................................................

......................................................................

......................................................................

5. Have you got/can you think of a suitable tagline?

......................................................................

......................................................................

......................................................................

......................................................................

6. Who is your customer? What is their age range, where do they live? If there is more than one group you are trying to address prioritise them.

......................................................................

......................................................................

......................................................................

......................................................................

7. What sort of information will your audience want from your website?

......................................................................

......................................................................

............................................................................

............................................................................

8. Do your audience have any special access requirements because of disabilities or because of the technology they will use to access your site?

............................................................................

............................................................................

............................................................................

............................................................................

9. If you are developing an existing website why are you doing this? What are you trying to achieve with a redesign?

............................................................................

............................................................................

............................................................................

............................................................................

10. List the relevant topics you expect to see on your website.

............................................................................

............................................................................

............................................................................

............................................................................

11. Do you want to collect email addresses?

..............................................................................

..............................................................................

..............................................................................

..............................................................................

12. What additional functionality do you want e.g.
downloadable brochures, password protected areas, guest
books, videos, music, maps.

..............................................................................

..............................................................................

..............................................................................

..............................................................................

13. Circle the words that you feel reflect the image you want to
give of your company.

| | | |
|---|---|---|
| Professional | Lively | Ambitious |

State of the Art    Market Leaders

Dependable    Funky    Honest    Unpretentious

Sincere    Sophisticated    Customer Focused

Fun    Reliable    Credible

Informational    Friendly    Cool    Inspirational

Serious    Trustworthy    Glamorous

Trendy

$$4$$

# Who Should Create Your Site?

*Who should create your site? – Web design or web development?*
*– Selecting a web design company – Contracts and ownership*

## Who should create your site?

All you need to do is to ask around a bit and I expect you'll find a whole host of people who could 'provide' you with a website – the teenage son of a neighbour down the road who has been doing a bit of web development at school, or a friend who has created their own 'personal' page. You may have even been tinkering around with a few of the 'free' templates and web editors. Then there are the professionals, but you're not quite sure what to expect for your money and talking to them may be slightly intimidating. So the question is, who should create your website?

The options you have are:
- Do it yourself (or a willing friend)
- Use one of the template options
- Hire a web design company.

What you need to consider:
- Complexity of your site
- Budget
- Skill.

Even after creating your site there are a host of other things to consider:

- **Accessibility issues.** It is a legal requirement to make sure your website is accessible to people with disabilities and there are guidelines that need to be followed to comply with this requirement. A web developer will automatically ensure that these accessibility issues are covered.
- **Site promotion.** How will people know your site exists? Most people will find your site through a search engine. If you want to attract new customers you need your site to appear in the first few pages when someone searches on a keyword to describe your business. There is a whole science to getting sites ranked by the search engines (and a number of consultants specialising in this area).
- **Content management.** Who will update and maintain your site and content?

---

**Your website is going to be a gateway to your business, so you want it to be sleek and professional and not like someone's hobby.**

---

## Complexity

If you want to collect information on people or you want your customers to access information or view products then you are going to need a database, and I would recommend using a professional as there will be technical issues to address. If the site is just going to be text and a few images then you could consider a friend to set it up or do it yourself. Whilst a friend may be willing to create a website for free, will they be happy to continue updating a site for you? Do you have the time and skills to create one yourself?

## Budget

There are some costs to pay even before you think about the design of your company.

You will need to buy your domain name, which can be £10 - £35. You buy the name for a limited period usually 1-10 years and will

need to pay periodic renewal fees to keep it.

Depending on the complexity of your site the cost of hosting it may be an annual fee of £30-£1,000 plus a monthly fee of £7-£100.

Even if you do it yourself you will need to buy software and learn the skills. Some companies do 'starter' packages of around four to six pages from selected templates for about £200-£300. If you are thinking about selling products or a degree of user interaction then use a professional and expect to pay around £800-£1,000 and for more sophisticated sites you can expect to pay anything over £2,000.

## *Skill*

You are an expert in your field and a web designer is an expert in theirs. Have you the time to become an expert in another subject?

There are many tools out there that can help you create a website but you are relying on them to work correctly all the time and in my experience they will invariably go wrong or produce an unexpected result at one point or another, so you will need to understand the tools and know how to reconfigure or correct them if they do go wrong. As a starting point you should at least understand HTML and the package that you are using to create the website. You also need to be familiar with how the internet works and transferring files to your server. Learning these skills will take time and usually investment in a couple of books or courses. Most people's first attempt at a website looks amateurish and I have seen many people try and give up because the software doesn't do what they want and they don't know how to manipulate it.

If you have a very simple site an option is to use a 'template' site that costs about £100. Just do an internet search on 'Creating your own website' and you will get many providers of this service. You have a selection of templates to choose from and can add your own photographs and words. You can have these up and running in a matter of hours. However, you risk having another site look identical to yours and they are just basic sites. If you have a limited budget and you just want a web presence then this could be an ideal solution.

# Choosing a Web Design Company

You need to have a good relationship with your web designer. Make sure you choose someone you feel you can trust and with whom you can work closely.

You may have heard the terms 'Web Designer' and 'Web Developer' and be wondering if they are the same thing. A designer usually has a graphic design background and may also work with print publications. A developer has more of a programming background. Both will be able to create your website and many are competent at both skills. Sometimes web design companies have designers who concentrate on the design aspects of the site and developers who build the site.

Well, you've got your brief together and have decided that you would like a web company to create your website. If you look in your local telephone directory or do a search on the internet I am sure you will come up with numerous companies providing this service, so how do you go about selecting one?

The best way to select a web designer is through recommendation. Failing that, shortlist two or three and then arrange to meet them to discuss your requirements.

It is not necessary to choose a local web designer. Many sites are built by designers who have never met their client, but it can help to actually meet your designer to build a good working relationship. It is much easier to discuss issues and sort out problems face to face than over the telephone.

## *Selecting the shortlist*

Shortlist the designers you are interested in, based on their house 'style', the size of websites they usually design, their portfolio and testimonials.

Most web designers have their own 'style' so it is important that you like the sort of sites that your web designer produces. Look at their client portfolio on their website and assess what you think of them. Is their style suitable for your business? Are the websites easy to use and is the content well planned and up to date? Don't just look

at the design; think about whether the site would meet the business needs of the companies they are promoting.

Are the sites created by the designer small (less than 3 pages), medium-sized (5-30 pages) or large (30+ pages), and do you see your website falling in the category they work in?

Some designers specialise in 'niche' markets such as accountancy and engineering and this information should appear on their website. Select one of these if your business falls into their niche category. Ideally, select a designer who has already created a website for businesses like yours or has an idea of your industry. It will give them a background understanding on what you want to achieve.

Check the testimonials from past clients if they exist on the designer's website. If not, you can contact the clients shown in the portfolio. Ask them how easy the designer was to work with. Did they deliver on time and to the agreed budget?

## The preliminary meeting

The key things you should be looking for when you meet with a web designer are:

- Attitude
- Services
- Experience
- Price
- In house administration and project management processes.

These initial meetings usually take 2-3 hours and will cover everything in the design brief. If you haven't written a brief it will be necessary for you to have at least thought about the different areas, as a good web designer will be keen to find out as much as possible about what you need and your reasons for having a website.

If the designer is not interested in what you want and what you want to achieve then look for another designer.

## *Attitude*

A good website is not created with the press of a button and can take weeks and even months to complete. It is important that you feel able to work with your web designer and that they take the time to explain things to you in a way that you understand. They should be interested in understanding your goals and be able to add to your initial ideas. Do you feel comfortable with the designer and are they open to your suggestions?

## *Services*

Apart from creating your website what services can they provide? Will they register your domain name and host your site? Can they provide an initial marketing plan and handle search engine submission? Can they maintain your site for you or will they be able to provide training if you require it? Will they provide graphics and create the content?

## *Experience*

If you want a particular function for your website such as e-commerce, a database, content management system or flash videos, then check that the web designer has the appropriate experience. Sometimes web designers will contract parts of the site build out to other designers or developers and you should be aware of who is doing what up front.

It may be important to you that the web designer is established and likely to be still trading in the future, especially if you know you will want your website re-developed at a later date. Many web designers come and go every year and anyone who has lasted more than three years is deemed to be a veteran at the game.

## *Price*

Find out whether you will be paying an hourly rate or a fixed price for the site. You will usually need to pay a deposit of up to 50% for

work to begin. Remember the cheapest is not always the best. Price and quality usually have a direct relationship. Equally, don't discount anyone who is just starting up if they can prove they have the experience that you need. Usually, they will charge a discounted fee to get their portfolio together.

## *Administration*

Just as important as being able to build the website is how the project will be handled whilst it is in development. Will they be easily contactable? How will they keep you informed of the progress of your project? Will they provide a release schedule and a project completion date?

## *Questions to ask*

| | |
|---|---|
| Will they register your domain name? | If the web designer will assist you in registering your domain name, make sure that the domain name will be registered in your name. If it is registered in their name then they have total control and can pull your site down at any time. |
| Can they provide hosting for your website or recommend a hosting company? | Whoever hosts your site needs to provide a reliable and secure service. If your website is down it could lead to lost orders or reputation. Some companies will provide a service level agreement which will refund your money if there is a given amount of unscheduled downtime. Check on the average up time of the hosting server you will be using. Make sure you know your user name and password in case you want direct access to it in the future. |

| | |
|---|---|
| How will they help you appear in the search engines? | No guarantees can be made as to search engine rankings and there are companies that specialise in Search Engine Optimisation (SEO). For a small business the cost of this does not justify the returns but there are many things your web designer can do to ensure that you are well placed in the rankings by using key words, well structured content, coding and navigational links as well as submitting your site to the search engines. |
| Who will provide the content for the website? | Writing the text for your website will usually be your responsibility as you know your business best. The web designer may be able to provide a copywriting service or recommend a copywriter if you are concerned about good sales copy. Photographs or images can be provided by you or your web designer. If you are not providing the images then be prepared to pay royalty fees for any photographs that are used. |
| How will the website be maintained? | Over time you are going to need to update your website. Nothing will lose your reputation quicker than an out of date website. The easiest option is for your website to be built over a content management system so you can make any changes you need. If your website does not have content management discuss how much will be charged to make amendments and how long these changes would normally take. Some companies will have a services contract to do so many hours a month to maintain the website. |

| | |
|---|---|
| Copyright and Ownership | The copyright and ownership of the website should revert back to you as soon as the designer has been paid. Check who has permission to use text and graphics created especially for your site. |
| What are the costs and terms? | Will you be charged a fixed cost or an hourly rate? What will affect the overall cost of the project? How much deposit will need to be paid and will there be interim payments? Are domain registration, hosting, search engine submission, and royalties included in the costs? |
| What sort of visitor statistics will be provided? | You can get statistics showing the number of new and returning visitors to your site, whether they have got there through a link from another site or a search, and the number of times a page has been viewed. Checking your statistics can help you improve your site. If visitors only ever look at the home page then you may want to review it to encourage them to look further at what you offer. If you want these sort of statistics then you should let your web designer know. |
| Will they check the site on browsers other than internet explorer? | Websites look different depending on the size of the visitor's monitor and the browser they are using. Although the majority of people use Internet Explorer they are not all on the latest version. All browsers cannot be tested but you need to check that your site will be tested with the most commonly used browsers such as Internet Explorer, Firefox, Safari and Netscape. |

| What coding standards will be used? | Websites are written in HTML which has its own rules. The World Wide Web Consortium publishes rules for HTML. It is possible to create a website that works that doesn't follow all the rules. Following the rules means that a website is likely to work in the different types of browsers, and different technologies (e.g. mobile phones or PDAs) and will help in your search engine ranking. |
| --- | --- |

# In Summary

- Consider the complexity of your site and the skills that will be required to build it.

- Budget for your site. As well as the cost for development, you will need to pay for domain registration and hosting. You might want to consider search engine optimisation or pay-per-click advertising (more on this later).

- Check out the portfolios of potential web designers, and visit the websites listed. Not only should they be easy to use but they should meet the business needs of the company they are promoting. Shortlist the web designers based on their:

  - Portfolio
  - Previous experience in your industry
  - Testimonials/References.

- At the preliminary meeting consider the web designer's:

  - Attitude
  - Services
  - Experience
  - Price
  - Administration.

- Chose a web designer who you feel you can trust and understands your requirements.

---

**A good web designer should have good graphics and programming skills, an understanding of the web and be able to respond to your needs and ideas. Do not settle for less.**

---

45

# 5

# Understanding E-Commerce

*What is e-commerce? – How does it work? – Your processes to support your e-commerce site – Shop front software – Security issues – Marketing and maintenance – Integration with your existing systems*

## What is e-commerce?

The establishment of the internet has brought about a new way of doing business. No longer do people need to visit shops to buy their goods; they can check prices, order and pay for their goods, and track their delivery online. E-commerce (electronic commerce) is a term used for buying and selling goods and services on the internet and is usually interchangeable with e-business.

> **Two thirds of the UK's consumers have bought online, making it the largest ecommerce economy in Europe.**

The different types of e-commerce include

- **Business-to-Consumer (B2C)** – where companies sell direct to the consumer and virtually any product is now available, from books and CDs to clothes, food, flowers, flights, hotels, and gambling.
- **Business-to-Business (B2B)** – where businesses deal with other businesses in the provision of business supplies, products and services. A growing area is the use of extranets to share data with suppliers and customers.

- **Business-to-Government (B2G)** – this is still in the early stages of development and includes completion of VAT or tax returns online.

## How can you benefit from e-commerce?

As a small business your website can help you generate sales leads by advertising and promoting your products or services. Everyone with access to the internet around the world is a potential customer and traders have been surprised at how their business has expanded outside their local or national communities through the use of the internet.

Possible applications include:

- **Online shop front** – accept orders through your website.
- **Booking system** – allows booking for hotels, restaurants, flights, tickets for concerts, sports or theatre.
- **Online service provision** – completion of application forms for insurance, mortgages, loans etc. Government agencies provide services that include passport applications and vehicle licence applications.
- **Online subscriptions** – for example offering paid access to specialised information.
- **Online support** – provision of after-sales support, for example through the publication of technical information or answers to frequently asked questions on your website, perhaps through a password protected area only accessible to your clients.

---

**You should consider e-commerce an important part of your business strategy over the next few years before you think about implementing it.**

---

# How does it work?

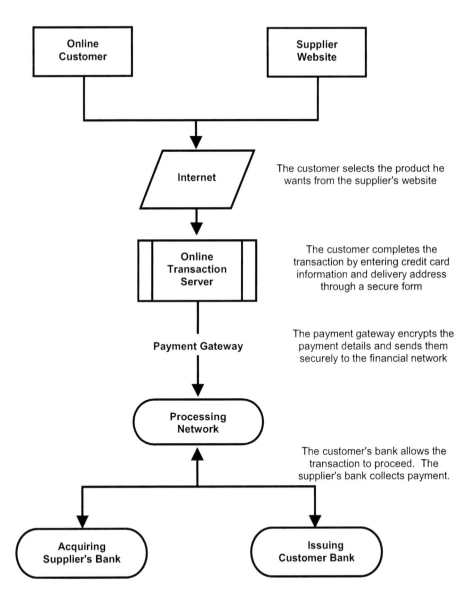

| | |
|---|---|
| **Online Customer** | **Supplier Website** |

**Internet** — The customer selects the product he wants from the supplier's website

**Online Transaction Server** — The customer completes the transaction by entering credit card information and delivery address through a secure form

**Payment Gateway** — The payment gateway encrypts the payment details and sends them securely to the financial network

**Processing Network**

The customer's bank allows the transaction to proceed. The supplier's bank collects payment.

**Acquiring Supplier's Bank**

**Issuing Customer Bank**

# What you need to consider

- Your market
- Your IT infrastructure
- Resources and administration
- The purchase process
- Payment processing
- Shop front software
- Security
- Global marketing and localization issues
- Marketing
- Integration with your existing systems.

## *Your market*

Check that you have an online market. Are goods or services like yours available online elsewhere? Have existing customers asked to be able to buy or find out more information from a website? Who will buy online and how will you attract new customers? As a rule those products that can be fully defined in a few paragraphs and have the same price structure for everyone are the easiest to sell online.

## *Your IT infrastructure*

If you are going to be doing business online you will need something more than an old PC in the corner of the office. Just as your web server needs reliable hardware, so too your own internal hardware needs to be reliable, fast and secure.

- Do the PCs you use have enough memory and storage space to run your software and hold your database?
- Have you got a high speed connection to the internet that is reliable?
- Have you got a secure firewall so that your systems and data are protected from hackers and viruses?

- Have you got a system in place to ensure regular backup of your data in case something does go wrong? Backups should be run daily so at the very least you will only lose a day's work if something does go wrong.

> **Think carefully about going online if you are not comfortable with computers and using the internet.**

## *Resources and administration*

Having a web shop front is only the first step in providing e-commerce. Make sure you have a team in place to deal with the administration of you e-commerce site. Things to consider include:

- Who will fulfil the orders – how will you manage the process for sending out orders and tracking their status? You will need to know the status of orders right to the point of delivery.
- How will you deal with returns and complaints? These need to be dealt with promptly in order not to lose credibility with your customers.
- Who will update the site with new content, prices and special offers and remove out of date information?
- Will you offer telephone and email support? What supporting information will you have online to reduce the number of support calls?
- How will you manage your stock?
- How are you going to handle the personal information you collect on your customers? This needs to be handled in line with the principles of the Data Protection Act and you should not needlessly reveal information about customers.

## *The purchase process*

Make sure that your online purchase process is easy to understand and use. You don't want someone abandoning the purchase because

they don't know what key to press next.

- Explain the delivery process and how long it will take for the customer to receive the items ordered.
- Make sure your returns policy is explained clearly.
- Make sure shipping costs are stated with full details of the different options.
- Make it easy to select colours, sizes and quantities of an item. Show stock availability before a customer checks out.
- Make it easy to amend orders or delete an item. Make sure your customer knows they are making a commitment to buy before finalising the purchase.
- Consider holding records of payment details and purchase history so that you can make the buying experience more personal for the user. You can also benefit from analysing a customer's purchasing history to cross-sell or promote similar products.
- Make sure that orders can be tracked so that customers can check if an order has been sent.
- Make sure that all enquiries and purchases are automatically acknowledged by email.

---

**Customers trading online expect value for money, clear explanation of products and an intuitive way to choose and pay for their purchase. Make sure you give them what they want.**

---

## *Payment Processing*

Buying online should be quick and simple. Your customers are going to want to pay by credit or debit card and you will need some way of handling these payments. The options for collecting payments are to set up a merchant account or use a payment processing company. These options are discussed in detail in the next chapter.

52

## *Shop front or shopping cart software*

This is the software that lets the user select and pay for goods. This should be easy to use and customers should be able to find what they want quickly.

There is a vast selection of companies providing ready-made solutions; some are even free but with limited functionality. Make sure that the software is easy to install and you won't need programming skills to get it to do what you want. Features to consider include:

- Customisation of the look and feel of your product by changing colours and fonts or adding your own logo.
- How easy it is to upload your product details, and the maximum number of products available. If this information is held on another database consider having a way to import the information onto the database for your website.
- If you are considering selling abroad you need to find out what currency and languages are supported.
- What is the maximum number of clients you can have and how easy is it to maintain your client list?
- Is there a limit on the number of orders that you can have, daily or monthly?
- How is inventory tracked, and what information is provided?
- How does it handle discount options?
- Is the page that is displayed to the customer after an order is placed customisable so that you can put your own message on it?
- Does it support various shipping methods?
- Does it automatically send out confirmation emails to the customer when a product is ordered and when it has been sent?

Sometimes it can be difficult to find something that matches your exact requirements, so you may need to get it built yourself by a web developer. However, this can be an expensive option and you will be re-inventing the wheel in many areas. Where possible, try and use an off-the-shelf solution that provides for the majority of your requirements.

> **Whatever shop front you choose, make sure that it will be able to grow with your business and work with your payment processing software.**

## *Security*

Security covers confidentiality of information, integrity of your data and reliability of your systems, and is of primary importance in an e-commerce strategy.

Consumers worry about giving their credit card details online and hackers can attack your system. Breach of security can lead to financial losses if you cannot trade because your system is not working; it can create unwelcome publicity, and cause loss of reputation because of unreliable service; and in some cases it can have legal implications. Some of the risks include:

- **Spoofing**, where your web site is copied and used to illegally obtain peoples credit card information.
- **Data alteration** where hackers get into your website or database and gain access to personal information, prices, product information and can maliciously alter the data.
- **Theft** of a laptop with sensitive information. Always make sure your laptop is password protected.
- **Viruses** sent by email that can corrupt your systems.
- **Denial-of-service** attacks which prevent authorised users from accessing and using your web pages

You need to make an assessment of the security risks and the impact they will have on your business and set up the appropriate security controls. Ways to reduce the risk include:

- **Authentication** – verification that you are who you say you are, usually with use of a user name and password. You need to consider a password policy both for your website and also for your internal systems. How many times can a user

fail to have the right combination? Can previous passwords be re-used? What combination of characters will the password use? Watch the message given when an incorrect password or user name is entered. If it is specific (e.g. 'The password is incorrect') then a hacker may know that they have a correct username or vice versa.

- **Authorization** – restricting users' access to certain areas of the system if they are not authorised to use them. This prevents them seeing other users' information, changing prices, deleting bills, etc.
- **Encryption** – this codes the data that is being transmitted over the network so that only the sender or receiver can understand what is being sent.
- **Firewalls** – a firewall is like putting a locked door onto your internal systems to prevent unauthorised access from the internet. Only those users with a key can enter the door. As a minimum a firewall should be installed on your servers and as an added precaution firewalls can be added to individual PCs or network level for multiple PCs.
- **Anti Virus Software** – viruses are spread through emails and infected documents on CDs. They can corrupt and even delete your data as well as slowing your system down to make it unusable. You should consider installing anti-virus software that will trap viruses before they enter your system and prevent downloads of unauthorised programs and documents from the internet. You need to ensure your virus checker is kept up to date as new viruses are continually being introduced into the system.
- **Contingency Planning** – how will you continue operating if your systems are attacked? Backing up your system should be done regularly. Backups should be correctly labelled and stored safely, offsite if possible.

## *Global marketing and localisation issues*

If you are planning to deal with customers worldwide then you will

need to modify or localise the website so that it is understood and appeals to audiences in other countries – perhaps offering different language options to visiting browsers. Research has shown (not surprisingly) that people are more likely to visit and buy from websites in their own language. In addition returns and service calls are less likely if the customer understands exactly what they are buying. You should consider:

- **Language** – you will need to have your website interpreted.
- **Cultural nuance** – understand the customs and the differences in colour association and symbols of the countries with whom you want to trade.
- **Pricing** – this will need to be in the appropriate currency, or alternatively you may want to consider adding a currency converter.
- **Access to computers** – in some parts of the world access to the internet is not as easy and secure as it is here.

## Marketing

There is little point in having a site that no-one visits, so you need to consider how to attract the visitors to your website. Some of the options will be no different from traditional methods of marketing such as advertising and getting listed in local business directories, but you can supplement this with some specific activities to increase visibility of your website. Marketing is covered in the chapter on promoting and administering your website.

## Integration with your existing systems

Eventually you will need to consider how your online database integrates with your existing systems for stock control and accounting. Re-keying sales made on the internet into your back office systems is time-consuming, not to mention boring to whoever has to do it, and mistakes can be made. As a minimum you need some way of importing these to your back office, and a well-followed process to ensure these updates take place.

True integration means getting the customer connected, not only with the website, but with your business, so that stock is checked before the customer makes a payment and staff and customers can easily check progress of orders and payments.

> **Before you start on an e-commerce strategy make sure your staff, hardware, software and processes can handle it.**

# In Summary

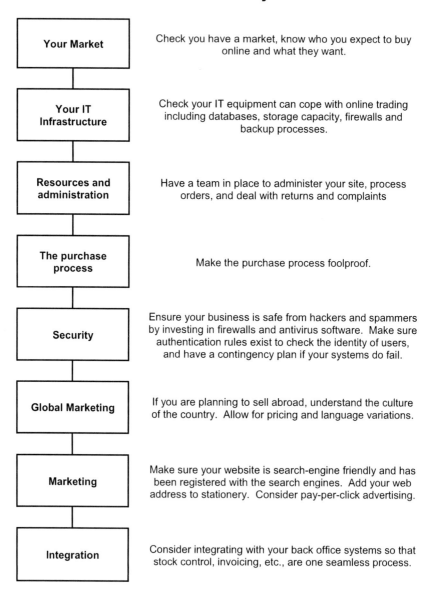

| | |
|---|---|
| **Your Market** | Check you have a market, know who you expect to buy online and what they want. |
| **Your IT Infrastructure** | Check your IT equipment can cope with online trading including databases, storage capacity, firewalls and backup processes. |
| **Resources and administration** | Have a team in place to administer your site, process orders, and deal with returns and complaints |
| **The purchase process** | Make the purchase process foolproof. |
| **Security** | Ensure your business is safe from hackers and spammers by investing in firewalls and antivirus software. Make sure authentication rules exist to check the identity of users, and have a contingency plan if your systems do fail. |
| **Global Marketing** | If you are planning to sell abroad, understand the culture of the country. Allow for pricing and language variations. |
| **Marketing** | Make sure your website is search-engine friendly and has been registered with the search engines. Add your web address to stationery. Consider pay-per-click advertising. |
| **Integration** | Consider integrating with your back office systems so that stock control, invoicing, etc., are one seamless process. |

- Don't consider e-commerce unless you are comfortable with using the internet and the technology involved.

- Set yourself clear objectives of what you want to achieve, immediately and in the future. E-commerce is a long-term strategy in the development of your business.

- Research your market and your competition. Know the profile of your customers in all the countries you want to sell to.

- Work out your budget, not just for the development of your website but for additional marketing, updating of hardware if it is needed, and integration of your back office systems.

- Have a team in place and trained to fulfil orders, handle complaints and provide customer support.

- Decide if you are going to use an off-the-shelf shop front or have one built to cover your specific requirements.

- Choose the way you are going to collect payments.

- Determine your process for maintaining and updating your shop front.

- Put your marketing plan in place.

# 6

# E-Commerce Payment Processing

*Costs and features of merchant accounts – Understanding
payment gateways  – Payment-processing companies –
Chargebacks and how to avoid them*

Buying on the internet is meant to save time and be a quick way to
make a purchase.  People who buy online want to be able to use their
debit or credit card for payments and receive their goods quickly.
They do not want to send a cheque and wait for it to clear before
their goods are delivered.   Research has shown that the average
consumer will spend more if they are able to use their bank cards and
that websites who do not accept credit cards do not have sales as
high as competitors in the same industry.

To be able to accept credit card payments you need either to have
a merchant account or to use a payment processing company.

The success of an e-commerce business relies on the ability to
accept credit card payments.

## Merchant accounts

A merchant account is an account that lets a retailer accept credit
card payments.  There are three types of merchant accounts:

- **Retail merchant accounts** allow for the traditional way of
  accepting credit card payments when the customer and card
  are present for the transaction.
- **MOTO merchant accounts** (Mail Order Telephone Order)

are used when there is not a face-to-face transaction and the credit card details cannot be swiped. The credit card details are processed manually by entering the details into a terminal or through the payment provider's website.

- **Internet merchant accounts** allow the customer to key in their credit card details online and the payment is processed in a matter of seconds. This is the account you will need to accept payments online.

Both MOTO and internet accounts are 'Card not present' transactions and there is a higher risk of fraud so fees for providing these services are higher than a for a retail merchant account.

To open a merchant account the bank will need to approve your credit history and they will want to know details of your business and your e-commerce process. The information you will need to provide may include:

- Details of your product or services.
- Audited business accounts and trading history.
- Your process for online transactions and details of the secure server you will be using.
- The average number and value of online transactions you expect to process.
- Your business plan and details of the directors or partners in your business.

---

**If you already have 'offline' card payment processing facilities set up with a bank, you should find it easier to obtain an internet merchant account.**

---

Banks that provide merchant accounts include:

- Alliance and Leicester
- American Express
- Bank of Scotland
- Barclaycard Merchant Services

- Diners Club
- HSBC
- Lloyds TSB Cardnet
- Nat West/Royal Bank of Scotland Streamline
- Ulster Bank

## *Merchant account fees*

- **Credit card commission rate.** This will make up the majority of your costs and is the percentage charged by the merchant account from each sale. This is generally between 2.2% and 3.5% but can vary depending upon the kind of internet sales you do and the average sale amount.
- **Merchant account up-front fees.** Most merchant account companies charge either an application fee, set-up fee or charge for the software you will use to process payments manually. These fees can range from £50 to £200
- **Merchant account monthly fees.** Most merchant accounts charge a minimum monthly fee for maintaining the account whether or not the account is actually used. This can be £15 to £30.
- **Transaction fees.** This is the fee charged to process each transaction and can range from 20p to 50p per transaction.

As well as the fees for the merchant account there are also fees payable to the gateway service that you use. Some merchant account providers may charge a reserve fee that is based on your estimated sales. This is usually applied where a high volume of sales are expected and is used to cover the cost of chargebacks on the merchant account due to customer disputes or credit card fraud.

When you select a merchant account provider, check that they handle all the major credit cards. Also check the length of time it will take for your funds to appear in your account and the level of support they provide.

# Payment gateways

If you have a merchant account you will also need the services of a payment gateway. A payment gateway takes your customer's payment details and transmits them securely to the processor for your merchant account. It sends a reply back to your website saying if the card payment is accepted, declined or has failed because of missing information. This whole process takes about 3 seconds. Popular payment gateways include:

- Authorize.net (www.authorize.net)
- Verisign (www.verisign.com)
- Paypal (www.paypal.com)

---

**Your shopping cart software, payment gateway and merchant account must all work together and be compatible.**

---

Your shopping cart software will define the payment gateway options you will have. The gateway options define the transaction processors they will work with. The transaction processors will dictate which merchant accounts you can use.

When selecting a gateway provider, check:

- Reliability of the service. If your customers cannot pay, they may use a competitor's site to make their purchases. Your gateway should be up and running 24/7.
- That you will also be able to process orders manually. If a customer calls with a query about your products or services and then decides to purchase, you don't want to tell them that they will have to use the website. You should be able to take their order over the phone.
- What fraud prevention tools do they provide? These include address verification system protection (AVS) which checks the customer's address against the one held on the bank's system and the use of CVV2 (Card Verification Value) which is the 3 digit security number that appears at the back

of Visa and MasterCard. This helps prevent fraud by verifying the card number and ensures that the card is in possession of the customer.

- If you have a subscription or a membership-based business then you may be interested in having recurring billing which allows you to set up billing information with your gateway and tell it how often to charge the customer.
- Does it allow for e-checks and allow you to define when they can be accepted for a purchase? Some people do not use credit cards and still want to pay electronically. E-checks allow them to enter their bank details and the purchase amount is deducted directly from their bank account. Like normal cheques you will need to ensure the cheque has cleared before processing the order.

There will be charges for additional features but those like fraud prevention tools are worth considering. Like merchant accounts you can expect to pay a set-up fee (£80-£200), monthly fees for gateway access (£10-£60) and transaction fees (around 5-10p per transaction). Monthly fees are fixed and not based on the volume of transactions.

# Payment processing companies

If you have a small turnover or do not have the trading history to qualify for a merchant account then you can use a payment processing company to process your credit cards. You actually use the merchant account of the payment processing company and their payment gateway so you will not need to set up a secure payments system. Paypal (www.paypal.com) and WorldPay (www.worldpay.com) are leading providers of this sort of facility. Barclays Bank has introduced the ePDQ internet payment systems to offer such a service. (www.barclaycardbusiness.co.uk/accepting_cards/index.html). It is much easier and quicker to get accepted by a payment processing company, especially if you have no trading history. In some cases successful applicants have been able to start accepting payments over the internet within 48 hours.

A main disadvantage of using a payment processing company is that customers know that they are not paying directly to you. Sometimes they are even taken to another website to process their credit card details. Your name won't appear on their statements; instead, the name of the payment processing company will.

> **The major disadvantage of using payment processing companies is that it can take up to 60 days before payment reaches your account as these companies hold payments for a settlement period to allow for fraud and disputes.**

### *Payment Processing Company Fees*

The fee structures for using a payment processing company are similar to those for a merchant account. Charges for using a payment processing company are falling because of the competitive nature of the market, but generally they are higher than a merchant account.

You should check support levels, stability of the system, credit cards and currencies that are accepted. Ensure your shopping cart software integrates with the system you select for payment processing.

# Chargebacks

A chargeback refers to a dispute between a customer and a business it has purchased an item from. This could be because of processing errors, fraud or dissatisfaction with services or goods received. The customer asks their credit card company for a refund. If the credit card company agrees the customer is entitled to the money, they will require the business to refund the payment as well as pay a chargeback fee.

## *Reasons for Chargebacks*

- The card is not valid at the time of transaction. It could have expired or been accepted before it was valid.
- The transaction was processed more than once.
- The transaction was processed for the wrong amount.
- The customer did not receive the goods or returned them.
- The customer received faulty goods or goods that were not as described on the site.
- In the case of subscription services the customer has cancelled future subscriptions but they are still being collected.

---

**Charge backs cannot be totally avoided but you can do certain things to minimise their occurrence.**

---

## *Avoiding Chargebacks*

- Using fraud prevention tools such as AVS and CVV2.
- Set up your own rules that flag for suspicious purchasing. This can include checking for customers who purchase a high volume of goods or customers who order several times in a day.
- Make sure the products or services you sell are accurately described on your website.
- Be clear of the costs of the products and any additional fees such as postage and package.
- Have a clear returns policy.
- Deliver goods promptly. If there is to be a delay in delivery for whatever reason, keep the customer informed.
- Use recorded delivery to deliver goods so that you have proof that goods have been received.

# In Summary

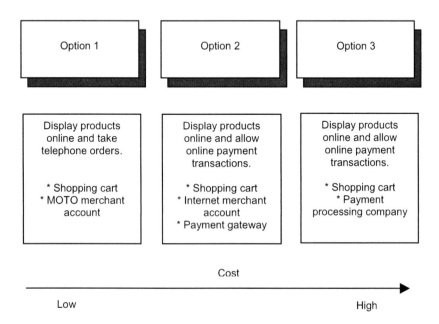

| Option 1 | Option 2 | Option 3 |
|---|---|---|
| Display products online and take telephone orders.

* Shopping cart
* MOTO merchant account | Display products online and allow online payment transactions.

* Shopping cart
* Internet merchant account
* Payment gateway | Display products online and allow online payment transactions.

* Shopping cart
* Payment processing company |

Cost

Low ——————————————————► High

- Your sales will be restricted if you do not provide a way for customers to pay online.

- The rules are strict to get a merchant account. You will need to provide details of your trading history, business plan and e-commerce processes.

- It takes longer to get accepted for a merchant account than with a payment processing company.

- Your merchant account, shopping cart software and payment gateway must all work together and be compatible.

- You will wait longer for your money if you choose a payment processing company, but they are a good alternative if you have been trading for less than a year or you cannot get a merchant account for any reason.

- Review several providers for the service you require. As well as costs, check on reliability, support, security and additional features that are provided.

- Make sure any service you choose can be upgraded as your business expands.

- Avoid chargebacks by making sure you explain your products, charges, delivery, and refund processes clearly on your website.

# 7

# Good Design and Testing

*Checking for good design – Rules for writing web copy – Testing
your site*

## Check for good design

The design of the website is not limited to how it looks but includes
how it *feels* to use.  If you are planning to design your own website
then there are many brilliant books that will advise you on good
design and what to avoid.  If you are planning to contract a web
designer then they will ask you your opinion about colours, fonts,
graphics and photographs to be used on the website.  Whoever
designs your site, this chapter will give you a broad overview of
good design practice so that you can check if the website you have
follows these principles.

The best place to start when thinking about design is to look at
other websites on the internet.  If there is a particular site or feature
that you like then make a note of it.  You may be able to use the idea
on your site but avoid having your site as a straight copy of another
site.

If you already have some marketing material then the choice of
colour, fonts and logo may already be determined.  The look of your
website should match the look of your current promotional material
such as business cards, brochures or leaflets.  This will create a
'brand' image for your company.

If you don't yet have any marketing material then you have an
opportunity to create a marketing image for your business.

The following are areas you need to consider when checking the design of your site:

- General Impression
- Content and Message
- Colour
- Use of Graphics
- Readable Text
- Download Times.

## *General impression*

As I said earlier your website gives an impression of your business. Does it look organised, attractive and professional? Like many other things in life keeping it simple applies with web design as well.

> **Your home page should have visual impact and make the message you want to give about your business clear.**

- All the pages in your site should look as though they belong together. This is usually done by using the same navigation bar, layout and colour scheme on all pages, which unifies the whole site.
- Don't clutter pages with lots of information and graphics. It is very rare to look at a page and think it needs more information on it!
- Pages should be easy to scan for information and read in a straightforward way without your eye being distracted. It gives a much calmer feeling to the user. Too many focal points on the page can be confusing.
- Is it easy to use? Can you get to the information you want easily?

## *Colour*

> **The colours you select can make your site look sophisticated and professional, and create the mood of the site.**

Highlighting headlines or key products with colour can attract the user's attention adding emphasis to the message or product. You can use colour to organise information on the page.

Consider your audience when using colour. Adults prefer more subdued colours, whilst a younger audience will be attracted to brighter colours. Colours that are overdone or bright can be distracting and confusing as they can be difficult to read or your visitor may not be able to look at them for any length of time. If in doubt, keep your colour scheme subtle.

Use soft neutral colours for your background, adding strong colours to draw the eye to the more important elements of your site.

Reading web pages is already slower than reading printed material, so don't make the process more difficult by choosing a background and text colour that merge into each other. One of the easiest colour schemes to read is a white background with black text and the majority of websites stick to these colours. As a general rule there should be a good contrast between the text and the background.

## *Use of graphics*

Graphics bring colour to a page, add interest and catch the eye, which can result in a visitor staying on your site.

Graphics can be photographs, pictures or navigation buttons. All sites will include some graphics. The most common are navigation buttons, fancy bullet points, logos, title graphics (also known as the masthead) and divider lines. Use graphics sparingly. They increase the download time of your web page and you could lose visitors.

Make sure there is a reason for graphics to be on your site. They should be big enough to be meaningful but not so big that they take forever to download.

All graphics on your site should complement each other in

typeface, colour and special effects like shadows.

Navigation bars, bullets and divider lines should match the colour scheme of your logo.

If you are showcasing photographs then use thumbnails that download quicker. Your visitor can decide if they want to see a larger image. Make sure your thumbnails are large enough to be seen but not so large that they are nearly as big as the original image.

Like colour, images have a directional aspect and should point to things that are most important in your page.

# Rules for writing web copy

## Content and message

If you can't write good copy get someone else to do it. Remember you have seconds in which to grab someone's attention and make them look around your site. Whenever someone hits your site the first question they will ask is "Does it have what I'm looking for?" be that information, products or services. Understand your visitors and give them what they want. You don't want to send them to sleep or even worse select a competitor.

| Capture Attention | Hold Interest | Answer Questions | Overcome Objectives | Compel Action |
|---|---|---|---|---|

- Get to the point, use plain language, short words and phrases.
- Don't use technical jargon without explanation unless you're sure that your visitor will understand what you are talking about.
- The tone of your writing should reflect the way that you would talk to your visitor. Vocabulary and grammar of your text should be appropriate to the visitors you want to attract.
- Avoid hype. You want to establish your company as a credible business to buy from or work with.

74

- Organise the content. Try and keep to a few points a page. Use headings and sub-headings to help your visitors scan for information.
- Check spelling and punctuation. Getting it wrong can destroy the professional image of your website and create the impression that you don't care. It is much easier to correct on a website than on the printed page so if you notice a mistake put it right.

## *Readable text*

It may be obvious, but make sure that your visitor can actually read your site. I've already mentioned using text colours and background colours that merge and make things hard to read but your text should also be big enough to read but not so big that very little of the information you want to say can be displayed without scrolling. Remember that it is harder to read text that is all in italics or capitals. Text columns are easier to read rather than text spread across the page.

The way you write your content is also significant in helping with your page ranking. Read the topic on Search Engine Optimisation in the chapter 8.

> **When you look at your website, if it looks hard to read –**
> **IT IS! Change it.**

## *Navigation*

Unlike a book where you open the cover and read to the end, your visitor may not enter your site through your home page, so, you need to ensure that visitors can make sense of your site from whatever page they start.

It is so important that your website is easy to use and your visitors can get to the information they want easily. Your navigation should be logical and not confuse your visitor.

75

Your navigation buttons should be easy to understand and your visitor should be able to get to your home page or where they have come from easily.

If your site opens up new pages in a separate window then your user won't be able to use the back button to get back to where they were so avoid this unless it is a link to another site.

If your site is very large then consider having a site map or index to help visitors find the information that they want.

Place navigation links at the top and bottom of pages especially if you need to scroll down to the end of the page. There is no need to use graphics both top and bottom. It is common practice for navigation links at the bottom of the page to be text only.

### Download times

Your site should load as quickly as possible. Audio and large graphics add to the download time. Surfers are impatient and if it takes more than about 10 second to download, they may move on and you will have lost an opportunity to make a sale or gain a client.

# Testing your site

There is nothing more annoying then to choose the link to the vital information that you want and then get a 'page not found' message. People expect websites to be secure and available 24 hours a day. If you have a web designer check what sort of testing they will do on your website. As a minimum they should check all the graphics load, the website works in a variety of browsers and all the links work. You should be prepared to test this for yourself once the website goes live and periodically thereafter. You should also re-test the site if new pages are added or existing pages are amended.

- Check content for accuracy, spelling and completeness.
- Check that all links work and that you can navigate to every page from every page.
- Check that the web pages of our site download in a suitable

time. Around 8 seconds is acceptable. If it takes longer than that review the use of graphics or audio files on the page.

- Check that there are no missing graphics.
- Get someone who has not been involved in the design of the website to use it without guidance from you. Give them tasks to do such as buy a product or find out some information. Watch how they navigate through the site and how quickly they perform the tasks. Get feedback from the person doing the tasks and if necessary make the adjustments to make the site easier to use.
- If your site is integrated with your back office make sure that the information that should be passed between systems is passed correctly.
- Check that visitors cannot access information that they shouldn't in password protected areas.
- Test that your site will perform adequately if several people access it at the same time. If you have a popular product then this is likely to happen.

# In Summary

- The general impression of your web pages should reflect the message you want to give about your business.

- Use colour to attract your visitor's attention and emphasise the message that you want to tell your visitor.

- Use graphics sparingly. They should be there to emphasise your message to your visitors or highlight important points.

- Content should be clear, concise, easy to read and understand. It should be written in the appropriate language and tone for your target audience.

- Your navigation system should be intuitive and easy to use, allowing your visitor to decide what path they should go down to get the information that they want.

- To test if the site is easy to use and intuitive get someone else to use it without your prompting and note where they struggle.

- Test your site periodically to ensure that all links and graphics are available.

# 8

# Promoting and Managing Your Website

*How to submit your website – An overview of search engine optimisation (SEO) – Other ways to promote your website online – Managing your website – Analysing Statistics – Content Management – Disaster Recovery*

Before you get any results from your website you need to tell people that it exists and that they can visit it. As a small business you probably have already put together a marketing plan using some of the more traditional forms of promoting your business – business cards, advertising, brochures, leaflets, press releases. Make sure your website address appears on all printed documentation and advertising. If people pick up a leaflet or see an advert and are interested in your goods or services, chances are they will look up your website to get more information.

Word of mouth is equally valuable to get people to visit your site. Talk about your site, tell existing customers and friends that it exists, how easy it is to use and what sort of information they can expect to find on it.

Research has shown that you are likely to get up to 70% of visitors to your website from people using search engines. Two of the most important things to do are to ensure that the site is registered with the search engines and that your website is written so that it is more likely to appear at the top of any search engine listing. Your web designer should make sure that your website has been

registered with the search engines but you can also do it yourself and re-register it if there have been any changes to your site.

## Search engine submission

If you search for 'Search engine submission' then you will get a listing of various companies who will submit your site to various search engines for free. But do you really need to submit it to 200 sites, many of which will be specialist sites and have nothing to do with your business? How many do you know and use? The most common ones are Yahoo, Google and MSN. Others that are popular are AltaVista, AOL and ASK. Registering with these plus any speciality ones for your site should be enough. You submit your site by giving the search engines your site address. You only need to give them the address of your home page.

- **Yahoo** – https://siteexplorer.search.yahoo.com/submit
- **Google** – http://www.google.com/addurl/
- **MSN** – http://search.msn.com/docs/submit.aspx
- **AltaVista** – powered by Google
- **AOL** – powered by Yahoo
- **ASK** – like many other search engines no longer accept submissions as they are confident that they will find your site.

> **Search engine submission is free but it can take weeks even months to appear in the listings. Yahoo allows you to select a paid submission service, which will get you listed within a week for $49. Consider this if getting listed quickly is a priority to you.**

## Search engine optimisation (SEO)

Search engines use 'spiders' or 'crawlers' to index web pages based

on keywords. Crawlers often rely on the way your pages are constructed. It is fundamental that your web designer has followed the HTML coding standards and used 'Meta' and 'title' tags in the coding to describe your website, as these are used by the crawler to determine what the page is about, and keywords within the text. They store this information in their database and when someone searches a keyword they check the database to see which sites match what has been entered. Unless a spider has indexed your site it will never appear in a search.

In the early days of the internet SEO was relatively easy and achieved just by using title, meta tags and lots of keywords in the text. This system was abused by people adding keywords that couldn't be seen in their text by having background and text in the same colour or by having paragraphs full of keywords that didn't make sense.

As search engines have advanced and the algorithms used to get a page ranking have become more complex a whole new industry has built up around the subject. However, no-one can promise you the number 1 slot, and certainly, if they do, to maintain it needs constant vigilance, as the way that search engines work is constantly changing.

There are a number of ways that you can help to ensure your ranking is high. Search engine crawlers can't read pictures, videos, or flash; they only read text. After all that is what the web is about, giving people information, and the people looking for your site are after that too.

The way your content is structured and what you say is important to your ranking so don't be tempted to have pages where 'the picture says it all' or a website designed totally in flash. They may look great but they will be ignored by the search engine. To help search engines find you, use keywords and key phrases in your content, make sure they are used in headings and above all make sure there is text on your site.

## *Linking*

Search engines also use the links on your site to find the other pages of your site and to find other sites. Search engines also think the more links to your site by sites that have related content the more of an 'expert' you are in your field and will rank you accordingly. Web crawlers are aware of artificial link building to irrelevant sites and will penalise you when it comes to rankings.

Once more your web designer should follow the principle of good web page design and not have a 'Click Here' for more information link but a more meaningful phrase such as 'Available Walking Shoes'.

You can help get additional links to your site in the following ways:

- Use free listing services for businesses, for example sites like www.freeindex.co.uk, www.ufindus.com, or www.redhotchilli.co.uk. If you search on 'free listing business directories' there are a whole host of local and national sites.
- Get listed in industry directories and association webpages.
- Used paid listing services for businesses for example www.yell.com, www.uksmallbusinessdirectory.co.uk, or www.mirago.co.uk. Again you can search to find out other sites which will list you.
- Exchange links with complementary sites – ones that don't sell the same products as you but whose customers might be interested in what you are selling. For example if you give music lessons consider linking up with music stores. It will take some time from you as you will need to contact the owners of these sites and you have no control over whether they will link to you. Having good content and a high quality website will encourage others to link to your site.

# Online site promotion

Other things you can do for free include;

- Adding your website address to all emails, letterheads and other stationary.
- Having an easy way for someone to bookmark your site. That way someone will find it easier to locate it again and is more likely to re-visit and even make a purchase.
- Mailing lists. Ok we all hate the spam mails that block up our email accounts, but give your customers the option to receive details of offers, promotions or a newsletter that will give them a timely reminder that you exist.
- Include a 'tell a friend' option. Perhaps include an additional discount if a standard email can be sent to a number of friends.
- Online newsletters are a great way to keep in touch with your customers and encourage them to visit your site.
- Online press releases and articles to relevant websites in your industry.
- Blogging has been extremely successful for encouraging people to websites and is even used by Bill Gates at Microsoft. People are naturally curious and want to know what other people are up to. If you want to do this, then spend time reading and analysing what you like or dislike about existing blogs, especially ones in your own industry. Plan to post one or two blogs a week and include content that people will find useful.

## *Pay-per-click sponsored advertising*

If you want to maximise your market then I have heard very positive feedback from people who have used the pay-per-click options available. This option allows you to bid on the keywords that someone might use to search for your website. If the user searches on that keyword, then your advert will appear in the 'Sponsored' Ads section at the top of the search engine listing. You do not pay for your advert, you only pay for the service if someone actually clicks the advert and goes through to your website. Like search engine optimisation there are many companies out there who will help you

select the best keywords for your business and put a pay-per-click campaign together.

There are also other online advertisements you can place on blog sites, shopping malls and e-zines. You can also find sites that target particular industries or products and you can pay to get listed on these sites. Do a search on the industry you are in to find out where you can advertise. The advantage of advertising in this way is that you will attract people who are already computer savvy and more likely to buy online.

> **A high level of visitors does not equal high interest. Stay focused on getting the right people on your site. Get listed on the major search engines and the right sites for your industry.**

## Managing your Website

Your website is up, people are finding it in the search engine, and suddenly you have people emailing and phoning you with queries. Next month your pricing structure is going to change and the details on your website will need to be updated. You've received some statistics from your ISP about who has visited you. What does it all mean and should you do anything about it? How are you going to deal with these scenarios?

Ensure that you have the staff trained, and procedures in place, to deal with these eventualities:

- Dealing with queries. These can be queries on your products, services or other information you provide on your site. They may be technical queries as to why a link doesn't work, why a download doesn't work, or a new password request. Different queries will need different skills, so make sure you have staff that can handle all types of queries or at least know where to get more help, be it from your ISP, hosting provider or web designer.
- Periodical re-testing of the live site. Checking that links still

work and everything loads correctly.

- Periodic re-submission of your site to search engines.
- Writing blogs or newsletters if you want to provide these services.
- Updating the site with fresh content.
- Analysing your statistics.

## *Updating your site*

How many times have you tried to get information from a website and realised it was out of date? I once checked the timings of a film and when I got to the cinema was told it was no longer on. I can't say I was very impressed or happy and my confidence in using the site has been destroyed. Websites that are out of date give the impression that you don't care or that you are so busy you can't cope, and that's not the feeling you want to give to your visitors. Visitors are attracted to new content so it is important to regularly update your site to attract and inspire them to visit your website. Apart from the benefit of keeping your visitors interested and encouraging them to return to the website, the search crawlers look for new content and if your site hasn't been updated then your rankings can drop.

The areas that you will need to keep updated include:

- **News.** Out of date news is so obvious. If you have news on your website keep it current. As well as company news, include relevant stories about your industry that will be of interest to your visitor.
- **Prices.** You are legally obliged to ensure that your prices are accurate as well as any terms and conditions on your site.
- **Graphics.** These can include staff photographs, products or company premises. If these change then update your site.
- **Promotions.** Change promotions frequently so that visitors return to the site regularly to see what is on offer.
- **Contact details.** If people can't contact you, it is a lost opportunity. Make sure addresses, emails, maps and phone numbers displayed on your website are current.

- **Product availability and delivery times.** If these are wrong, it damages the credibility of your business and you may lose future sales.

> **Regularly update your content to show that you are an active company who cares about its online visitors.**

## Content Management

Content management is updating your website text and graphics without affecting the navigation and general design. To keep your website updated you have several options:

- Agree a support contract with your web designer for the number of hours you think you will need of maintenance every month.
- Buy a software package which gives you visual presentation of your site (rather than just HTML coding) so that you can do the updates yourself without learning how to code in HTML. The advantage of this is that you are in complete control of any changes that you want to make. The disadvantage is that this software is not always easy to manipulate and if something goes wrong then you will have to return to your web designer to sort it out for you, or learn HTML. Software such as Dreamweaver is complex, expensive and difficult to learn if you are not using it regularly.
- Some web designers have created their own content management systems and you should discuss this with them when you are selecting their services.
- Buy software such as Adobe Contribute, which allows you to update the content of your website safely with no technical expertise. It costs around £123.
- If you have a larger site with lots of pages that need constant updating which is not part of a shopping cart system you

may want to consider having your site built on a Content Management System (CMS). As well as being able to make changes to your site it will log what has been changed and by whom. These are often expensive and whoever is in control of the updates will need some training on how to maintain the site. However, there are a few 'open source' CMS systems around. Open source software is free software that you are allowed to develop yourself. If you are interested in this there is a site that allows you to try the software http://www.opensourcecms.com/ and it may be something your web designer will be able to help you with.

# Analysing your website statistics

Your website is attracting visitors and you can look at your visitor statistics. Your statistics will give you information about who is visiting you, where they have come from, what pages they have looked at, and how long they are staying on your site. Different statistic tools give you different reports on the following:

- Unique visitors and new visitors. Unique visitors are the number of different visitors to your site in a chosen timescale – day, week, month or year. New visitors are always unique and are people who are looking at your site for the first time. Check the number of unique visitors against the number of pages viewed. If the number of pages viewed per visitor is high, then they are interested in your content. If it is low then you should consider revising your pages to make them more interesting. If the number of unique visitors is low but the number of pages viewed is high then your content is interesting but you need to market your site more so that people can find you.
- Returning visitors will give you an indication of whether you are building up a relationship with the people who visit your site and they consider your site worth coming back to. You don't want people to visit once and then disappear.

- Popular pages show what area of the site has grabbed people's attention. You may want to increase the information given on these pages.
- Least popular pages are candidates to be removed or re-drafted to make them more inspiring to your visitors.
- Browser statistics will tell you what browsers your visitors are using as well as what screen resolution they are viewing your site on. You can check to see that your website still displays correctly in these browsers and with these resolutions.
- Some statistics will tell you what countries your visitors are from. You may need to put up caveats if you feel your site doesn't meet the laws of these countries or you may consider making the site bi-lingual.
- You can tell which day of the week is most popular and use this information to decide when to do upgrades to your site with least disturbance to your visitors.
- Referrers will tell you where people came from. Whether they typed your name directly in the browser, took a link from a search (and if so, which one), what keyword they used, or if it was a link from another web site.
- A popular exit page could indicate that users have got bored or may be experiencing problems in navigation or a delay in the page loading so it will be worth checking out if there is a problem. If your entry pages and your exit pages are the same then you have a problem as your visitors are not looking around so amend the entry page to give them the information that they want.
- Your most popular downloaded file could indicate the sort of thing your visitors are looking for. Can you provide more files like this?

---

**By analysing your website statistics you can make tweaks to your website to achieve your objectives.**

---

# Disaster recovery

OK, we all go through life to some degree thinking 'It will never happen to me,' and it may be true that a disaster such as a flood, fire will never happen to you, but in the world of IT there are events that happen quite regularly that could cause enough damage to stop your business from trading.

- **Viruses** that come in through email. These have the potential to wipe out data, to grind your systems to a halt. New viruses are introduced regularly and your software may not catch them.
- Accidental or deliberate **sabotage** by an employee. I've worked in a company where one of the directors 'accidentally' deleted the drive with all the client data. Luckily we did have a backup that we could restore but it lost a day's work for everyone as no-one could do anything until the data was back where we needed to use it.
- **Equipment failure.** Servers, laptops and desktops have been known to 'die' for unknown reasons and unexpectedly. What happens if you have the only copy of your invoicing on a spreadsheet on your laptop when it dies or your office server dies and you lose all your data?
- **Hackers** can and do get into systems and can delete or corrupt files – sometimes maliciously, and sometimes just because they can.
- Your **hosting company** goes bankrupt, has disappeared and you can't access the files on your server or get hold of anyone from the company.

Not having a disaster recovery plan can mean that you cannot maintain operational trading, customers may go to competitors and you get a reputation for being unreliable and disorganised, all of which can be avoided with a little planning. You need to plan to keep downtime to a minimum and have your systems up and running as soon as possible after the event.

In connection with your website you need to be able to rebuild it

quickly on a new webserver. In order to do this you will need to have all the latest files and data that make up your website (not just the web pages), including the following:

- Copies of the HTML files, images and scripts that make up your website. Don't depend on your hosting company to do backups as they may be the ones who are having a disaster! Make sure you get the copies of the files when the website is completed and after any changes that your web designer does for you.
- Database backups. These should be more often than monthly, unless you are prepared to lose a months work. Ideally you should get a script written so that these are done automatically everyday.
- Usernames, passwords, email addresses if these are not available on one of the databases that you have backed up.
- Any other software or special program that you have running for your shopping cart or merchant account including licence numbers.
- Access to your domain name so that you can transfer it to a new server. You may want to leave this to your web designer but if you have to wait for someone else to do it then it adds to the time that your systems are down, especially if they are not available immediately.

Make a plan and make sure your staff understand it.

> **If something goes wrong it can either be a minor inconvenience or a complete disaster depending on whether you have taken the time to plan for it or not.**

# In Summary

- Make sure that you put your web address on all your documentation.

- As well as traditional marketing such as advertising and leaflets, consider online advertising in some way. That way you will reach people who are already computer literate.

- Optimise your search ranking, free, by ensuring your webpages are regularly resubmitted and exchanging links with complementary businesses.

- Consider paying for your website submission if you want it to appear more quickly (4-7 days) in the search engine listings than for free submission (up to 3 months).

- Consider pay-per-click advertising to promote your website to the top of the listings.

- Make sure you have a team or someone responsible to deal with the additional queries your website might generate and to keep content up to date.

- Update your site regularly to keep it original and interesting to encourage people to re-visit.

- Discuss how you will keep your content up to date with your web designer.

- Analyse your web statistics and tweak you site so that you provide information that is of interest to your visitors.

- Make sure you have a disaster recovery plan and your team know what to do if things do go wrong.

# 9

# Quiz

*Select one answer for each question:*

| 1. | One of the most important things, if not the most important thing, when considering your website is: | ❏ The colours that you choose.<br>❏ Your graphics.<br>❏ Your audience.<br>❏ Your home page.<br>❏ Interactivity you want to include. |
|---|---|---|
| 2. | Domain names should be: | ❏ Short and concise.<br>❏ Easy to remember.<br>❏ Easy to spell.<br>❏ Appropriate for your business.<br>❏ All the above. |
| 3. | You should consider creating your own website only if: | ❏ You have the experience of web development.<br>❏ You have time to learn the software and techniques involved.<br>❏ You have a limited budget.<br>❏ Any of the above. |
| 4. | A design brief is: | ❏ What your web designer provides you to approve the design of your website.<br>❏ A document you provide your web designer explaining what you want your website to provide. |

| 5. | When selecting a web designer it is important that: | ❑ They register your domain name.<br>❑ They are the cheapest.<br>❑ They have been in business a long time.<br>❑ They provide a contract to maintain your website.<br>❑ You trust them and feel that you can work with them. |
|---|---|---|
| 6. | When shortlisting a web designer, consider: | ❑ Testimonials/references.<br>❑ The size of their advert.<br>❑ Their portfolio.<br>❑ Previous experience in your industry.<br>❑ Your budget. |
| 7. | For maximum benefit from e-commerce you need: | ❑ An easy way for your visitors to order.<br>❑ Back office integration.<br>❑ To sell worldwide.<br>❑ Reliable internal security.<br>❑ A way for your customers to pay online. |
| 8. | Chargebacks can be avoided by: | ❑ Credit checking all your customers.<br>❑ Using a secure server to process your credit card details.<br>❑ Allowing customers to change their orders before they pay.<br>❑ Using fraud prevention tools. |
| 9. | Video, audio and graphics should be used: | ❑ As much as possible to make the site interesting.<br>❑ Only to support the objective of the website.<br>❑ Never because the files take too long to download.<br>❑ Only if you want to create the impression of being a state of the art company. |

| 10. | When writing for your website you should: | ❏ Use technical jargon. <br> ❏ Copy what you have in your brochures. <br> ❏ Use plain language, short words and phrases. <br> ❏ Use a copywriter. |
|---|---|---|
| 11. | To ensure that your web pages look uniform on all the pages: | ❏ Use the same colour scheme. <br> ❏ Use the same navigation. <br> ❏ Use a similar layout. <br> ❏ All the above. |
| 12. | When you test your site your main concern should be: | ❏ It looks good. <br> ❏ There is lots of colour and graphics to catch the eye of your visitor. <br> ❏ It is easy to use and intuitive. <br> ❏ There is a lot of information about your company on the home page. |
| 13. | You are guaranteed to be placed near the top of listings if: | ❏ You make sure that your site is search engine optimized. <br> ❏ You link to lots of other sites. <br> ❏ You use an abundance of keywords in your text. <br> ❏ You pay for it. |
| 14. | Your web statistics are: | ❏ A useful tool that allows you to analyse how your visitors have come to your site and the pages they have visited. <br> ❏ Provided by your ISP. <br> ❏ A guide to the information that your visitor wants to see. |
| 15. | Providing a disaster recovery plan stops: | ❏ Viruses coming in through email. <br> ❏ Accidental deletion of data. <br> ❏ Your servers going down. <br> ❏ A minor inconvenience becoming a disaster. |

## Answers

1.  Your audience. You should know what sort of information they want, their background and technological skills.

2.  All of the above. It is your business's presence on the internet. Make sure that it is easy to recall and easy to type.

3.  Any of the above although if you have a limited budget it would be worth considering using a ready made template.

4.  A document you provide the developer explaining what you want your website to provide. You need to at least think about the information that is provided in the brief, as your web developer will want to cover it when you meet.

5.  You trust them and feel that you can work with them. You may have a long relationship with them. They should listen to your opinions and be able to explain things in a language you understand.

6.  A trick question – sorry – as three of the answers are correct: their testimonials/references, their portfolio, and their previous experience in your industry.

7.  A way for your customers to pay online. Consumers are looking for convenience when they shop online and will spend more if they can pay online.

8.  Using fraud prevention tools. A Chargeback is a fee paid when a customer gets a refund, usually because of a dispute with a business or because of fraud.

9.  Only to support the objectives of the site.

10. Use plain language, short words and phrases. Get to your point quickly. Visitors scan pages for information and don't want to read lots of waffle.

11.  All the above.

12.  It is easy to use and intuitive. People are impatient when it comes to using the internet. If they can't get to what they want quickly they will move on to the next site.

13.  You pay for it. The algorithms that the search engines use are constantly changing and no-one can guarantee where you will be placed by them.

14.  A useful tool that allows you to analyse how your visitors have come to your site and the pages they have visited. You can use this to see what information they are looking at and how effective your website is on achieving your objectives.

15.  A minor inconvenience becoming a disaster. It helps to ensure your business is up and running in the shortest possible time if something untoward should happen

$$\overline{\overline{10}}$$

# Regulations

*Electronic Commerce Regulations 2002 – Consumer Protection (Distance Selling) Regulations 2000 – Data Protection Act 1998 – 2006 Companies Act – Privacy and Electronic Communications Regulations 2003*

---

**Details in this chapter are only a general guide. If you need further information on how the laws apply then contact a legal advisor.**

---

## Electronic Commerce Regulations 2002

This legislation covers the details you must give to your customers about your goods, services and business together with the procedure for online contracts.

The E-Commerce regulations apply to you if you:

- Advertise goods or services online, by email or SMS text.
- Sell goods or services to businesses or consumers online.
- Transmit or store electronic content or provide access to a communication network.

If you don't comply with the regulations your customer can:

- Cancel their order.
- Seek a court order against you.
- Sue you for damages if they can demonstrate that they have suffered loss as a result of your failure to comply.

## How to Comply

| Information requirements | These requirements include providing your end users with: <br><br>• The full contact details of your business. <br>• Details of any relevant trade organisations to which you belong. <br>• Details of any authorisation scheme relevant to your online business. <br>• Clear indications of prices, if relevant, including any delivery or tax charges. | In practical terms this means giving your: <br>• Business name, address and email address. <br>• Your VAT registration number. <br>• Details of any registered bodies with which you are registered and supervisory bodies together with registration numbers and professional titles you hold. <br>• Clear prices and all associated taxes and delivery costs. |
|---|---|---|
| Commercial Requirements | These requirements include providing your end users with: <br><br>• Clear identification of any electronic communications designed to promote (directly or indirectly) your goods, services or image (e.g. an email advertising your goods or services). <br>• Clear identification of the person on whose behalf they are sent. <br>• Clear identification | It must be obvious that any form of electronic communication to promote your goods is a commercial communication and that the person who has sent it is clearly identifiable. |

| | | |
|---|---|---|
| | of any promotional offers you advertise e.g. any discounts, premium gifts, competitions, games.<br>• Clear explanation of any qualifying conditions regarding such offers.<br>• Clear indication of any unsolicited commercial communications you send. | |
| **Electronic Contracting** | These requirements include providing your end users with:<br><br>• A description of the different technical steps to be taken to conclude a contract online.<br>• An indication of whether the contract will be filed by your business and whether it can be accessed.<br>• Clear identification of the technical means to enable end users to correct any inputting errors they make.<br>• An indication of the languages offered in which to conclude the contract. | Users must be able to understand the process for completing a contract, and print and store a copy of the terms and conditions.<br><br>If they make an error then they should be able to correct it before the order is placed.<br><br>All orders should be acknowledged electronically without due delay. |

# Consumer Protection (Distance Selling) Regulations 2000

The purpose of the legislation is to ensure that businesses which trade at a distance (i.e. when the customer is not present at the time of sale) follow some basic regulations in order to increase the confidence of the consumer in these types of transaction.

The Consumer Protection (Distance Selling) Regulations apply to you if you provide goods or services without face-to-face contact with your customer via:

- The internet
- Phone calls
- Text messaging
- Faxing
- Interactive TV
- Mail order

The regulations do not apply to:

- Business to business transactions
- Auction sales
- Sales from vending machines
- Financial services (these are covered by the Financial Services Distant Marketing Regulations 2004)
- Hire purchase sales

## *How to Comply*

| Pre Contractual Information | • Your business in enough detail for your customer to understand who they are dealing with.<br>• A description of your goods and services.<br>• Pricing including | This can be provided on a website, appear in a catalogue or given over the phone and must be clear. |
|---|---|---|

| | | |
|---|---|---|
| | taxes, delivery costs and how long the price is valid.<br>• Your payment arrangements.<br>• Your delivery arrangements.<br>• Cancellation rights.<br>• Cost of calls of premium rate phone numbers.<br>• Minimum duration of any contract.<br>• That you will pay postage costs if goods are sent as substitutes and then returned as inappropriate by your customer. | |
| **Post Contractual Information and Rights** | All the above including:<br><br>• Full physical address of the business (not a PO box).<br>• Conditions for terminating contracts greater than a year.<br>• After sales service and guarantees even if they are free, written confirmation of their order.<br>• When and how to exercise their right to cancel. | This information must be in a form that can be stored and reproduced for future reference. If the pre-contractual information was not provided in a way that could be stored i.e. on the phone or a website, then this information must also be given in writing at this time. This can be provided in email or a fax. |

| **Other details** | • Unless otherwise stated a contract must be carried out on 30 days. <br> • Customers have seven days cooling off period from the day after the goods are delivered. | If you cannot carry out a contract in 30 days then you should negotiate a suitable delivery date with the customer. <br><br> If you do not notify the customer that they have a seven day cooling off period then this could be extended to three months and seven days. <br><br> Some of the cases where customers cannot cancel include contracts for transport, accommodation, catering or leisure for a specific date or for a specific period, perishable goods, sealed audio, video or software that has been opened. |
|---|---|---|

# Data Protection Act 1998

The Data Protection Act covers the use of personal data by businesses and affects computer-based records as well as paper-

based records. It gives rights to individuals (data subjects) over the information held about them and it places responsibilities on the organisations who process the information (data controllers).

The Data Protection regulations apply to you if you hold any information about living individuals (personal data) from which they can be identified. Personal information covers both facts and opinions about the individual. The only exemption is where personal information is held for domestic reasons e.g. an address book.

---

**Anyone processing personal data must inform the Information Commissioner's Office (ICO) that they are doing so unless they are exempt. Notification costs £35 a year.**

---

Criminal offences under the act are:

- Notification offences when the data controller hasn't notified the ICO that they are processing data or hasn't made changes to their processing entry where required.
- Procuring or Selling offences where data is knowingly or recklessly obtained, disclosed or personal information is sold without the consent of the data controller. However, you can obtain or give information for crime prevention reasons.

The ICO can prosecute anyone it believes may have committed a criminal offence. The ICO has responsibilities to act for the promotion and enforcement of the Data Protection Act. The ICO can ask for information to assess whether the act is being followed. The ICO can also serve an enforcement notice, which requires the data controller to take steps to comply with the Act.

## *How to Comply*

Anyone processing personal information must comply with the following eight enforceable principles of good practice. Information held must be:

1. Fairly and lawfully processed.

2. Processed for limited purposes.
3. Adequate, relevant and not excessive.
4. Accurate.
5. Not kept longer than necessary.
6. Processed in accordance with individuals' rights.
7. Kept secure.
8. Not transferred to countries outside the European Economic Area without adequate protection.

You should tell people what you will use their personal information for and let them know that they have the right to access their information and correct it if it is wrong.

At least one of the following six conditions must be met for personal information to be considered fairly processed:

- The individual has consented to the processing.
- Processing is necessary for the performance of a contract with the individual.
- Processing is required under a legal obligation (other than one imposed by the contract).
- Processing is necessary to protect the vital interest of the individual.
- Processing is necessary to carry out public functions e.g. administration of justice.
- Processing is necessary in order to pursue the legitimate interests of the data controller or third parties unless it could unjustifiably prejudice the interest of the individual.

For sensitive data (see below), you also need to meet one of the following conditions (as well as one of the previous six conditions) so that organisations only use this data when it is essential:

- Having explicit consent of the individual.
- Being required by law to process the information for employment purposes.
- Needing to process information in order to protect vital interests of the individual or another person.

- Dealing with the administration of justice or legal proceedings.

For these purposes 'sensitive data' is any information regarding:

- Racial or ethnic origins
- Political opinions
- Religious or similar beliefs
- Trade union membership
- Physical or mental health conditions
- Sex life
- Offences or alleged offences committed
- Proceedings relating to those offences or alleged offences.

## *Rights of Individuals*

There are seven rights for individuals under the act:

| | |
|---|---|
| The right to subject access | Allows individuals to find out what information is held about them on a computer or some manual records. Individuals must send a subject access request asking for access to their information. You can charge a fee of up to £10 to provide the information requested. You can ask for proof of identity and must reply as soon as possible after receiving the request and within 40 days. |
| The right to prevent processing | Allows the individual to ask the data controller not to process information that might cause unwarranted damage or distress to them or anyone else. |
| The right to prevent processing for direct marketing | Allows an individual to ask the data controller not to process information that relates to them for |

| | direct marketing purpose. An individual must put the request in writing and you should comply, in most cases, within 28 days. |
|---|---|
| Rights in relation to automated decision making | Individuals have a right to object decisions made about them only by automatic means. |
| The right to compensation | An individual can claim compensation for damage or distress caused by breach of the act. Damages must relate to physical or financial suffering and must be claimed through the courts. |
| The right to rectification, blocking, erasure and destruction | Individuals can apply to the court to correct, block or destroy any information if it is inaccurate. |
| The right to ask the ICO to assess whether the act has been contravened | If someone believes that their information has not been processed in line with the Data Protection Act they can ask the ICO to investigate. The ICO can serve an enforcement notice if the act has been breached. |

# Companies Act 2006

The Companies Act regulations apply to you if your business is either a limited company, or a Limited Liability Partnership (LLP).

Under the terms of the regulations your website, order forms and emails must show:

- The full name of the company or LLP.
- The registered office address, registered number and place of registration of the company or LLP.

- If the company is being wound up, that fact.

This information does not need to be on every page of the website but must be present. Failure to comply will result in a fine to the person who issued the non-complying document or website.

# Privacy and Electronic Communications Regulations 2003

The Privacy and Electronic Communications regulations apply to you if you send unsolicited direct marketing messages electronically by phone, fax, emails and texts.

If you don't comply with the regulations then the Information Commissioner's Office can issue an Enforcement Notice. A fine can be imposed for breach of the Enforcement notice and criminal sanctions can be imposed.

## *How to Comply*

- You must not contact individuals without their prior consent unless you have obtained their details in the course of a sale or negotiations of a sale. You only contact them about your own similar products or services.
- You must give individuals the opportunity to opt out of receiving further marketing messages each time.
- All direct marketing must be easily identifiable as the advertising or marketing of a product.
- The identity of the person who sent the communication must be clear.

# In Summary

- The breach of any of these regulations can lead to action against you, including fines and criminal santions; it can also damage your reputation and lead to a loss of goodwill from your customers.

- The Electronic Commerce Regulations 2002 covers details that you must give about your goods, services, business and the handling of online contracts.

- The Consumer Protection (Distance Selling) Regulations 2000 are designed to protect customers who are not present at the time of the sale, and cover information that must be provided, cooling off periods and cancellation rights.

- The Data Protection Act 1998 covers the use of personal data by businesses.

- The 2006 Companies Act stipulates details about limited companies and limited liability partnerships that must appear on websites and emails.

- Privacy and Electronic Communications Regulations 2003 regulate the use of direct marketing electronically.

# Glossary

| | |
|---|---|
| **Accessibility** | Accessibility in web development is an approach to make sure the Web site is usable by people with disabilities. The World Wide Web Consortium (W3C) have defined a set of guidelines for making web pages accessible. Web pages often have access issues for the following groups of people:<br>• Visually impaired people using screen readers<br>• Hearing impaired people using browsers with no sound<br>• Physically impaired people<br>• Colour blind people |
| **Animation** | An image that moves, such as lightning that flashes or a ball that bounces. |
| **Backup** | To create a copy of a disk's contents on another location for safe keeping. Since hard drives are not infallible, it is recommended that you backup its contents regularly. |
| **Bandwidth** | Bandwidth refers to how fast data flows through the path that it travels to your computer; it's usually measured in kilobits, megabits or gigabits per second. The higher the bandwidth, the greater the amount of information that can be transmitted. An analogy would be a water pipe where a larger diameter pipe can carry more water per second than a narrow pipe. |
| **Broadband** | A type of data transmission that allows high-speed, high-capacity internet and data connections. |

| | |
|---|---|
| **Browser / Web Browser** | These are software programs that allow you to see the documents on the internet. The popular browsers are internet Explorer and Netscape Navigator. |
| **Cache** | When you visit a webpage the elements, text and graphics that make up that page are downloaded to your computer. These files can be stored or 'cached' and are accessed next time you visit the site by the browser so that it doesn't need to download it again and the page will load quicker. |
| **Cascading Style Sheet (CSS)** | A method of coding for the Web, to define the style (look and feel) of a Web page. Cascading Style Sheets can define: fonts, colours, layouts, and more. It allows the web designer to separate the design elements of a web page from the text content. |
| **CGI** | Common Gateway Interface. CGI usually means the program that is run on the server to add dynamic actions to the Web site. |
| **Content Management Systems** | Systems for managing content of a Web site allow the user to amend the content of the website without knowledge of web programming. |
| **Cookie** | Small data files written to a user's hard drive by a web server. These files contain specific information that identifies the user, such as user preferences, passwords etc. Only the website that created the cookie can use its contents. |

| Crawler / webcrawler / spider | A web crawler (also known as a web spider or ant) is a program run by the search engines automatically to check the pages of the internet and index them with keywords. These are the words which will be matched when someone makes a search. Ranking by search engines is not only by keywords. They use other sophisticated algorithms. |
|---|---|
| Database | A database is an organised collection of information records that can be accessed electronically. |
| Dedicated Server | In the Web hosting business, a dedicated server is the exclusive use of a computer that includes a Web server, related software, and connection to the internet, housed in the Web hosting company's premises for the sole use of one organisation. The server can usually be configured and operated remotely from the client company. |
| Dial-up Access | Connection to the internet using normal phone lines. Because the quality of this connection is not always good and the speed is limited it is fast being replaced by broadband access. |
| Discussion Group | Discussion groups are also known as bulletin boards or newsgroups and exist on nearly every subject – hobbies, music, sport, news. The users post their message onto the server and other users can respond to them. A discussion group differs from a chat room as chat rooms are 'live' and allows users to have a 'conversation' on line. |
| Domain name | A domain name is the text identifying a website and must be unique. It is usually in the form of yourcompanyname.co.uk. |

| | |
|---|---|
| **Domain Registration** | Domain names need to be unique so they are registered on a central database. Domain names are bought for a defined period of time and there is a renewal fee after your initial registration period expires. |
| **Download** | Downloading is copying a file from a server to your computer. How long it takes to download a file depends on how big the file is, how many people are downloading at the same time and your internet connection. |
| **E-Commerce** | E-commerce (electronic commerce) is the purchase and distribution of goods or services across the internet. |
| **Encryption** | Encryption is a technique used to help safeguard private information while it is sent via the internet and is often used for online credit card purchases. The data is scrambled and can only be read by the person sending or receiving it. |
| **Extranet** | Similar to the Intranet where information is shared internally, an extranet shares company information externally with customers and suppliers. |
| **Firewall** | A firewall is a hardware or software that has built-in filters that can disallow unauthorised users from entering the system. It also logs attempted intrusions. |
| **Flash** | Flash is animation software from Adobe (previously Macromedia). Its use is popular in web pages for animation, as they are quick to download, are high quality and look the same in all browsers. |

| FTP | File Transfer Protocol (FTP) is the system by which files are copied to- or from a server across the internet. |
|---|---|
| GIF | GIF stands for graphics interchange format. This format is used for graphics and photographs where there are only a few colours. |
| Hacker | Unauthorised users who break into systems, destroy data, steal copyrighted software, and perform other destructive or illegal acts with computers and networks. |
| Hits | The number of times a web page has been viewed. Special Statistics software can be used to analyse the pages visited and how visitors reached those pages i.e. through a search engine or link from another web site. |
| Home Page | It is a first page (also called opening page) of a Web site. |
| Hosting /Web Hosting | Web sites are hosted or stored on a special computer called a server. The server or host computer allows internet users around the world to reach your site when they enter your domain address, for example www.yourcompany.co.uk. |
| HTML | Stands for Hyper Text Markup Language, the authoring and editing language used to create web pages on the World Wide Web. |
| Interactive | An interactive web page is a page that responds to the input from a user. Examples of this would be completing a form, banking, shopping carts. |

| | |
|---|---|
| **Internet Service Provider (ISP)** | A company that provides internet access. |
| **Internet/Web** | A global network connecting millions of computers. Although 'internet' and 'web' are interchanged, the internet provides the structure to access and provide information on the web, while web is the content of that information such as the web pages. If you were having a telephone conversation the internet would be the phone line and the web would be your conversation. |
| **Intranet** | A computer network based on the same technology as the internet, used internally by companies to share information. |
| **IP Address** | IP stands for internet Protocol. All computers across the internet are assigned a unique identifier called an IP address. IP addresses are used like street addresses so other computers can locate them. IP addresses are numerical numbers between 0 and 255, separated by periods. For example, an IP Address may look something like: 56.234.22.12. Because it is difficult to remember these numbers a domain name can be assigned to them making them more memorable and easier to use. |
| **Jpeg (JPG)** | Stands for Joint Photographic Experts Group and is the format most commonly used for photographic images and graphics which have lots of different colours. |
| **Keywords** | A keyword is either a single word or shot phrase to define the main topics of a website and what a user might type in to a search engine to find web pages like yours. |

| **Link /Hyperlink** | Sometimes called hyperlink, this can be text or graphics that when clicked on will take the user to another web page or point on the same web page. The most common form of these are the navigation links on a website. |
| --- | --- |
| **Linux** | Linux is popular as a powerful, low-cost operating system for running servers. The source code is freely available to everyone. |
| **Memory** | Is the area of a computer where programs and data are stored. |
| **Merchant account** | A specialised bank account that allows you to process credit cards online. |
| **Modem** | A device that converts the digital signal from a computer to an analogue signal that can be transmitted along an ordinary phone line. This allows computers to connect to the internet through a telephone line. |
| **MP3** | Is the technology and format for compressing a sound sequence into a very small file by removing the frequencies not audible to the human ear and preserving the original level of sound quality when it is played. |
| **Open Source** | Open source refers to any program whose source code is made available for use or modification and is usually developed as a public collaboration and made freely available to anyone who wants to use it. |

| | |
|---|---|
| **Pay Per Click (PPC) Advertising** | Sponsored advertising on search engines where adverts are placed at the top of search engine results depending on how much has been bid on the searched keyword. Payment is only made if the user then clicks the advert to the site. |
| **Payment Gateway** | A software usually provided by a third party that allows a website to be integrated to a merchant account. Most major merchant account providers include a gateway with their services. |
| **Plug-In** | A plug-in works with your web browser to allow it to do other things, such as play videos and music. Common browser plug-ins include Flash, QuickTime, Java. |
| **Search Engine** | A search engine helps people find what they are looking for on the web when they enter keywords for the subject on which they want information. Some of the more common search engines are Google, Yahoo and Alta Vista. Details of websites need to be submitted to search engines before they will appear in their listings. |
| **Search Engine Optimisation (SEO) or Website optimisation** | Search Engine Optimisation is a process or strategy to improve a webpage's ranking on a search engine results page. The factors involved in optimising a website include the content and structure of the website's copy and page layout and the submission process. The higher a Web site ranks in the results of a search, the greater the chance that your site will be found by a search user. |
| **Server** | A server is a networked computer that allows other users to access files (e.g. webpages) and/or applications (e.g. email ). |

| Shared Server | A server which provides service for many different Web sites. |
|---|---|
| Shopping Cart | A shopping cart is a piece of software that acts as an online store's catalogue and ordering process. A shopping cart is the interface from a website that allows visitors to select the products they want to buy and make a purchase. |
| Site or Website | A collection of related web pages on the World Wide Web under a common address that can be viewed through a browser. |
| Spam | Spam refers to the practice of blindly sending commercial messages or advertisements to email users or posting to newsgroups. |
| Spoofing | Is an attempt to gain access to a system by posing as an authorised user or the fraudulent imitation of a website in an attempt to gain credit card or bank details. |
| Static Pages | Pages that don't change. |
| Thumbnail | A small version of a bigger image on a web page, usually containing a hyperlink to a full-size version of the image. |
| Traffic | Traffic describes the amount of visitors who come to your website. The more traffic, the more visitors. |

| URL | The Uniform Resource Locator is a way of uniquely specifying the address of a website or file on the internet. The protocol used on the internet is Hyper Text Transfer Protocol (http).<br><br>The URL is usually made up of four parts:<br><br>**Protocol**: http://<br>**Domain or IP address**: www.mycompany.co.uk<br>**Path**: /public/<br>**Filename**: index.html<br><br>When this is typed into the address bar of the browser as http://www.mycompany.co.uk/public/index.html it would take you to the index page of the my company website. |
|---|---|
| **Virus** | A software program capable of reproducing itself and usually capable of causing great harm to files or other programs on the same computer. It spreads by copying itself into other programs or documents. |
| **W3C** | W3C is an acronym standing for the World Wide Web Consortium. This is the group that determines the standards for the technology behind the Web. |
| **Web Page** | A Web page is a document written in HTML and meant to be viewed in a Web browser on the internet or World Wide Web such as Netscape, internet Explorer, or Opera. |
| **World Wide Web** | The millions of pages of information on the internet that you can view through a browser. |

# Further Information

This list is not a recommendation of products, simply a list of alternatives. You will need to do your own analysis against your requirements and select what is suitable for you.

## *Web Authoring Tools*
Microsoft Front Page www.microsoft.com
Dreamweaver www.adobe.com

## *Template Sites*

www.buytemplates.net
www.webtemplatebiz.com
www.templatesbox.com

## *Payment Gateways*

www.authorize.net
www.verisign.com
www.worldpay.com
www.netbanx.com
www.durangomerchantservices.com
www.paypal.com

## *Shopping Cart Software*

www.netsuite.co.uk
www.paypal.co.uk
www.monstercommerce.com
www.shoppingcartdirect.com
www.quickcart.com
www.storefront.net
www.mals-e.com

### Payment Processing Company

www.epdq.co.uk
www.paypal.com
www.netbanx.com

### Search Engine Submission

Yahoo https://siteexplorer.search.yahoo.com/submit
Google http://www.google.com/addurl/
MSN http://search.msn.com/docs/submit.aspx

### Content Management Systems

http://www.opensourcecms.com allows you to try out some of the free open source content management systems.

http://www.cmsmatrix.org allows you do compare content management systems.

Adobe contribute www.adobe.com allows easy updates of existing websites with no technical expertise.

### Regulations

The Office of Fair Trading www.oft.gov.uk provides information about different trading laws and how they affect businesses.

The Department of Trade and Industry www.dti.gov.uk provides background information and guidance on all aspects of running a business.

### Data Protection Act

www.informationcommissioner.gov.uk
The Information Commissioner's Office
Wycliffe House
Water Lane
Wilmslow
Cheshire SK9 5AF

# Index